BEAUTY AND THE YEAST

A PHILOSOPHY OF WINE, LIFE, AND LOVE

DWIGHT FURROW

Probe Head Publications, San Diego, CA.

To Lynn

My wife and steadfast wine tasting partner

Copyright 2020 Dwight Furrow

All rights reserved. No part of this publication may be reproduced, distributed, or transmitted in any form or by any means, including photocopying, recording, or other electronic or mechanical methods, without the prior written permission of the publisher, except in the case of brief quotations embodied in critical reviews and certain other noncommercial uses permitted by copyright law. For permission requests, contact Dwight Furrow at dwightfurrow@gmail.com

Ebook ISBN: 978-1-7359832-0-2

Paperback ISBN: 978-1-7359832-1-9

Hardback ISBN: 978-1-7359832-2-6

LCCN: 2020920383

Published by Probe Head Publications, San Diego CA
https://foodandwineaesthetics.com/

Contact: dwightfurrow@gmail.com

Cover and interior design by Andy Meaden / meadencreative.com

Names:	Furrow, Dwight, author.
Title:	Beauty and the yeast : a philosophy of wine, life, and love / Dwight Furrow.
Description:	San Diego, CA: Probe Head Publications, [2020] \| Includes bibliographical references and index.
Identifiers:	ISBN: 978-1-7359832-2-6 (hardcover) \| 978-1-7359832-1-9 (paperback) \| 978-1-7359832-0-2 (ebook) \| LCCN: 2020920383
Subjects:	LCSH: Wine and winemaking—Aesthetic aspects. \| Wine and winemaking—Philosophy. \| Wine tasting—Philosophy. \| Wine—Sensory evaluation. \| Wine selection—Philosophy. \| Wine—Terminology. \| Wine—Psychological aspects. \| Aesthetics—Philosophy. \| Art—Philosophy.
Classification:	LCC: TP548 .F87 2020 \| DDC: 641.2/2--dc23

CONTENTS

Preface	3
Acknowledgments	5
Introduction	7
CHAPTER ONE Wine's Promise	21
The Epiphany	24
Love and Value	26
The Importance of Origins	30
Nature's Murmur	32
Inspirations:	35
CHAPTER TWO Vinous Vitality: Wine as a Living Organism	39
Biological Accounts of Life	42
Wine and "Thing-Power"	48
Natural Wine	57
Inspirations:	65
CHAPTER THREE Winemaking and Creativity: The Slow Art of Wine	69
Artists, Winemakers, and Their Materials	73
Artistic Intentions	79
Creativity in Winemaking	88
Inspirations:	92
CHAPTER FOUR Ambiente: It Takes a Village to Raise a Wine	97
The Importance of Traditions	102
Stasis and Change in the Wine World	104
Wine Criticism and Stylistic Innovation	110

The Threat of Homogeneity	118
The Difference Machine	124
Inspirations:	131
CHAPTER FIVE Wines of Anger and Joy: Vitality and Expression	135
Representation vs. Expression	136
Expressing Vitality	138
Music, Wine, and Emotion	142
Wine and Vitality Forms	155
Inspirations:	162
CHAPTER SIX Wine Criticism and Appreciation	167
What is Appreciation?	173
The Role of the Wine Critic	177
Inspirations:	180
CHAPTER SEVEN Wine and Aesthetic Experience	183
Burnham and Skilleås on Aesthetic Practice	186
Aesthetic Attention	190
Wine Tasting and the Sublime	197
Inspirations:	200
CHAPTER EIGHT Metaphor, Imagination, and the Language of Wine	203
Metaphor and Interpretive Challenges	208
Conceptual Metaphor Theory	211
Imagination and Metaphor	213
Inspirations:	219
CHAPTER NINE Beyond Objectivity and Subjectivity	221
Smith's Realism	226
The Non-Realist Account of Objectivity	229
Cain Todd's Limited Relativism	232
Burnham and Skilleås and the Authority of Traditions	234
Non-Realism and the Clash of Values in the Wine World	237
Dispositional Realism	244

The Failure of Representation	252
An Apprenticeship of Signs	256
The Skill of Wine Tasting	260
Creative Wine Tasting: Tasting the New	262
Objectivity Revisited	266
Inspirations:	272
CHAPTER TEN Beauty, Pathos, and Rhythm	279
Mystery, Ephemerality, and Pathos	282
Rival Communities and the Normativity of Beauty	286
The Sensual Dimension	291
Inspirations:	299
About the Author	303
Appendix: Tasting Vitality	305
Mouthfeel Characteristics:	307
Structure in Motion	312
The Intersection of Movement and Aromatics	321
Bringing Movement Characteristics into Focus	323
From Vitality Forms to Personality: Describing the Individuality of a Wine	324
The Meaning of Aromas and Flavors	325
Formal Arrangement of Flavors and Aromas	327
Metaphorical Attributions	333
The Attribution of Emotion or Personality Characteristics: A Few Examples	334
A Summary of Important Holistic Properties[3]	335
Index	337
Bibliography	345

PREFACE

This book emerged from a puzzling personal experience. For most of my adult life, I have been thinking and writing about issues that deeply touch everyone's life—moral values, free will, autonomy, and the fate of civilization. These are important issues, hard issues. Thinking about them inexorably leads to drinking more wine because they are, well, important and hard. The more wine I drank the more fascinating wine became and I felt compelled to write about it. So here we are. I still ponder the fate of civilization but only after taking notes on the latest pinot noir to cross my desk. Why would an academic contemplating the origin and justification of moral values feel a need to think about something as inconsequential as wine? I suppose the alcohol might be disrupting my good judgment, but I remain fascinated by wine even when stone-cold sober. I set out to discover the source of that fascination.

After roughly one thousand winery visits, conversations with hundreds of winemakers, extensive travel through wine regions in North America and Europe, and countless wine samples, I think I have the answer. However, only the reader can make that final judgment.

This book could not have been written without the many winemakers who have been so generous with their time in discussing their winemaking philosophy and strategies with me. Special thanks to Rick Jones, Clark Smith, and the participants in the Postmodern Winemaking Symposium who planted the seed for many of the ideas in this book. Those redoubts of the wine community where quality matters more than anything else have been genuinely inspiring.

BEAUTY AND THE YEAST

ACKNOWLEDGMENTS

I owe a special debt of gratitude to my beta readers. Their feedback has made this a much better book. Stephen Pacheco was especially helpful, as were suggestions from my wife Lynn and son Jordan. Thanks also to Clark Smith, who read and commented on a portion of the book.

Early versions of some of the chapters of this book were published on the blog site Three Quarks Daily. Thanks to Abbas Raza, editor of Three Quarks Daily, for the opportunity to publish there.

I also thank my editor Will Myers who helped polish my leaden prose and my book designer Andy Meaden for his creative input.

BEAUTY AND THE YEAST

INTRODUCTION

Since its origins in Eurasia some eight thousand years ago, wine has become a staple at dinner tables throughout the world. For a substantial portion of those wine consumers, wine is more than just a beverage. Some devote a lifetime to its study, spend fortunes tracking down rare bottles, and give up lucrative careers to spend their days on a tractor or hosing out barrels. For them, wine is an object of love. This book is an attempt to understand why fermented grape juice is worthy of such devotion.

My answer to this question is that wine, unique among beverages, displays the characteristics of a living organism. This "vitality" exhibited by wine in its production and appreciation has a distinctive appeal that is not well captured by conventional aesthetics and not well understood within the wine industry. Wine, when made properly, produces continuous, unpredictable, unintended variations that are aesthetically meaningful yet depend on processes of nature that we do not control. Thus, wine challenges concepts of artistic agency and subjectivity currently in favor in philosophical aesthetics. This creative entangling of nature and culture requires an analysis that deviates from mainstream aesthetics as well as existing work in the philosophy of wine. I hope to show that a proper understanding of fine wine requires us to revise our concepts of creativity, objectivity, aesthetic experience, expressiveness, and beauty to accommodate this collaboration between culture and nature.

I address these fundamental questions in aesthetics while being

fully aware of the controversies that roil the culture of wine lovers. When we are buried in tasting notes, scores, competitions, marketing trends, and sommelier exams that define our contemporary wine culture, we can lose sight of wine's deeper significance as a source of "soulfulness" or spirituality. In part, this is because wine is both a commodity and an art form, a pairing which muddles tasting practices that tend to address marketing imperatives with only perfunctory gestures at aesthetic appreciation. Furthermore, confusion regarding the supposed subjectivity of wine evaluation and our general lack of awareness of wine's power to express emotion limit its potential as an art form. The practical result is that even committed wine lovers fail to fully realize the opportunities for genuine aesthetic experiences. My primary aim in this book is to uncover this missing aesthetic dimension and show how it can enhance our experience of wine. By considering what makes wine a worthy object of love, we can deepen our connection to the distinctive aesthetic experiences it offers. I should note that I use the terms "wine world" or "wine community" to refer to people who enjoy learning about wine and think of their wine experiences as an important part of their lives, which includes most of the people in the wine industry. This is a relatively small subset of all wine consumers. However, they are crucial to the health of the wine industry because they support the premium and fine wine categories and the many thousands of small and medium-size wineries that define the culture of wine.

There are five main issues in the wine industry that I intend to resolve:

(1) The relative virtues of artisanal and industrial methods of production and why these distinctions matter in understanding wine as an aesthetic experience.

(2) The destructive and misleading debate around the question of whether wine evaluation is subjective or objective.

(3) The appropriate language to use when describing and evaluating

wine, a topic that addresses the conflict between marketing and aesthetics.

(4) The limitations of our current tasting model, which fails to capture the distinctiveness and individuality of wines.

(5) Because of climate change and the emergence of new wine regions, the wine world is rapidly changing. How should we think about these changes and their impact on wine appreciation?

An adequate program of wine education requires a clear understanding of these issues. More broadly, wine education should help wine lovers get the most out of their tasting experiences. However, wine education classes are seldom based on the appreciation of aesthetic value, and technical evaluations of wine mention only occasionally such aesthetic concepts as finesse, grace, or elegance.

The reason for the marginalization of aesthetics in the wine world runs deeper than the mere existence of wine as a commodity. In recent decades, wine has become democratized as more and more people, some of limited means, make wine a part of their lives. This democratization was facilitated by an increasingly sophisticated science and technology of wine production that enables wineries to produce mass quantities of pleasant, quaffable wines at low cost. Yet, these salutary developments have a negative impact on the aesthetics of wine.

Contemporary discussions of wine quality tend to oscillate, unhelpfully, between subjectivism and objectivism. These positions align with the trend toward democratization and a science-based understanding of wine. Proponents of wine democracy argue that wine quality is thoroughly subjective. They argue that individual differences among tasters preclude agreement on the nature or quality of what is being tasted. Some writers in the media enter the fray claiming that genuine wine expertise is non-existent since even experts disagree in their assessments. This radical subjectivism is promoted as a means

of making wine more accessible to a public intimidated by the arcane language of the wine community.

By contrast, a more science-based approach points to objective, scientific analyses of chemical components in wine that influence taste and smell, thus demonstrating an objective foundation for wine tasting. But chemical analyses cannot explain what makes a wine distinctive or aesthetically valuable.

Thus, neither objectivism nor subjectivism can explain the attention wine lovers pay to the aesthetic value of wine. For a subjectivist, there is no such thing as wine quality or aesthetic value. But neither does aesthetic value show up within objective, scientific analysis. Scientific analysis makes no attempt to address emergent properties of the whole wine, such as elegance or finesse. Since the terms of this debate leave no room for aesthetics, it isn't surprising that the significance of wine as an aesthetic object often goes unrealized.

Furthermore, the tasting method employed by wine professionals and wine educators fails to capture what is most captivating about wine. The current tasting model is based on analytic tasting, which employs blind tasting as the vehicle through which wine is presented for evaluation. In blind tasting, tasters are trained to dissect wine into its component elements while being unaware of the producer who makes the wine, the geographical region in which the grapes are grown, and sometimes the grape varietal used. By eliminating bias, analytical tasting seeks to provide an objective assessment of the wine. While such a methodology is important when commercial expectations of a wine's elements are well-defined, it limits aesthetic appreciation of the wine as a whole. Without knowing the origin of a wine, it is impossible to assess the degree to which the wine realizes the potential of the materials from which the wine is made. Furthermore, in the interests of maintaining objectivity, analytic tasting discounts the emotional connection that helps explain our fascination with wine. Even when not tasting blind, the aesthetic categories commonly used to describe the expressiveness of wine are too limited to communicate

the full potential of wine as an aesthetic object. Part of my aim in this book is to supply these missing aesthetic categories and show how they can enhance our experience of wine.

Percolating beneath the surface of these controversies is the question of whether wine is a proper object of aesthetic attention at all and, if so, what kind of object it is. On the one hand, mammoth global wine companies turn out an industrial product with brands distinguished by marketing and sold on supermarket shelves like orange juice and milk. On the other hand, small, artisan producers, using traditional methods of production, adhere to the ideology that the winemaker's role is to stay out of the way and allow the distinctive character of the grapes to be expressed. There are, of course, many winemakers who fall in between these two extremes. Does either production method look like art production, which provides the model for much of our thinking about aesthetics? What role does imagination or creativity play in wine production? Are the categories we use to understand aesthetics in the arts appropriate when applied to an object that is, in part, a product of nature? Disagreements about the "being" of wine, the kind of object it is, inhibit the acknowledgment of wine's aesthetic potential.

The result of these difficulties is a wine community that falls head over heels for fermented grape juice but lacks the resources to explain such devotion. These are practical matters because they influence our ability to articulate the nature of wine quality. Sommeliers, winemakers, and wine writers confront the difficulty of explaining wine's allure. Despite a sophisticated tasting model and a robust public discourse about wine, we lack a conceptual framework that provides a comprehensive understanding of wine quality and aesthetics.

In order to solve these problems, we need a clearer understanding of what wine is—an ontology of wine—and a firmer grasp of the aesthetic ideals toward which winemaking strives.[1] We also need a more robust grasp of what we mean by "subjective" and "objective." These traditional philosophical questions are at the root of the more

practical problems in the wine world mentioned above. Thankfully, this conversation on the aesthetics of wine has already begun. Although still a relatively minor topic, discussions of the aesthetics of wine in philosophical circles have become more common in recent years. The work of Barry Smith, Douglas Burnham and Ole Skilleås, Cain Todd, and the contributors to various anthologies on the philosophy of wine have ably demonstrated that wine is a worthy object of aesthetic attention and philosophical contemplation.[2] Yet, most of these discussions explain current tasting practices and make only muted calls for reform. If those tasting practices are limited, so will be the philosophical accounts of them. Furthermore, eighteenth-century philosopher Immanuel Kant still deeply influences aesthetic discourse both in philosophy and in the larger culture. Although his powerful account of our shared cognitive capacities has enabled us to escape the worst excesses of subjectivism and relativism, the account of intersubjectivity that emerges from Kant's view is too thin to explain the justification of aesthetic judgments, from which he excluded wine, in any case. Kant's excessive focus on aesthetic pleasure at the expense of the processes of aesthetic production omits important dimensions of aesthetic appreciation. *Beauty and the Yeast* aims to solve these problems by providing a richer account of what wine is and how we come to discover its properties, ultimately providing a realist account of the capacity of wine to generate aesthetic pleasure.[3]

The argument framing this book is that wine is an expressive medium. What do wines express? The general answer is that wines express "vitality." Wine should be understood as a living thing, the focal point of a living system that includes the wine, its production context, the wine lover, and her community. Wine is both a natural object and a culturally embedded artifact. The "living" aspect of wine—its constant variation, rootedness in nature, and resistance to human intentions—is itself alluring. In the wine world, beyond the big, industrial wine manufacturers, everything about the process of making wine is unpredictable. Each vintage is different, even minor

changes in weather disrupt expectations, and methods that work for one winery do not work for the winery next door. The surprise, the indeterminacy, the unknowns about how it will develop, and the promise of new flavor experiences lend wine an aura of mystery. This unpredictability is best described as "thing-power," to use Jane Bennett's felicitous phrase, by which I mean that wine is, in part, a natural object with its own dispositions that resist human intentions. Wine exists at the intersection of the wild and the cultivated, and that delicate dance between nature and culture gives wine its allure, at least for wine lovers who devote their lives to the pursuit of vinous beauty. "Vitality" is therefore a master concept in this book, which I use to identify different aspects of wine's allure. The reader should be aware that the precise meaning of "vitality" shifts depending on whether the topic under discussion is the grapes in the vineyard, the wine in barrel or bottle, or our appreciation of wine as we taste it. In all cases, however, "vitality" refers to "signs of life," indicators of underlying processes of continued existence. The various uses of the term "vitality" in this book point to different aspects of living processes, all of which wine expresses.

If we fully embrace this notion of wine as a living thing, important implications for wine production, appreciation, and wine aesthetics follow. Wine production and wine tasting become a search for meaningful differences and originality. The collaborative creativity of nature and the wine community becomes part of wine's allure. The emergent property of vitality takes its place alongside complexity, elegance, and intensity as criteria for wine excellence.[4] An understanding of the emotional resonance of wines then becomes a central component of wine appreciation. Most importantly, we can replace the unhelpful concepts of subjectivism and objectivism, as traditionally conceived, with a more nuanced view of the dynamic, constructive intercourse between mind and world in aesthetic appreciation. But if we are to understand the allure of these "wild" aspects of wine, we must understand not only the dispositions in the

materials winemakers use in making wine but the intentions and aesthetic aims of winemakers as well. Wine is an achievement, an achievement of nature, culture, the winemaker, and her community. The way in which these elements come together in a specific wine is crucial to understanding wine quality. In fact, this attention to the process of winemaking will help resolve many of the debates about objectivity and subjectivity. Objective facts about how a wine emerges constitute criteria for what counts as fine wine.

Thus, in answering the question "what is wine?" the first part of this book focuses on the aesthetics of the winemaking process. Chapters One and Two are devoted to laying out the conceptual framework that will inform the rest of the book. In Chapter One, I argue that wine is a suitable object of love, a beverage that has the depth of meaning that sustains long-term commitment.

Chapter Two explores the aesthetic appeal of this struggle with nature and develops an ontology of wine. The variations and transformations that wine undergoes have led to claims that wine is a living organism. Our aesthetic response to wine is, in part, a response to this vitality. I analyze this claim through the lens of biology and argue that living systems theory provides a definition of life most appropriate to wine. However, the aesthetic appeal of wine as a living thing must be supplemented by Jane Bennett's notion of thing-power. Thing-power refers to the capacity of objects to resist human intention and exhibit their own quasi-agency. This "wild" aspect of both grapes and wine helps explain its appeal. Because thing-power resists human intentions as well as our ability to conceptualize it, this ontology of wine is the initial move in reframing the conflict between subjectivism and objectivism. The conclusion of this chapter is that unexpected variation is the key to an aesthetics of wine. The chapter closes with a discussion of natural wine, a contemporary movement in wine production that represents an avant-garde in which thing-power has ultimate value.

In Chapter Three, I argue that some wines are works of art by

providing a theory of creativity that is, in some respects, unique to the winemaking process. The most important argument against wine as art is that art requires an artist's intention to produce particular aesthetic effects. Because winemakers have limited control over weather and depend on the quality of their grapes to produce aesthetic effects, the argument goes, they cannot control their product in the way artists can. This argument misunderstands the creative process both in the arts and in the process of winemaking. Artists depend on the dispositions of their materials just as winemakers do, and much of what occurs in artistic creativity is not the result of specific aesthetic intentions. I go on to show that the "watchful waiting" that characterizes wine production requires imagination and intention and that winemakers concerned with originality share with artists a common set of general intentions sufficient to confer artistic status on their wines.

One upshot of this discussion is that creativity does not reside in the activities or intentions of a single person. Expanding on the claim that wine is the focal point of a living system, in Chapter Four, I describe the surrounding milieu of wine production, viewing some aspects of wine production as a group project requiring a form of collective intentionality. Wine traditions, origin stories, laws that regulate wine production, tasting norms and procedures, critical discussions in media, the connection to food consumption, and the romance of wine as a symbol of the good life are part of what I call "ambiente." The argument in this chapter seeks to explain the dynamics of change in the wine world. This is related to the issue of creativity in the previous chapter but looked at from the perspective of how the new emerges from a social milieu that is often deeply tied to traditions and social status.

After laying out the ontology of wine and the aesthetics of the production process, I then turn to the aesthetic experience of wine. Chapter Five deepens the analysis of vitality and thing-power by embedding these concepts in an expressivist theory of aesthetics. The

fact that wine exhibits features of a living thing justifies the claim that wine expresses vitality. I then show that wine can also express emotions and, to fully appreciate wine, we must include emotional expression among its properties. I show that the attribution of specific emotions to wine is based on real psychological phenomena called "vitality forms" in the psychological literature. This argument proceeds by comparing wine's expressiveness to musical expression.

Chapter Six takes up the role of wine criticism. The main purpose of wine writing and criticism is not to aid purchasing decisions but to help wine lovers appreciate a wine. Wine evaluation aids appreciation by pointing to markers of quality and explaining their significance. From this discussion, I draw the conclusion that the most important feature of any wine, the characteristic on which appreciation depends, is the degree to which a wine is distinctive. By "distinctive," I mean variation that is of value or high quality. Thus, the primary job of the wine critic is to track variation and distinctiveness and report it to her readers. This chapter begins to make the case that wine aesthetics is too often focused on judgment at the expense of appreciation.

How does wine move the mind and the heart? Chapter Seven situates wine tasting within the context of everyday aesthetics and develops an account of aesthetic experience appropriate to wine. Relying on work in the philosophy of perception, I argue that aesthetic experience should be understood as a distinctive form of aesthetic attention that is focused on a perceptual object, distributed with regard to properties, and admits of degrees of focus and concentration. I distinguish aesthetic attention from other forms of attention associated with consuming wine. This chapter includes a critique of the concept of an aesthetic project developed in *The Aesthetics of Wine* by Burnham and Skilleås, which I argue excludes a variety of manifestly aesthetic experiences. In this chapter, I devote special attention to how we can respond to aesthetic experiences that escape our analytic categories and induce an experience of the sublime, which is central to the aesthetic appreciation of wine.

The experience of wine is notoriously difficult to capture in language. Attempts to do so are often treated with derision in the wine world. Chapter Eight makes the case that general criticisms of wine language are misguided; the wine community cannot do without these attempts to describe aesthetic experience. The role of metaphor and imagination in communication about wine is elaborated and defended as the best way of capturing the variations of which wine is capable.

Chapter Nine discusses the concepts of objectivity, intersubjectivity, and subjectivity, arguing that, as they are conventionally understood, these are not helpful in understanding wine aesthetics. Disagreements about wine quality, even among experts, are legion. This leads many to argue that wine quality is a subjective matter, thus diminishing the role of critical and aesthetic standards. In opposition to this account of subjectivism, I argue that wine appreciation and evaluation are a product of the meshwork through which our psychology becomes engaged with an independent world, a relationship that can be neither wholly subjective nor wholly objective. After a detailed discussion of the philosophical debate about this issue in the work of Barry Smith, Cain Todd, and Burnham and Skilleås, I develop a dispositional realist theory of objectivity in aesthetics based on the idea that objectivity is best understood as judgment constrained by something not within our control. The virtue of this theory is that intersubjective agreement is neither an indicator nor a condition of objectivity, thus setting aside worries about disagreement among critics.

Finally, Chapter Ten pulls together several threads from earlier chapters in developing a theory of beauty specific to wine, while drawing on traditional discussions of this difficult concept. In earlier chapters, I have argued that the essence of our love of wine is a mystery that draws us in, inducing a longing for further experience that, since the ancients, has been associated with beauty. This sense of mystery is deepened by the constant variations that wine exhibits and wine's inherent ephemerality. The concept of beauty, when applied to wine, has to do with how the ephemerality of a wine's properties are staged

and dramatized in a sensual medium, an account that relies on the dynamic movement of wine on the palate. The fecundity of life and the pathos of its disintegration are the underlying themes of beauty readily expressed by wine as it emerges, ages, and fades. I include a discussion of the normativity of beauty that departs significantly from Kant's view that genuine aesthetic judgments aspire to universal validity.

The foregoing chapters have argued that distinctive variation and the expression of vitality are essential to the aesthetics of wine. Thus, we need tasting practices oriented toward tracking these features. In the appendix, I provide a conceptual framework for characterizing the vitality and individuality of wines and the variations of which wine is capable that is compatible with, but goes beyond, the aroma wheel and conventional understandings of typicity now used in wine-education courses. I develop parameters for identifying the vitality of wine by focusing especially on the perceived movement of wine on the palate.

Notes

1 Ontology is the philosophical study of what exists, the kinds of things that exist, and their relations. An ontology of wine asks the question: What kind of object is a wine?

2 These works, in my judgment, along with Carolyn Korsmeyer's seminal work, *Making Sense of Taste: Food and Philosophy*, and articles by Keven Sweeney, among others, have thoroughly refuted claims that wine or other taste objects cannot be serious aesthetic objects. Thus, I will not rehearse these arguments in this text but will, instead, trace new implications of them. For seminal work in the aesthetics of wine see the following texts: Carolyn Korsmeyer, *Making Sense of Taste* (Ithaca: Cornell University Press, 2002); Douglas Burnham and Ole Skilleås, *The Aesthetics of Wine* (New Jersey: John Wiley and Sons, 2012); Cain Todd, *The Philosophy of Wine: A Case of Truth, Beauty, and Intoxication* (Montreal: McGill-Queens University Press, 2010); Kevin Sweeney, "Structure in Wine," in "WineWorld: New Essays on Wine, Taste, Philosophy, and Aesthetics," edited by Nicola Perullo, special issue, Rivista di Estetica 51 (2012). https://journals.openedition.org/estetica/1388?lang=en.

3 For philosophers familiar with debates in the philosophy of wine, it is worth briefly comparing my theory to others. Like Burnham and Skilleås, I defend a contextualist aesthetics, but I emphasize the emergence of new variations

as the focus of aesthetic appreciation rather than the historical factors emphasized by Burnham and Skilleås. I also anchor my aesthetics in an ontology of wine in contrast to their phenomenological approach. Like Cain Todd, I defend an expressivist account of wine appreciation. However, unlike Todd, I understand expression in wine as manifesting an emergent vitality that is not reducible to subjective experience. Like Barry Smith I defend aesthetic realism, but mine is a realism of capacities and dispositions, not properties.

4 I use the term "emergent property" throughout the book. An emergent property is a feature of a complex system that is not shared by the system's components or elements. For example, the flavor of salt is an emergent property because neither a sodium molecule nor a chloride molecule tastes salty.

BEAUTY AND THE YEAST

CHAPTER ONE

WINE'S PROMISE

"Wine is one of the most civilized things in the world and one of the most natural things of the world that has been brought to the greatest perfection, and it offers a greater range for enjoyment and appreciation than, possibly, any other purely sensory thing."

Ernest Hemingway

We throw the word "love" around without really meaning it. We "love" ice cream, sunsets, or the latest soon-to-be-forgotten pop song. Such "love" requires no commitment and hardly seems worthy of being in the same category as the love of one's children or spouse. Yet, some objects or activities are worthy objects of love because they solicit sustained attention and care—for example, great works of art, a vocation, baseball, or religion. For some people, wine falls into this category of worthy objects of love. For people who abandon lucrative, stable careers for the uncertainties and struggles of winemaking or those who put in the time and effort to understand wines' considerable intricacies, wine has an attraction that goes beyond mere "liking." This attraction has a spiritual dimension that requires explanation.[1]

The spiritual dimension of wine has a long history. Dionysus, the Greek god of wine, was said to inhabit the soul with the power of ecstasy. The Ancient Greek word *ekstasis* meant standing outside the self via madness or artistic expression, and wine was thought to encourage that transformation. The Romans called the same god Bacchus with similar associations. The Judeo-Christian world tames the ecstasy yet still acknowledges the virtues of wine. Judaism has long included wine in its rituals, for which it incorporates a specific blessing, and, of course, to Christians wine represents the blood of Christ and receives many mentions in the Bible. Other alcoholic beverages have existed for as long or longer than wine, but none have its spiritual connotations. Today, wine is just one among many alcoholic beverages consumed in great quantities. Yet it sustains its sacramental role—as status symbol, fashion statement, a sign of class, refinement, or sophistication, a source of intellectual delight, the object of a quest for a peak experience, or the focal point of social life—all contemporary renderings of "spiritual," some more debased than others.

What makes wine an appropriate object of love? Why does wine have this spiritual dimension? It is not only because of the alcohol. Cheap whiskey doesn't have it. It is not because it tastes good. Many beverages and foods taste good, but they lack wine's power to move us. Spirituality is about inward transformation. Dionysus was a gender-bending, shape-shifting god who entered the soul and transformed the identity of the one afflicted. Go with Dionysus and achieve ecstasy by escaping the confines of one's identity; resist and be torn apart by conflicting passions, according to the myth. Wine, too, is about transformation—the grapes in the vineyard, the wine in the barrel and bottle, the drink in the glass as its volatile chemicals release an aromatic kaleidoscope of fleeting, irresolute incense. Wine changes profoundly over time. In turn, the drinker is transformed by the wine. But not merely by the alcoholic loosening of inhibitions or the ersatz identity appropriated through wine's association with status. Instead,

the wine lover, at least on occasion, is transformed by the openness to experience she undergoes when gripped by sensations whose beauty compels her full attention. For unlike any other drink, wine can arrest our habitual heedlessness and distracted preoccupation. It rivets our attention on something awe-inspiring yet utterly inconsequential, without aim or purpose, lacking in survival value or monetary reward. Wine is an object of love that achieves this connection through its mystery, a claim that will require several chapters to fully defend.

To be gripped by a sensation of genuine quality—not merely having a sensation but being moved by it—is a pre-condition of love. By "genuine quality," I mean the properties of something or someone that promise more than superficial engagement because they exhibit great complexity and intensity and provide a deep contrast with static, familiar, ordinary things. Complexity, intensity, and stark singularity move us because they indicate that our relationship to an object that possesses them has great developmental potential. They extend the promise that further involvement will take us on a journey where we can forge new paths and make new connections. There is mystery about the object and how it unfolds over time that sparks the imagination and draws us to it. This felt potential for further engagement is a natural lure that makes something "loveable" and demands that we care about it.

The people we fall in love with engender this mystery by virtue of their complexity, intensity, or stark contrast with the ordinary. The wines we fall in love with have this as well. It is the essence of the "aha" moment that most wine lovers experience and strive to rediscover. It is not merely sensory qualities that matter but the potential for further engagement signaled by those sensory qualities that captivates, a promise of things to come that sparks the imagination. Ice cream, sunsets, and mere acquaintances don't provide that spark. Whether we fall in love or not depends on how that engagement proceeds, but the initial impetus toward love is aesthetic and seems akin to a sculptor seeing potential in a block of stone. Love begins as a promise of

adventure dragging us toward an indeterminate end, opening worlds that, in the throes of infatuation, we see only dimly. When we are so transfixed by the sensory surface of the world, we stand outside the nexus of practical concerns and settling of accounts that makes up the everyday self. Shorn of that identity, we drink in the flavors seduced by the thought that there is great promise in the world toward which the self opens and is drawn. This is part of the attraction of great art and music: a moment of ecstasy. So it is with wine. No other beverage has the depth and complexity to create that momentary mutation of the self, a claim I will defend in greater depth as we proceed.

The Epiphany

Almost everyone with deep ties to the culture of wine has a story about their "aha" experience, the precise moment when they discovered there was something extraordinary about wine. For some, that moment is a sudden, unexpected wave of emotion that overcomes them as they drink a wine that seems utterly superior to anything they had consumed in the past. For others, it is the culmination of many lesser experiences that, over time, gather and build to a crescendo, and they recognize that these disparate paths all lead to a consummate experience that should be a constant presence in their lives. For me, it was the former. As a casual and occasional consumer of ordinary wine for many years, I had my first taste of quality pinot noir in a fine Asian "tapas" restaurant. I was blown away by the finesse with which the spice notes in the food seemed to resonate with similar flavors in the wine. The wine, I now know, was an ordinary, mid-priced pinot noir from Carneros; Artesa was the producer. But to me, in that moment, it was extraordinarily beautiful, and I resolved to make that experience a regular part of my life.

A simple Google search will turn up any number of these stories. *The Wall Street Journal*'s Lettie Teague interviewed several wine lovers

about their "aha" moment.[2] One became intrigued by wine while an art student in Italy, another when he discovered he had a discerning palate. Many report childhood experiences of being impressed by the serious conversations about wine among the adults in their lives. Others were intrigued by wine's complexity or the sense of adventure and risk involved in the winemaking process. Teague herself reports that the wine talk of her study-abroad family in Ireland was the catalyst that launched her career as a wine writer. These stories have two things in common. In each case, the experiences are motivating. Like all experiences of beauty, we do not passively have them and move on. The recognition of genuine beauty inspires us to want more. As philosopher Alexander Nehamas writes, comparing our response to beautiful persons to our response to art:

> A work we admire, a work we love, a work we find, in a word, beautiful sparks within us the same need to rush to converse with it, the same sense that it has more to offer, the same willingness to submit to it, the same desire to make it part of our life.[3]

The second feature of these stories is that the "aha" moment happens only after the stage has been set. A novice with little prior experience with wine or engagement with wine culture lacks the discernment to experience an "aha" moment. It is fundamentally an experience of difference that can have an impact only if a storehouse of ordinary experience has already been assembled. Only after we build an intuitive sense of what wine should taste like and what quality means can the conditions for an "aha" moment be present. Some of the above reports are of people who experienced their epiphany when very young, but in these cases they had been exposed to wine and wine talk over a significant period of time and were already thoroughly absorbed in wine culture and exposed to the belief that wine is something extraordinary.

These two features, the motivational dimension and the need for

stage-setting, suggests that the "aha" experience is more than just an experience of pleasure. It has the depth of meaning and allure that we associate with falling in love. To the uninitiated, this may sound peculiar if not hyperbolic and confused. Wine talk is relentlessly criticized for being pretentious and without substance, and wine lovers can be an object of derision when their obsession is on display. Shouldn't the word "love" be confined to our feelings for persons, pets, or spiritual beings? For those who have not yet swooned, perhaps wine seems too insignificant to be a proper object of loving attention. To see why this dismissive attitude is mistaken, we need to explore the nature of love and the role that sensibility plays in the development of loving attachments.

Love and Value

Love is a response to the perception of value. We love something when we discover consummate value in it. But we do not love something because we have reasons to do so. Love is not primarily an intellectual apprehension like assenting to the conclusion of an argument. It is a feeling of strong attraction, but one based on perception and sensibility. Love begins when we sense that something is pregnant with possibility.

This claim that love in its initial stages rests on perception and sensibility is controversial and requires some defense. Even ordinary, everyday perceptions are infused with implicit value judgments related to possibilities and our expectations about them. I do not simply see the bus hurtling down the street but judge its trajectory as benign or threatening, as normal or abnormal, and these value judgments are as much a part of our perceptions as sensing a color, shape, or flavor. This is especially true of what we ingest. When we taste, we immediately make a value judgment—we like it or we don't, it's familiar or unfamiliar, apparently safe or potentially dangerous.

These judgments we make as part of our perceptual sensibilities are not judgments of something static. The things we perceive are disposed to change. A glass bowl is disposed to break even when sitting comfortably on a shelf, a disposition that becomes more evident when the shelf tilts. This expectation of change, the intuition that objects exist on a trajectory of ordered transformation related to an object's possibilities, is built into our perceptual judgments, and we, therefore, without deliberation, reach out to prevent the bowl from falling. Part of our perceptual sensibility is recognizing the potential of a situation; often, this is nothing more than a pervasive feeling of rightness or wrongness that motivates us to act.[4]

So it is with love. The initial affinities that ultimately become full-blown love emerge from this pervasive quality of pregnant possibility of a thing as we encounter it in experience. The example above of a generic bowl sitting on a generic shelf was of a simple object with a limited set of dispositions that result in routine expectations. It isn't pregnant with unfolding possibilities and is unlikely to be loved without special circumstances that allow it to acquire more potential. However, many persons, objects, or practices that we encounter have deep and diverse potential based on the recognition of developing but incomplete patterns in their nature, some of which our actions can help complete. We see in them the potential for further involvement, not as a plan or policy but as a felt richness when they seem tailor-made for our engagement.

Wine offers this kind of engagement. Once we have some knowledge and experience with wine, we sense many dimensions influenced by a vast number of unpredictable factors. It is only fermented grape juice, but it displays a seemingly infinite array of ways of being delicious. All these differing flavor profiles reflect significant geographical variations across much of the globe, as well as deeply embedded cultural traditions and the imaginations of dedicated winemakers, all in symbiotic relation to the foods we eat, and all in constant change. Immersion in wine culture enables us to sense this potential for difference and variation.

This is the real meaning of "quality": a set of dispositional properties that promise more than superficial engagement because they have great variety, intensity, and depth that contrast with static, familiar, completed patterns.[5] This felt potential for further engagement is a natural lure, an attractant that demands our active pursuit. In the "aha" moment, we sense a world opening up that seems to have no boundaries yet draws all of life together. In this respect, wine is no different from other things we love. Everything we encounter offers an opportunity for a continuing transaction, whether through attraction or repulsion. The things we end up loving—our children, romantic partners, friends, activities, or objects such as wine, music, sports, books, etc.—initially grip us because we sense they are redolent with possibilities. Sensation has a holistic, agential quality; the restless energy of curiosity commandeers our sensory mechanisms and employs them as probes seeking intensity, qualitative contrast, and potential patterns to be completed by further actions. The value judgments we make about objects, activities, or persons begin as this affective "standing out" against a background of normalcy. The "aha" moment is possible only when we have enough acquaintance with wine to sense all of this. The love of wine, therefore, is not merely a passive, pleasurable response to a stimulus. It is shot through with expectations, judgments, and lures to act.

The "aha" moment is a moment in which you taste something you have never tasted before, even if you had consumed that wine in the past. It is an experience of depth and a recognition that there is more here than one might expect; the wine and the wine world have more to give; my engagement hasn't reached its full potential. Beauty draws us in because the patterns we sense in beautiful objects are incomplete, a claim I will discuss in more depth in Chapter Ten.

This anticipation of something more, this surfeit of potential, amounts to a love of mystery. As we dig into the wine world, we discover that wine is full of surprises. As tasters, we are surprised by new, unexpected taste experiences that seem inexplicable despite our

background knowledge. For winemakers, every vintage is different and poses new challenges that their university textbooks and theories struggle to explain. How a wine will develop in the barrel, in the bottle, or in the glass is unknown even to experts, and predictions about these matters are continually flouted. Even the nature of what is in the glass in front of you is a bit of a mystery. Wine is inherently a vague object with features difficult to detect even with training. Unlike the clarity of objects directly in our visual field, wine gives us only hints of flavors, scents, and textures. Furthermore, because wine is continually changing, and so are we as we experience it, a wine will not sit still for our analysis. Understanding a wine is like tracking a ghost through fog. This mystery drives people to make wine and study it. All of this is, of course, enhanced by alcohol, the mild buzz that stops short of drunkenness that enables heightened perceptions, an openness of the self to what lies beyond it. For those who claim wine is just a beverage and wine lovers are pretentious snobs for taking it seriously, we wine lovers have only compassion, or less generously, pity.

A caveat is in order before we explore more deeply the mystery of wine. It is essential we keep in mind that wine is many things to many people. When I refer to the epiphany of wine, I am referring to a subset of wine experiences not necessarily shared by most wine consumers. For most casual wine drinkers, wine provides a pleasant way to relax after a hard day at work. It may be a necessary ingredient of a satisfying meal or a means of generating conviviality and good cheer when gathering with friends or family. These are all among the joys of wine and quite central to wines' place in culture, and there is an aesthetic dimension to these activities that we will explore later. For wine to serve these everyday functions, I doubt that mystery plays a central role. I suspect that most casual wine drinkers would be puzzled by the claim that wine is mysterious. However, for people who call themselves oenophiles, who look upon wine as a pursuit, wine acquires this added dimension of mystery.

Is wine uniquely capable among beverages of producing this

loving attachment? Far be it from me to argue with beer or scotch fans, but only wine seems to have the strong connection to place, traversing the boundary between nature and culture that becomes more fascinating the more "nature" disappears under the onslaught of modern technology. That something so cultured and refined is subject to the vagaries of geography and utterly dependent on farming is one of the enduring mysteries of wine, a transformation to which bearing witness deserves to be called epiphany.

The Importance of Origins

What is it about wine that can deliver on this sense of mystery and adventure? Is wine just a pretty face promising something that in the end remains superficial and incapable of sustaining mystery? Sensuality is only the beginning of love; a beloved must reward sustained attention. It must really have the depth of meaning the sensory surface promises, or we will lose interest. Indeed, attraction to wine does not remain purely sensual. Most people who are captivated by wine do more than drink it. They want to learn about it or produce it or seek it out; to embark on a path of discovery.

Beyond sensory enjoyment, wine is an object of love because it reflects its origins. Wine, when properly made, exhibits the features of the vineyard and climate in which the grapes are grown, the decisions of the winemaker when contemplating her approach to a vintage, the craft and skill of the crew that makes the wine, and the taste of the community that has nurtured a style of winemaking for decades if not centuries. It is that fascination with origins that sustains the pursuit. Why should this evocation of origins be so important? Psychologist Paul Bloom has argued that fascination with origins is baked into human experience. Bloom writes:

> [W]e respond to what we believe are objects' deeper

properties, including their histories. Sensory properties are relevant and so is signaling, but the pleasure we get from the right sort of history explains much of the lure of luxury items—and of more mundane consumer items as well.... We are not empiricists, obsessed with appearance. Rather, the surfaces of things are significant largely because they reflect an object's deeper nature.[6]

According to Bloom, a genuine Armani suit or Rolex watch is worth more than an identical knock-off because we care about their origins. We value objects more if we own them, chose them, or had to work hard to get them. We value objects that have been touched by celebrities or have some special story behind them, especially if they have something to do with our own past. What all these examples have in common is an evocative history. In his book *How Pleasure Works*, Bloom assembles compelling empirical evidence that this focus on history is universal and emerges early in childhood. Bloom's analysis seems especially appropriate for wine because the wine world has traditionally been organized to reflect the importance of history and place of origin. Connoisseurs spend thousands for a bottle of Lafite-Rothschild, a storied chateau in Bordeaux, the most famous wine region in the world, even though there are wines with sensory features equally compelling at a fraction of the cost. Classic wine regions have, for centuries, marketed wines based on location rather than varietal because consumers value this connection to place. Wine lovers fall head over heels for wines from obscure regions or that are distinctive because they reflect the unique characteristics of a vineyard, even though perfectly acceptable industrial wines are available at the supermarket. Wine tourists are willing to spend forty dollars for a bottle at the winery that might be worth ten dollars on the supermarket shelf, especially if they meet the winemaker and tour the facility where the wine is made and thus are able to connect the wine to its origin. Wine is a beverage uniquely able to reflect its origins via flavors, aromas, and textures, and classic wine regions have spent

centuries cultivating those characteristics that make them distinctive.[7] Newer wine regions are hard at work trying to discover what sets them apart because having a compelling story about origins will connect them to wine lovers.

However, Bloom is wrong to discount the importance of sensory properties. The origins of wine matter because they create sensory differences, distinctive sensory properties that are available only from that place of origin and have aesthetic value. If a wine lacks interesting sensory properties, we won't care about its origins and will quickly lose interest. When I first attentively encountered a well-stocked wine aisle of the supermarket, I was fascinated by the differences in varietals, geography, and symbolic associations suggested by the wine labels—until I discovered many of these wines taste the same. Although love begins with sensation, the beloved must deliver more—only the constant search for difference will preserve the mystery of wine. The allure of distinctive locations and the unique human qualities of their inhabitants feed its production and engender a love of wine, because they have the depth to carry us on a journey of discovery and connection.

This is why artisanal winemaking methods and an ideology that resists industrial winemaking processes that cover up or distort the influence of origins are so important in preserving wine's status as an object of love. Without that connection to origins, wine risks becoming just another commodity, pleasant and enjoyable to be sure, but without the depth of meaning that wine lovers crave, and therefore incapable of fulfilling the promise to climb love's ladder.

Nature's Murmur

For many wine lovers, I suspect the foregoing has not been controversial since the importance of origins has long been a feature

of serious wine appreciation. But I want to argue that there is a deeper connection with origins that explains wine's attraction. Although wine is one of the most alluring products of human culture, we are attracted to it in part due to its capacity to reveal nature. When made with proper care, the structure and flavor of a wine reflect its origins in grapes grown in a unique geographical location with unique soils, weather, and sometimes native yeasts. Although the grape juice becomes wine through a controlled fermentation process and is the outcome of an idea brought to fruition by means of modern technology, the basic material came into existence through nature's bounty—roots, trunk, and leaves interacting with soil, sun, and rain. Despite the technological transformations that occur downstream, a wine's character is thoroughly dependent on what takes place inside the clusters of grapes hanging on the vine in a unique location.

As any winemaker will tell you, you cannot make good wine from bad grapes, and the character of a wine will depend substantially on those natural processes in the vineyard. When you savor a delicious wine, you savor the effects of morning fog, midday heat, wind that banishes disease, soil that regulates water and nutrient uptake, bacteria that influence vine health, native yeasts that influence fermentation, the effects of frost in the spring, of rain during harvest—an endless litany of natural processes over which winemakers and viticulturists often have only limited control. In this respect, wine differs from most other beverages, some of which are made in a factory by putting ingredients together according to a recipe, others that are direct products of agriculture but do not as readily display the unique character of their origins. Orange juice from California tastes like orange juice from Florida once it is processed for mass consumption. Beer can be made anywhere without significant geographical effects on flavor or texture. Not so with wine. The taste of geographical difference fascinates, but importantly, these differences are, in part, nature's murmur.[8]

However, the nature revealed through wine is not "unspoiled nature." All agriculture is a form of cultivation and thus equally part of

culture. The influence of nature on wine is made possible by countless human decisions in the vineyard and winery. The effects of midday heat can be shaped by positioning vine shoots on wires and controlling the leaf canopy. Vine health can be controlled through chemical sprays or herbal teas that discourage pests. The effects of native yeast can be counteracted by commercial yeast and the threat of spring frost mitigated by wind machines and thoughtful planting. Of course, processes of vinification and ageing also contribute substantially to the final product. Wine does not make itself and, although grapes can grow wild, only careful cultivation in the vineyard and the winery will make a wine drinkable, let alone worthy of being savored.

Although it is a highly edited version of nature that wine lovers admire, it is nature nevertheless because the central fact about winemaking is that nature is obdurate, recalcitrant, always pushing back against even the most ingenious cultivation. Despite our significant advances in technology, winemaking is a matter of riding the maelstrom. Or, to employ a different metaphor, nature throws curves that only the best winemakers can hit out of the park, and every curveball is a little different from the last. Even minor variations in weather, especially the timing of weather events, can profoundly affect the condition of the grapes and, ultimately, the taste of the wine. Whatever the intentions of the winemaker, nature will influence the wine in ways that are unpredictable and independent of those intentions. Woe to the winemaker who ignores that unpredictability—which is why there can be no recipe for making wine. Every vintage is like a new baby, and past practices can be only a rough guide. These differences, rooted in nature's unpredictability, stage a drama of human struggle with nature. Unpredictability in the struggle with nature is a narrative trope with its own distinctive aesthetic appeal that wine lovers crave.

How should we understand this nature that is in part culture? How should we understand the aesthetic allure of this "natural" dimension of wine? Is nature's murmur relevant to the aesthetic appreciation of

wine? These questions will be addressed in the next chapter.

We have made progress in understanding the allure of wine. Wine is a suitable object of love because it calls us to a journey of discovery, because its variations are redolent of mystery and possibility, and because it connects us to its origin in people and places, and ultimately in nature's resistance to human intention. We now must unpack how these factors acquire aesthetic value.

Inspirations:

For most of the wineries I visited while working on this book, it is evident that a deep love of wine is a persistent motivation; any of them could serve as inspiration for the content of this chapter. However, I think the love of wine is best highlighted by wineries operating in extreme environments where challenges are many and risks are high. It is hard to imagine a more inspiring story than that of Serge Hochar, co-owner of Lebanon's Chateau Musar, before his death in 2014. He shepherded his family's winery through fifteen years of Lebanese Civil War in a religious environment hostile to alcohol consumption, and he put Lebanon on the wine map through extensive international travel. I never had the opportunity to visit Chateau Musar, but I have tasted several vintages of their red blend. It is invariably funky, complex, distinctive, and delicious—one of the most interesting wines on the planet.

One must also really love wine to deal with the challenges of growing grapes in the cold climate regions throughout the world. Although still a challenge when temperatures plunge, the warming influence of large lakes makes it possible for wineries such as Michigan's Left Foot Charley to make delicious Riesling and Black Star Farms to make stunningly good Riesling and

Pinot Noir. But at some distance from the Great Lakes, wineries such as Minnesota's Alexis Bailey Vineyards and Wisconsin's Botham Vineyards resort to using cold-hardy, French-American hybrid grapes, or new varietals developed by the University of Minnesota, all of which have been bred to survive a deep freeze. The challenges of surviving winter kill and finding customers for unfamiliar varieties mean that all winemaking in these regions is a labor of love. Unfortunately, going forward, the danger of fire in the western states of the U.S will shape our understanding of what an extreme environment is.

Notes

1 By "wine lover," I mean someone who drinks wine frequently and takes an interest in wine as a disciplined pursuit, whether as a hobby or in a professional capacity. The community of wine lovers is a small subset of the people who drink wine regularly but includes most people in the wine industry if they enjoy wine and enjoy learning about it.

2 Lettie Teague, "A Case of You: When Oenophiles Fell for Wine," *Wall Street Journal*, February 10, 2016. https://www.wsj.com/articles/a-case-of-you-when-oenophiles-fell-for-wine-1455116412, accessed 8/25/18.

3 Nehamas, Alexander, Only a Promise of Happiness: *The Place of Beauty in a World of Art* (Princeton: Princeton University Press, 2007), 205. The concept of beauty and the attractions of art that I employ in this book draw heavily on Nehamas's work.

4 The evidence for this future-oriented, predictive aspect of perception is discussed at length in Andy Clark's *Surfing Uncertainties: Prediction, Action and the Embodied Mind* (Oxford University Press, 2015). The holistic perception of value, at which I gesture here, was inspired by John Dewey's paper "Qualitative Thought." The take- away point from Dewey's paper is that our ability to discriminate, differentiate, and conceptualize objects in any perceptual modality rests on our global grasp of a situation. Only then can the various properties and relations be meaningful. This claim receives support from neuroscience, one seminal text being Don M. Tucker, *Mind from Body: Experience from Neural Science* (Oxford University Press, 2007). See John Dewey, "Qualitative Thought," in On Experience, Nature, and Freedom, Richard Bernstein (ed.) (Indianapolis: The Bobbs-Merrill Company, 1960).

5 This is not restricted to wine. I would argue that all aesthetic experience is a

search for meaningful variation, although a full defense of this claim would take me too far afield.

6 Paul Bloom, "The Lure of Luxury," in *Boston Review*, November 2, 2015. http://bostonreview.net/forum/paul-bloom-lure-luxury. For a more comprehensive discussion of Bloom's theory, see Paul Bloom, *How Pleasure Works: The New Science of Why We Like What We Like* (W.W. Norton and Company, 2010).

6 Coffee, too, can claim some connection to its origins. But the coffee routinely available is not specific to a narrow geographical location that confers a distinctive sensory identity on the beans.

8 Wine writer Andrew Jefford makes this point well in his essay "Wine and Astonishment," in *The World of Fine Wine*, issue 36, 2012. The essay is available at Jefford's website. http://www.andrewjefford.com/wine-and-astonishment/ accessed 10/2020.

BEAUTY AND THE YEAST

CHAPTER TWO

VINOUS VITALITY: WINE AS A LIVING ORGANISM

"To exist is to change, to change is to mature, to mature is to go on creating oneself endlessly."

—Henri Bergson

Contemporary discussions of wine oscillate unhelpfully between subjectivism and objectivism. Wine quality appears to be subjective because even well-trained tasters disagree about the nature and quality of the wines they taste. Yet, science provides objective analyses of chemicals in wine that produce aromas and flavors in normal tasters, which suggests there is an objective component to wine tasting. However, neither the subjective nor objective view can explain the aesthetic value of wine. If subjectivism is true, then aesthetic value is nothing but individual preferences that may or may not be shared. "I like this," and there is nothing more to be said about quality. But objective, scientific analysis cannot reveal aesthetic qualities such as elegance, harmony, or beauty. Aesthetic value is not the sort of

thing science can discern. Thus, neither objectivism nor subjectivism explains our aesthetic responses to wine. Does intersubjective agreement among wine experts give us a better handle on aesthetic assessments of wine? As I discuss in Chapter Nine, those agreements are not universal, and the very notion of expertise is constantly under attack in the media. The possibility that the emperor has no clothes continues to trouble our discourse about wine.

In order to make progress on clarifying the nature of wine quality, we need a clearer understanding of what wine is—an ontology of wine. This might seem like an unnecessary inquiry. Don't we know what wine is? Wine is a liquid containing alcohol that we drink for pleasure or consume with food. But therein lies the problem. We tend to think of objects, including wine grapes and bottles of wine, as inert substances just sitting there until we decide to do something with them. If wine is of interest, it is because we confer value on it. But this is a mistake because it reinforces the unhelpful subject/object dualism just mentioned—human subjectivity conferring value on inert, inherently valueless objects. But what is the alternative?

I want to begin to sketch an alternative by showing that wine is a living organism with its own character and dispositions that resists our attempts to control or categorize it. If wine resists human intentions and produces variations that continually escape the way we frame and categorize it, then subjective or personal evaluations that rely on these intentions and conceptual categories would be inadequate for understanding it. Furthermore, this living dimension of wine would give us important clues about how wine should be appreciated. It would support the claim that the aesthetic allure of unexpected variations and resistance to human intentions is grounded in the real nature of wine.

I often hear people in the wine world claim that wine is a living organism. They are impressed by the capacity of wine to evolve and interact with its environment as living organisms do. Writer and sommelier Courtney Cochran writes: "Wine, with its clear ties to

the lifecycle of plants, its ability to evolve and change (to grow) and its delicate fragility in the face of danger (TCA, oxygen, light), fairly screams "alive." In today's overly sanitized, automated world, could our wine be more alive—perhaps even more "human"—than us?"[1]

Despite Cochran's enthusiasm, the case for wine as a living thing is not immediately obvious, and it will take some unpacking to show in what sense wine, the finished product, is alive. Wine grapes are sensitive to the conditions under which they are grown. They are a product of an ecosystem, as well as a reflection of that ecosystem, with the influence of the vineyard, community, winemaking team, and weather living on in the finished wine. A bottle of wine is a storehouse of the past, a series of "memories" transmitted to the consumer through the wine's flavors and textures. Even after the grapes are harvested and fermented, wine as it ages responds to stimuli, adapts to its environment, and, like a child, requires guidance and nurturing to reach its potential, expressing its aesthetic worth through its own "evolutionary" path, which is influenced but not wholly directed by the winemaker. People in the culture of wine think of it as "living" because wine not only persists but changes and, in some cases, improves with age. There is a trajectory of maturation that seems analogous to the development of living organisms.

The claim that wine is a living thing has received some philosophical endorsement as well, although in most discussions of wine aesthetics the possibility is ignored. In philosopher Nicola Perullo's Introduction to his online anthology *WineWorld: New Essays on New Essays on Wine, Taste, Philosophy and Aesthetics*, he argues that we should treat wine as a living thing in order to reform tasting practices and gain a deeper understanding of the aesthetics of wine production.[2] If we accept this view, Perullo argues, wine is best understood not as a commodity but as something with emotional resonance and authenticity, an object we can engage with as emotional beings; this view provides an approach to wine that analytical tasting regimes ignore. I think Perullo is correct, but there are some obstacles

to overcome before we can make sense of the claim that wine is alive.[3] Is wine really a living thing, or is this discourse just making use of a particularly resonant and vibrant metaphor?

Biological Accounts of Life

Definitions of life in biology are controversial, especially when the definition tries to accommodate the possibility of extraterrestrial and artificial life. However, for most purposes, there is a workable, conventional definition of life that includes several criteria. Living organisms are composed of cells that undergo metabolism, grow, adapt to their environment, respond to stimuli, maintain homeostasis, and reproduce. Wine obviously lacks the capacity for sexual reproduction, and its development cannot be explained by Darwinian evolution. Although wine develops, it does not grow biologically since it lacks a cellular structure that undergoes mitosis or meiosis. It thus seems implausible to think of wine as a living thing, except in a metaphorical sense, because it does not share many of the most important characteristics of life. Yet, it is not obvious how we should understand the criteria of this working definition of life. Mules, most bees, elderly human beings, and the last rabbit on earth are all alive yet cannot reproduce. The capacity for biological reproduction is not a logically necessary condition for life since organisms that cannot reproduce are nevertheless alive. More interestingly, if we discover extraterrestrial beings who pass their genetic code to the next generation via an information processor without sexual reproduction, would we deny they possess life if they exhibit all the other characteristics of life? I am not sure of the answer to this, but I doubt these criteria would have the force of logical necessity were we to make such discoveries.

Dead organisms also have DNA, proteins, and other components characteristic of life—what they no longer possess are metabolic processes that use these components. Thus, the presence of a

metabolism is a central feature of life. Does wine have a metabolism? This question is worth considering in some detail. Metabolic processes are life-sustaining chemical processes that convert fuel to energy in order to run cellular processes, maintain cellular structure, and eliminate waste. Metabolic processes enable organisms to grow, reproduce, and respond to their environment. The metabolic process of converting food to energy involves two kinds of reactions: catabolic reactions govern the breakdown of food to obtain energy, and anabolic reactions use that energy to synthesize larger molecules from smaller molecules. If the catabolic reactions release more energy than can be used by the anabolic reactions, the energy is stored by building fat molecules. If the anabolic reactions need more energy, they use that stored energy to compensate.

Wine grapes are the result of metabolic processes taking place in the vine and fruit. Fermentation is also a metabolic process since yeasts are living organisms that produce alcohol by consuming sugar and producing a waste product, carbon dioxide, in the process. Thus, while fermentation is active, there are metabolic processes that explain the development of the wine, providing some reason for claiming wine is a living organism. However, much of the development of wine and its resistance to degradation occurs after the yeast cells are inactive and have been removed. Is post-fermentation wine resting in the barrel or bottle alive?

There is much about the ageing process of wine that we do not understand. However, it appears that the process of building structure in a wine, if not metabolic, is a close analog to a metabolic process. This point will require a brief and overly simplified introduction to how winemakers build structure in wines. To further simplify matters, I will focus on red wine.

The ability of certain wines to take up and deploy oxygen when young is a key factor in how a wine will develop through the ageing process. This ability depends on the management of tannins.[4]

Tannins are phenolic compounds found in grape skins and seeds that are extracted during the fermentation of red wines and become part of the finished wine. They are responsible for the drying sensation you feel on the finish of a red wine. However, their purpose goes far beyond providing the sensation of breadth and power when tasting. Tannins are crucial in preserving the wine and giving it complexity. When tannin polymers come into contact with acidic grape juice during fermentation, the polymers break down but re-form as wine polymers during the ageing process. Driven by the polarity of water, they aggregate into colloids that in well-structured wines should be small and stable. These small, stable colloids ultimately give the wine a soft mouthfeel and integrated flavors and aromas while protecting the wine from oxidation, thus increasing the wine's longevity as it sits in the wine cellar.

The creation of this fine colloidal structure depends on the early polymerization of tannins, while preventing that process from getting out of control. These goals are achieved through the introduction of oxygen and the stabilization of color. Tannins in grape skins take up an oxygen molecule and, as a result, become highly reactive. They link to other phenols, creating a cascade of polymer formation, which protects the wine from oxidation later as it matures. This polymer formation is controlled by making sure there is enough color extracted from the grapes. The color molecules cap off the ends of the tannin polymers, which ensures that the polymers are short and will feel soft on the palate. It also prevents the formation of long-chain polymers that will too readily precipitate out of the wine. (This is the residue you find at the bottom of a well-aged bottle.)

Thus, although oxygen in the environment is the enemy of finished wine, causing it to degrade rapidly once the bottle is opened, in the winemaking process it is essential in building structure. This early introduction of oxygen has long been the purpose of barrel ageing but now can be done via the technology of micro-oxygenation. This technology is part of the reason we find young red wines on

the supermarket shelf that are soft and smooth. Although it is a controversial practice, the introduction of oxygen allows winemakers, who want to make more serious, cellar-worthy wines, to capture and preserve even more tannin since the oxygen increases the capacity of the tannins to bond, thus building structure for ageing potential. When young, these wines are harsh and will take time to come around. Whether the early introduction of oxygen will be successful or not depends in part on the grape varietal. Cabernet sauvignon has a voracious appetite for oxygen. Sauvignon blanc has much less capacity for oxygen uptake, making it a mystery why some white Bordeaux will age well.

Tannins will continue to evolve over the life of a wine. During ageing they continue to polymerize into larger molecules with higher molecular weight, bonding with color molecules as well, which then drop out of the wine and create sediment in the bottle. The result of bottle age, if the wine is well made, is a lighter color, reduced bitterness, and a satin-like mouthfeel.

In a finished wine, there are no cells to undergo catabolic or anabolic reactions, so strictly speaking this ageing process is not a metabolic process. But there are a series of chemical processes that use oxygen as fuel to synthesize larger molecules, and the chemical bonds are a form of stored energy. Thus, this process of building structure in wine shares with metabolism a set of general functions. These larger molecules enable the structure of the wine to develop into a coherent system that would otherwise fall apart, supporting esterification, hydrolysis, and other chemical reactions that give wine its character. They also defend that structure from degradation, thus achieving a kind of homeostasis, another general function of metabolic processes. Although these processes require minimal intervention from the winemaker to bring elements together at the right time, wine is capable of a good deal of self-maintenance. Once the elements are in place, the wine develops on its own, according to its internal structure and the influence of the environment, with the winemaker making only

occasional adjustments, largely having to do with placing the wine in the appropriate vessel for ageing. The fact that wine development requires some intervention from the winemaker does not mean the wine is non-living. The self-maintenance of living organisms does not require complete autonomy since many social organisms can maintain their biological functions only with the help of others.

The upshot of this description of the chemistry of wine production is that we are in ambiguous territory with the question of wine as a living thing. If we use strict biological criteria, wine may not qualify as alive. But it is surely life-like, with processes that resemble homeostasis and metabolism. Furthermore, when we step back and look at the broader functions of living things, wine shares many of those functions. Living organisms have an active internal structure that uses matter to resist degradation while accelerating and directing change. As Darwin showed, life is creative. It is a continuous process of developing novelty. Resistance to degradation, continuous variation, and integration of outside forces are the markers of life. As the above account demonstrates, wine also has an internal structure that resists degradation, produces continuous variation, and integrates forces from the environment, oxygen among them, as it develops. Establishing this likeness does not settle the question of whether wine is a living thing, but it clarifies why many have been tempted to attribute life to a solution of chemicals resting in a bottle.

As mentioned above, the biological definition of life is fraught with difficulties. There are living organisms that cannot reproduce and ambiguous entities such as viruses that cannot reproduce on their own and lack a metabolism. Furthermore, the prospect of artificial life on the horizon will likely scramble this conventional definition of life. Thus, many biologists and philosophers of science have defended an alternative model for defining life, called living systems theory, which gets us closer to an understanding of the nature of wine.[5]

According to living systems theory, living systems are self-organizing systems that have the characteristics of life and

interact with their environment through the exchange of material and information. A single cell is a living system, but so is a nation. All living systems depend on processes that enable survival and propagation. Some of these processes are metabolic processes that take in and store energy, while others manage the flow of information that enables control of the system. Thus, the defining characteristic of life is the ability to maintain, over time, a state in which disorder (entropy) within the system is lower than in its non-living surroundings. All living systems have, as a component, complex organic molecules such as DNA or RNA that enable some of their properties. However, information flow is also essential. It is the process of maintaining order via self-organization of the whole system, not of individual components, that distinguishes life from non-life.

Thus, I would argue that wine is best thought of as the focal point of a living system that includes the vineyard and regional ecology, the winemaker and her staff, and the larger wine community, which provides feedback and material resources and aids in the exchange of information. The evolution and reproduction of the wine is a function of the interaction of all these components. The vineyard, the winemaker, and her staff reproduce each vintage in a way that replicates, up to a point, the signature and identity of the wine. The wine community gives feedback to the replicators, influencing their decisions about wine quality. Reproduction thus occurs via a web of relationships; it is not solely a function of the internal mechanisms of metabolism and cell division within the organisms that are part of the system. Wine reproduction depends on a chain of processes that include information flows, planning, and interaction with weather and soil, along with the biological mechanisms of the grapes, yeasts, bacteria, and the human beings that are components of the system. In the end, the connection to human culture gives wine its ability to exhibit differentiation and development, the features of its evolution that we identify with life. Wine is indeed a living thing if we understand it as the locus of a dynamically interacting living system rather than a discrete, mute object.

Wine and "Thing-Power"

Thus far, I have been arguing that, according to conventional biological criteria, wine is life-like, and if we take into account recent developments in how we define life, wine is a central component in a living system. It is now time to trace the implications of wine's living dimension for the aesthetics of wine. This living dimension is best labeled "vitality," a term I use to highlight not only wine's changeable, developmental character but also its ambiguous relationship to human intentions. Wine is not a passive object but has its own form of agency, which is essential to explain its attraction. To clarify this idea, I will draw on the work of the political philosopher Jane Bennett in her book *Vibrant Matter*.[6] Bennett does not discuss wine, but her way of linking the ontology of objects to an aesthetic appreciation of them can help make sense of our love of wine and its rootedness in both nature and culture while also exposing the limits of the notions of subjectivity and objectivity that persist in our discourse.

Bennett argues that all matter is, in a sense, life-like. Obviously, the word "life" has a specialized meaning for Bennett since we do not typically think of inorganic objects as alive. By "life," she means, essentially, the ability to act and be acted upon. If we think of objects as stable and largely passive until acted upon by something else, the most important actors are human beings, fulsome subjects actively manipulating the world to serve human ends. Such a picture might seem defensible as an account of wine. After all, human beings make the wine and enjoy it, and wine is as deeply a part of human culture as blue jeans and automobiles. However, Bennett argues this picture of the relationship between human beings and things is misleading and incomplete. She shows how seemingly insignificant objects—worms, a dead rat, or gunpowder residue—have the capacity to act, influencing their environment in ways not intended and often not comprehended by human beings. Worms, it turns out, make vegetable mold, thus making seedlings and eventually forests possible. They

also protect buried artifacts from decay, thus helping to preserve human culture. A bit of detritus, gunpowder residue, can catalyze a jury to judgment. A dead rat, surprisingly and without conceptual stage-setting, sparks an aesthetic response in her. All things, human and non-human, organic or inorganic, exist in a complex network of relations, and each thing has the capacity to shape that web of relations in ways that are unpredictable and not immediately available for conceptualization. Thus, things not only have the capacity to block human intentions but also to act as quasi-agents with dispositions and trajectories of their own that produce profound effects on the things around them.[7] Bennett's main point is that things and their powers are not reducible to the contexts in which human beings place them and are not exhausted by the meanings we assign to them. Things are always escaping our attempt to nail them down and assign permanent, unchanging functions to them.

How does this apply to wine? Putting aside an important distinction between industrial and artisan winemaking for the moment, the relationship between the winemaker and her materials is complicated. Winemaking is a collection of open-ended problems that can be provisionally solved only through experimentation and seldom reach a final solution. Grapes are uniquely responsive to differences in climate, weather, soils, and the geology of the site on which they are grown. Even within vineyards, subtle differences in soil composition, elevation, or aspect to the sun have profound effects on the character of the grapes. Furthermore, each vintage is a new challenge because each vintage is subject to distinctly different weather patterns, each vineyard has unique characteristics that require individual solutions to problems that may not be generalizable, and even materials such as wine barrels have individual characteristics that influence wine in ways that are not fully predictable.

Thus, the idea that the winemaker is in charge, with the grapes and other materials lying about waiting to be used, set in motion by the winemaker's intention, is misleading. No doubt a winemaker

and her team make a substantial difference in determining the taste of a wine. Winemakers continually make selections that influence wine quality and a wine's distinctive characteristics. However, that outcome is seldom a certainty, and it is often impossible to give a comprehensive account of what is responsible for creating a specific effect in the finished wine. The vineyard, grapes, and equipment are "agents," at least in the sense that they have their own dispositions that are not fully under the control of the winemaker. Thus, in the production of wine, there are multiple centers of causal power, and the winemaker's intentions play a role but cannot guarantee outcomes. To be effective means to make a difference, not to exercise total control.

In addition to this complexity and uncertainty in the causal structure of any collection of related objects, things both organic and inorganic tend to persist, to maintain their integrity in the face of attack. This persistence sometimes requires change and adaptation in response to environmental pressures, which again may have little to do with human intentions. As wine ages unpredictably in barrel and bottle, it too stages a drama of persistence and degradation, which humans can influence but neither direct nor fully comprehend. As will become clear in subsequent chapters, this drama of persistence and degradation, and the uncertainty surrounding it, is an essential part of wine aesthetics.

These dispositions and tendencies that do not fit neatly into human intentional frameworks have a vividness to them that Bennett calls "thing-power." Thing-power calls to us focusing our attention on the thing's singularity and excessiveness and on the diverse, mutually affective web of relations in which a thing is embedded. Bennett characterizes thing-power as a kind of wildness, explicitly invoking Henry David Thoreau in her account. For Bennett, even the most ordinary things are strange. Regarding a glove, some pollen, that dead rat, a bottle cap, and a stick, Bennett writes:

I caught a glimpse of an energetic vitality inside each of these things, things that I generally conceived as inert. In this assemblage, objects appeared as things, that is, as vivid entities not entirely reducible to the contexts in which (human) subjects set them, never entirely exhausted by their semiotics. In my encounter with the gutter on Cold Spring lane, I glimpsed a culture of things irreducible to the culture of objects. I achieved, for a moment, what Thoreau had made his life's goal: to be able, as Thomas Dumm puts it, "to be surprised by what we see."[8]

When applied to wine appreciation, Bennett's account illuminates the allure of those unique, surprising characteristics that emerge from the grapes and winemaking materials. Sensitivity to emerging difference, the ability to spot the deviations that nature and materials throw at us, is at the very essence of winemaking and wine tasting. In other words, winemakers and wine enthusiasts are especially sensitive to thing-power. Things have a dual nature in which they have, simultaneously, a use value for humans and something about them that is unique and enchanting because they are "wild." Their resistance to us is itself alluring.

Instead of thinking of a finished wine as the product of a specific intention, the winemaking process is what Bennett calls "a swarm of vitalities." The task for the winemaker is to "identify the contours of the swarm, and the kind of relations that obtain between its bits." There is human agency and intentionality in winemaking, but it intersects with a quasi-agency that the materials have, and neither form of agency can guarantee particular outcomes. By "materials," I mean all the physical inputs to the grape growing and winemaking process, including the ecology and characteristics of the vineyard and the materials used to modify them. In trying to control the winemaking process via intentions, something unintended inevitably emerges. The job of winemaking is to preserve that difference and find a way of presenting it, harmonizing it with other elements of the assemblage

of constituents that make up a wine. Without the intentions of the winemaker and her culture, the new may never be revealed. But "wild" nature will also have its influence.

Bennett's examples of thing-power tend to be objects that conventional aesthetics would deem unattractive, highlighting the fact that materiality has an aesthetic resonance even when it does not conform to conventional aesthetic categories. Wine, of course, differs from these examples because its aesthetic appeal is beyond question. Yet, the importance of wine's materiality is no less salient, and it has an appeal that is similarly independent of conventional aesthetics. Wine is delicious, but its aesthetic appeal is not exhausted by its ability to satisfy conventional tastes.

Within the culture of wine, the appreciation of thing-power is not a concern only of winemakers. Wine appreciation also requires sensitivity to thing-power. Wine tasters continually search for unexpected taste sensations, new expressions that indicate new directions for a varietal, region, vineyard, or winery. That sense of discovery motivates people to travel the world searching for obscure *cuvées*. Furthermore, today in the culture of wine, the influence of the physical context on wine tasting is increasingly salient. The taste of a wine is influenced by the atmosphere in which one tastes—the people you're with, the music playing in the background, the food that accompanies the wine, and even the glass in which the wine is served. This contextualization of taste also fits snugly into Bennett's ontology. In our intentional activity, much of what influences us is a background of which we are only dimly aware. Cold air keeps us awake, sounds of machinery can irritate, buildings evoke awe or serenity, the sounds of nature or of music influence our mood, and we are usually only half-conscious of these effects. The things we eat and drink influence our mood, and our appreciation of them, in turn, is influenced by our environment. Bennett argues that the effects of the objects we surround ourselves with are not solely a product of sociality, language, or enculturation.[9] Their agency is a product of the physicality that directly influences the body. Wine is no exception.

In this respect, Bennett's discussion of the Chinese concept of *shi* is especially appropriate. She defines *shi* as follows:

> Again, the *shi* of an assemblage is vibratory. It is the mood or style of an open whole in which both the membership changes over time and the members themselves undergo internal alteration.... The *shi* of a milieu can be obvious or subtle. It can operate at the very threshold of human perception or more violently. A coffee house or a schoolhouse is a mobile configuration of people, insects, odors, ink, electrical flows, air currents, caffeine, tables, chairs, fluids, and sounds. Their *shi* might at one time consist in the mild and ephemeral effluence of good vibes, and at another in a more dramatic force capable of engendering a philosophical or political movement.[10]

Shi refers to the relative alignment and disposition of forces that enable things to act or show themselves.[11] Although we can become aware of *shi* and sometimes modify it, it nevertheless has an agency of its own, as the relative alignment of interacting forces shift providing us with new, potential experiences that often remain on the edge of awareness. Aesthetic objects such as wine are particularly replete with *shi* since they have this capacity to affect us at or just below the threshold of conscious perception. I will return to this idea of *shi* in subsequent chapters. For now, *shi* is significant because it indicates the ontological location, if you will, the place within Being that operates at the limit of human conceptualization and intentionality but plays a crucial role in aesthetics.

Bennett is writing from the standpoint of a modern, cleaned-up version of "vitalism," a view that has not received much attention in mainstream aesthetics. Vitalism was a nineteenth-century philosophical view which held that living organisms differ from non-living organisms in that living organisms are governed by a "vital force," which differs from the mechanistic and chemical forces that

explain the rest of the universe. Vitalism has been widely discredited as a metaphysical view. Science has increasingly demonstrated the importance of causal relations and chemical interactions in explaining biological phenomena. Few philosophers today would endorse nineteenth-century vitalism, least of all Bennett, who is resolutely materialist in her ontology. But this notion of an independent "vital force" is not the key insight of vitalism. Bennett and other interpreters of this tradition, especially the French philosopher Gilles Deleuze, view vitality as a field of forces emerging out of and thoroughly dependent on physical phenomena. They emphasize the part of vitalism that still seems true: beneath the stable, geometric forms and qualitative distinctions that make up the visible world, reality is a self-organizing process of unpredictable, creative transformation that disrupts boundaries and makes identities obsolete as soon as they are formed. I must confess some agreement with this view. However, this is not the occasion for a comprehensive discussion of metaphysics. Nevertheless, vitalism offers insight into the practice of art and aesthetics including the aesthetics of wine—art worlds themselves are self-organizing processes of "unpredictable, creative transformation" that disrupt boundaries and make identities obsolete as soon as they are formed. This is a useful lens through which to view art and, I would argue, the wine world as well.

If we take on board this notion of vinous thing-power, the opposition between subjectivism and objectivism is too starkly drawn to be helpful. Thing-power escapes subjectivity. It resists conceptualization, intention, and understanding and represents a barrier or limit that perhaps can be grasped piecemeal, in particular cases, but always presents itself as just beyond our ability to grasp it whole. It is that part of reality that is not imposed or projected by us. Yet, neither is it definable in terms of objective scientific analysis. There can be no systematic, law-like account of thing-power, because thing-power refers to unique, individual assemblages of things and their capacities. As singular occurrences, thing-power resists the

generalizations in which science traffics.[12] I will come back to these notions in Chapter Nine when I take up the issue of objectivity more directly.

If wine is not reducible to our subjective idea of it, then winemaking and wine appreciation are less about purely sensuous pleasure and more about discovery, more about unlocking hidden potential than finding something comfortable and familiar, more of an adventure than a holiday. This focus on thing-power grants that preferences are subjective but asserts that there is more to wine tasting than preferences. It is about what is interesting, what grabs attention and piques curiosity, and how the underlying potential of things affects us independently of conscious reflection.

This idea of thing-power is useful in drawing a distinction between industrial winemaking and artisan winemaking. As some of Bennett's examples show, thing-power is not absent from the products of technology. However, while all things potentially have thing-power, it is in contexts where our intentions and plans can be disrupted that thing-power is most salient. Industrial winemakers, like their artisanal colleagues, routinely deal with uncertainty and contingency. But industrial winemaking aims to take as much of the uncertainty and risk out of winemaking as possible, along with the individuality of vineyard and vintage expression. Thus, its potential to generate thing-power is diminished. The products of industrial winemaking are seldom surprising or uncanny. More importantly, in industrial winemaking, thing-power is not celebrated or appreciated; it is condemned as an unwanted intrusion on our ability to predict and control. This difference in attitude toward thing-power is one way to distinguish industrial wines from more authentic wines that celebrate variation and uncertainty.[13]

Thing-power gives us insight into the nature of wine's allure. I argued in Chapter One that wine is mysterious, and that mystery is part of its allure. Thing-power is the substance of that mystery. Although thing-power is, in many contexts, easy to ignore, and has been ignored

by theory until recently, once you become deeply acquainted with the culture of wine, thing-power is unavoidable. Thing-power is the recalcitrance and creativity of the physical world pushing back, reminding us of the importance of the uncanny and the unexpected. What I want to pull out of Bennett's work is the idea that things exhibit vitality when they exhibit unexpected variation. Unexpected variation is intimately tied to the concept of life. Biological evolution works by producing unexpected variations in species, some of which may be adaptive, and thus through natural selection transforms a species into something new. The importance of unexpected variation is the aesthetic insight highlighted by the idea that wine is a living thing. Wine lovers are fascinated by the distinctive geography of the various wine regions and vineyards in the world because those geographies produce meaningful variation. Nature is creative, especially when guided by the stage-setting creativity of winemakers and their teams.

Bennett also makes clear that everything, whether organic or inorganic, exists in a field of forces that exceeds the powers of the individual. Bennett's analysis implies that human agency—will, imagination, and reason—is not sufficient to create a human world. For will, imagination, and reason to be effective, they must be linked to forces that exceed them and are not fully under our control. Human subjectivity is a dependent variable constituted by these linkages to outside forces. This is why subjectivism is such a limited framework for understanding most philosophically interesting phenomena. Subjectivism creates the illusion of control as if human beings somehow stood outside the nexus of causal forces that constitute reality. Part of my aim in this book is to show how creativity and the new emerge from these force fields that surround us, with particular attention to how creativity functions in winemaking. Wine is particularly useful for grasping thing-power because wine's ability to evolve according to its own dispositions in ways not intended by human beings is celebrated and valued by wine lovers. Wine has its own quasi-agency, its own developmental potential, which explains

some of our fascination with it and distinguishes it from commodities that are more fully under our control.

Natural Wine

Before turning our attention to a more focused account of creativity in winemaking, it is worth showing how the allure of nature's differences and the thing-power they generate is creating wine's newest avant-garde—the natural wine movement. Natural wine enthusiasts can be distinguished from lovers of conventional wines by an explicit, more focused fascination with thing-power.

If you are one of the billions of people on this planet who avoid the wine press, you might never have heard of natural wines. Yet, they are a source of great controversy in the wine world, dividing brother from brother and tearing at the delicate fabric of overwrought sensibilities. It's not quite civil war, but it's serious enough to generate plenty of creative insults. A *Newsweek* article a few years ago was entitled "Why Natural Wine Tastes Worse than Putrid Cider," which, as you might imagine, caused natural wine proponents to launch diatribes about smug, snobbish, closed-minded traditionalists. It's not a polite disagreement.

Natural wines are made from organic or sustainably grown fruit and use no cultured yeast in the fermentation process. They contain a minimum of the preservative sulfur dioxide or none at all. They are produced without fining, filtration, or advanced, modern winemaking technology such as reverse osmosis or micro-oxygenation, and they contain no additional acid or additives such as the coloring agent and sweetener Mega Purple. Natural wine producers often advertise an aspiration to make wine the way it was made one hundred years ago.[14]

What is wrong with modern winemaking technology? Modern winemaking can contribute to environmental ills such as soil depletion

and potentially harmful chemicals. Natural wine enthusiasts also claim that modern industrial winemaking destroys flavor, creates generic wines that lack freshness and complexity, and destroys the flavor components that indicate the grapes' origins. These claims are controversial because modern winemaking technology is, in part, designed to eliminate flaws and bad bottles and to preserve the wine for shipping and storage. Making (and purchasing) wine without that technology is often risky. Many a consumer has opened a bottle of natural wine only to be greeted by fizzy, funky juice that has begun to re-ferment in the bottle because modern filtration techniques were not employed. It is, moreover, not quite true that natural winemakers eschew modern technology or that conventional winemakers embrace it unreservedly. Many natural winemakers obsessively test their wines in the lab, use the latest in storage technology, and scrupulously clean the winery using the best equipment they can find to make sure their facilities, storage containers, and equipment are free of bacteria. The idea that they are Luddites is absurd. And, of course, they all use electricity and most use refrigeration, so it's not quite like 1880. Furthermore, many conventional producers follow sound sustainability practices in the vineyard and winery. They try to minimize harmful chemical pesticides and fertilizers and refrain from using additives or technological wizardry in the winery. The dividing line between natural wines and conventional wines is sometimes less than clear.

Biodynamic farming adds complexity to these controversies over ideology. Biodynamic farming views the vineyard as a holistic, self-sustaining ecosystem. Chemical fertilizers and pesticides are forbidden, and biodynamic farmers emphasize the long-term health of the land in their decisions about how to farm. Animals and insects keep the vineyard ecology in balance, and various composting practices and natural treatments are used to maintain the health of the vines and stimulate microbial growth in the soil. More controversially, farming practices are controlled by a biodynamic calendar that

specifies when harvesting, watering, and pruning should be done. Biodynamic farming is thus a close cousin to natural winemaking. However, many winemakers who use conventional approaches in the winery nevertheless farm biodynamically, and many natural wines are made from grapes grown without strict biodynamic practices. Thus, although natural winemaking and biodynamics are not co-extensive, they share a fascination with holistic living systems and the thing-power they generate.

In the end, the real controversy is about flavor. On one side, the lovers of conventional wines claim that natural wine enthusiasts ignore flavor in favor of a dogmatic ideology, deceived by the romantic lure of the idea of "authenticity" into making inferior wine. On the other side are the enthusiasts who claim that the wine revolution is upon us if only the close-minded, hidebound apologists for big business would learn to taste for freshness and vineyard expression. But in the middle are the vast numbers of artisanal wine producers who use technology when necessary but only as a last resort, who believe vineyard expression is what matters most but who also believe that some intervention is occasionally necessary to produce the best wine they can, especially in bad vintages.

Part of the controversy arises because the word "natural" is ill-defined, and there have been, until recently, no standards for what counts as natural wine.[15] Food and cosmetic companies have been using the word for decades to imply their competitors are "unnatural" without having to precisely define what they mean. The word "natural" has largely been evacuated of meaning, but it does have the misleading connotation that conventional winemakers are making plastic, inauthentic, industrial wines. It is no surprise that winemakers, who otherwise are sympathetic to the view that the winemaker should minimize the use of chemical additives and winery tricks when possible, object to an ideological straitjacket when some intervention is necessary to avoid making bad wine.

By contrast, defender-in-chief of natural wines Alice Feiring insists the word "natural" is squishy only if we allow backsliders and pretenders to get in on the fun:

> The category of natural wine is a somewhat slippery slope except predicated by the tenets of nothing added, nothing taken away, a touch of sulfur as needed if needed. Basic to the cause is no inoculations and please, no acidifications. There is a transparency in the wines that excite out of control affection for certain drinkers predisposed to the wine roller coaster.[16]

The reference to a "roller coaster" is Feiring's way of pointing to thing-power. Feiring is right that if you stick to the rigorous definition "nothing added, nothing taken away," except for a bit of sulfur when necessary, there need be no deep confusion over the meaning of "natural." But it is precisely the rigor of this ideology to which many object. In some parts of the world and in some vintages, technological intervention is the only thing staving off disaster. Yet, winemakers who use it are implicitly (or explicitly) falsely accused of being "unnatural," serving up "frankenwines" to the unsuspecting masses, with all the connotations of perversion and abnormality the word "unnatural" conveys.

Are natural wine proponents describing their wines accurately, or is the word "natural" a sinister marketing device that unfairly mischaracterizes legions of honest winemakers? *New York Times* wine writer Eric Asimov wrote regarding the word "natural" that "even defining the term incites the sort of Talmudic bickering usually reserved for philosophers and sports talk-radio hosts."[17] I promise not to invoke the Talmud or sports talk radio, but sorting through conceptual distinctions is the job of philosophers, and perhaps a bit of hair-splitting is what we need to avoid confusion.

The word "natural" sometimes refers to anything that is not supernatural or anything not made or influenced by human beings.

Neither of these meanings is helpful. In the former sense, everything is natural, and, in the latter sense, almost nothing is natural. I doubt there is anything on earth that has not been influenced by human beings—least of all wine grapes. Wine grapes are among the most cultivated of plants; the varieties we have available today are the result of centuries of quite conscious selective breeding in order to exhibit qualities desired by winemakers. There is nothing "untouched by human hands" about grapes or wine.

However, there is a third sense of "natural" that I think is more helpful. "Nature" sometimes refers to the inherited make-up of something—what makes a thing be the sort of thing it is. For example, "human nature" refers to characteristics that distinguish human beings from animals (at least most of us). For plants and animals, their natures are given, inherited, not a product of human invention (even though we influence their development). Although the nature of wine grapes is in part determined by human beings, there are constraints and limits to our ability to control the nature of grapes—despite selective breeding, their genetic and molecular structure remains that of grapes and not something else. Furthermore, the changes that we make through grafting, cloning, and crossing are themselves natural in that they are expressions of the possibilities inherent in grapes. In other words, despite human cultivation, there is still something "given" about grapes, a potential that is not the product of human intervention, a constitution upon which the cultivation depends.

For some people, this givenness, this inherited constitution, is intrinsically valuable. For folks so inclined, it is important that there be something beyond the human tendency to manipulate and control—a gift or bestowal from which they draw a sense of awe or wonder. This is a dimension of the aforementioned "thing-power," a resistant materiality that is a source of joy. Human beings tend to value what is rare and vulnerable. In this tamed and colonized world where humanity's footprint is everywhere, even a partially non-human "given" is rare and vulnerable, and so the natural wine

movement locates intrinsic value in this "given." They value the gift that weather, soil, soil bacteria, native yeasts, and the inherited constitution of grapes bestow on the winemaker (or winegrower, a term some prefer), who must respect this "given" by keeping modern technological interventions to a minimum. It doesn't matter that the grapes are cultivated; what matters is preserving this maximal sense of the "given."

Contrary to some claims made by opponents of natural wine, if the word "natural" is deployed to mean "essential, inherited characteristics," there is no abuse of the language involved. This is one standard usage of the term "natural." It is important to notice that this use does not contrast with "perverted" or "abnormal." The appropriate contrast would be the "accidental" (in philosophical parlance), which refers to something added on but not necessary. Conventionally made wines would then be an example of human artifice that unnecessarily shapes nature. It is this idea of an inheritance from nature that natural-wine proponents admire.

Does a reverence for nature as an inheritance necessarily entail disdain for artifacts and human contrivances? Must there be an implicit, negative judgment regarding standard winemaking if one loves natural wines? It is hard to see what would justify such an attitude, other than personal preference. There is nothing wrong with having reverence for an increasingly rare, natural world. But it is hard to credit a general disapproval toward human intervention since much of the world would then be a source of disapproval. A robust, general disapproval toward any human intervention is at best eccentric and at worst utterly cynical and misanthropic. We can praise the gift of nature and honor human achievement without invidious comparisons. We can enjoy both natural wines and conventional winemaking if the conventional winemaking follows sound sustainability practices. If they are tearing up the environment, that of course is another matter. To the degree proponents of natural wine help themselves to dollops of moral virtue rather than good taste because of the style of wine they

prefer, they risk straying into this territory of eccentricity, and their critics may have a point. The problem is dogmatism, not their strategy of low intervention during the winemaking process.

However, there is another side to this debate that I do find disturbing—a dismissive attitude toward debate, such as the view expressed by *Wine Spectator* columnist Matt Kramer, whose writing I usually admire. He writes, "For those of us on the sidelines, watching the crusaders on both sides saddle up for yet another joust leaves a bad aftertaste. And that is surely not what fine wine is supposed to be about."[18]

The idea that we should not disagree about such matters takes wine out of the realm of the aesthetic. As philosopher Immanuel Kant insisted, the idea of beauty (as opposed to mere subjective preference) produces judgments that aspire to be universal. I don't think Kant is wholly right about this, but his claim is in the right direction.[19] The fact that the taste of wine matters enough to argue about it, with the aim of convincing others, means that wine is not just a preference but an attempt to experience something of genuine value and import. If it were like a preference for Minute Maid or Sunkist, then arguments would be beside the point. Everyone in the wine world should welcome this controversy over natural wine because it is a sign that wine is not merely a commodity but a work of art worthy of our commitment.

We cannot distinguish flavor from the idea of what we are drinking. Flavor is an idea influenced by our past, our environment, and, most importantly, our thoughts about what we are tasting. Natural wine enthusiasts are not ignoring flavor in favor of dogma. They define flavor differently because they have a different idea of what flavor should be. The current conventional notion that great wine must be made from very ripe grapes, filtered and refined to remove any rough edges, and heavily oaked to add complexity, is itself a kind of dogma. There is no neutral ground called "flavor" that defines what flavor is, and our various ideologies inevitably influence our judgments about taste.

Some find natural wines intriguing; some don't. I am surely not arguing that natural wine is inherently better than conventionally produced wine, as long as conventional producers follow sound environmental practices. I have tasted many conventionally made wines that are just as alive as natural wine. Natural wine is another source of variation, perhaps a very powerful source of variation, and should be encouraged from an aesthetic point of view.[20] Controversies over whether natural wines taste good or not are relevant because every healthy culture needs a group of dissidents to induce self-reflection and prevent those in power from getting complacent. Wine culture is no exception. Natural wine is playing the role of the avant-garde, forcing both producers and consumers to examine their assumptions and pushing the boundaries of what wine can be. Some natural wines are better than others; some are flawed; others are just ordinary. But some are extraordinary, such as the wines of Tony Coturri, for instance, a pioneer in U.S. natural wine. I recently tasted a 1984 Pinot Noir from Coturri that was still fresh despite the fact no sulfur was used in its production. Someone who claims they all taste like "putrid cider" is just ignorant. The trick is to know the producer so you can return a bad bottle, buy local if possible, and drink young if you're worried about storage problems.

Even those wines you might think are flawed force us to imagine a form of beauty that is just beyond our reach. There is something about them that doesn't fit, that cannot be easily integrated into conventional notions of what wine should taste like. In other words, natural wines are loaded with thing-power. Whether they succeed as wines is not the whole story. What matters is that they stimulate the imagination because that is what keeps a culture moving forward. A wine culture that disdains such challenges is on its way to extinction.

At this point, we are part of the way through our journey to discover new horizons in the aesthetics of wine. I have located wine as a kind of thing that exists at the intersection of nature and culture and exhibits characteristics—resistance to human control and a

tendency toward constant, meaningful, unexpected variation—that give wine a vitality with its own aesthetic allure. These characteristics are far from the only qualities that explain our love of wine, but they are an important part of the picture. In the process, we have found reasons to reject the approach to aesthetics that treats subjectivism and objectivism as fundamental categories, although there remains much to say about this topic.

Wine reveals the co-creativity of humanity and nature in generating the continuous, meaningful variations that explain wines' allure. However, this requires that we revise some of our assumptions about creativity. The next two chapters describe the creative collaboration of nature and humanity that produce a finished wine capable of producing aesthetic pleasure.

Inspirations:

The idea that the dynamic features of a wine's structure have important implications for an aesthetics of wine came to me while I was sipping a fine Tempranillo from Texas produced by Perissos Vineyard and Winery. I have since discovered interesting dynamic variations in wines made from most varietals and from every wine region. More recently, the Trail Estates Chardonnay Unfiltered Vintage 2, 2017 from Ontario, in Canada's Prince Edward County, was wild and quirky with great rhythmic intensity. Equally vibrant in a quite different way is the massive, but breathtakingly exuberant, Fasoli Geno's Alteo Amarone della Valpolicella, 2011. On the natural wine/ low intervention front, Jolie-Laide's Trousseau Blend 2019 from California is juicy yet diaphanous and pulsating with kinetic energy.

Notes

1. Courtney Cochran, "Is Wine Living?" *Appellation America* 5/6/2009. http://wine.appellationamerica.com/wine-review/700/Is-wine-living.html

2. Nicola Perullo, "WineWorld: Tasting, Making, Drinking, Being" in Perullo (ed.) "Wineworld: New Essays on Wine, Taste, Philosophy and Aesthetics," *Rivista di Estetica*, issue 51, 2012. https://journals.openedition.org/estetica/1388?lang=en

3. My account of the consequences of understanding wine as a living thing will, in the end, depart significantly from Perullo's. Perullo argues that appreciation involves feeling a wine's effect rather than discerning its properties, and how a wine makes us feel is related to how it is made and the context in which it is enjoyed. I endorse that general claim but not his specific way of understanding it. Perullo writes, "My thesis is that the beauty of a wine, completely corresponding to its goodness, to its whole aesthetic value, dwells mostly in its thorough ease of absorption, in its drinkability and in its consequent digestibility," and he relates this to how these contribute to socialization and conviviality. "Absorption in human tissue" is somehow central to aesthetic value, for him. Further, he argues, manipulated wines are "inert, without grace or gustatative tension," "aromatically fake and incongruous" as opposed to natural wines. Aside from personal preference, I see no reason to assert "manipulated wines" across the board lack aesthetic value. I also fail to understand an aesthetics based on digestibility that would capture the aesthetic differences of which wine is capable. See Nicola Perullo, "WineWorld: Tasting, Making, Drinking, Being," 42-45.

4. This account of how to build structure in wines relies on Clark Smith, *Postmodern Winemaking: Re-Thinking the Modern Science of an Ancient Craft* (University of California Press, 2013). The comparison with metabolic processes, however, is entirely my own as are any mistakes that arise from the comparison.

5. Living Systems Theory is a branch of Systems Theory, the interdisciplinary study of systems in general that attempts to understand the interdependence between groups of individuals, structures, and processes that enable an organization to function. Living Systems theory was first developed by James Grier Miller in his 1978 tome, *Living Systems*, New York: McGraw-Hill, 1978. Today it has application in diverse fields such as ecological modeling, management science, and the study of emergent properties. See especially George Terzis and Robert Arp (eds.) Information and Living Systems: Philosophical and Scientific Perspectives (Cambridge: MIT Press, 2011); and Fritjof Capra and Pier Luigi Luisi, *The Systems View of Life: A Unifying Vision* (Cambridge: Cambridge University Press, 2014).

6 Jane Bennett, *Vibrant Matter: A Political Ecology of Things* (Durham: Duke University Press, 2010).

7 Bennett's rhetoric sometimes suggests she is attributing intentionality to inanimate objects. But that is not the proper understanding of her concept of agency. She is arguing that things have efficacy when their interactions with other bodies produce a unique configuration of forces that can have a wide range of effects. Their efficacy is modified by the complexity of these interactions, whether intended or not. The philosophical background for Bennett's view of agency is the notion of an assemblage in the work of Deleuze and Guattari, as well as Bruno Latour's notion of an actant.

8 Bennett, *Vibrant Matter*, p. 4.

9 See Chapter Nine, where I pursue this idea in more detail.

10 Bennett, p. 35.

11 Randall Grahm, proprietor of Bonny Doon Vineyard, made the comment during a meeting of the "Postmodern Winemaking Symposium," that as a winemaker he was in search of a wine's "*shi*." I interpreted that to mean what I am calling a wine's vitality, that which "thing-power" expresses.

12 I do not intend anything mystical here; neither am I asserting some form of non-physicalism nor skepticism about science. Thing-power is the product of causal forces that, in isolation, can be understood by science, but when placed in unique contexts become chaotic and unpredictable because of interaction effects. This is not the place for a full-blown discussion, but my thesis presupposes that emergent properties are not fully reducible to the more fundamental entities which give rise to them. In other words, I am assuming non-reductive materialism. For a scientifically informed account of the limitations of science in explaining winemaking practices and the dangers of employing a reductionist view of science, see Clark Smith, *Postmodern Winemaking*.

13 The size of the winery matters in its sensitivity to thing-power, but annual case production does not necessarily determine the aesthetic value of the wines it produces. Wineries are complex operations and differ significantly from producer to producer. There are industrial wineries using mass production techniques that nevertheless reserve some of their resources for the production of authentic wines. There are small, artisan operations who are concerned with little but production goals and profit. As I will argue later in the book, part of judging a wine is judging how it was produced, what methods were used, and what kind of aesthetic sensibility governed its making.

14 Some winemakers prefer the phrase "low intervention" instead of "natural" when describing their wines. It is not clear that "low intervention" admits

of a more precise definition than "natural." In any case, the phrase "low intervention" refers to minimal use of technology in the winery. The idea of "hands off" does not apply to work in the vineyard, which requires much active labor and strict attention to the vineyard and its ecology. This is especially true of biodynamic farming.

15 France has recently developed standards that must be met to label a wine "vin méthode nature." The wine must be produced from hand-picked grapes from certified organic vines and be made with indigenous yeast. Practices such as cross-flow filtration, flash pasteurization, thermovinification, and reverse osmosis are prohibited. This rule, announced in 2020, is in effect for a three-year trial period.

16 Alice Feiring, "SF Natural Wine Week," *The Feiring Line*, 8/25/2010. http://www.alicefeiring.com/blog/2010/08/sf-natural-wine-week.html accessed, 8/27/18. Feiring has been writing about natural wine for many years and has been at the forefront of attempts to define it more precisely.

17 Eric Azimov, "Natural Winemaking Stirs Debate," *New York Times*, June 16, 2010. https://www.nytimes.com/2010/06/16/dining/16pour.html.

18 Matt Kramer, "When Did Wine Become So Partisan," *Wine Spectator*, July 15, 2014. https://www.winespectator.com/webfeature/show/id/50261

19 See Chapter Ten for more discussion of the normativity of beauty.

20 Wine science writer Jamie Goode and winemaker Sam Harrop argue that low intervention winemaking is essential to preserving diversity and variation, which comes primarily from expressive terroirs. See Jamie Goode and Sam Harrop MW, *Authentic Wine: Toward Natural and Sustainable Winemaking* (Berkeley: University of California Press, 2011), Chapter Two. Their definition of "authentic wine" is not co-extensive with natural wine. They argue that some interventions discouraged in natural winemaking, including the use of SO2 and filtering, may be necessary to enable a wine to express terroir. For an account of how modern technologies can contribute to variation when used appropriately, see Clark Smith, *Postmodern Winemaking*, especially Part Four.

CHAPTER THREE

WINEMAKING AND CREATIVITY: THE SLOW ART OF WINE

"You start a painting and it becomes something different altogether. It's strange how little the artist's will matters."

—Picasso, Tate Gallery Notes, 2018

Among the most striking developments in the art world in the past 150 years is the proliferation of objects that count as works of art. The term "art" no longer applies only to paintings, sculpture, symphonic music, literature, and theatre, but also includes architecture, photographs, performances, film and television, found objects, assorted musical genres, conceptual works, environments, and installations. The Museum of Modern Art in New York proudly displayed a Jaguar XKE roadster as a work of art. With this proliferation of art objects, some of which are familiar and commonplace, contemporary art is neither independent of nor fully absorbed into everyday life. Art occupies a borderland between the everyday and the extraordinary, and it is art's function to continually negotiate that frontier. Art is about having a

certain kind of aesthetic experience; it is no longer about a kind of object.

Wine is an everyday beverage that has, among its functions, the ability to provide or contribute to an aesthetic experience. Can wine be a work of art? No doubt, some will object that wine is not designed to provide aesthetic experiences but rather to get you drunk. But, as an alcohol delivery system, wine is terribly inefficient and expensive; the alcohol by itself does not explain why connoisseurs love wine. The mild buzz one gets from the kind of restrained imbibing associated with wine appreciation is not only compatible with aesthetic appreciation but enhances it. The presence of intoxication is compatible with the appreciation of art, as the frequent invocation of Dionysius in the history of art attests. If aesthetic experience is incompatible with the ecstasies, we have clearly lost our way in trying to understand aesthetic phenomena. The presence of alcohol is no impediment to at least some wines being classified as art.

The question of whether wine is art is no idle conceptual matter. The issue is important because it is about the future of wine. We value art, in part, because it is inexhaustible. There are constantly new developments and new modes of expression that enliven art for each new generation. Can something similar be said about wine? Will wine continue to develop as an aesthetic experience with new, distinctive expressions to explore? If the answer is yes, then wine will continue to command the interest of people fascinated by taste. Thus, thinking of wine as an art not only reflects that aesthetic potential but encourages the right sort of engagement with wine, treating it as a robust aesthetic object rather than merely a commodity. On the other hand, if wine lacks the aesthetic potential we associate with art, perhaps in the future there will be few new developments because we have reached a limit to what can be done with wine, and it becomes a mere commodity like orange juice or milk.

Most writers, including many philosophers who have addressed this question, are skeptical that wine can be art. The salient fact

about quality winemaking is that good wine requires quality grapes, and, despite the efforts of grape farmers to maintain the health of their vineyards, wine quality ultimately depends on weather, soil composition, and geography. Many argue that this fundamental dependence on nature, and the constraints it imposes on a winemaker's intentions, means that wine cannot be an art. The *Wine Spectator's* Matt Kramer wrote:

> So why isn't fine wine "art?" The answer is surprisingly simple. Art is creation; wine is amplification. The big difference between an artist and a winemaker is that an artist starts with a blank sheet while a winemaker works with the exact opposite. A grape arrives at the winery with all the parts included, a piñata stuffed with goodies, just waiting to be cracked open. Is there a craft to doing that? You bet there is. But where an artist conceives of something out of the proverbial thin air, no winemaker anywhere in the world can do any such thing.[1]

Kramer is wrong that artists "start with a blank sheet" or conceive of something "out of thin air," but he is not alone in this belief. Philosophers Burnham and Skilleås are also skeptical about claims that wine is art and for similar reasons. Writing about winemaking decisions, they argue:

> These decisions are intentions certainly and wine is also a product of human artifice. However, it is not intention in the same sense as a painter might have when he approaches a blank canvas. Vintner's decisions have only a very tenuous connection with expression in the arts, which is typically expressions of aesthetic intention, feeling, and the like.... Wine is not as malleable to intention as paint and the most important factor beyond the vintner's control is the weather. Try as they might, few vintners can remove the sensory impact of the vintage.[2]

According to Burnham and Skilleås, winemaking and artistic creation differ in two ways. First is a difference in intention. Unlike the intentions of artists, a winemaker's actions are not "expressions of aesthetic intentions, feelings and the like." The second difference is that winemakers differ from artists in their ability to carry out their intentions. Winemakers lack the control over their materials that artists enjoy. Burnham and Skilleås are mistaken in their conception of the role of intentions in the creation of art. I will argue that the production of art and wine are sufficiently similar to warrant the claim that some wines can be works of art.

It is worth noting that although Burnham and Skilleås are right that a vintner cannot wholly erase the influence of weather, their view underplays the degree to which modern technology, if they decide to use it, has given winemakers substantial control over their product. Vineyard managers can now measure the amount of water uptake for each leaf on the vine and regulate water supply to each individual vine through irrigation; sophisticated planting strategies and canopy management optimizes sun exposure; careful clonal selection produces vines more adaptable to local weather conditions; and optical sorting devices eliminate all but the best grapes from the crush. In the winery, fermentation temperatures can be precisely controlled, aromas given off by the fermenting grapes can be captured and reintroduced into the wine, and microbursts of oxygen can be introduced at various points in the process to build and control structure, not to mention the availability of hundreds of yeasts, oak products, and chemical additives that contribute to flavor, aroma, and texture. Although much of this technology is used primarily in industrial winemaking, small producers sometimes make use of it to correct problems or sculpt the flavor or texture profile they seek. With modern winemaking techniques and technology, winemakers increasingly have the tools to shape their wines according to their aesthetic vision, which suggests that wine might be a medium of self-expression and creativity for winemakers.

Thus, we could draw a distinction between "art" wines and artisan wines based on how much technological and chemical control and creative intention is deployed in the production process. However, that argument is unlikely to be successful. Many of the best wines in the world are made the old-fashioned way, using none of these newest technologies. Since many artisan wines are as aesthetically pleasing as some "technological" wines, if not more so, this distinction is artificial and incapable of capturing the aesthetic dimension of wine quality. It would be strange to argue that although wine is an art, the most aesthetically interesting wines do not count. The contrast between wines that express the geographical features of the vineyard or region and wines that are heavily "manipulated" in the winery has become a fraught aesthetic conflict in the wine world. It is safe to say that most wine writers and dedicated wine lovers prefer wines that express *terroir* since one of the most intriguing features of wine grapes is their ability to reflect geographical differences. Thus, an argument for wine as art must make the case by including artisan wines as central examples of "art wines," and we will have to describe the artistry of winemaking in a way that does not depend on the use of advanced technology.

Artists, Winemakers, and Their Materials

The skeptical arguments about wine as art, cited above, are mistaken because they make unwarranted assumptions about the nature of creativity in the arts. Thus, before we can understand wine's credentials as an art form, we must clarify the nature of artistic creativity. One unwarranted assumption evident in the above quotations is the idea of the artist as an unconstrained creator, a fashioner *ex nihilo* who brings something new into being through the force of her imagination and capacity for self-expression. We might contrast this with an older view of art perhaps best expressed by this quote attributed to Michelangelo: "In every block of marble I see a statue as plain as though it stood

before me, shaped and perfect in attitude and action. I have only to hew away the rough walls that imprison the lovely apparition to reveal it to the other eyes as mine see it."³ According to this quote, an artist in the initial stages of developing a work is like a skillful craftsperson who attends to the inherent qualities of a piece of raw material, its shape, grain, texture, or color, and then decides what she can do with it.

Art is too varied and complex to wholly fit either description of the creative process, both of which are drawn too starkly, but Michelangelo's view has more to recommend it than first meets the eye. Aesthetic appreciation is often described in terms of adopting an aesthetic attitude in which one attends sympathetically and with focused attention to the aesthetic features of objects. Part of that aesthetic attitude is a willingness to be receptive to what is in the work, to refrain from imposing preconceptions on it, to let the work speak for itself. The viewer or listener must open herself to being moved by the work and to absorbing all there is to be discovered in it. As important as this attitude of openness and receptivity is to appreciating art, it would be odd if this aesthetic attitude were not also part of the process of creating the work. However, if we take this receptive attitude seriously, it shows the limitations of our assumptions about artists as ultimate masters.

No doubt artists create. They bring something into being that did not exist before. However, their creation is not an entirely new object. Prior to the existence of the work, there are the materials and media to be shaped by the artist—canvas, brush, paint, and a visual field for a painter, a variety of instruments, recording equipment, and a soundscape for the composer or musician. These materials and media are not a "blank slate" but have their own properties that inform the final product, some of them dispositional properties that will be fully revealed only in the final work. Think of the dispositional properties of an artist's materials as a set of potentials—what the materials can do—that the artist must be aware of if she is to transform these materials into a work of art.

Dispositional properties are strange beasts. You cannot always see them or touch them. You cannot see the fragility of a glass bowl until it strikes the floor. But our understanding of reality cannot do without them, and they are, probably, what Michelangelo recognized in his block of marble. Just as a glass bowl is disposed to break when pushed off the table, a C note is disposed to harmonize when combined with an E note under the right conditions, and converging lines are disposed to lend a sense of depth to a painting, again under the right conditions. These are simple examples of an enormously complex domain of potentiality that quality materials exhibit. As talented as Itzhak Perlman and Jean-Luc Ponty are, their quite different approaches to melody are, in part, differences between what a Stradivarius and an electric violin with a low C- or F-string can do.[4] These are dispositions, properties of an object that are not necessarily perceivable until actualized in the work but which exist latently in the materials.[5]

When an artist or composer shapes their materials and media in order to express or embody an idea, they must first discover what their materials are capable of, which possibilities can be elicited from the materials and which cannot. Artists imagine but with the aim to discover which dispositional properties of their materials can be made actual. When a composer elects to write a musical passage in the key of C major, she may or may not be adding something of herself to the work. But she is by necessity recognizing what the key of C major can do in the context of that work, and she perhaps reveals something new about the key of C major. A painter may or may not be expressing something about her experience, but what she surely does is show what properties those colors, those lines, and that canvas have when viewed as the artist presents them. Art is about execution as well as inspiration, and that crucially involves being receptive to how the world is. Before being worked on, the materials possess properties that the artist must recognize if she is to create a successful work. She cannot make them do what they are not disposed to do. Art gets its

friction from the obduracy of matter, the stubbornness of physical objects, and that makes art more than the idle spinning of ideas. Therefore, this need to develop creative intentions only after assessing the condition of one's materials is not unique to winemaking; much art also requires sensitivity to one's materials. Artists do not start with a blank sheet but with materials that have certain dispositions but not others. Oils produce a quite different look than do watercolors. A melody played by a violin will sound different when played by an oboe. Painters must work with a two-dimensional space. The whole history of modern art is a struggle with that limitation.

All artists work under the constraints of their materials, just as winemakers do. As the skeptic insists, artisanal winemakers lack a degree of control over their final product. However, such control is not a necessary condition for an object being a work of art. The collages of Jean Arp, some of Ellsworth Kelly's paintings such as *Seine* or *November Painting*, not to mention Pollock's drip paintings all eschew artistic control, allowing chance to significantly influence the results. In his book *Ulysses Unbound*, the social scientist Jon Elster defines creativity in the arts as the maximization of aesthetic value under constraint.[6] The reference to constraint is important. Elster argues that the relationship between creativity and the constraints imposed on the creative process is an upside-down U-curve. The greater the constraint, the more potential for creativity exists, unless the constraints are so severe that creativity becomes impossible. Except in the case of disaster such as hail or fire, the constraints that weather and other contingencies impose on winemakers encourage creativity; they do not preclude it. Of course, it is not true that artisan winemakers have no control over the character of a vintage. Winemakers influence the effects of weather by blending from multiple lots, careful filtering, the judicious use of oak or other ageing vessels, the inclusion of wine from earlier vintages, and, most importantly, careful management in the vineyard when the weather is bad. They cannot turn a bad vintage into a great vintage or make a distinctive wine from generic grapes.

But as noted, artists also cannot ignore their materials. Of course, artists can usually discard materials that are not working for them. Winemakers have a limited supply of raw material each year and must make do with what is available. But surely the difference between art and non-art is not the ability to substitute materials. If there is a difference between winemakers and artists in the manipulability of their raw materials, it will be a matter of degree, and for artists whose work is really about expressing what their materials can do, they will be under constraints similar to winemakers.

Another harmful assumption regarding art is our tendency to view all art as a form of self-expression. This, too, is at best an exaggeration. Sometimes a work of art has a clear message that can be explained by the artist's psychology. However, in many cases, there is no answer to the question of what an artist intended to express. She is simply able to intuit the intensity and vivacity of that passage if played by an oboe rather than a flute or of a triangular shape against the background grain of the canvas. To make such a judgment, the artist must grasp the dispositional properties of oboes rather than flutes or that precise triangular shape when placed in the context of particular curves and textures. The nature of the self has little to do with these artistic judgments.

Furthermore—and this is a key point—many works of art are not about the self, ideas, or emotions at all. They not only explore the nature of the materials the artist is using, but that exploration is itself the point of the work. This highlighting of the nature of materials is especially evident in found art, assemblage art, collage, mixed media, installations, and textile art. However, even traditional fine arts such as painting have explored the nature of the artist's materials. Impressionists were exploring the nature of light; the fauvists, the nature of color; and the technique of impasto glories in the properties of paint. The fact that a work of art is inspired by the raw materials of which it is made does not disqualify it as a work of art. Similarly, the fact that winemakers seek to explore the expressive possibilities of

their materials does not disqualify wine from being art.

Artists are more like sponges than gods. What distinguishes an artist from a dilettante or amateur is, in part, her degree of receptivity to the dispositional properties of her materials. A great composer hears with great acuity; a great painter sees with perspicacity not the finished product but the condition of matter before being worked on. The materials and medium condition how the content of the work is to appear. The artist will search the limits of the medium they work in and can modify those limits but can never entirely erase them. The vision we want to see in a work is not only an idea. The idea behind many a work of art is banal; it gains depth when it gains materiality, when the idea is fused with matter. It is the idea shaped by the inherent qualities of materials, the manner of that fusion, which sustains our interest. For both artists and winemakers, their intentions are limited and shaped by their materials.

Why does it matter that we recognize this receptiveness in the creative process? Part of creativity involves responding to the claim things make on us. Artistic creativity is a battle between the imagination and the recalcitrance of matter. When the cubists dismantled the use of perspective or when Cézanne abandoned line in favor of shading and texture, it was not simply a bright idea that enabled the work but a battle with the limits of paint and surface that had to be won. The environmental artist Andy Goldsworthy refers to this struggle when he describes a work he created in a forest using dappled light, stones, and leaves as his materials:

> I have learned a lot this week and have made progress in understanding a quality of light that I have never previously been able to deal with properly...not understanding a woodland floor on a sunny day has represented a serious gap in my perception of nature.[7]

Obviously, for Goldsworthy, making art is not simply a matter of imposing an intention on inert matter. It requires a process of

discovery in which the properties of the materials are clarified through the work. Thus, the skeptical arguments regarding wine as art in the above quotations are based on a limited understanding, at best, of the creative process in the arts. They underplay the role of materials and their qualities in the artistic process and wrongly assume that artists are less constrained by their materials than winemakers.

Artistic Intentions

The second class of objections raised by Burnham and Skilleås to the claim that wine is art concern an alleged difference between the intentions of winemakers and the aesthetic intentions of artists. In writing that "Vintner's decisions have only a very tenuous connection with expression in the arts which is typically expressions of aesthetic intention, feeling, and the like," they appear to suggest that, although winemakers have intentions, they are not about aesthetics. This is a questionable assertion. There are countless decisions made by winemakers and their teams in the vineyard and winery that influence aesthetic properties such as the intensity, harmony, finesse, and elegance of the finished wine and are intended to do so. In an interview, winemaker Randall Grahm of Bonny Doon Vineyards noted that all of these aesthetic concepts matter. "Remember that you can't simply dial up elegance, harmony, etc. Typically, these features spontaneously arise from great *terroirs* that are farmed thoughtfully."[8] For many winemakers, the intention behind thoughtful farming just is these aesthetic concepts that winemakers are allegedly lacking. Burnham and Skilleås are quite clear that they believe wine is a robust, aesthetic object. It is not obvious why they appear to deny that winemakers have aesthetic intentions.

Their denial that wine is art is apparently driven by their concern that creativity plays a diminished role in winemaking when compared to art. They insist that "a vintner is simply not to be understood on

the model of Kantian or Romantic aesthetics of fine art for whom originality or creativity are absolutely central features."⁹ Again, this is a questionable assertion, although it may be true of commodity wines. As James Frey, proprietor of Trisaetum Winery in Oregon's Willamette Valley, and an accomplished artist as well as winemaker, told me in conversation, "Originality matters a great deal. No winemaker wants to hear that his wines taste like those of the winery down the street." And Randall Grahm concurs: "'The genius of a grand cru or a unique terroir is its originality; in other words, wines from that place don't taste like anything else out there; in crass commercial terms, that is their "value add."'¹⁰

Originality and creativity are central concerns of at least those winemakers for whom quality is the primary focus. Nevertheless, it may be that there is some fundamental difference between how creative intentions function in winemaking compared to the arts. Thus, to fully make the case that wine can be art, we need to explore the nature of artistic intentions in general. For this inquiry, we need at least a working definition of art. When we claim that winemaking is an art, what exactly are we claiming?

Philosophical definitions of art are not only controversial but tend to be unhelpful in understanding the nature of art. While trying to accommodate new, sometimes radically unfamiliar, developments in the art world, many philosophical definitions do not explain why art is something we care about, arguably something a definition should do. For instance, institutional theories that treat art as any work intended to be displayed for the art world, or historical theories that view a work as having some intended relationship to prior artworks, leave out any reference to why art is worth making and appreciating. Aesthetic theories get closer to bringing the value of art into the picture. They privilege an artist's intention to imbue objects with aesthetic character, which, when successful, produces aesthetic pleasure, surely one primary reason for valuing art. However, embodying an intention to produce aesthetic pleasure is not sufficient for something to be

an artwork. An attractive, mass-produced set of dishes or a potted plant might be intended to have aesthetic properties, but these are not works of art. Furthermore, the appeal of some works of art such as the ready-mades (e.g., Duchamp's shovel or up-side-down urinal) is not straightforwardly aesthetic, in that they do not aim to create aesthetic pleasure (although irony can be delicious). Clearly, aesthetic pleasure is an important goal of some art and one reason why we value it. However, the counter-examples suggest there must be other reasons to value art.

In addition to art's ability to direct aesthetic attention or produce aesthetic pleasure, we value works of art because they are accomplishments. We admire and appreciate the skill, effort, depth of insight, and conceptual dexterity required to produce art. More importantly, we appreciate works of art because they exemplify creativity. Above all, works of art are works of imagination that constitute a departure from the everyday and the mundane. They surprise us and move us because they are extraordinary. Creativity constitutes the distinctive kind of accomplishment that is a work of art. It is puzzling that most philosophical definitions of art do not include creativity among their conditions. One notable exception is Nick Zangwill's "creative theory," which is the most promising approach to defining art because it incorporates this crucial dimension of creativity.[11]

However, Zangwill's theory suffers from a lack of attention to the creative process, especially regarding the nature of aesthetic intentions, which is precisely the issue Burnham and Skilleås use to distinguish winemaking from art. By reconsidering Zangwill's theory in light of the above discussion of the receptive dimension of creativity, I want to show that winemaking can satisfy the conditions for being an art.

According to Zangwill, "Something is a work of art because and only because someone had an insight that certain aesthetic properties would depend on certain nonaesthetic properties; and because of this, the thing was intentionally endowed with some of those aesthetic

properties in virtue of the nonaesthetic properties, as envisaged in the insight."[12] Nonaesthetic properties include ordinary physical properties such as shape, size, color, and sound. Aesthetic properties are properties such as beauty, gracefulness, elegance, ugliness, etc. For something to be an artwork, in Zangwill's theory, the artist must have insight into how nonaesthetic properties can be manipulated to produce aesthetic properties, an insight that must be successfully executed to count as a creative act. To put the point more simply, Zangwill argues that artistic creativity is a matter of the artist knowing the aesthetic end she wants to achieve and the means to achieve it. Zangwill is clear that for the action to count as a creative act, the insight must occur before or along with the execution since the intention must cause the actions that execute the work. He also seems to think the insight is a consciously held belief about this relationship between the nonaesthetic properties and the aesthetic properties.

On a natural reading of this definition of art, it seems to be in tension with accounts of how the creative process works that do not require specific intentions. No doubt, some art does proceed from clearly defined intentions regarding artistic aims and methods to achieve them. But much art is more serendipitous. The role of inspiration in creativity has long puzzled philosophers and gave rise to the ancient idea that artists are divinely inspired, aided by a muse, or simply crazy. Where do their outlandish ideas come from?

There is a generative step in the creative process akin to brainstorming, in which the point is to generate ideas. A painter imaginatively juxtaposes shapes, colors, and lines. A musician juxtaposes notes and rhythmic sequences in her imagination and perhaps conceptualizes the emotional expression of a musical passage. There is a large literature on the psychology of creativity that debates whether this is a spontaneous activity or a matter of ticking through organized patterns of possibility. At any rate, it is mostly unconscious, as is attested by the many references in the literature on art to inspiration that appears to come out of nowhere. A study of the

creative process by neuroscientist Nancy Andreasen found common phrases used to describe the serendipity of creativity: "I can't force inspiration. Ideas just come to me when I'm not seeking them—when I'm swimming or running or standing in the shower." "It happens like magic." "I can just see things that other people can't, and I don't know why." "The muse just sits on my shoulder." "If I concentrate on finding the answer it never comes, but if I let my mind just wander, the answer pops in."[13]

These common phrases suggest that creative activity, at this generative stage, does not require specific intentions about aesthetic properties. It is the unconscious aspect of this stage of the creative process that has fascinated writers throughout the centuries. Aesthetic ideas belong, in some sense, to the artist, but the notion of an intention may not be the way to characterize this belongingness. Artists often begin with a vague feeling about what they are trying to achieve, or they may proceed with no end in mind at all. They experiment with various techniques or combinations of colors or textures until something aesthetically significant appears. In these cases, they are creating but with little insight into how the aesthetic effect is to be achieved. Or alternatively, artists sometimes gain insight into what they are aiming for as they proceed. The insight is a result of their process, not antecedent to it. Often the aim of a work is constituted as the artist discovers how to execute the work, as she continually breaks with her prior aims and constraints as new possibilities unfold. Many years ago, when I was a musician and songwriter, some of my best songs (from an exceedingly modest comparison class) were created by aimlessly plucking out melodies on a guitar until something compelling emerged. Even after going into the studio to record tracks, I would discover the genre, subgenre, or main motifs of a song only as the recording process was concluding, with results radically at odds with my assumptions going in. In summary, the creative process does not necessarily proceed from clearly defined, specific intentions. Zangwill anticipates these objections:

Am I implying that every aspect of a work of art is intentionally produced? No. Chance often plays a role. This is most dramatic in the paintings of Jackson Pollock. But even in his paintings, chance plays a role only within certain confined parameters. How his paintings turned out was very far from being completely a matter of luck. There is always some result that was deliberately produced.[14]

Zangwill seems to be claiming that as long as "some result" was deliberately produced, his claim that creativity is a product of specific intentions is vindicated. But this response to my objection above is inadequate. Zangwill's theory purports to give us insight into the creative process and the value of art as a creative accomplishment. If only minor features of a work are the result of well-defined creative intentions, the ability of the theory to explain the major features of art works is undermined. Zangwill needs the stronger claim that the main aesthetic features of artworks are the result of specific intentions about how an aesthetic effect is achieved. However, that level of conscious intention and specificity does not necessarily characterize the creative process, as Pollock's methods make clear, and as the quote from Picasso at the beginning of this chapter indicates.

Thus, I doubt that the notion of a specific intention helps us think about the development of aesthetic ideas or effects, at least at this generative stage of the creative process. The aesthetic effect need not be conceptualized before or during the attempt to create that effect.[15] Nevertheless, Zangwill is right that aesthetic intentions of some sort must be involved, even in those cases in which chance plays a role. My intention to create a song with aesthetic value motivated my aimless, experimental picking on the guitar, even though I lacked a specific intention. If a work exemplifying creativity is an accomplishment of the artist, then that accomplishment must reflect something about the artist's intention, vision, or point of view. Random acts of creativity would seem not to do that. If creative insight does not necessarily involve a deliberate identification of how aesthetic properties can

be created from nonaesthetic properties, what does creative insight involve?

The most widely held philosophical definition of creativity holds that creativity "is the capacity to produce things that are original and valuable."[16] This second condition that a work must be valuable to count as genuinely creative is necessary to rule out frivolous novelty or creative nonsense, neither of which would count as an accomplishment.[17] However, the first condition, originality, is problematic. The creativity embodied in a work is not diminished by the fact that someone, somewhere created something similar, assuming that the second work is not a copy of or derivation from the first. Creativity is, in part, about the process through which something is created—it is not exclusively about its relationship to other works. Originality and creativity are both valuable in the arts but should not be collapsed.

I do not have a fully fleshed-out theory of creativity in my pocket, but the second condition in this definition of creativity gestures in the direction of where we should look for one. Creativity is a capacity, a disposition, and thus a quality of character that stands out in some people more than others. Aside from the fact that we enjoy their creations, what is it we admire about creative people? To put it in the vernacular, we admire their ability to "think outside the box," to be relatively less constrained by norms, habits, and conventions than the average person within the boundaries of some sphere of activity.[18]

There are two components to this capacity for creativity. One is the ability to have creative thoughts—an imagination that ranges broadly and deeply outside the conventional range. The second component is the willingness to nurture this imaginative ability and go with its results. Creativity involves receptivity—an openness to what is new, atypical, or unconventional and a willingness to be affected by it. I wrote above that we value art because individual works are accomplishments, and I raised the issue that, if creative acts are often the result of unconscious processes and chance occurrences,

these might not be an accomplishment of the artist since they were not intended. But what the artist can take credit for is nurturing this receptivity and honing its products into an artistic vision. Receptivity, making oneself available for the unconventional, requires a certain kind of attention and energy that can be enhanced or suppressed. The lives of creative people often involve resistance to external and internally imposed attempts to stifle imagination. A disposition to be creative involves self-overcoming and hurdling obstacles, even when such a capacity comes naturally.

Furthermore, and perhaps more importantly for the issue of intention, creative people must take the results of their mysterious unconventionality and shape it into something intelligible. Ultimately it is that work, that shaping into intelligibility, which constitutes the artist's vision and their accomplishment. Aimless noodling on the guitar or experimental brush strokes, however inventive they may be, are not yet works of art. They need to be worked on until they acquire intelligibility and aesthetic character. The spark of insight that constitutes creativity may not be intentional, but the deployment of the idea, its materialization, must involve intentions of some sort. The intention may occur downstream from the spark of insight, but it is no less a part of the process of creation represented by the finished work.

This may be what Zangwill had in mind. In shaping their artistic media to make their idea intelligible, artists manipulate nonaesthetic properties of sound, line, or color to bring out aesthetic properties made available by the materials being worked on. If this is what Zangwill intended, the creative theory can be rescued by paying more fine-grained attention to the creative process and locating intentionality, at least in part, in the materialization of the creative idea rather than the idea's generation, and acknowledging that such ideas and intentions can be unconscious.

Furthermore, it is important to see the regulative role of *general* intentions, rather than the *specific* intentions regarding particular aesthetic properties that Zangwill emphasizes. Even in those

moments of serendipitous inspiration, it is a mistake to think there are no aesthetically relevant intentions at work. Behind the scenes, there are general intentions that guide artists in their projects. Artists intend to produce something of aesthetic interest and meaning, with some originality. They may know the genre in which they operate, have a sense of what can be done in the media in which they work, and may be cognizant of the likely response of their audience or patrons to their art. They may adhere to theoretical commitments or a sense of how their own body of work is evolving. However, most importantly, through their training, experience, and close observation, artists develop a cluster of tendencies and ways of making perceptual discriminations among works of art. In other words, they develop an aesthetic sensibility that guides their decisions about their own work. It is one thing to generate lots of ideas that are sufficiently unconventional to count as creative. Successful art requires selecting which ideas are worth pursuing. The general intentions, formed by an artist's sensibility and background, act as a filter enabling the experimentation and brainstorming to be productive and focused by tossing out what does not work and preserving what does.

These high-level, general intentions may be unconscious and inarticulable and, contrary to what Zangwill argues, do not require conscious judgments about specific aesthetic properties. Nevertheless, they regulate creative activity. Thus, although specific aesthetic properties of a work of art may not be intended, they are a product of the more generalized intentions that arise from artists working within their art world. This is the best way to understand creative intentions that avoids attributing excessive deliberation and calculation to the creative process. In summary, Zangwill's creative theory of art can be successful if it acknowledges the central role of general rather than specific intentions, the development of a creative sensibility that functions as a filter to determine what is worth developing, and the role of unconscious intentions. I will assume this modification of Zangwill's theory in what follows.

Creativity in Winemaking

The issue in this discussion of winemaking is whether artistic creativity plays a role in wine production. Is it directly analogous to creativity in the arts?[19] In winemaking, the analog to the imaginative, generative process in the arts is the tasting winemakers do in the vineyard and in the winery. Based on what they taste, they begin to imagine and conceptualize what the finished wine will taste like. Experienced winemakers have a sense of their style preferences and know the tendencies and dispositions of their vineyards. Yet, every year, because of the influence of weather and changes in vineyard practices, they must revisit those intentions, re-conceptualizing their intention when their tasting reveals something new or unexpected, as it routinely does. If a new taste, aroma, or texture sparks a "vision" of new ways of expressing nature in the finished wine, then winemaking begins to look more like an art than a craft. Imagination, as well as tasting acuity, are prerequisites for great winemaking. Creative intentions are present in winemaking but can be solidified only after tasting.

The crucial point, for my purpose, is that winemakers share with artists the aforementioned artistic background commitments and general intentions, which guide their winemaking. Like artists, winemakers also intend to produce something of aesthetic interest that has meaning in light of the winemaking traditions they work in. They also are cognizant of the creative possibilities within their media and materials, the genres and styles they work in, and the evolution of their work. Many, such as producers of natural wines, have theoretical commitments to which they adhere.

The most important background commitment that shapes the final product is an aesthetic sensibility developed through their years of tasting. The goal for many artisan winemakers is to preserve *terroir*, the distinctive features of grapes from a particular vineyard or region. Because each winemaker tastes differently, their final product, if not distorted by the goal of homogeneity or consistency, will be different

as well. Each winemaker has an interpretation of what it means to preserve *terroir* through the idiosyncrasies of their tasting sensibility.

Furthermore, since originality and distinctiveness are abiding concerns, part of this background intention is an implicit understanding of what counts as original within their winemaking culture. In summary, the capacities and dispositions that constitute artistic creativity, discussed above, apply equally to at least some winemaking, including the disposition to seek out and nurture what is new or distinctive. This is not to say they all succeed at making original wines. But neither do all artists succeed in their struggle for distinction.

There are countless decisions made in the vineyard and winery designed to realize these general aesthetic intentions. Most of those decisions have to do with nurturing and shaping the materials of winemaking—soil, vines, grapes, winery equipment, barrels, etc.—in order to set the stage for the grapes and then the wine to develop according to their dispositions and tendencies. It is important to remember that winemaking is a collaboration with nature. However, the distinction I made above, between specific aesthetic intentions and more general intentions that function as aesthetic background commitments, is especially important in understanding creativity in winemaking. In the vineyard and winery, the purpose of tasting is usually to check on the condition of the grapes or the wine during production. At harvest, winemakers measure Brix levels and taste for tannin development and acid levels to determine when the grapes should be picked. Picking decisions are so important because of the influence they have on the aesthetic properties of the finished wine. In the winery, the purpose of tasting and smelling is to find flaws or evidence of something going wrong or to determine when the wine is ready for the next stage in its production. Once again, these decisions will profoundly affect the aesthetic character of the wine. It may be that winemakers carry out these practical tasks without having in mind a specific aesthetic effect they are trying to achieve—the grapes,

the wine, and environmental conditions will have their say in how the final product develops. However, the aesthetic sensibility of the winemaker continuously operates in the background, informing the more practical decisions that make up their daily routines. And, of course, when deciding on the final blend, aesthetic intentions play a much more explicit role. The paradox in artisan winemaking is that even though *terroir* is supposed to transcend human control, it is nevertheless open to interpretation. That paradox can be resolved only if the winemaker's sensibility plays a central role in how *terroir* is expressed.

As I argued above, though, specific aesthetic intentions are not necessary for the creation of art either. Aesthetic intentions serve as general background commitments that regulate the myriad practical decisions that constitute both art production and winemaking. Thus, there is little reason to endorse the claims made by Burnham and Skilleås that winemakers lack aesthetic intentions or that winemaking differs markedly from the creation of art with regard to the kind of intention involved.

However, there is one fundamental difference between winemaking and creativity in most arts. Painting, music composition, literature, and theatre usually involve persistent activity with lots of experimentation, erasure, and more experimentation as the work takes shape. Winemaking is different. As Randall Grahm told me in conversation, artisan winemaking involves a lot of "watchful waiting": waiting for the weather to give shape to the growing season, waiting for grapes to develop in the vineyard, waiting for fermentations to finish, and especially waiting for the wine to age in barrel and bottle before it's ready to release. Watchful waiting does not seem like an accurate description of painting or musical composition and performance. Nevertheless, given the above account of creative intentions, "watchful waiting" in the vineyard and winery turns out to be the way in which winemakers realize their creative intentions.

I have been arguing that we should understand creativity in the

arts to involve the possession of general intentions that regulate decisions. These general intentions operate even in the absence of deliberation and do not require consciously held intentions to realize specific aesthetic qualities. I want to suggest that the central regulative role that these general intentions play is to provide criteria for a variety of "stopping heuristics," intuitive judgments about when a process is complete and needs no further additions or modifications. At various stages in every work of art, there are points at which the artist says, "OK—that is what I'm looking for." She may not have known what that was ahead of time; she may in fact be surprised by the result. This is not necessarily a conscious process. But that eureka moment, which may not be a moment but can require an extended process of receptivity, when you judge "that's it," the recognition that an aesthetic intention is realized, is possible only given a sensibility that defines the parameters of what the artist is doing. Of course, these commitments can change during the process. This is not a set of rules but a sensibility that defines a point of view that is always a moving target.[20]

That is precisely what winemakers accomplish with their watchful waiting. They are, after all, watching *for* something and waiting *for* something, although what they are waiting for need not be consciously held or formulated ahead of time. These are intentional activities with the aim of identifying when the grapes in the vineyard or the wine in the tank, barrel or bottle show their aesthetic potential, as intended by the winemaker given her aesthetic sensibility. Thus, a good artist (or winemaker) is not only someone who has the gift of coming up with new combinations of ideas and the skill to manipulate the medium in which she works. They are able to react sensitively to their results, selecting those that correspond to a scheme of artistic value embedded in the aforementioned general intentions. And, of course, part of this scheme will be an understanding of what counts as a new development or a departure from the past.

No doubt, in painting or musical composition, as compared to winemaking, there is more active, moment-to-moment shaping of

materials. The results of brush strokes or new harmonic configurations can be assessed immediately or at least without undue delay. Not so with winemaking. It is a slow art because experiments can take years to unfold. The results of modifications in vineyard practices or winemaking techniques may not be apparent until the wine has aged for several years. Yet, surely the slow pace of experimental results does not subtract from the aesthetic quality of the intention. Neither does the fact that winemakers depend on the cooperation of their materials. The fact that winemakers give direction to nature in the development of their work is no more an impediment to artistic intent than the fact that painters depend on the cooperation of light or musicians on the structure of their instruments. The medium always shapes the message. Thus, when sipping your next glass of pinot noir, slow down and savor the moment, for it was made with more patience than even Monet or Mozart could manage.

Inspirations:

When thinking about the conception of art that I would use to frame the arguments in this book, three names and their wines pushed me towards the creative theory—Randall Grahm of Bonny Doon Vineyards, James Frey of Trisaetum Vineyards in Newburg, Oregon, and Clark Smith and his WineSmith label. Randall Grahm's latest project, the Popelouchum Vineyard, is an experiment in creative viticulture. Rare European varietals (timorasso, ruché and rossese) and alternative species (vitis berlandieri) share space with new clones being bred for drought tolerance, and all are farmed using biodynamic techniques. But Grahm's experiments in utilizing novel ageing vessels—including five-gallon carboys left out in the sun—go back many years. Try any pre-2018 vintage of Bonny Doon's Le Cigare Volante or Le Cigare Blanc to see how these experiments worked out.

Clark Smith has long been one of the wine industry's most prominent technology/wine chemistry gurus. He developed technology for using reverse osmosis to remove alcohol and contributed to the development of micro-oxygenation for building structure in wine. He continues to probe new ways of building structure and flavor. All that experimentation needs a playground. That would be WineSmith, his small batch winery that produces outstanding delicious and distinctive wines always with an unusual twist. The Roman Syrah, made with no added sulfites, and a rare Norton made from California grapes, for me, generated the most "wow" factor.

James Frey makes gorgeous Riesling and Pinot Noir. He is also an accomplished artist who, at the beginning of this project, generously responded with great insight to my questions about the relationship between art and winemaking. This chapter took shape only after that interview.[21] His paintings are on display at Trisaetum Vineyards.

Notes

1 Matt Kramer, "Why Wine Isn't Art—and Why That Matters," *Wine Spectator*, October 2008.

2 Douglas Burnham and Ole Skilleås, *The Aesthetics of Wine* (New Jersey: John Wiley and Sons, 2012), 99-100.

3 I have seen this quote attributed to Michelangelo many times, even in scholarly work, but to my knowledge it has never been authenticated. Nevertheless, it captures the idea I wish to articulate.

4 Thanks to Stephen Pacheco for this example.

5 I defend the reality and importance of dispositions in more detail in Chapter Nine

6 John Elster, *Ulysses Unbound* (Cambridge: Cambridge University Press, 2000).

7 Andy Goldsworthy, *Passage* (New York: Abrams, 2004), 74.

8 Randall Grahm interview conducted by Dwight Furrow, posted at Bonny Doon's blog, May 15, 2017. https://www.bonnydoonvineyard.com/aesthetics-of-wine-prof-dwight-furrow/ accessed 10/14/2020

9 Burnham and Skilleås, *The Aesthetics of Wine*, 101.

10 Randall Grahm interview, posted at Bonny Doon's blog. https://www.bonnydoonvineyard.com/aesthetics-of-wine-prof-dwight-furrow/

11 On the general question of which theory of art would help elucidate the nature of wine, I agree with Gabriele Tomasi that Zangwill's aesthetic theory is the most promising. And I agree for largely the same reasons. Wine is an artifact, a bearer of aesthetic properties, and when made properly, made with the intention that it have aesthetic properties. The fact that many, if not most, works of art give us aesthetic pleasure is in part why we value art. Thus, wine seems to have the same function as most works of art, as Tomasi rightly argues. The fact that some works of art may have a nonaesthetic function does not harm this view; there is no requirement that all works of art have only one function. I part company with Tomasi on the same issue for which I express reservations about Zangwill's theory below. I suspect the requirement that works of art must embody quite specific intentions about how nonaesthetic properties contribute to aesthetic properties is too strong and cannot explain the role of chance in the art-making as well as the winemaking process. In a footnote, Tomasi acknowledges that aesthetic intentions may be quite general. See Gabriele Tomasi, "On Wines as Work of Art" in *Wineworld: New Essays on Wine, Taste, Philosophy and Aesthetics*, ed. Nicola Perullo, special edition, *Rivista di Estetica*, 51 (2012), 55-174. https://journals.openedition.org/estetica/1388?lang=en pp.

12 Nick Zangwill, *Aesthetic Creation* (Oxford: Clarendon Press, 2007),36.

13 Nancy C. Andreasen, "A Journey into Chaos: Creativity and the Unconscious," in *Mens Sana Monographs,* 9 (1) (2011), 42–53 https://www.ncbi.nlm.nih.gov/pmc/articles/PMC3115302/

14 Zangwill, Aesthetic Creation, 49.

15 At this point, the notion of an unconscious intention may do some work. For an account of unconscious intentions, see Alfred Mele, *Effective Intentions: The Power of Unconscious Will* (Oxford: Oxford University Press, 2009).

16 Berys Gaut, "The Philosophy of Creativity," *Philosophy Compass*, vol. 5, no. 12 (2010), 1039. This is a useful survey of the philosophical literature on creativity.

17 This seems to rule out creative violence and other creative acts that lack value yet would exhibit creativity. It might be nice if we could define evil out of the pantheon of creative acts, but evil is always a stubborn thing that resists wishful thinking.

18 To be creative, one need not be in general unconventional, but only unconventional within a domain.

19 No doubt, winemaking involves a great deal of practical creativity. Winemakers must create novel ways of working with their equipment. They must find ingenious ways of manipulating time and space to conform to production schedules and imaginative ways to market their product. However, my focus here is on artistic creativity, creativity in producing the artistic properties of their wines.

20 For a comprehensive account of the role of intention in artistic production, as well as the importance of an artist's decision to stop, see Paisley Livingston, *Art and Intention: A Philosophical Study* (Oxford: Oxford University Press, 2005), Chapter Two.

21 The James Frey interview is available at my blog Edible Arts, posted 2/8/2017. https://foodandwineaesthetics.com/2017/02/08/winemaker-interview-james-frey-of-trisaetum-winery/

BEAUTY AND THE YEAST

CHAPTER FOUR

AMBIENTE: IT TAKES A VILLAGE TO RAISE A WINE[1]

"Community cannot for long feed on itself; it can only flourish with the coming of others from beyond, the unknown and undiscovered brothers."

—Howard Thurman

Winemaking is a collaboration between the creativity of nature and the creativity and skill of wine producers. Yet that creative collaboration takes place in a wine world thoroughly saturated by tradition. The wine styles on offer today have been around for centuries. The best-known wine regions, and many of the most respected producers, trace their lineage back through the ages, and this history is a prominent feature of those producers' reputations as well as their marketing materials. It is difficult to think of a contemporary social practice more bound to tradition than wine. Nevertheless, innovation occurs, and new variations are abundant enough to constitute the heart of the aesthetics of wine. How do these variations occur and achieve prominence in a tradition-bound practice like winemaking?

Discussions of the main factors that influence wine production tend to oscillate between two poles. In recent years, the focus has been on grapes and their growing conditions as the main inputs to wine quality and the primary source of variation. The reigning ideology of artisanal wine production has winemakers modestly claiming to be caretakers of the grapes, making sure they don't do anything in the winery to screw up what nature has worked so hard to achieve. Such modesty about winery interventions has not always been the norm. Beginning in the 1970s and continuing into the first decade of the 21st century, the winemaker as auteur, a wizard at winery tricks, was ascendant, as new winemaking technologies, farming methods, and remarkable advances in wine science transformed a formerly artisan practice. Yet, only the wealthy, educated, and connected had access to these advances. Thus, the "flying winemaker," a globetrotting consultant who made his knowledge and expertise available to the wider wine community, was common. According to this ideology, grapes are a blank canvas awaiting a winemaker's vision to transform them into quality wine, and new variations are the result of winemaking innovations.

In fact, both ideologies ignore the collaborative, social dimension of winemaking. There is more to wine production than the winemaker and her grapes. Although the winemaker and her team contribute a great deal to the final product, wine is made in communities that are part of traditions with a variety of agents influencing the final product. Thus, the account of creativity in the previous chapter was incomplete because it treated creativity as a function of only the winemaker and her vines. In this chapter, I want to show how the larger social milieu in which wine is produced contributes to that creative project. By focusing on the creativity of this social milieu, we gain a better understanding of how new variations and changes in style occur in the wine community.

Although the head winemaker makes executive decisions about wine quality, the winemaker's team does much of the physical labor

and executes the winemaker's plan, except in very small wineries.[2] Winery owners, even if they employ a winemaker, may contribute to creative decision-making. In addition, the community of which the winery is a part plays a role in wine quality. Zoning ordinances, land prices, business regulations, and political factors contribute to how wineries think about wine quality. Laws that govern winemaking and labeling in each region—some in Europe, for example, are quite restrictive, specifying yield per acre, planting densities, and winemaking techniques—also influence the kind of wine produced. Winery associations function as a clearinghouse of information and a forum for discussion about wine production norms and quality assessments. Consumers provide feedback that influences winemaking decisions, and critics, writers, and sommeliers create a discourse about wine and help set consumers' expectations. The scientific and academic communities increasingly supply crucial information to winemakers in all phases of their operation, as do technology firms that often undertake significant research to advance their products. In addition, the general business and economic environment provides powerful incentives and constraints on decisions in the winery. The larger society within which both producers and consumers function has its own norms and preferences that may influence how wine and alcohol are perceived. My point is that agency in the wine community is widely dispersed. Creativity, the birth of the new, is seldom the work of an individual but emerges from a social milieu that shapes the final product. Yet, if agency is dispersed, with independent actors making individual decisions affecting wine production, how is this activity coordinated?

Some sociological research on this question in the world of art is directly applicable to wine. In his seminal work, *Art Worlds*, Howard Becker studied the social context that enables artistic production.[3] Although he describes the armies of support personnel that facilitate artistic creativity, they are not the main organizational feature of art worlds. According to Becker, art worlds are organized by conventions

that constrain both artists and their support personnel. Conventions, based on earlier agreements that have become customary, are the glue that bind art communities and foster the reproduction of styles and genres therein. The conventions might arise from the technology or raw materials used in the production process or from the interpretation and consumption of cultural texts that comment on art. Regardless of their source, customs and conventions constrain the choices available to artists long before they are faced with a creative decision.

Conventions play a similar role in the wine community. Just as composers and musicians work under implicit agreements to use particular scales and modes, winemakers use particular grape varieties for winemaking, employ methods and techniques inherited from previous generations even while supplemented by new technology, and create within stylistic frameworks that in some cases have been around for centuries. For example, stylistic distinctions between red wine and white wine, sweet and dry wine, and sparkling and still wine are maintained, with occasional exceptions. Just as painters use an abstract idea such as perspective to convey the illusion of three dimensions, winemakers employ the abstract idea of *terroir* (the French term meaning "of the earth") to convey a sense of authenticity and attachment to the geographical location in which the grapes are grown. Just as composers use the form of the symphony or sonata to make combinations of musical phrases intelligible to their listeners, the appropriate size of a wine bottle, the information conveyed in tasting notes, and the proper format for tasting—starting with dry, light-bodied white wines before moving to heavier reds and then sweet wines—are all a matter of convention [4]

The stylistic consistency of wine within winemaking regions is also a matter of convention. In Barolo or Madiran, highly tannic red wines are the norm, while fans of Beaujolais or Emilia-Romagna expect more modest tannins. These style preferences are influenced by decisions about which grape varieties to plant in a region. However, these decisions are not made in a vacuum. A

lengthy collaboration between nature and culture shapes the flavor identity of wines grown in a region. This includes the interactions of consumers, communicators, and producers within a social discourse that designates certain patterns of taste as authorized and worthy of reproduction. Thus, *terroir*, the sense of place that wines grown under particular geographical conditions exhibit, is as much a social structure as a set of physical characteristics. The concept of *terroir* guides the actions of winemakers and consumers within a wine region that views itself as a coherent entity. As a certain style of wine becomes entrenched in a region, it comes to be understood as an expression of that place—again, a matter of convention.

Winemaking and wine consumption, today, are replete with organizing conventions which include the following: the relative absence of faults such as excessive volatile acidity or off-flavors that result from the spoilage yeast brettanomyces; the assumption that most quality wine (with the exception of dessert wines) will be dry or off-dry; the use of oak to age red wines but typically not most whites; norms governing pairing food with wine; the tendency on the part of consumers to drink wines young; and tasting room etiquette. Each convention embodies assumptions that prescribe a standard by which a work is judged aesthetically successful, a violation of which might lead consumers to judge a wine distasteful if not disgusting.

If conventions are the centripetal force that holds wine worlds together, why do people remain committed to them in the absence of a centralized authority that enforces them? Becker argues that intelligibility and efficiency are the two primary reasons for the reproduction of conventions within art worlds. Audiences can grasp the meaning of a work of art and emotionally respond to it only because they share, with the artist, implicit agreements about how works are constructed. Similarly, wine lovers share with winemakers and others in the wine community conventional understandings of what wine should taste like that help consumers make sense of what the winemaker is doing. The need to be intelligible constrains the degree to which artists or winemakers can violate conventions.

Conventions are also important because they promote efficiency. Conventions facilitate the coordination of activity among winemakers, support personnel, and the rest of the wine community. Equipment manufacturers, winery designers, and vineyard laborers must share assumptions about what wine is and how it is made if they are to do their jobs. Without conventions, each step in the production process, as well as the process of appreciation, would require separate negotiations and constant retraining, and experience would count for nothing.

The Importance of Traditions

However, wine worlds embody an additional factor that is relatively absent from art worlds, which helps to explain the persistence of conventions—a prevailing, sometimes all-consuming respect for tradition. Among the norms that govern wine worlds is a shared understanding of what wine is and the abstract meanings associated with wine—as a complement to meals, a symbol of the sweet life, a reflection of the sensibility of a community or a people, or a heroic struggle with nature. We view wine as an aesthetic object against the background of these traditional meanings. They have a powerful influence on the styles of wines that consumers are willing to accept, and thus they constrain what winemakers do in the vineyard and winery and how wine lovers and communicators talk about wine. The fascination with stories about the origins of a wine and its rootedness in family traditions emerges from a shared understanding of the wine life and its associations. Long before there were armies of Instagram addicts looking for the next new wine fad, wine was rooted in local folkways and geography. Most winemakers and their customers look at wine through this traditional framing that constrains their thinking about new possibilities. Attacks on these sacred aesthetic beliefs undermine the existing status arrangements within the wine

community, which strongly resists any pressures to change. Art worlds, especially in contemporary society, lack the deep respect for tradition that is one of the central meanings of wine.[5]

Yet, despite the important role that conventions and traditions play in the wine world, change does occur. Over the past few decades, there has been a massive shift in preferences for dry wine over sweet wine. New-world wine regions in the U.S., South America, Australia, and New Zealand, among others, have risen to challenge the old world, largely on the basis of greater ripeness and higher alcohol, although this style has recently come under attack by a strong counter-movement toward more balance and lower alcohol. Thanks to technologies that enable a homogenized flavor profile that can be produced almost anywhere, an international style emerged in the latter part of the twentieth century to challenge the hegemony of local tastes. A whole new category of wine—"super Tuscans"—sprouted from the bastions of Italian tradition, toppling Chianti, Brunello, and Barolo from the list of the most sought-after Italian wines, while styles of chardonnay shift like mountain weather. Natural wine continues to grow in popularity, in some cases showing flavor profiles that transform our idea of what wine should taste like. Despite the commitment to tradition, the wine world is dynamic and changing.

The problem is to explain aesthetic change in the wine community. In a community so tied to tradition, how is innovation possible? What guides shifts in style? Who are the main actors fostering change, and what do they contribute? The wine world is an amalgam of stability and variation. Although the genetic instability of grapes and their sensitivity to minor changes in weather, soil, and topography are agents of change, most of these changes are minor variations within a context of stability. We create new varietals, discover new wine regions, and develop new technologies and methods, but these innovations produce minor deviations from a core concept that often seems immune to radical change. There are, after all, only so many ways to ferment grape juice. Red and white still wine, sparkling wine,

and fortified wine have been around for centuries and are still the main wine types on offer. Every wine we drink is a modification of those major themes. Nevertheless, sometimes wine styles do undergo radical change.

Stasis and Change in the Wine World

One example of a massive change in taste took place in the U.S. in the decades following World War II. Over a period of about twenty years, American wine consumers changed their preference from sweet wine to dry. How did such a revolution in taste occur in such a relatively short period of time? American wineries in the nineteenth century were widely acknowledged to produce quality, dry, European-style wines. However, Prohibition virtually eradicated the domestic American wine industry, except for the few wineries that survived by making sacramental wine or growing grapes for private use. Gone were the winemakers and vineyards, along with the knowledge, culture, and equipment necessary to make quality wine. After the repeal of Prohibition in 1933, it took several decades to get Americans to drink wine again. Although, by 1960, we were consuming about 160 million gallons per year, in the 1950s and '60s, seventy percent of the wine sold in the U.S. was cheap, sweet, and very high in alcohol. People drank Thunderbird, Ripple, and Wild Irish Rose (remember those?) because it was a cheap high, and producers such as E. & J. Gallo were happy to satisfy that demand. Yet, by 1978, seventy percent of wine sold in the U.S. was dry (or relatively dry) table wine. That trend continues today. In 2018, the percentage of dessert wine sold in the U.S. was just under ten percent of total wine sales.[6]

What caused such a dramatic shift? Americans emulated the French, whose reputation for quality wine was unmatched at the time. Although the French made lovely dessert wine, most of the storied vineyards of Bordeaux and Burgundy made wine with little residual

sugar, modest alcohol levels, and nuanced aromas intended to be consumed with their refined cuisine. That French image of wine—dry, nuanced, food friendly, a source of aesthetic experience, and a symbol of the sweet life—was transplanted to the U.S. in a few short years. It is often claimed that the U.S. had no wine traditions to act as a constraint on innovation. We didn't need them; we borrowed French traditions.

The emergence of a fine wine culture in the U.S. cannot be disentangled from the simultaneous emergence of an American food culture.[7] Even amid the dreadful landscape of American cuisine in the 1950s, change was afoot. Julia Child was cooking her way through France. Soldiers returning from World War II and its aftermath in Europe had acquired a taste for European cuisine, and, as air travel improved, prosperous Americans traveled to France and Italy and were exposed to refined tastes and a focus on flavor. Furthermore, immigrant communities kept alive their ties to the old country by preserving some of their food and wine traditions—the role of Italian immigrants would be especially important in this wine revolution. Thus, by the 1960s, the ingredients were in place for some Americans to begin a serious exploration of flavor.

Importers and media, as well as American commercial wine producers, were quick to recognize this increase in our interest in European-style wine. Julia Child advised Americans on the finer points of wine and food pairing in her book *Mastering the Art of French Cooking*, while toasting "*bon appetite!*" with a glass of wine at the close of each episode of her long-running TV cooking show. Advertisements in magazines such as *The New Yorker*, *Gourmet*, and *Time* instructed consumers on the nuances of wine appreciation and how to read wine labels. Airlines and fine hotels began to emphasize wine as a component of first-class service. Thus, in addition to advertising a product, the wine trade was creating an imaginative discourse around wine in which it came to symbolize a life of refinement, ease, aesthetic appreciation, and sophistication. As a result, wine gradually shed its reputation as a cheap way of getting drunk and separated

itself from spirits and beer as a more civilized alcoholic beverage no longer associated with barroom brawls or so-called "bum wine." What appears to be a radical change in taste was, in fact, an extension and reinforcement of a long European tradition led by the French, with important contributions from the Italians, Germans, and Spanish, among others.[8]

While Americans were discovering their palate, Californians were rediscovering how ideal their climate was for growing wine grapes. Although Prohibition had put an end to most commercial California wine production, by the 1940s the foundation of a reborn wine industry emerged in the Napa Valley, with fifteen or twenty wineries active by 1950. French winemaker André Tchelistcheff had joined Napa's Beaulieu Vineyards in 1938. He introduced a variety of French winemaking techniques, such as malolactic fermentation and cold fermentation, and he championed the planting of French varietals, especially cabernet sauvignon, as well as the use of French oak barrels for ageing wine. Just as wine appreciation would later adopt the French image of wine, wine production, in those redoubts where quality mattered, had already done so. As American winemakers increasingly focused on quality, they were trying to emulate the best, and that was French wine. Even Robert Mondavi, the son of Italian immigrants and a tireless promoter of improved quality in the Napa Valley in the 1960s, planted French varietals and used French winemaking techniques.

However, this picture of the U.S. adopting the French image of wine is more complicated than a simple mimetic relationship. That transplantation of European traditions did not occur without some variation. There were differences in the United States' context that immediately began to transform the transplanted French image of wine. These differences were magnified, ultimately producing a distinctly different style of wine. When something is copied in a new context, new causal factors emerge, which induce a kind of "drift" that continues to transform the copied material. Under the right conditions, "drift" can produce radical change.

There were two crucial innovations and some good fortune that modified the French model as it was being transplanted to the U.S. One innovation was varietal labeling. Most European wineries labeled their wine with the name of the place where the grapes were grown. With few exceptions, the name of the grape varietal never appeared on the bottle, and few consumers knew or cared which grape was used to make the wine. It was the land and the winemaking tradition that mattered, not the varietal. The bulk wine market in the U.S. continued this practice, calling their white wines "Chablis" and their red wines "Burgundy," despite the fact there was no connection between what was in the bottle and these famous place-names in France. However, the influential importer Frank Schoonmaker had long advocated the use of grape varieties on the label, and wineries increasingly adopted this approach. This made wine more accessible to a mass market in which consumers lacked the knowledge or inclination to keep track of what was, to them, "obscure" vineyard sites and regions in France. This focus on varietals influenced winemaking as well, allowing wine science to experiment with measurable dimensions of particular varieties under controlled conditions in their test vineyards, rather than the less calculable historical traditions tied to the land in Europe.

The second innovation was the introduction of new technology. Without domestic traditions to limit their approach to winemaking, Americans were free to experiment and experiment they did. California winemakers were early adopters of stainless-steel, temperature-controlled fermentation tanks, which were developed in the 1950s. They quickly took advantage of new filtration techniques and commercial yeasts. Mechanical harvesters, drip-irrigation systems, and laboratory testing of wine components were deployed with the help of the Oenology and Viticulture Department at the University of California, Davis.

The bit of good fortune was California's climate. California was fortunate to have the sunlight and warmth to bring out even more fruit flavor and to do so more consistently than the cooler sites in France.

The cumulative result of these differences was clean, consistent wines with bold, bright fruit flavors and reliable secondary fermentations in red wine to soften the acidity. The role of technology was not only to increase production capacity to satisfy a mass market; it had a discernible influence on wine quality as well. Americans were emulating the French, but they were also trying to surpass them, an aspiration partially achieved in the famous Judgment of Paris event in 1976. In a blind tasting, French wine experts surprised the wine world by giving first place to two Napa Valley wines—the Stag's Leap Wine Cellars 1973 Cabernet Sauvignon and the Château Montelena 1973 Chardonnay. Ultimately, the focus on grape variety, California sun, and advanced technology would lead to a distinctive new style of wine.

At the time of the Judgment of Paris, it is probably not correct to say the California style of wine was radically new. After all, some of the blind tasters in the Paris event mistook California wines for French, although the British wine writer Oz Clarke described the California wines as "startlingly, thrillingly different." However, the small differences American winemakers achieved with their methods were celebrated, worked on, and enhanced in the ensuing decades. California had the sun; why not use that as their competitive advantage? Grapes were left on the vines longer in the relatively dry, sunny early autumn months, which allowed them to develop more sugar to convert to alcohol while softening tannins and reducing acidity. This innovation spread to other countries that also had the sun and technology. Australia was especially aggressive in pursuing these same developments. New-world wines were born. Today, for blind tasters, one of the first judgments one makes about a wine's origin is "new world or old world." They are distinctly different styles, although climate change is beginning to blur those differences.

What can we conclude about change in the wine world from this brief history of twentieth- century wine in the U.S? When traditions and conventions are reproduced, they do not make exact copies. They are reproduced in different contexts, and those differences beget more

differences. When traditions cannot be rigidly enforced by rules or norms, the constant demand for improvement encourages tinkering with new methods and techniques, which induces drift—minor changes in quality that become major when taken up and advanced. Thus, while consumers were busy buying wine as an aspirational beverage in a quest to acquire "good taste," innovators on a quest for difference and with their own understanding of excellence sent wine in new directions.

Yet even when a tradition is supplanted by something new, the old ways often reassert themselves. The influence of the French image of wine would continue in the U.S. as a return of the repressed. As California wines became richer, denser, and more alcoholic, there was a powerful backlash, as more restrained styles came back into fashion. The "anything but chardonnay" movement of the late 1990s and the highly publicized but now disbanded "In Pursuit of Balance" winery association, launched in 2011, were part of this backlash. The recent interest in very dry, Provence-style rosé, and the generally lighter, less alcoholic wine styles we find today are all a re-assertion of the French image of wine. (This is an image the French are struggling to maintain in the face of climate change and market pressures.)

The model of change I have described thus far is conservative. Consumers tend to follow the crowd. Change is induced through drift and a few entrepreneurs who strive to do things differently, while traditions remain a powerful force. However, the distributed model of creative agency has more resources for explaining change. The manner in which these innovations are evaluated and communicated is of crucial importance. We get a more expansive account of change when we factor in changes in the authority structure of judgments about wine and taste. Among the factors that play an important role in this contest between stasis and innovation is feedback from wine critics who influence consumer tastes as well as production styles. How much do critics influence wine styles, and how is that influence transmitted?

Wine Criticism and Stylistic Innovation

Any discussion of the influence of wine critics must start with the iconic Robert Parker, Jr., who is widely credited with rousting wine production from its complacent slumber in the early 1980s. Yet, he is also blamed, rightly or wrongly, for making wine more homogeneous and less interesting by encouraging more alcoholic, riper wines that lacked nuance and for introducing a scoring system for wine judging that made wine more accessible to consumers by suppressing its complexity. Regardless of which side of this fence you're on, Parker was no doubt extraordinarily influential, and it's worth looking at the sources of that influence to better understand how wine styles change.

Parker's main innovation was to change the authority structure of wine criticism. Prior to Parker's emergence in 1978, most wine writers were in the wine trade, and their writing was disseminated through newspapers and magazines such as *Gourmet*, *Vanity Fair*, and *The New Yorker*. Parker, a lawyer by training and a wine lover, accused wine writers of being in cahoots with producers, leading to complacent winemaking that allowed little input from consumers. As he reports in an interview:

> When I started in 1978, there was little competition. The British dominated wine writing. But most of these writers were in the wine business. They were never truly objective. I was influenced by Ralph Nader and by attending law school during the Watergate era. I would be there for the consumer—against corruption or conflict of interest. It caught on with my generation—a consumer approach to wine, in contrast to the British approach.[9]

It was not only the British writers who had a financial interest in the wines they wrote about. Although there were exceptions, such as the journalist Frank Prial at the *New York Times*, most of the other celebrated American wine writers—the Russian/American

Alexis Lichine, the legendary Frank Schoonmaker, the *Los Angeles Times* critic Robert Lawrence Balzer, and Darrell Corti, among many others—were wine merchants who also wrote about wine. Merchants are entitled to write about the wines they sell, but we cannot expect independence from such an arrangement. Furthermore, especially in the relatively small wine world of the mid-twentieth century, which focused mainly on a few regions in France, merchants and producers depended on each other for their business success and maintained personal relationships built over many years. There was little incentive to bite the hand that feeds or for the merchant-critics to express strong disapproval with producers. After all, there were only so many places to sell wine and only a limited number of places from which merchants could get their supply. Thus, producers could effectively police tasting practices and slap down any attempt to taste outside the box. Authority rested with producers and their spokespersons, and the legitimacy of that writing was based on personal relationships. The readers were informed by someone on the inside, in the know, and the reader's trust was based on those connections, which the writer fostered.

Robert Parker was not part of that cloister when he established his subscriber-based newsletter, *The Wine Advocate,* in 1978. He had no financial interest in the wines he wrote about and had fewer incentives to submit to policing by the producers. He disrupted that incestuous connection between producer and writer; it was his reputation for independence that was the key to his success. (Whether he maintained that independence throughout his career is a matter of some dispute.) As Parker's subscriber base and influence grew, the merchant-writer/producer relationship lost authority to an outsider who, it should be emphasized, also possessed tasting skill, a prodigious memory for wine, and the charisma to effectively communicate his skill and authority.

As a result of this shift in authority, new wines and wines that had been previously ignored were able to get publicity. Getting out from

under the policing of the producers enabled Parker and the other critics who followed his lead to influence nascent trends. With this new publication model for wine reviews, he needed to please only his subscribers, who were likely more adventurous than a general newspaper or magazine audience. Thus, creative tasting—a mode of appreciation that is alive to new developments—became permissible and expected.

The second innovation introduced by Parker was his system of wine scoring. The Parker scoring system was a one-hundred-point system modeled after the grade reporting in U.S. schools. In reality, it is a fifty-point system. Wines start out with fifty points, and he then added points for merit—fifteen points for the intensity, complexity and cleanliness of aromas; twenty points for flavor, which includes balance, depth and length; and fifteen points for overall quality and potential for ageing.

Although Parker's is not the only system of wine scoring available, it is the most widely adopted in the U.S., and its appeal is obvious. It was a handy reference for the burgeoning market of busy middle-class consumers that did not require they know anything about producers, regions, or varietals. Equally important was the fact that the score lends itself to nonverbal communication. When I bring a wine to a dinner party, I'm unlikely to bring tasting notes, and reporting them to the assembled (presumably non-geek) guests would, in any case, be tedious and invite ridicule. By contrast, reporting the score is instantly recognizable, not as a descriptive statement but as a quality talisman that instantly confers importance on the wine. No doubt, it misleadingly reduces the complexity of wine to a single dimension, but a score's utility as a communicative device has firmly entrenched the metric in wine culture as a marker of quality.

The significance of Parker's disruptions is that all wines, if they are to be looked upon favorably, must meet an independent standard that is no longer rooted in tradition. The origins of a wine are no longer the sole determinant of quality—the judgments of independent experts

armed with independent criteria have a central role in determining quality.

The third line of influence was Parker's alleged preference for ripeness—wines that were powerful and overtly hedonistic. There is no doubt that he advocated greater ripeness and enjoyed wines that were powerful and often flamboyant. However, I think his influence in this regard is often exaggerated since there are other factors that influenced drinkers' preference for bold wines. The move to riper grapes and modern vineyard techniques was already in the works in France in the 1950s because of the influence of prodigious researcher Émile Peynaud, Professor of Oenology at the University of Bordeaux. Furthermore, alcohol levels did not substantially increase until several years after Parker became established, and the trend toward higher alcohol was initiated in new-world wines, especially the U.S. and Australia, not in the French wines to which he devoted the most attention in his reviews. In fact, Parker continued to prefer the wines of Bordeaux, even though Bordeaux's climate was not conducive to consistent ripening. Furthermore, sociology has long rejected the view that single, charismatic opinion leaders are responsible for new trends, which require visibility that extends well beyond the reach of one person and his team.

The impetus driving the new-world style of riper, more hedonistic wines with higher alcohol was the natural *terroir* of the sun-drenched, new-world wine regions that winemakers increasingly chose to express. They did so because of increased demand for these wines by a public under the sway of wine's romantic image. While Parker's influence among connoisseurs was growing, much wine criticism was appearing in lifestyle magazines such as *Wine Spectator*, which began publishing in 1976, and *Wine Enthusiast*, beginning in 1988. Both publications appealed to a broader audience than the newsletters and emphasized wine as a luxury product. When we imported the French image of wine, we imported the notion of wine as a symbol of luxury, heritage, romance, and the good life. The democratization of wine as

a middle-class symbol of aspiration was reinforced by a beverage that was lush, plump, and sexy. It is easier to sell wine as a symbol of luxury when it has the texture of velvet and tastes of chocolate and opulent, nectar-like fruit. The promotion of this style of wine required exposure that extended far beyond the serious connoisseurs and industry trade people who subscribed to Parker's newsletter.

Thus, Parker's influence was important not because it led to a new style of wine—he was only one of many factors contributing to new-world styles. Instead, his influence began the process of reorganizing the culture of wine. Prior to the emergence of the independent critic armed with numerical scores, wine was thoroughly a cultural product woven into the social, historical, and agricultural fabric of the region in which it was produced and consumed. The shift in authority ushered in by this new style of criticism begins a process of what some social theorists call "deterritorialization."[10] The term only tangentially refers to geography. It is a process of de-contextualization in which something becomes isolated from its milieu and, freed from its function there, becomes available to form new relations. In the process, it begins to shed its identity, losing the meanings and attachments formed in its original context.

In other words, after the emergence of the independent critic who becomes the conscience of an international trading regime, the identity and standards of excellence of Barolo, for instance, are no longer defined solely by the common taste references of the people in the hilltop villages of Piemonte and their customers. A Barolo is now to be judged on a continuum that compares it with Napa cabernet, right-bank Bordeaux, and shiraz from Australia. Its identity is stretched over multiple comparison classes and influenced by people who lack the historical and cultural resonances of its original context. The context of evaluation is no longer one's tradition only but other wines one has tasted from far and beyond.

This disruption of local networks and local knowledge in the wine world had to happen. As global markets opened and demand for wine

increased among the well-connected middle class, local networks and local knowledge were not up to the communicative task that was required to sell wine. If Parker had not existed, we would have had to invent him. Consumers and producers were not led around on a leash by Parker. It was a combination of drift, tinkerers looking for new ways of making wine, the distinctive climate of newly emerging wine regions, and the formation of new evaluative assemblages—new comparison classes and the resulting revised standards—that pushed wine in a new direction.

To what degree do these changes reduce variation and complexity and contribute to greater homogeneity? The factors contributing to deterritorialization mentioned above are only part of the story. Anything that begins to shed its identity and open itself to new relations is in danger of being captured by those influences, reforming an identity around a new set of relationships. The move to establish an independent tribunal for evaluating wines disrupts local traditions and provides impetus for change, but that change can be slowed if the parameters of the new relationships are too constrained and not allowed to proliferate. Parker had all the advantages of being the first to solidify disinterestedness as a condition of authority, and for a significant stretch of time he sucked up all the critical oxygen in the room. Regardless of how skilled or eclectic he was, he represented only one perspective, and his outsized influence crowded out other voices, although eventually those new voices were heard.

In time, Parker's considerable influence began to shape how wineries conceptualized their wines. Some winemakers likely began chasing higher scores by making the wines they thought Parker would like rather than the wines they wanted to make. Yet, some of that tendency to make similar wines was part of a natural process. When we place an object to be evaluated in a new comparison class, it inevitably is affected by these new influences. That is the point of deterritorialization. But that flow of affectivity can easily overwhelm what was originally distinctive about the object. If the new,

independent standards and the sharing of techniques and methods across boundaries fail to acknowledge an organic process that preserves what is distinctive about a wine or wine region, homogeneity and mimicry can result from neglect rather than conscious intent. This is the source of the charge that so-called "Parkerization" led to an international style in which wines seemed to taste the same regardless of their origin. The problem is inherent in the development of independent standards, which can shave off the rough edges of what is being evaluated in the interests of getting them to fit a mold shaped by those standards.

The problem of homogeneity is surely exacerbated by the context in which critics evaluate wines. Typically, critics taste dozens of wines over the course of a long tasting session with little time given to each wine. Palate fatigue is a real problem, and intense, powerful wines are likely to show better in such tastings. Furthermore, complex wines evolve in the glass and show different dimensions over time—some aromas are released more readily than others when exposed to oxygen. Wines with subtlety and finesse do not necessarily reveal their charms in a few seconds.

Wine scoring as a quantitative measure is another source of worries about homogeneity. Many commentators argue that the reduction of a wine's complexity to a quantitative score inevitably misses the nuances that make a wine distinctive. No doubt, for effective criticism, a numerical score is a poor substitute for a full description of a wine. However, a numerical score fails to capture complexity only if the score is in part a cardinal rather than a purely ordinal ranking. Any numerical scoring system will be an ordinal ranking. A ninety-point wine is, in some sense, better than an eighty-five-point wine. The crucial question is how "better" is defined. The beauty of an ordinal ranking system is that the numbers can mean almost anything you want them to mean. In other words, the symbol "ninety" means "of greater rank" than the symbol "eighty-five." But what "ninety" or "eighty-five" refer to—greater with respect to what quality—is up to

the user. It is a flexible system of ranking and highly deterritorializing because the identity of what is being ranked need not be specified.

However, wine scores are not typically a purely ordinal system. The meaning of the score is often specified in terms of a variety of dimensions of a wine, thus introducing a degree of cardinality. Parker measured factors such as complexity, intensity, length, ageing potential, etc. The wine-scoring system was an attempt to codify and standardize the features of a wine that are markers of quality. Parker's scoring system was only weakly codified—he did not precisely specify the relative value of the factors he measured within the various categories he used to assign points. There was ample room for judgment to influence scores. Furthermore, different wine critics could use different criteria and weigh them differently. There are no enforcement mechanisms to dictate evaluation practices among independent wine critics. However, there has been a strong tendency in the wine community to want standardized meanings across critical perspectives so the perspectives can be compared. The often-expressed ideal is that wine scores should measure the intrinsic quality of a wine, and competent critics should largely agree on a wine's quality. Notoriously, critics disagree sharply about individual wines. The ideal of universal agreement is as achievable as global justice and Christmas ponies for everyone, but its value remains an underlying assumption of much criticism of wine scores.[11] But we should keep in mind that this attempt to rigidly codify wine quality is strongly reterritorializing, as it cancels differences that do not fit the categories that define quality for the critics—the upshot of a too rigidly codified account of wine quality would likely be greater homogeneity and fewer variations.

Thus, the influence of Robert Parker was mixed. He introduced remarkable changes in the practice of wine criticism that improved wine quality and recognized variations that previously had gone unrecognized. But the values he fostered—independence and attempts to codify wine quality—introduced new limitations that future wine criticism must overcome. Eventually, Parker's influence

and the preference for bold, ripe wines that were so disruptive to wine traditions became the establishment.

Thus, with the emergence of this international wine style and the hordes flocking to reinforce its hegemony, the central issue in wine aesthetics emerges: the problem of homogeneity. The wine world thrives on variation. If care is taken to plant grapes in distinctive locations and preserve those differences, then each region, each vintage, and each vineyard can produce differences that wine lovers crave. However, if the thousands of bottles sitting on wine-shop shelves all taste the same, there is no justification for the variety of brands and their price differentials. The modern wine world is built on processes that can dampen variation and increase homogeneity. If these processes were to gain power and prominence, the culture of wine would be under threat.

The wine world is a battleground in which forces that promote homogeneity compete with forces that encourage variation; at stake is the aesthetics of wine. We need to understand these forces in order to understand the nature of the threat homogeneity poses to the wine world and the reasons why, thus far, we have avoided the worst consequences of that threat.[12] I will be addressing this issue of homogeneity from the perspective of the United States, although the themes will resonate within wine regions throughout much of the world.

The Threat of Homogeneity

The modern wine world that began to emerge and solidify in the U.S in the 1950s was built on the four pillars discussed above, all of which contributed to the remarkable quality revolution that transformed wine into a readily accessible symbol of refinement that graces even middle-class dinner tables throughout the world. Those pillars include

the adoption of the French image of wine as a dry, food-friendly, nuanced aesthetic object; advances in wine technology that extracted more flavor from grapes and enabled clean, consistent wines with little vintage variation; an increase in ripeness levels encouraged by improved vineyard practices and the emergence of warm-climate wine regions; and the adoption of independent standards of wine criticism that pressured complacent traditions to increase quality. These factors led to higher quality, and they explain why we can today purchase a consistent, drinkable bottle of wine for ten dollars. But they also contribute, potentially, to a more homogeneous product. It is worth examining each of these factors to see how they might contribute to homogeneity.

When the U.S. reproduced the French conception of wine and winemaking techniques, "wine" was thereafter understood to mean "grape wine," although good wine can be produced from a variety of fruits and plants. Furthermore, despite the thousands of grape varieties used throughout the world to make wine, most winemakers in the U.S., and other emerging regions, focused on eight to ten French varietals that were widely recognized to produce quality wine. The French model introduced refinement and quality by erasing multiple sources of potential variation.

U.S. winemakers were tinkerers and, without the constraints of "old-world," European traditions, began experimenting with new technologies and techniques driven by the science of oenology. This technology produced cleaner wines with less bacteriological activity and enabled more consistent ripening, thus reducing the year-to-year variations that often produced inferior vintages in Europe. But that vintage variation is prized by many connoisseurs who prefer surprise and differentiation over consistency. Furthermore, although excessive bacteriological activity (the infamous barnyard aromas) and a high concentration of aldehydes (which have a pungent, bruised-apple aroma) can destroy flavors in a wine, in smaller concentrations, they can make wine more interesting and distinctive, depending on one's

personal taste. Wine science has driven the quality revolution, and winemakers who do not know the science are at a disadvantage. But if the practices of winemaking become too standardized and lack sensitivity to different contexts and the need to preserve variation, science can have a homogenizing effect. Given the sensitivity of grapes to environmental conditions, what works in one region or vineyard will not necessarily work in another. It is commonplace for winemakers to ruefully explain that, in order to make good wine in their vineyards, they had to unlearn their school lessons, not because the science is wrong, but because the variations of which wine is capable do not easily lend themselves to the causal generalizations in which science traffics.

One of the most controversial issues in the wine world is the relationship between ripeness and wine quality. In old-world, European wine regions, the most significant source of vintage variation was the inability to properly ripen grapes because of cool weather or cloud cover. Under-ripe grapes make wine that lacks concentration and shows hard acidity and rough tannins. The new, emerging regions had the solution to that problem: sunshine, along with the new vineyard techniques that enhanced ripening. There is still vintage variation in California and other warm wine regions, but it is within a narrow acceptable range. Although early in America's wine revolution in the 1960s and '70s, winemakers kept ripeness (and thus alcohol) to levels typical of the cooler regions of France, gradually they learned to pick grapes later in the season to allow more sugar development, higher alcohol, lower acidity, and softer tannins. This tendency toward ripeness exploded in the early 1990s. These rich, plush alcoholic wines were controversial. Many people thought they were too powerful to serve with most foods and that excessive ripeness destroyed flavor expression, eliminating herbal and earthy aromas in favor of one-dimensional fruit expression. Yet, these wines were popular and sold well. As noted above, our idea of wine was of an aspirational, luxury item. That image was reinforced by these plump,

sexy, new-world wines, despite their tendency to sacrifice variation and distinctiveness. Our idea of wine—our expectations about what wine should be—is a powerful constraint on those variations.

Does ripeness inevitably lead to homogeneity? Not necessarily. Sunlight and warmth are a source of distinction in some wine regions. Some of the best wines in the world, from Napa cabernet to Amarone della Valpolicella, use ripeness to achieve their distinctive flavor profile. Although allowing grapes to hang on the vine can cause a loss of aromatic complexity, raisin flavors, and a muddy flavor complexion, it depends a great deal on the vineyard site, the variety of grape, and how the canopy is managed. Some vineyards do better than others with extended hang time. It is more accurate to say that, when poorly handled, excessive ripeness destroys flavor distinctions. Thus, a general trend toward more ripeness will produce more wines that lack distinction, especially when increased demand encourages more planting in vineyard sites that are less than ideal.

Wine criticism and education can also increase the potential for homogeneity. Robert Parker contributed significantly to the quality revolution. However, as noted above, reliance on the opinions of one person with an outsized reputation likely contributed to increasing homogeneity, as some winemakers began chasing higher scores by making wines they thought Parker would prefer. These new, independent standards were no longer beholden to traditional assumptions about quality. Yet, they were not necessarily sensitive to the distinctiveness of local traditions.

While Robert Parker was developing his wine rating system, UC Davis was also at work on the wine-evaluation side of the quality equation. Professor Ann Noble developed the aroma wheel that has now become a primary tool in educating wine professionals and consumers about wine tasting. The aroma wheel divides aromas into categories and subcategories, thus giving wine tasters the vocabulary to describe what they are tasting. In the instructional materials developed to accompany the aroma wheel, each aroma was associated

with a reference standard—an accessible household item or food with an aroma that students could use to develop their aroma memory and fix the reference of the vocabulary term. The motivation behind the development of the aroma wheel was the very real need for a common, reasonably objective vocabulary to facilitate discourse about wine.

Wine science was also contributing to this emerging tasting model. Scientists began to identify compounds in wine that explain why we smell the various aromas on the aroma wheel. Thus, not only did we gain a common vocabulary for describing wine, we now had well-established causal relationships between compounds objectively "in the wine" and the subjective impressions of tasters, thus enabling standards of correctness to be applied to wine tasting. This development of what has come to be known as the "referential model"—aromas directly referring to chemical compounds in wine—has provided the foundation for the rigorous certification exams that sommeliers must pass to gain access to top jobs in the wine industry.[13]

There is no doubt that the aroma wheel has helped bring professionalization to the industry. It has made wine education more available and provides argumentative ammunition to counter the claim that wine tasting is thoroughly subjective. Yet, there is the potential for increased homogeneity if these tasting tools are too rigidly applied. For instance, the aroma wheel encourages wine tasters to look for those aromas that appear on the wheel. But, because wine grapes are notoriously changeable and sensitive to environmental conditions, there are many more aromas in wine than those appearing on the aroma wheel. This is not a problem if the wheel is used as a rough guide or entryway into wine tasting, and there is nothing preventing the aroma wheel from being updated. But when mechanically applied, over-reliance on the aroma wheel leaves out much of the allure of the search for differentiation that drives the wine community.

There are similar worries about the referential model of wine flavors based on the identification of chemical compounds, which some people advocate should replace our less precise aroma

descriptors. No doubt, pyrazines cause green, vegetal aromas, and vanillin smells like vanilla. These causal relationships provide a firm foundation for the legitimacy of professional wine tasting. But in the real world, these compounds interact in complex, non-linear ways to produce emergent properties that cannot be predicted from the mere presence of a chemical compound. These emergent properties create the heady aromatics that make wine enjoyable and distinguish one wine from another. In other words, it is not simply the presence of, for instance, herbal aromas that matter. Wine aesthetics is interested in how those herbal aromas interact with other aromas to create an overall impression. It remains to be seen how successful science will be at analyzing complex relations between these flavor compounds. But, at present, aromatic complexity far exceeds the ability of a chemically-based vocabulary to describe it.

Furthermore, both the referential model and the aroma wheel ignore aesthetic properties, such as beauty, elegance, harmony, or finesse, for which there is no scientific account. We respond aesthetically to the overall impression of the wine, not only to its individual parts. The referential model is inherently a reductionist view of wine that fails to capture many of the variations that make wine interesting.

Finally, turning to economic sources of homogeneity, as wine becomes increasingly popular, wineries must plant vineyards in less-than-ideal locations to keep up with demand. Most of these vineyards cannot produce distinctive wines and differentiation is left up to the winemaker's ability to produce artful blends that show some distinction, a strategy that will usually fail if the grapes lack quality. The need to market wines to these new consumers also creates conditions that tend to increase homogeneity. The use of varietal labeling made wine more accessible, and relaxed appellation rules in the new world gave producers more freedom to produce the wines they wanted. In theory, this freedom gave new-world producers the ability to create more differentiated wines, since they were not legally

constrained to make wine typical of their region. However, since regional distinctions were no longer guaranteed by law in the new world, regional designations on the bottle were a less reliable marker of difference. The consumer must know the producer's approach to winemaking to know what is in the bottle. And varietal labeling does not help much as a marker of specific differences. No doubt, pinot noir is different from cabernet sauvignon; varietal labeling is informative if the winery strives to maintain varietal typicity. But varietal differences are generic differences that tell the customer little about the specific character of what is in the bottle since each varietal can be made in a myriad of styles. Because there was less legal enforcement of differences in the new world, compared to old-world wines, and less information about differences on the label, the consumer had fewer resources for resisting homogeneity.

Thus, as wine culture approached the twenty-first century, the table seemed set for a collapse of the differentiation that motivates wine lovers. Today, is the wine industry a hellscape of overpriced, monotonous juice differentiated by cute bottle labels and dubious "branding strategies?" Despite some disturbing trends, the answer to that is no. Thus, there must be forces operating in the wine world that preserve differences in the face of the potential for homogeneity.

The Difference Machine

Wine writers often observe that wine lovers today live in a world of unprecedented quality. Advances in wine science and technology have made it possible to mass-produce clean, consistent, flavorful wines at reasonable prices, without the shoddy production practices and sharp bottle or vintage variations of the past. This general improvement in wine quality is welcome. However, for wine aesthetics, a more important development is the unprecedented diversity in our wine choices. What wine writer Jon Bonné recently referred to as "weird

wine"—natural wine, orange wine, wine in cans, wine from unfamiliar locations—is an important part of the wine conversation.[14] Wine is now made in every state in the U.S., and most of those states have their own indigenous wine cultures with distinctive varietals and unique *terroirs*. Throughout the world, emerging wine regions, such as Great Britain and China, promise to add to the stock of diverse tasting experiences. Wine grapes are increasingly grown in extreme environments—from high in the Andes, to the deserts of the Golan Heights, to the chilly lakesides of Canada. Projects such as Vox Vineyards in Kansas City, Bodegas Torres in Spain, and Randle Grahm's Popelouchum Vineyard near Santa Cruz, California, are rediscovering lost or ignored varietals, while the University of Minnesota develops new varietals that can survive northern winters. If you are willing to navigate the spotty distribution system in the U.S., most of this diversity is widely available. Although the best wines from the storied vineyards of France are now available only to the super-wealthy, new generations of wine drinkers are growing tired of the hamster wheel of cabernet/chardonnay/merlot and seek something more adventurous. As described above, this focus on variation has not always been an intrinsic part of wine culture. What happened? How did we avoid that monotonous landscape of homogeneous juice?

One factor is that, in matters of taste, variation is a persistent norm. The reason for this has to do with the inherent features of taste. The phenomenon of sensory adaptation occurs when sensory receptors are exposed to stimuli for a prolonged period. Under repeated exposure, our sensory receptors become less sensitive to the stimulus, which is why people who live next to a freeway are not disturbed by the constant noise. In the context of wine tasting, this means we eventually get bored when tasting something too often. The flavors and aromas no longer seem vibrant or interesting. Thus, some resistance to homogeneity is present in any taste community.[15]

Furthermore, in an aesthetic community, styles that become too popular will inevitably produce a backlash for economic reasons. As

noted above, as the popularity of a product increases, more producers enter the market. Many of them make an inferior product that consumers reject. This is, ultimately, what happened when wineries expanded production rapidly and over-indulged in excessive ripeness in the 1990s. Vineyards were planted in less-than-ideal locations, and excessively ripe grapes in the hands of people who lacked the skill or resources to manage them produced unbalanced monstrosities that were a caricature of genuine quality.

Enthusiasts were quick to react to these excessive yet mediocre wines. As mentioned above, the "anything but chardonnay" movement, which was first identified by name in 1995, continues to influence wine choices today. Chardonnay develops florid tropical aromas in warm sites, takes well to oak, and produces buttery aromas when undergoing a secondary, malolactic fermentation. Thus, it became known as the "winemaker's wine" since it allowed winemakers to get creative with their winery techniques. This style of blowsy chardonnay became so popular that, throughout the world, less popular yet distinctive local grape varieties were pulled up and replaced by chardonnay. As a result, serious wine drinkers, who loathed the style and resented the loss of indigenous varieties, backed away from the grape until winemakers eventually got the message and began making chardonnay in a wider variety of styles. Throughout this period, chardonnay remained enormously popular and has become the most widely planted white grape, but a minority of dedicated enthusiasts kept the pursuit of variation alive.[16]

The backlash against excessively ripe, opulent wines has continued well into the twenty-first century. In Pursuit of Balance was an association of wineries committed to producing dry wines with less than fourteen percent alcohol, thus mandating for its members less ripeness and a lighter style of wine. That association, launched in 2011, has since disbanded, but their cause continues to be influential and partly overlaps with the natural wine movement, which tends to prefer less alcohol as well.

Today, excessively ripe styles still exist, and an ersatz version that uses residual sugar to mimic ripeness dominates supermarket shelves. None of these counter-movements amount to more than an eddy in the vast ocean of commercial wine. But they illustrate something important about aesthetic communities. Although the existence of aesthetic communities may require commercial success, their heart and spirit are the usually small number of dedicated enthusiasts who resist trends, start new ones, and continually search for meaningful variations.

One point that should not be underestimated is that winemakers as a group are not prone to excessive conformity or orthodoxy. They tend to be tinkerers, always experimenting to find new ways of improving quality. They value independence—some are fiercely independent—and each has their own firmly held opinion on wine quality and how to achieve it that varies widely from person to person. Obviously, there are exceptions, and everyone works under financial constraints, but the ethos of artisan winemaking is not compatible with a corporate culture where people trim their sails to conform to a party line.

The sheer growth in wineries and wine regions over the past thirty years also contributed to increased diversity and variation. New wineries and wine regions, along with less well-known traditional regions trying to enter the international market, immediately face a marketing problem: they are unfamiliar to consumers and have no track record to instill confidence. Thus, they need to set themselves apart by pushing for higher quality and finding a distinctive product to offer. For example, Argentina got behind malbec and Chile embraced carménère, both varietals that were in sharp decline in France and widely unavailable until they were promoted by these emerging regions. New Zealand, with its distinctive version of sauvignon blanc, may be the best example of an emerging region that managed to acquire a distinct identity because it offered a distinctive taste profile.

The appellation system in the old world, although not a source of

innovation, has been reasonably effective at preserving authenticity and resisting homogenization. With their tightly regulated production practices, most of the distinctive vineyards of France and Germany have resisted attempts to increase yields to expand profits or tart up their wines to appeal to "new-world" tastes or consumers at the bottom of the market. They, for the most part, continue to target consumers with the experience (and disposable income) to appreciate distinctive *terroirs*.

It is worth noting that the emergence of so-called "terroirists" in the new world has contributed mightily to diversification in the industry. During those decades when wine technology and wine science were making rapid gains, many industry people in the new world were skeptical that wine quality and distinctiveness were a function of specific vineyard sites. They believed that skillful winemaking created distinctive wines. Today, it is hard to find a winemaker who still believes that the vineyard site is not the primary input for wine quality, even though the slogan "wine is made in the vineyard" is an exaggeration. Because vineyards vary greatly in factors such as weather, drainage, aspect to the sun, elevation, and soil composition, attempts to preserve and take advantage of these differences have made significant contributions to the range of expressions of which wine is capable.

Is it only relatively small, artisanal wineries that engage in this pursuit of difference? There is a persistent discourse in the wine community that is suspicious of large wineries and their products. Is this suspicion warranted? The problem with big wine is not size itself. There are large wineries that make good wine, and there is nothing to prevent a large winery from using their considerable resources to promote innovation and pursue difference. They can hire the personnel and reserve winery space to pay loving attention to a vineyard or *cuvée* if they wish. The problem is that they have few incentives to do so. It is a challenge for a large winery to preserve a distinctive *terroir*. A *cuvée* based on grapes from a specific vineyard or

region cannot expand beyond the borders of what that special piece of land will support. Thus, any winery is limited in its ability to expand the production of a line of wines without importing grapes from some other location or increasing yields, which will usually diminish quality. A master blender can make a great wine out of many different lots, but that means choosing wine from only the best barrels, which also limits production.

For these reasons, distinctive winemaking tends to be limited to small-lot production. It is inherently a labor of love, and a costly one, for a winery that does not need it for their bottom line. The path of least resistance is to make generic wine and leave it up to the marketing department to create differentiation. There are exceptions, and, in fact, many of the storied Grand Crus chateaux of Bordeaux are mid-sized wineries with annual production over fifty thousand cases, when you include all their production lines. As with much about wine, it is best not to generalize. Quality is less about size and more about commitment, but size plays a role in decisions about production methods.

Finally, the discourse community that surrounds the production and selling of wine provides important feedback about quality standards and styles and ultimately bears the responsibility to encourage variation. As noted above, as the twentieth century came to a close, Robert Parker's *Wine Advocate*; the critics at publications such as the *Wine Spectator*, *Wine Enthusiast*, and *Decanter*; and a few large-circulation newspapers were the primary tastemakers with the clout to influence what people purchased. This is a relatively small group who, despite some well-publicized spats, shared basic assumptions about wine quality.

Today, the situation is dramatically different. Although wine journalism has suffered immensely from the Internet's disruptive influence, this has led to the proliferation of voices having some impact on what people drink. Friends share recommendations on Facebook, Instagram, and Twitter. Wine blogs and online magazines are

pervasive, and wine-education programs encourage non-professional consumers to acquire more knowledge of the complexities of wine and to become more reflective about what they drink. Despite the "influencer" moniker that has been attached to some of the more active voices, few people have much influence, although many people have some influence. But what is interesting about these non-formal wine communications networks is that participants stand out by discovering something different, something no one else knows about. Add to that mix small importers and distributors, buyers for wine bars, and restaurant sommeliers, all with similar incentives to discover what is new and exciting, and you have a community of "difference hounds" scouring the wine landscape for significant variation. The oft-repeated diatribes against sommeliers with peculiar tastes who impose their preferences on unsuspecting restaurant-goers are usually unwarranted. Sommeliers are in the service industry, and a customer's wants should be their priority. But part of a sommelier's legitimate mission is to expose consumers to available variations. The primary responsibility of wine writers and critics to the wine community is to report on what's new, to track variations in wine styles, and judge which variations ought to be preserved.[17]

Thus, the key factor in maintaining the health of the wine community is that the difference engine continues to grind away, producing more of what is the essence of wine: its capacity for variation. The active search for variation among producers, consumers, and writers sustains the health of the wine community and its aesthetic aims. This is not to say that variation is the only aesthetic value—flavor and its enjoyment matters. However, flavor is not a stable, fixed quality but a matter of constant negotiation. Some variations are inferior and should not survive. That is why it is important to have critical standards.

The heart of the wine community is not the million-dollar French chateau or the wine palaces of Napa. They may be important as benchmarks, as standards of excellence. However, it is the

tinkerers and innovators, drift, shifts in authority relations, and the difference hounds that maintain the vibrancy of wine traditions. These advocates of variation are not best understood as enforcers of norms or conventions. They are more like glitches that probe for new potential, engage in practices that might be dead ends from a conventional perspective, or that mobilize chance and error to produce something new, the value of which may not be apparent to any but a small minority. Wine lore is filled with stories of visionary pioneers who defied conventional wisdom to establish new plantings, new production methods, and especially new wine regions. There is a reason why these stories resonate.

Inspirations:

To experience ambiente in its most developed iteration as the embodiment of tradition, one has to visit the old-world regions of Europe. In Italy, ambiente is readily accessible in the hilltop villages of Piemonte where wine is thoroughly woven into the fabric of life and tourism is still modest. Our visit to Barolo producer Aurelio Settimo and the famed Rocche dell'Annunziata Vineyard, followed by lunch with an artisan cheese producer and his flock of sheep, was an unforgettable reminder that in some parts of the world the past is never past.

In the U.S., ambiente has more to do with the atmosphere of collective effort and loving attention to each input of the winemaking process. Tyler Thomas of Dierberg and Starlane Vineyards introduced me to the concept of "human terroir"—the idea that winery staff make an important contribution to the taste of a wine. He also earns the moniker "vine whisperer" for his detailed attention to every foot of vineyard space in Dierberg's extensive acreage. Dierberg's line up of Pinot Noir is wonderful. The Astral Star Lane Vineyard Cabernet Sauvignon is stunning and distinctive.

Perhaps no one in the wine world better represents the ideal of the pursuit of difference than the former philosophy professor Abe Schooner, who left the academy to take up winemaking in 2001. He has since earned the reputation for mad experimentation and delicious, otherworldly outcomes through his wine label, Scholium Project. Mn1, a 2017 Cinsault from Lodi's Bechtold Ranch Vineyard, shows how the wild and untamed can be guided toward exquisite subtlety and refinement. La Severita Di Bruto 2016 is a Sauvignon Blanc like no other. It lives up to its name—a force of nature, ethereal yet fierce and utterly unlike any Sauvignon Blanc you have tasted.

Notes

1. I first came across the Italian word "ambiente" used in the context of wine in a blog post by wine writer Steve Heimoff, who referred readers to its original use in Vino Italiano: The Regional Wines of Italy, by David Lynch and Joseph Bastianich. The word refers to both the geology and climate of a place where wine is made as well as the culture that surrounds it. Steve Heimoff, "I Learn a New Lesson About Wine Writing," Steveheimoff.com (blog), 6/1/2015. http://www.steveheimoff.com/index.php/2015/06/01/ambiente-i-learn-a-new-lesson-about-wine-writing/ accessed 9/7/2020

2. In a personal interview, winemaker Tyler Thomas from Dierberg and Starlane Vineyards near Santa Barbara California, used the term "human terroir" to refer to the importance of his winemaking team and support staff in maintaining wine quality. The interview is posted at Edible Arts. https://foodandwineaesthetics.com/2018/04/05/the-art-of-wine-a-conversation-with-tyler-thomas-of-dierberg-and-star-lane-vineyards/

3. Howard S. Becker, Art Worlds (Berkeley: University of California Press, 2008).

4. There is an ongoing debate in the wine community about whether "terroir" should be restricted to geographic and geological features of a place or whether the term should include cultural factors. It seems to me useful to have a term, such as terroir, that refers specifically to geography and geology. Thus, I introduce the term "ambiente" to include the cultural factors.

5. I will challenge this over-riding dependence on tradition in Chapter Nine.

6. The data regarding 2018 sales of dessert wine are from the Wine Institute press release, "California Wine Sales in U.S. market Hit $40 Billion in 2018," June

24, 2019. https://wineinstitute.org/press-releases/california-wine-sales-in-u-s-market-hit-40-billion-in-2018/ accessed 9/7/2020. Historical data are from Ai Hisano, "Reinventing the American Wine Industry: Marketing Strategies and the Construction of Wine Culture, Harvard Business School Working Paper, 2017. https://www.hbs.edu/faculty/Publication%20Files/17-099_7df59b7d-8e42-414c-8478-7bb14ca90ba1.pdf Accessed 6/18/20

7 For a more detailed account of the American food revolution, see my American Foodie: Taste, Art, and the Cultural Revolution (Lanham: Rowman & Littlefield, 2016).

8 See Hisano "Reinventing the America Wine Industry" for a more detailed account of this adoption of the French model in the United States. I rely extensively on this paper for my discussion here.

9 "Interview with Wine Critic Robert Parker, Jr.," conducted by Ken Adelman, The Washingtonian, March 1, 2005, https://www.washingtonian.com/2005/03/01/interview-with-wine-critic-robert-parker/ accessed 8/20/2019

10 The terms "territorialization" and "deterritorialization" originated in the collaboration of French thinkers Deleuze and Guattari. These concepts are central to what has come to be known as "assemblage theory," a social theory employed by some social scientists and philosophers to explain social and political change. Gilles Deleuze and Felix Guattari, A Thousand Plateaus: Capitalism and Schizophrenia (Minneapolis: University of Minnesota Press, 1987).

11 I question this assumption in Chapter Nine.

12 For an account of winemaking and grape growing strategies that encourage variation, see Jamie Goode and Sam Harrop, Authentic Wine: Toward Natural and Sustainable Winemaking (Berkeley: University of California Press, 2011). Goode agrees that homogeneity is a threat to the health of the wine industry.

13 For more on the development of the aroma wheel, see Steve Shapin, "The Tastes of Wine: Towards a Cultural History," in Wineworld: New Essays on Wine, Taste, Philosophy and Aesthetics, Nicola Perullo (ed.) special edition, Rivista di Estetica, 51 (2012). https://journals.openedition.org/estetica/1388?lang=en

14 Jon Bonné, "When It Comes to Wine, Weird is the New Normal—And That's for the Better," The Washington Post, 4/19/2019. https://www.washingtonpost.com/lifestyle/food/when-it-comes-to-wine-weird-is-the-new-normal--and-thats-for-the-better/2019/04/19/c2f878a4-611c-11e9-bfad-36a7eb36cb60_story.html accessed 9/7/2020

15 For a brief discussion of adaptation and wine tasting, see Gordon M. Shepherd, Neuroenology: How the Brain Creates the Taste of Wine (New York: Columbia University Press, 2017), 78.

16 For a history of California Chardonnay see Elaine Chukan Brown, "The Story of California Chardonnay, Part 1-4," at Jancis Robinson https://www.jancisrobinson.com/articles/the-story-of-california-chardonnay-part-1 , accessed 6/24/2020.

17 I pursue this point in more detail in subsequent chapters, especially Chapters Six and Nine.

CHAPTER FIVE

WINES OF ANGER AND JOY: VITALITY AND EXPRESSION

"Is it charming, imperious, hyperactive, pensive? What sort of texture does it offer? Is it crisp or creamy, nubby or sumptuous? Is it contemplative, energetic, clever, profound? I feel it terribly sad that such language is often debased as inauthentic because it tells us much more about a wine than the prevailing geek-speak."

—Terry Theise, What Makes a Wine Worth Drinking

Why does wine move the mind and the heart? And how does it do so? If a rectangular canvas splashed with paint and lines can express freedom or joy, why not liquid poetry? Works of art are often pleasing, but they also communicate or express something. Something is shown or made manifest through a work of art. In many cases, what is communicated is a feeling, idea, or attitude that, in some way, belongs to the artist. However, art is not always about self-expression. As discussed in Chapter Three, some works reveal something about the artist's materials or subject matter. To express is to reveal something

hidden or not obvious, but that is not limited to revelations of human psychology.

Can wine be expressive in the way works of art are expressive? There is one obvious way in which wine is expressive. Some wines express the nature of the grapes in a vintage, or the soils and climate of a vineyard or region. A wine might also express the winemaker's idea of what the grapes of a particular vintage and location should taste like, or they may express the sensibility of a community or tradition. However, wine's expressiveness extends well beyond these traditional notions. Wine expresses something important about life, and that will lead us to consider wine as a medium of emotional expression as well. In this chapter, I develop the insights from earlier chapters into an expressivist account of wine aesthetics.[1]

Representation vs. Expression

I will begin by explaining why the idea of expression is important for a philosophy of wine. One of the obstacles to fully endorsing the idea that some wines can be works of art is that wine does not seem to have one of the standard functions of art. When painting, sculpture, or literature are the prime examples of works of art, they naturally lead us to conclude that one primary function of art is to present a subject matter. Prior to the twentieth century, most paintings were of a person, event, scene, or landscape, and the artist's job was to present that subject matter from her own point of view and to enable the viewer to acquire a new understanding of it. Some theories went so far as to claim that the artist's job was to imitate the object or scene being represented. This theory does a poor job of explaining abstract art that doesn't depict an object. Neither can it explain instrumental music in which the absence of lyrics deprives the music of a conventional narrative. Nevertheless, it was the dominant view through much of the history of aesthetics, and for many works of art it clearly applies.

Picasso's *Guernica* is, after all, about the bombing of the town of Guernica in the Spanish Civil War. The painting presents that event as its subject matter.

Many people have argued that wine does not have a subject matter. It isn't about anything and thus cannot be a work of art. I think it is not quite true that wine lacks a subject matter. I noted above that a wine can express the nature of its origins. The language of representation works here as well. A wine can represent the flavor profile of a vineyard or region. It can also represent the flavor sensibilities of a community or a tradition. In both cases, the wine can bring us to understand its *terroir* or culture in a new way. A wine invites us to explore its origins just as a painting invites us to explore its subject matter. Nevertheless, unlike painting, sculpture, or literature, the range of subject matter represented by wine is limited. To the extent one adopts a representational view of art, wine may not qualify as art because it cannot represent the complexities of life as painting or literature do.

However, the representational view of art is fatally flawed. As noted, it fails to explain the appeal of abstract works or instrumental music. More importantly, it assumes that when experiencing art, we are most concerned with the subject matter of a work, not the work itself. But this is not how we engage with art. We are intensely interested in exploring the work and often pay little attention to the person or situation depicted. Even with representational works such as *Mona Lisa*, we appreciate it by exploring color, line, and the meanings embedded in the work itself. Aside from historical interest, we don't care about its relationship to its subject matter—Lisa del Giocondo, the model who sat for da Vinci. The appreciation of wine has a similar relationship to its subject matter. Although we might use a particular wine from Hermitage to explore the terroir of the Northern Rhone, we are also intently interested in the wine's features for their own sake, independent of their representational function. Wine has aesthetic appeal independent of what it teaches us about *terroir* or tradition. The aim of representation fails to capture the full significance of wine just as it fails to capture the full significance of painting or music.

Thus, we need to look elsewhere for our understanding of the nature of art and wine's artistic credentials. Expression theories are the alternative. Although works of art do present a subject matter, artists create in order to express an attitude, point of view, or feeling toward that subject matter, and audiences are interested in discovering what is expressed in the work. However, as I explained in previous chapters, although winemakers express a point of view in their wines, creative agency is dispersed throughout the wine community, and nature and the vineyard are part of that assemblage of creative agents that contribute to wine styles. Thus, to make sense of wine as an expressive medium, we will need an expression theory that is not restricted to the expression of psychological states. Although emotions will play a central role in my account, I begin by articulating a more general mode of expression: wine's expressive relationship to life.

Expressing Vitality

Wine enthusiasts devote most of their attention to tracking and appreciating variation. Life, vitality, is also fundamentally about variation. This shared connection between life and wine is the key to understanding wine's expressiveness. The art of winemaking is the art of expressing vitality.

To see the connection between life and wine, we must engage in a bit of metaphysics. Reality is not merely a collection of objects dispersed in space and time, constituted by predictable relations, and governed by deterministic causal laws. Reality is also a field of potential differences, latent, unactualized dispositions that inhere in material objects and their relations to be unlocked when some new event traverses a threshold.[2] New relations expose new dispositions; for instance, when you make a new acquaintance who brings out a hidden dimension of your personality, or when weather variations expose new flavor potential in a vineyard. Beneath the stable world

of visible objects and our practical dealings with them, reality is a seething chemical soup where boundaries are porous, new potential continuously emerges from the formation of new relations, and the duration of a state is always a change in state. In this chemical netherworld, nothing is exactly repeated. There is always variation and difference.

Living things have a special role to play in this economy of change. They have an active internal structure that uses matter and energy to resist degradation, while their tentacles penetrate the inorganic world, seeding, accelerating, and directing change. Life takes advantage of the break points in matter where a difference creates a new tendency, redirecting forces and extracting surplus energy to meet its needs. The effects of human beings on the environment are an obvious example but think also about how fungi recycle dead plants into reusable nutrients. As Darwin showed, life is creative, a continuous process of developing novelty and natural selection, a process that pulls the past into the present, using it as a springboard for the future, without plan or program. Any individual entity that emerges out of this chemical soup is merely a passageway, a stage, a provisional outcome within a larger process of change. But that individual is also a solution to a problem posed by the convergence of conflicting forces. Living things assimilate and integrate elements of their environment, contracting, selecting, and harmonizing the forces that affect them, thus making a life for themselves.

Yet, a living thing never quite achieves self-identity or perfect unity. Change is a persistent feature of all life, and it must be managed to serve an organism's needs. There is always disparity, a new problem to solve, a variation that must be integrated. Resistance to degradation, continuous variation, and continuous integration are the hallmarks of all life. This is a brief summary of what philosophers such as Bergson and Deleuze share regarding the relationship between the organic and the inorganic.[3]

The art of wine puts this process of difference, disparity, and integration on a pedestal, glamorizing it and showing the process itself to be captivating. It reveals and makes alluring the tensions between stability and change, degradation and maintenance, and predictability and contingency. The mediation between these conflicting demands is a persistent feature of all life. Wine makes this mediation a sensuous event. Wine is where the intersection of nature and culture becomes entangled with the tensions of eros and pathos and becomes poetry.[4]

It could be argued that all art infuses matter with life, not by imposing form on an inert substance but by unlocking hidden dimensions of the artist's materials and making them pulsate with energy. An artist's materials are a swarm of unactualized dispositions, a capacity for variation, that the artist intensifies and actualizes, giving something non-living a life of its own, integrating conflicting forces in the process. Those materials, in turn, intensify and transform life.

Wine is the quintessential example of life as art because it begins with living organisms and preserves the residue of that life in the finished product. Winemaking accelerates variation and change through the fermentation process, and then takes the resulting inorganic liquid and, through careful stewardship, allows the features of an organism to re-emerge, infusing the wine with a field of latent differences that gradually show themselves as the wine ages, preserving the thread of life as it inexorably returns to the chemical soup. The winemaker's job is to find the singularities—the variations in their vineyards and grapes that promise a new direction—intensify those variations, and then integrate them into something people want to savor, building into the wine a capacity to resist degradation and support continuous change as the wine lives on in barrel and bottle.[5]

Thus, both wine and life share a process of differentiation and integration. What makes wine an expression of life? How does wine express this vitality? Wine expresses vitality by exemplifying vitality, to use philosopher Nelson Goodman's way of formulating the nature of expression. There are various theories of how expression works in the

arts, but Goodman's is the most robust.[6] It is worth pausing to briefly consider what Goodman means by "exemplification," especially in the context of the arts, in order to grasp how wine can be expressive.

Like the word "red," a red carpet sample points to the color red. But unlike the word "red," the carpet sample also possesses the color it refers to. Thus, according to Goodman, the carpet sample exemplifies—shows, makes manifest—the color (and texture) of the carpet. In order to exemplify a property, the object must possess that property. Of course, a carpet sample is not a work of art. Thus, Goodman must add another dimension to the concept of exemplification to explain how works of art are expressive.

Works of art differ from carpet samples because works of art exemplify properties they cannot literally possess. The carpet sample is literally red. But a song is not literally sad since a song does not have feelings or psychological states. Nevertheless, a song can express sadness by metaphorically exemplifying sadness. It possesses some of the properties of sadness—for instance, a slow tempo and a mournful melody—thus exemplifying the dispiritedness of sadness. A painting is not literally dynamic since it is a stationary object. But it metaphorically exemplifies dynamism by possessing some of the properties of dynamism in the way its lines are arranged to cause the eye to dart about the canvas. Metaphorical exemplifications highlight, show, or call attention to similarities between the object being labeled with the metaphor, e.g., a musical work, and a system of symbols drawn from some other domain, in this case, the domain of human emotion. For Goodman, a work of art expresses emotion when it metaphorically exemplifies emotion by possessing some of the features of an emotion.

Let's apply this to wine and vitality. As I argued in Chapter Two, depending on what definition of life we adopt, a wine may not literally be alive. However, a wine can express vitality by possessing some of the properties of living things. A wine expresses vitality by exemplifying variation, resistance to degradation, and integration as we experience

the wine. Movement on the palate, aroma notes that emerge and fade and emerge again, their persistence and variation over many years, the harmonizing of contrast and paradox—these are all expressions of vitality. Wines that refer to vitality because they possess some of the features of vitality also exemplify and thus express vitality.

The virtue of Goodman's theory with regard to the arts is that expression does not depend on the mental states of the artist or the audience. The materials or the work itself can be expressive. A song can express sadness even though neither the composer nor the audience is sad. The same feature of Goodman's theory benefits an expressive theory of wine as well. The vitality of a wine is not primarily about the winemaker's psychology. The properties being expressed are in the work, in the expressive possibilities of the materials, as interpreted by the winemaker and the taster. Of course, the expressive possibilities of the materials could not exist without the winemaker and the wine community as co-creators. But wine is distinctive because it reveals materials that have a life of their own and that exhibit possibilities not intended. The point of view expressed in a wine really is nature's murmur, what I referred to as "thing-power" in Chapter Two, although coaxed and prodded by humans and their creative imaginations. Winemaking is life taking advantage of the break points in matter and redirecting self-organizing forces to discover something new.

Music, Wine, and Emotion

This expression of life—which also embodies the life of the vineyard, the vines, and the wine community as they collaborate with nature— are the primary modes of expression for wine. However, wine's expressiveness is more extensive than has been elaborated thus far. Although frequently lampooned as excessive, there is a history of describing wines as if they expressed personality traits or emotions, even though wine is not a psychological agent and could not literally

possess these characteristics. Wines are often described as aggressive, sensual, fierce, languorous, angry, dignified, brooding, joyful, bombastic, tense, or calm. Is there a foundation for these descriptions, or are they just arbitrary flights of fancy? Can we make sense of the idea that wines express emotion or personality?

There is one straightforward way in which wine can express emotion. Some winemakers are trying to capture, for their patrons, their own feelings of awe and wonder when they first discovered the beauty of wine. Many winemakers talk about being inspired by a trip to France or Italy, where they encountered a flavor experience they try to embody in their own wines. Just as a smile expresses the presence of joy, or a piece of music in a minor key expresses sadness as intended by a composer, a winemaker can intend that her wines evoke an emotive response of awe and wonder akin to the awe and wonder she felt when first inspired by wine.

Perhaps the most widely acknowledged expressive trait attributed to wine has to do with romance. Wine has long been a symbol of romance, and Goodman's theory of exemplification explains how wine can express romance. Sumptuous fruit, seductive aromas, silky textures, and a languid evolution exemplify the allure of a romantic encounter. Furthermore, wine, through its alcoholic effects and place at the dinner table, induces feelings of conviviality. In doing so, it acquires symbolic significance. It becomes a sign exemplifying sociability and good cheer and thus becomes a metaphorical expression of conviviality as well.

If wine were able to express only feelings of conviviality and romance, its range of emotional expression would be rather limited. Can wine legitimately express a wider range of feelings? As noted above, "expression" sometimes refers to how something looks or sounds without there being anyone in the emotional state expressed by the work, and we can extend that notion of expression to taste. Consider the sense in which a fog-shrouded lake is gloomy or a melody ominous. The lake expresses gloom because of the way it looks,

regardless of whether it makes us feel gloomy. A melody is ominous because of the way it sounds, without the audience feeling a sense of impending doom. We seem to have a natural, perhaps unavoidable, tendency to attribute human emotional states to non-sentient objects. In the case of the fog-shrouded lake, there is no artist imbuing the lake with gloomy features. Rather, the perceiver is experiencing the lake as gloomy. The ominous melody was of course composed, but we might still justifiably experience the melody as ominous independent of whether the composer intended that and without the listener herself feeling a sense of doom.

Although it has fallen out of favor in some circles in recent years as wine language has become more technical and analytic, tasting notes from the not-too-distant past attributed a wider range of emotional expressiveness to wines.[7] Wines can be lively, dark, austere, fun, aggressive, sensual, luxuriant, fierce, muddled, unfocused, grandiose, angry, dignified, brooding, explosive, amiable, joyful, bombastic, calm, languid, carefree, feral, provocative, reflective, somber, tender, tense, or visceral. This list is far from exhaustive. These descriptors suggest that the taster perceives feeling or mood states in the wine via an interpretation. Is there a rational basis for these attributions? Should they be a central element in wine descriptions? A poll of subjects exposed to gloomy landscapes and ominous melodies would probably reveal widespread agreement about the appropriateness of these descriptors. Similarly, in paintings, there is some evidence that curved contours lead to a positive affect and angular shapes trigger negative emotions. Certain colors are thought to have emotional significance as well, with red associated with aggression and yellow the color of happiness.[8] Might the features of wine have similar associations?

Wine is a vague object, its features not as clearly discernible as fog over a lake or the contours of a melody. The features that make a wine angry are thick, aggressive tannins, high alcohol, and searing acidity supporting bold, dark fruit—some cabernet sauvignon is best described as angry, especially if it has not had time to age in the bottle. Without some understanding of what counts as searing acidity and

aggressive tannins, the perception of anger might not be available to a taster. But the fact that perception requires training or familiarity does not preclude it being a genuine expression.

Perceiving emotional expression in non-sentient objects is an imaginative process. I suppose we can project anything onto anything. Someone could view a fog-shrouded lake as cheerful or an ominous melody as lighthearted. But that projection is unlikely to be successful either as a description for others to enjoy or as a repeatable perception that would seem appropriate again and again. For such an attribution to be sustainable, there must be some relationship between the way something looks, sounds, or tastes, and the feeling state being expressed. For the attribution to be more than a subjective fantasy, it must be constrained by the features the object is perceived to possess.[9]

This introduces one of the knottier problems in aesthetics: What is the relationship between the perceived emotion and the features of the art object that expresses the emotion? This issue is usually addressed in the philosophy of music because music is generally considered to be the most expressive of the arts. Yet despite the obvious connection between music and emotion, the problem of stating how music is related to emotion has eluded a philosophical solution. The basic problem is this: We experience music as sad, joyful, or angry even if it does not genuinely induce such emotions in the listener. So what justifies attributing the emotions to music? And if the listener is not experiencing the emotion, where is it located? Our understanding of wine and emotion would profit from a comparison with the current state of this debate in music. Thus, I will pause the discussion of wine and briefly consider this debate in music, applying what we learn there to the case of wine. The main theories explaining the relationship between music and emotion are:

1. The arousal theory, which asserts that music causes listeners to experience basic, non-cognitive feeling states that anchor and make appropriate our more complex attributions of emotions such as anger or sadness.[10]

2. Resemblance theories, which assert there are similarities between music's dynamic character and the dynamic character of people experiencing emotions such as their vocal expressions or the contours of their bodily behavior.

3. Theories of metaphor, which assert that attributions of emotion to music are a matter of mapping relations from one domain (experienced emotions) onto relations in another domain (the experience of music).[11]

My view regarding music is that all three theories identify dimensions of the phenomenon we are trying to explain. What I wish to do below is show how elements of these theories work together to explain expressiveness in music. This will then help us understand how wine can express emotions.

The puzzle with music (especially music without lyrics to provide narrative context) is that music is an abstract system of sounds, and a musical environment is wholly unlike the natural environment that gives rise to ordinary emotions. How does music express these emotions when the listener's situation is unlike a situation in which an emotion would naturally arise?

We will consider the arousal theory first. There is substantial evidence that music produces physiological effects on the listener by directly affecting the motor system, facial expressions, postures, gestures, and even action tendencies such as tapping one's feet. Dance music is designed to have that effect. Countless studies show that listening to music affects heart rate, blood pressure, respiration, and galvanic skin response, and these studies are supported by subjective reports that music influences moods. Music can startle, surprise, thrill, bewilder, relieve, relax, excite, or calm us. Thus, music expresses some feelings because it directly arouses them in the listener.

Wine can have similar effects, although they are far less pronounced than with music. Like music, wine has a temporal

structure that unfolds through the tasting experience. As tasters, we respond to this unfolding with emotions such as surprise, bewilderment, relief, disappointment, satisfaction, excitement, or relaxation, at least in part independent of the effects of the alcohol. Experienced, knowledgeable wine drinkers have expectations of how a wine's structure should unfold and will respond with all these basic feeling states which involve initial, affective appraisals of the wine. Thus, there is some truth to the arousal theory with regard to the experience of music as well as wine.

However, this version of the arousal theory does not explain the higher-order, cognitive emotions that commentators attribute to music and wine. This is where the controversy heats up. How can music (or wine) express anger or sadness when there is no event to make us angry or sad? Unlike moods and the non-cognitive arousal states just mentioned, anger, sadness, and fear are laden with cognitive content, with an intentional object and beliefs about that object that are necessary for the emotion to proceed. To feel fear, you must believe that an object is dangerous; to feel sadness, you must believe something you care about has suffered a loss. The musical environment lacks these fundamental conditions for an emotion; and of course, so does wine.[12]

One solution is to simply deny that music expresses such emotions; it only appears to do so. Resemblance theories assert that there is a resemblance between music's dynamic character, the way the music flows, and the dynamic character of behavior that people exhibit when experiencing emotions, such as their vocal expressions or the attitudes of their bodily behavior. Based on that resemblance, we judge, for example, a sad song to be sad. Down-tempo, lugubrious, subdued music in a minor key resembles the bodily attitude of someone in the throes of sadness, and, therefore, such music is judged to be sad. This is probably the most widely held philosophical position on this question and has received a sophisticated defense from Peter Kivy, among others.

In his *Sound Sentiment: An Essay on the Musical Emotions*, Kivy argues that the face of a St. Bernard looks sad because it has a contour that resembles the face of a person who is sad. Similarly, music has a contour, a shape in the way it unfolds, that resembles the contour of the expression of sadness in a person's movements or vocal mannerisms.[13] It is not the felt sadness that resembles the unfolding of music but the outward expression of sadness that does so. Thus, for Kivy, the emotion in music is not felt but perceived. We perceive the contour of the music, note the similarity of that contour with a particular emotional expression, and thus attribute that emotion to the music. However, just as the sad face of a St. Bernard has nothing to do with the expression of a dog-emotion, the fact that the process of music resembles the process of an emotion does not entail that the music is expressing emotion. Because resemblance is a surface phenomenon, it is not revealing an inward state. Thus, it isn't obvious that Kivy's theory is an expressivist theory.

This points to a significant flaw in Kivy's theory. Almost everyone who listens attentively will, at some time, experience being emotionally aroused by music. Kivy is right that sad music does not typically make us feel sad—but it makes us feel something. The experience of music is not an affect-less comparison of similar contours but an engagement with feeling states. Music appreciation is a process in which the listener becomes enmeshed in the music's development, and it feels like something to be so enmeshed. It is this active involvement that needs explanation because it gives rise to the feelings we experience in musical environments.

What are those feeling states that music causes in us if not full-blown emotions? Above, I noted that music can startle, surprise, thrill, bewilder, relieve, relax, excite, or calm us. These are largely non-cognitive, affective responses that we have names for because they routinely occur in our natural environment, and we need to communicate them to others. Musical environments also induce a seemingly infinite variety of non-cognitive affective responses. The

way it feels to listen to Mozart is different from the way it feels to listen to Stravinsky. Yet, these affective states related to a musical environment lack names because we seldom have occasion to discuss them. Unless one is a music critic, communicating about them is not essential.

My hypothesis is that we use these nameless, felt responses to a musical environment as evidence to construct an interpretation that enables us to hear emotion in the music. That is, we imagine how particular emotions could be manifested through these fine-grained, pre-cognitive, partly physiological responses to distinctive musical environments. Music can directly stir the muscle-tensing, attentionally-focused response that is characteristic of anger, even though there is nothing to be angry about. For instance, think about a song by Nine Inch Nails played at high volume, with an up-tempo, pounding rhythm, notes played by sharply impacting the instruments, and a simple melody without smooth transitions between the notes. Such music would be instinctively appraised as aggressive and produce feeling states typical of such music, even without howling vocals and lyrics depicting aggression. We might be drawn to the music, find it attention-grabbing, and thoroughly enjoyable, but also feel the muscle tension and action tendencies that in the "real world" would constitute an urge to strike out or flee in response to aggression. In other words, the valences we experience in a musical environment are not simple positive or negative states but complex mixtures that might be attractive and interesting in one context but repulsive and disruptive in another. The response structure of music-induced feelings is not identical to the appraisal structure of anger since there is nothing to be angry about. But those feelings can readily be interpreted as angry because they feel like anger. It is literally true that the music is aggressive because we feel the aggression in the music. It can plausibly be interpreted as angry because it causes feeling states similar to anger, albeit at a lower intensity and without the belief states required for genuine anger.

Similarly, when I listen to Samuel Barber's *Adagio for Strings*, my feeling state, following the contours of the music, seems to retard and slowly swell. It settles into a calm place and becomes reflective, but with tension around the edges, then swells in volume and breadth until it reaches a heightened yet brittle intensity, disrupting the reflective mood. Then it induces temporary relief as the music seeks that calm place again but always with a sense of quiet distress. These feeling states are what the music directly expresses and, in some cases, may be unique to a musical environment. What is the best interpretation of these feeling states in seeking a label from ordinary emotions? They add up to something more particular than generic sadness, yet the intensity and surging volume is incompatible with an emotion such as melancholy. The closest I can come in assigning a familiar label to the *Adagio* is that it expresses feelings associated with grief, although the experience is in many respects utterly unlike genuine grief. This is largely a matter of interpretation and hypothesis testing, a highly cognitive task in which I cast about for the name of some general emotional state that roughly captures the highly particular feeling state induced by the music.

In these two examples, the music is genuinely expressive because the music arouses genuine feelings. But these feeling states are only muted, rough analogs of full-scale emotions. The labeling of the music as expressing emotions of grief or anger is tenuous and subject to disagreement, as different listeners will interpret the clues differently. It is also optional, as one could decline to engage in such labeling at all. Nevertheless, some interpretations are ruled out; *Adagio* could not be interpreted as angry because a typical affective response to the music would lack the underlying feelings associated with anger. And the interpretation is not a mere projection since it is based on evidence provided by feeling states directly aroused by the music.

However, this account is incomplete without some further specification of what these pre-cognitive responses are and how they justify the consequent interpretations. What is the relation

between these felt responses and patterns in the music? When we feel aggression or calm reflection, what are we responding to? There seems to be some sort of mapping or correspondence between features of the music and our affective, physiological responses. What is the nature of this correspondence? Furthermore, it is not obvious that this account helps us understand how wine can express emotion since wine seems less capable than music of inducing feeling states.

It is not often that work in the sciences directly solves a problem in aesthetics. But in this case, the work of developmental psychologist Daniel Stern provides us with a concept that significantly advances this debate about music and emotions and will be useful in explaining how wine expresses emotions. The now-deceased Stern, whose life's work culminated in a 2010 book entitled *Forms of Vitality: Exploring Dynamic Experience in Psychology, the Arts, Psychotherapy, and Development*, noticed early in his career that mothers, in responding to the vocalizations and behaviors of their pre-verbal children, used vocalizations that imitated the child's affect.[14] This ultimately led to his thesis that this affective attunement made use of what he called "forms of vitality," which, he argued, are the foundation of conscious experience.

Vitality forms constitute "the flow pattern" of human experience, "the subjectively experienced shifts in the internal states" that characterize sensations, thoughts, actions, emotions, and other feeling states. According to Stern, they "are the felt experience of force—in movement—with a temporal contour, and a sense of aliveness, of going somewhere. They do not belong to any particular content. They are more form than content. They concern the 'How,' the manner, and the style, not the 'What' or the 'Why.'"[15]

In short, any apprehension of motion or movement has a temporal contour consisting of its duration, acceleration, and intensity that make up its vitality form. To use one of Stern's examples, the term "rush" can characterize any number of conscious phenomena: "A rush of anger or joy, a sudden flooding of light, an accelerating sequence

of thoughts, a wave of feeling evoked by music, a surge of pain, and a shot of narcotics can all feel like 'rushes.'"[16] Experiences surge, burst, fade away, are fleeting or drawn out, explode, reach a crescendo or decrescendo, etc. Importantly, these vitality forms are not tied to any particular sensory modality or form of awareness. "A thought can rush onto the mental stage and swell, or it can quietly just appear and then fade."[17] So can sounds, visual experiences, tactile impressions, or emotions—anger can explode or emerge as a slow burn.

Thus, Stern shows that consciousness has two aspects: the content—the objects of consciousness, the "what" of an experience—and the temporal structure of an experience, how it occurs in time. Stern claims, with support from neuroscience, that these two aspects are implemented differently in the brain, although they are experienced as entwined. Although we experience vitality forms as a gestalt, they can be analyzed into five theoretically distinct aspects: movement, force, time, space, and intention. Movement unfolds over time, takes place in space, is experienced as the result of a force with a certain level of intensity, and has a direction or an intention.

Vitality forms are not limited to subjective experiences. The movements and gestures of other people and animals have a temporal contour as they move about in the world and thus exhibit vitality forms as well. We recognize someone in the distance based on the distinctive vitality form they exhibit, even when their facial features and other characteristics are indistinct. According to Stern, we identify something as alive rather than dead through their vitality forms, which may explain the role they play in evolution. (Unfortunately, he does not provide an analysis of the vitality forms of plants, which are no doubt alive but lack human-scale mobility.) Thus, the experience of vitality serves as a basis for experiencing the vitality of others and our capacity to apprehend their mental state. We are able to distinguish a genuine greeting from a perfunctory, insincere greeting because they exhibit different vitality forms.

Stern argues that music and the other time-based arts—dance, theater, and cinema—express the various vitality forms that constitute human experience. Music especially draws on these physical, affective, and cognitive "flow patterns," producing elaborations and variations on them to provide new aesthetic experiences. Vitality forms explain why we do not experience full-blown emotions such as sadness or anger when listening to music. Music does not express the "what" of emotions but rather expresses the "how," the underlying vitality forms that are recruited by the emotions on their way to being expressed. Sad music does not make us feel sad, but we do feel some of the force and contours of genuine sadness when listening because the experience of sad music shares vitality forms with genuine feelings of sadness. Vitality forms also explain why the appreciation of music is not merely a form of perceptual recognition but a distinctly affective, felt experience. We feel the form of vitality expressed by the music in a kind of sympathetic resonance with the music. This hypothesis of forms of vitality obviates the need to attribute complex emotions to artists during the creative process. Instead, the composer plays with felt vitality forms as an exercise in themes and variations. As listeners, we use the vitality forms as evidence to generate our interpretation of what a piece of music expresses.

How then do we answer the question with which we began: in music, where is the affect, the feeling state, located? Stern insists that vitality forms are subjective—they are the form of the movement of conscious experience. Thus, Stern seems to think they exist in the listener. Yet, if vitality forms enable us to identify persons or distinguish between things that are living or dead, there must be something about the object that indicates vitality. Objects actually move, and their motion unfolds in time, occupies space, and exhibits intensity and direction. Music itself must be an enactment of vitality forms that can, to some degree, be cognized by the listener in the musical structure itself. After all, composers and musicians manage the tempo, expectations, tensions, and releases of the music by

manipulating notes, chords, textures, and a system of accents. Notes, chords, and accents can be objectively described. Yet, on the other hand, there is no apprehension of vitality forms that could simply be read from a technical description of music. Traditionally, composers have indicated the outline of a vitality form by adding terms to the score, such as "andante" or "allegro." However, as any musician or experienced listener knows, these can be played mechanically or with feeling. To recognize tension as tension, or a passage as explosive, we must resonate with the music, be drawn in by it, enacting the temporal shapes as if they were part of us, while still maintaining a distinction between ourselves and the music.

Thus, vitality forms are neither in the listener nor in the music but emerge from their intersection. They do not exist without the meshwork necessary to build awareness of a world. Our interaction with the world requires affective resonance, whether that world consists of other humans, animals, or non-living objects such as music. Any movement in our environment—the drizzling of water, the drift of clouds, the texture of wood as we run our hands over a railing, or a dog bounding across a field—will be experienced as an integrated gestalt of various vitality forms. The qualitative character of the experience must come to resemble the object, and what the object and the experience share is a confluence of vitality forms. However, this is not merely a perceptual resemblance, as Kivy was arguing, but a felt sharing of vitality forms. Music is perhaps the richest of expressive objects because it readily and accessibly expresses the movement of our affective lives. Music also shows, perhaps more saliently than any other human practice, why there cannot be a sharply delineated boundary between self and world, or between cognition, perception, and feeling. At any rate, regardless of the larger epistemological and ontological framework we use to understand vitality forms, they are useful for understanding how we apprehend and appreciate the arts.

Wine and Vitality Forms

What does this have to do with wine? Compared to music, wine does not provoke powerful motor responses and action tendencies. Yet, wine has a temporally extended, fluctuating structure and is, therefore, in process much like music and emotion. Although there is some literal movement of wine in the mouth as we ingest and swallow it, the sensation of wine's movement involves the subjective sense of movement that gives us an impression of a wine's character. We experience wine as moving through phases, which for now I will refer to as the beginning, midpalate, and finish. In most modern wine styles, our initial impression is of juicy fruit stimulating the tongue with an impression of weight and shape. The structural components of the wine then emerge over time. The prickly, angular mouthfeel and tart flavor sensations of acidity make an appearance usually at midpalate, and gradually co-mingle with the impression of breadth and the drying sensation of tannins as the wine moves through the mid-palate toward the finish, which then has its own distinct characteristics of length and development. The experience of wine unfolding through time is a crucial part of our enjoyment, although it is often overlooked in tasting notes and tasting models.[18]

Changes in that structure, the perceived motion of the wine as it evolves on the palate, trigger particular feeling states, although they are subtle and unfold more quickly than is typical of emotions or musical passages. The experience of tasting wine is a process in which the pace at which textural and touch-sensitive qualities evolve control the character of the wine. Some wines are active and energetic, others more reserved. Qualitative changes gather momentum or seek repose, slowly diminish or reach a crescendo. Wines differ in the dynamic energy we perceive in them. However, that energy is not a fixed quantity but rises and falls, expands and contracts, as the wine proceeds from the initial impression through the finish. For example, we encounter wines that begin as lush and enveloping only to leap

aggressively at midpalate before sinuously executing an elegant finish. Others appear austere and edgy with an angular, slashing momentum before settling into a flighty, oscillating progression. These textural and touch-sensitive permutations are an under-explored dimension of complexity. Individual wines differ markedly in the touch-sensitive flow patterns and textural shifts they exhibit.

Like the pace and rhythms of an unfolding piece of music or the fluctuating drama of an emotional encounter, these changes in the evolution of wine express underlying vitality forms. The perceived changes arouse feeling states that respond to shifting degrees of intensity, momentum, and novelty. Some of these affective states are influenced by our expectations. We feel a sense of anticipation and resolution. We are surprised or confused, drawn to or repelled by qualitative changes in a complex mix of valences and hedonic tonal shadings.[19] Other feeling states directly respond to changes in tactile pressure. Some wines make us feel as if we are floating or being caressed. Others whipsaw with kinetic energy or attack with angular momentum. Aggressive wines are not just perceived as aggressive but are felt that way—we steel ourselves to appreciate them, are irritated by them but feel richly satisfied when they achieve resolution. Wines that are heavy, dense, and mysterious are not only perceived as brooding but are felt to induce reflection on something that seems vaguely menacing, although there is nothing menacing in our environment. By contrast, wines that are bright, fresh, and lively induce a sense of ebullience and light-heartedness. Based on these pre-cognitive appraisals and physiological responses, we judge a wine to be angry or joyful or to express a more complex array of emotions, just as a piece of music might embody several emotions.

My hypothesis is that when we describe wines as brooding, angry, joyful, lively, languorous, or dignified, we are picking up on a vitality form exhibited by the movement of the wine as experienced on the palate that is commonly associated with either a feeling state or the behavioral expression of a personality trait.

Stern provides a partial list of words describing motion that indicate the presence of a vitality form, some of which clearly apply to the experience of wine as it moves through its phases: exploding, swelling, drawn out, forceful, cresting, crescendo and decrescendo, rushing, relaxing, fluttering, tense, gliding, holding still, surging, bursting, disappearing, gentle, languorous, tentative, weak, fading, and many more. However, according to Stern, such words describe not only the motion of feeling states but also our experience of the expressive behaviors of other persons, in light of which we make judgments about their level of vitality. When we judge a person as animated or depressed, it is because their behavior exhibits vitality forms that enable the judgment. That is the key to attributing personality traits to wine.

However, this hypothesis will have explanatory power only if the apprehension of vitality forms is fine-grained enough to account for subtle differences in feeling states or expressive behaviors. For instance, "brooding," "languorous," and "dignified" all share a temporal contour that involves slow, deliberate, continuous motion without sharp accelerations or rapid changes in intensity over an extended period. Yet, as behavior patterns or psychological states, these examples differ significantly. Are these differences captured by differences in vitality forms?

Stern argues, rightly, that our perceptions of vitality forms are gestalts. They are holistic judgments, summarizing a wealth of complex information, and are more than the sum of their parts. As noted, he provides five elements that contribute to a vitality form—movement, force, time, space, and intention or direction. Recall that movement unfolds over time, takes place in space, is experienced as the result of a force with a certain level of intensity, and has a direction or an intention. Because these are components of vitality forms, they help us see how vitality forms are individuated. While brooding and languorous might share the trait of deliberate motion without sharp acceleration, over an extended period, they differ in intensity (force)

and the amount of psychic "space" they occupy. Brooding is a more intense and all-consuming feeling state than is languor. It occupies more psychic "space" than languor. Furthermore, brooding differs from languor in its intentional focus. Someone who broods looks inward, and the self is experienced as having depths to be explored—both depth and inwardness are spatial concepts. Yet, someone who broods has a relatively fixed, narrow focus on a problem or memory that is drawing their attention. Languor, by contrast, reveals neither depth nor an inward focus, and attention is usually dispersed and unfocused. Yet, another fundamental difference between brooding and languor is hedonic tone. Brooding is a darker mood headed in the direction of a depressive state, whereas languor is more neutral or mildly pleasant. Stern would probably argue that tone is a function of the content of the feeling state rather than its form, although one can brood or be languorous about nothing in particular. But enough brooding over the nature of "brooding." For my purposes, hedonic tone quality will be an essential element in assessing the expressiveness of wine.

What sort of wine can be described as "brooding"? Brooding wines have the following features: red wines with highly concentrated, dark fruit; intensity coming from just a few focused aromas; depth that comes from multiple, nearly indiscernible flavor notes that require exploration; low acidity to generate a sense of deliberate movement; an impression of weight on the palate; and broad, firm tannins to add to the sense of massive force exerted by the wine.

A languorous wine could be white or red and show the following features: fruity enough in tone to be modestly hedonistic but without much complexity; a degree of weight to suggest torpor; deliberate, low-intensity textural changes between beginning, mid-palate, and finish; nothing that jumps out and grabs your attention; and fluttering, inconstant flavor and aroma notes to suggest a lack of focus. As is evident in these descriptions, vitality forms supply ample raw material for describing the experience of wine in terms of feeling states and

personality traits. Such descriptions are neither arbitrary nor factitious but are grounded in the same psychological phenomena that allow us to recognize and describe emotions and personality traits in persons, film, or music. The identification of a vitality form is thus a literal description of the temporal form of an experience. The attributions of emotion or personality traits based on vitality forms are, therefore, metaphorical only in part. One is literally in a psychological state designated by the vitality form, which is partly constitutive of an emotion or behavioral pattern. However, the vitality form constitutes only the temporal form, the way the emotion or behavioral pattern unfolds, not the representational content of the emotion. The representational content of the emotion or behavior pattern, what it is about—be it joyful or lively, angry or edgy—is then metaphorically attributed to the experience in virtue of the vitality form.[20]

The upshot of this analysis is that wine is an expressive medium akin to music or other time-based arts. A skeptic might object that these affective states induced by wine amount to mere perceptions. We perceive in the wine properties related to human emotion, but they are independent of any affective states we might experience. Indeed, I think they are perceptions, but perceptions are laden with affect. We can analytically distinguish perception and feeling, but, in experience, perception and feeling are fundamentally linked.[21] It is, of course, true that to be so affected by wine, one must be receptive to experiencing these feeling states and must have developed the perceptual competence to discern them. The features of wine are subtle, and we must seek them out. But that is true of music as well. We can hear Barber's *Adagio* and feel nothing. But that is a diminished form of appreciation.

As with music, judgments about which complex, named emotions to attribute to wine will vary from person to person, but they are not arbitrary because they are constrained by the features of the wine and those aspects of our emotional lives that are widely shared. Someone who calls a delicate, floral, light-bodied pinot noir angry does not

understand "angry" or lacks the experience with wine to discern its features.

However, there are two important, fundamental differences between the expressiveness of wine and the expressiveness of music, differences that are likely quite closely related. In music, the experience of vitality forms activates the motor centers of the brain. There is ample research showing that, even when seated and relaxed, music influences the motor cortex.[22] I doubt that wine has that effect. If wine makes you feel like dancing, I suspect it's the alcohol or the company, not the vitality form, supplying the motivation.

The second difference might be related to the first. Vitality forms in music are more powerfully felt, while vitality forms in wine are closer to the perceptual side of a feeling-percept continuum. When listening to a sad song, one doesn't typically feel sad. However, we often feel a kind of weak lethargy, a modest dispiritedness that can be felt by the whole body, although it's not strong enough to be unpleasant, as genuine sadness would be, and can often be stirring and invigorating. There is an active, whole-body component to experiencing the vitality form in music. Wine does not produce that level of whole-body sensation in part because it does not activate the motor cortex in the way music does. The vitality form associated with lethargy and dispiritedness might be perceived in a wine and be recognized as the flow of experience but without the widely distributed bodily effects produced by music.

One might wonder, "Why do this? Why attribute feeling states or personality traits to wine?" In general, the point of viewing works of art, as well as wine, as expressive is that doing so captures features of a work that interest us and allows comparisons with other works. The vocabulary of emotion and personality allows us to describe how a work may be experienced and provides a dimension that facilitates comparisons and contrasts. This is especially important in wine appreciation. If the aesthetics of wine is about variation, then our ability to compare wines is central to our appreciation of them.

Emotion and personality terms enable us to articulate a wine's vitality, variation, and individuality.

When we say a wine is expressive, we mean that it is striking and extraordinary in a way that stands out from other wines. It means that the grapes have been developed to achieve excellence in expression, which ought to be the aim of quality winemaking. Thus, pointing to wine's expressiveness enhances the aesthetic experience of wine since it expands the aesthetic properties that wine exhibits and anchors them in structural features of the wine.

This suggests that our current habit of analytical tasting needs a reboot. Picking out aroma and flavor notes is a starting point for appreciating wine, but we do not drink wine to smell blackberries, just as we don't view (most) paintings to experience a shade of blue. A wine leaves an overall aesthetic impression; it evokes feelings, moves us, stimulates the imagination, invokes memories, and even makes us think. And different wines have different ways of doing so. If wine writing is to reach a higher level, it must capture that broader aesthetic experience.

Furthermore, I suspect there is a connection between wine quality and vitality forms, one that we've long recognized, although perhaps not as explicitly as is warranted. What is important in experiencing a wine is not identifying specific vitality forms but noting vitality in general as an important feature of wine quality. Perhaps wines that get the best reviews and attract the most attention from wine lovers are wines that have distinctive "personalities" grounded in vitality forms. Instead of treating wine as a static object with fixed characteristics, we should pay more attention to the experience of wine as a process. Perhaps "vitality" should be acknowledged along with intensity, complexity, and balance as an indicator of wine quality.

Nevertheless, it is worth repeating that both music and narrative are more efficient than wine at inducing affective states. Our felt responses to music and narrative are instinctive. Although learning

is involved, the learning is readily available to almost everyone. Our worldview is structured by narrative, and music powerfully influences physiological and motor states. Everyday experience is infused with the affective experiences afforded by narrative and music. By contrast, the subtle features of wine are less available, especially to non-experts, and its appreciation is more ephemeral. In fact, affective responses to wine are akin to affective responses to non-representational art, which requires focused attention on something that is not part of everyday experience and requires some knowledge and training to appreciate.[23] Yet wine's vagueness is no argument against its expressiveness. If wine is indeed "bottled poetry," then it might share poetry's mystery—as E.B. White wrote, "A poet utterly clear is a trifle glaring."

Inspirations:

Which wines are loaded with vitality forms and distinctive personalities? Most quality wines have movement and personality if you look for them. But two stand out among those I have tasted recently. In a tiny space occupied by mostly barrels and tanks, Scott Sampler, proprietor of Central Coast Group Project near Santa Barbara, makes mostly Rhone varietals using an old school technique from the "old world"—extended maceration. His "Behind the Purple Door" Syrah 2013 spent 101 days on the skins after fermentation. The result is a wine as deep as an ocean but with life "errant and flamboyant" to rob a phrase from the poet Baudelaire. The wine is lush, taut, and explosive.

Skin-contact white wines have distinctive textures and vibrant energy. They seldom combine those qualities with suppleness and elegance. But there is something about the border shared by Italy and Slovenia that attracts skin-contact expertise. On the Italian side, Gravner's Ribolla Gialla is both atmospheric and earthy, combining mystical exoticism with relentless friction

and drive. Just across the border, in Slovenia's Brda region, Marjan Simcic's skin-contact Ribolla is delicate and diaphanous yet creamy with a subtle, textured layer of tannins that allude to strength rather than speak its name.

Notes

1 My analysis of the expressiveness of wine, in this chapter, is in debt to the work of Cain Todd, who also provides an expressivist account of wine aesthetics. Todd argues that wine can express personality traits, character traits, and emotions. Although he suggests that wine may lack the "right kind of movement" to express human emotions, he goes on to argue that there is no principled reason why wine couldn't express emotions given the "right kinds of conventions," the identification of intrinsic properties of the wine that can usefully be described in terms of emotions, and the intention on the part of winemakers to express emotions in their wine. Although Todd grants that expression need not be of a mental state, it's fair to say that Todd's expression theory is largely about projections of psychological phenomena, including the winemaker's idea of the wine and our response-dependent attributions of human qualities to the wine when tasting. My view departs from Todd's in that I define expression more broadly to include the hidden capacities of winemaking materials to effect winetasters, the wine taster's dispositions to recognize those expressions, and the symbol systems tasters deploy in their descriptions. I argue that the perception of wine does in fact have the right kind of movement to express emotion. Furthermore, my account of expression, influenced by Nelson Goodman, does not require specific intentions on the part of the winemaker. As explained in Chapter Three, creative winemaking requires general intentions to imbue wine with aesthetic character, but specific properties are often the result of factors not fully in the control of the winemaker. See Cain Todd, *The Philosophy of Wine: A Case of Truth, Beauty, and Intoxication* (Montreal: McGill-Queens University Press, 2010), 161-172.

2 In Chapter Nine, I discuss this metaphysical picture in more detail under the banner of dispositional realism. However, a book on the aesthetics of wine cannot do justice to these metaphysical questions, and I will not attempt a comprehensive defense of this view. For my purposes, the limited defense I can offer here is that this way of looking at the ontology of objects is an effective means of articulating the nature of wine.

3 References to notions of life are scattered throughout Deleuze's corpus. See especially, Gilles Deleuze, *Desert Islands and Other Texts* 1953-1974 (Los Angeles: Semiotext(e) Foreign Agents Series, 2004); and *Bergsonism*, (New

York: Zone Books, 1991), originally published in 1966. For Bergson's account of the relation between matter and life, see Henri Bergson, *Creative Evolution* (Mineola: Dover Publications, 1998); and *The Creative Mind. An Introduction to Metaphysics* (New York: The Philosophical Library, 1946).

4 For more discussion of wine and pathos, see Chapter Ten.

5 The notion of "building" here is compatible with low intervention winemaking. Time, oxygen, and other environmental factors contribute to the "building" that winemaking enables.

6 See Nelson Goodman, *Languages of Art: An Approach to a Theory of Symbols* (Indianapolis: Hackett Publishing Company, 1976). As will become clear in subsequent chapters, I will not be relying on the metaphysics that supports Goodman's theory of expression. I take from Goodman the idea that aesthetic and artistic properties show, make manifest, what they mean. Some aesthetic properties are symbols and thus refer to something they stand for but also highlight and make manifest that for which they stand. Regarding other aspects of Goodman's theory, I dissent. Goodman's theory of expression notoriously eliminates psychological and historical phenomena from the account of what is expressed. I doubt that some expressive properties can be adequately accounted for without reference to what humans do, which must be explained by reference to mental states and contextual factors. Nevertheless, we must make room for non-mental forms of expression. Nature has its say in what is expressed in a wine.

7 For an account of the history of how wines have been described, see Steven Shapin's informative essay. Shapin credits a poetic approach to describing wine to the French in the 1920's and 30's. However, for much of wine's history, the use of expressive language to describe wine has been ridiculed. See my Chapter Eight for an account of why such ridicule is misguided. Steven Shapin, "The Tastes of Wine: Toward a Cultural History," in "*Wineworld: New Essays on Wine, Taste, Philosophy and Aesthetics*," ed. Nicola Perullo, special issue, *Rivista di Estetica* 51 (2012).

8 There is substantial ongoing research on this topic. For an overview of multimodal sensory experience as well as an extensive bibliography, see Jamie Goode, *I Taste Red: The Science of Tasting Wine* (Berkeley: University of California Press, 2016), Chapter 1. For an overview and extensive bibliography of the relation of line, shape, and emotions, see Xin Lu, et al "On Shape and the Computability of Emotions" in *Proceedings of the 20th ACM International Multimedia Conference* (2012). https://www.researchgate.net/publication/262403563. For an historically informed overview of research on color and emotions, see Andrew J. Elliot, "Color and psychological functioning: a review of theoretical and empirical work," *Frontiers in Psychology*, Vol. 6 (2015). https://www.ncbi.nlm.nih.gov/pmc/articles/PMC4383146/

9 One criticism of Goodman's theory of metaphor is that he did not explain how the mapping of one domain on another works or what would justify a particular use of a metaphor to describe some feature of an art object. I offer such an account in this chapter and in Chapter Eight.

10 For a particularly cogent account of this theory, see Jenefer Robinson, *Deeper Than Reason: Emotion and its Role in Literature, Music, and Art* (Oxford: Clarendon Press, 2007).

11 Goodman's theory incorporates both (2) and (3).

12 Robinson argues that we identify and experience emotion in music by postulating a persona, a fictional agent whose emotions are expressed in the music, and who guides the listeners attribution of emotion because the listener empathizes with the persona. Although this is one way in which we might attribute emotions to music, the imagining of a persona is not, as Robinson grants, a necessary condition for accurately attributing complex emotions to music.

13 Peter Kivy, *Sound Sentiment: An Essay on the Musical Emotions including the complete text of The Corded Shell*, (Philadelphia: Temple University Press, 1989).

14 Daniel Stern, *Forms of Vitality: Exploring Dynamic Experience in Psychology, the Arts, Psychotherapy, and Development* (Oxford: Oxford University Press, 2010).

15 Stern, *Forms of Vitality*, p.8.

16 Daniel Stern, *The Present Moment in Psychotherapy and Everyday Life* (New York: W.W. Norton and Company, 2004), 64.

17 Stern, *Forms of Vitality*, p.21.

18 See the appendix for more details on how this dimension of wine can be tasted.

19 Kevin Sweeney's work is especially noteworthy in pointing to the temporal unfolding of a wine as an important component of structure. Sweeney argues, rightly, that the perceived temporal progression on the palate allows for reflective assessment of a wine and is crucial to grasping wine as an aesthetic object. Sweeney, however, does not discuss the expression of emotion. See Kevin Sweeney, "Structure in Wine" in Perullo, *Wineworlds: New Essays on Wine, Taste, Philosophy and Aesthetics*, 137-148. See also, Kevin W. Sweeney, *The Aesthetics of Food: The Philosophical Debate about What We Eat and Drink* (London: Rowman Littlefield, 2018), 178-179.

20 In Chapter Eight, I provide an extensive discussion of how metaphors used in wine descriptions work.

21 For a review of research linking perception and affective states, see Jonathan R. Zadra and Gerald L. Clore, "Emotion and Perception: the Role of Affective Information," in *Wiley Interdisciplinary Reviews: Cognitive Science*, vol. 2, issue 6, Nov-Dec (2011), 676–685.

22 For a review of this research, see Jan Stupacha, Michael J. Hove, et al, "Musical Groove Modulates Motor Cortex Excitability: A TMS Investigation," in *Brain and Cognition*, vol. 82, Issue 2 (July 2013), 127-136.

23 I find that by pairing wine with music, the expressive features of wine can be made more available. The ability of music to shape our experience of wine has been empirically confirmed and has received a good deal of attention from researchers and some wine venues. For an account of this research, see the work of Spence and Wang. Charles Spence and Qian Wang, "Wine & Music (I): On the Crossmodal Matching of Wine & Music" in Flavour, 4, article number 34 (2015). https://flavourjournal.biomedcentral.com/articles/10.1186/s13411-015-0045-x ; Spence and Wang, "Wine & Music (II): Can You Taste the Music? Modulating the Experience of Wine Through Music and Sound" in *Flavour*, 4, article number 33 (2015). https://flavourjournal.biomedcentral.com/articles/10.1186/s13411-015-0043-z; and Spence and Wang, "Wine & Music (III): So What if Music Influences Taste? *Flavour*, 4, article number 36, (2015). https://flavourjournal.biomedcentral.com/articles/10.1186/s13411-015-0046-9

CHAPTER SIX

WINE CRITICISM AND APPRECIATION

Let us consider the critic, therefore, as a discoverer of discoveries.

–Milan Kundera

In Chapter Four, I argued that wine production and consumption are deeply influenced by a discourse about wine quality carried out by a variety of actors, including wine writers, wine educators, sommeliers, retailers, and producers, among others. Chapter Five demonstrated that wine is an expressive medium that reveals various dimensions of vitality. My aim in this chapter is to begin to provide an account of how the wine community makes sense of this expressiveness by first specifying the relationship between wine appreciation and wine criticism.

Although communication about wine takes diverse forms, wine evaluation is a persistent theme of much wine writing as well as informal discussions of wine. The major publications devoted to wine include tasting notes that not only describe a wine but indicate its

quality, and most wine blogs and online wine magazines include a wine evaluation component that is central to their mission. However, if readers of those evaluations are to make a judgment about whether an evaluation is legitimate or not, they must know what purpose evaluation serves. What are these evaluations aiming to achieve? Does wine criticism resemble film, literary, or art criticism? Or is it more akin to the evaluation of consumer products? The practice of using a numerical score to indicate quality is controversial, and much has been written about it.[1] But an assessment of that practice depends on answering this question about the goal or goals of wine criticism. Although wine evaluation takes place in a variety of contexts, I will begin by paying special attention to professional wine criticism.

It is commonly assumed, and for good reason, that the purpose of wine criticism is to help consumers make purchases or decide which wine to experience. Winery public-relations departments use positive evaluations to help sell wine. Wine shops use "shelf talkers," which include some evaluative language, to guide consumers toward a decision about what to buy. The alleged purpose of wine scores is to give consumers, who may not be well versed in the arcane language of wine evaluation, an easy way to judge whether they will enjoy a wine. Many wine evaluations refer to the wine's price and the degree to which it provides value. In fact, investors' decisions about which wines or wine futures to purchase for long-term investment depend almost entirely on critical judgments about the quality of individual wines or vintages. These considerations support the view that wine criticism is about purchasing decisions.

This view also has a reliable philosophical pedigree. Monroe Beardsley, one of the most prominent twentieth-century philosophers writing on criticism in the arts, thought that the primary aim of any criticism is to "make public judgments for the purpose of guiding the choices of others who are less qualified than they...."[2] No doubt, reviews are used to make purchasing decisions. The question is whether this is the primary or constitutive aim of a wine review. Is

the practice of providing consumers with information to shape their purchases part of the essential nature of wine reviews, or are they serving some alternative or larger purpose?

Despite Beardsley's argument, the claim that the goal of criticism, in general, is to aid purchasing decisions is not a plausible view of much evaluative writing about books, film, or art. Much critical evaluation of these items contributes to the scholarly research of academics or to a more general discourse about the norms, critical standards, available styles and genres, or future direction of the aesthetic communities that form around these objects. To reduce this communal discourse to "purchasing decisions" is to miss the importance of critical discourse to various aesthetic communities.

Similarly, it is implausible to think purchasing decisions are the primary function of wine reviews. If that is their primary function, why are there few negative reviews? At best, wines are dinged for failing to meet expectations because of a bad vintage, but we seldom see reviews about wines being aesthetic failures. Surely directing people away from a bad purchase is as important as directing them toward a good one. Consumer reviews of other products can be quite scathing, but we do not often see such negative evaluations in wine.

Secondly, many wine reviews provide context for an evaluation. They point out similarities and differences in relation to other wines in its comparison class, note factors regarding winemaking and viticulture that influence the wine, and discuss the history of the winery. In other words, such reviews seem designed to enhance the meaningfulness of the experience of tasting the wine. It is true that enhancing meaning might influence someone's decision about what to buy. But this kind of information also enhances the experience while enjoying the wine and can be useful after consuming it as well, cementing one's memory of the experience and providing knowledge of its significance. For reviews that provide context, there is no reason to privilege the purchasing decision as the primary target of the review.

Finally, many wine reviews are of wines that no ordinary mortal can afford or are not available for purchase because they are fully allocated upon release. This is the most salient counterexample to the notion that wine reviews are primarily about purchasing decisions. If wines are fully allocated or to be delivered only to wine-club members, they are already purchased. Yet, tasting notes are usually included in shipments of such wines. Thus, they must be serving some other purpose.

A more plausible view of the purpose of art criticism is that art critics are trying to shape our perceptions—how we view a painting or hear a musical work. Philosopher Arnold Isenberg articulated the canonical defense of this view in the mid-twentieth century, arguing that when a critic praises the figures in El Greco's *The Burial of the Count of Orgaz* for their "wavelike contour," that description is causing the reader to perceive something in the painting that the critic finds significant.[3] The accuracy of the description is not of primary concern; what matters is that the reader's perceptions have been properly directed toward the feature the critic wants her readers to experience.

This view of art criticism can be directly applied to wine reviews. When a critic favorably evaluates a wine because of its "richly evocative aromas of tar and dried roses which is typical of the best wines of this type," she is directing our attention to those features of the wine she finds important. We might not perceive precisely the same flavors and aromas as the critic. Nevertheless, when the description succeeds, we perceive what she considers essential to appreciating the wine. The aim is not a true description so much as it is an attempt to properly direct attention.

Isenberg's account, when applied to wine, is on the right track. Given that wine is a vague object, communicating about it helps readers perceive something they otherwise might miss. This is certainly the case when a critic has vast experience tasting wines of the relevant type and a finely-honed capacity for discernment. However, Isenberg's view applies only to people currently experiencing the wine

or those who can remember its flavor profile. As noted above, many reviews are written about wines we can never acquire, and Isenberg's theory would not apply at all in these cases. Nevertheless, Isenberg's view suggests that even when a review is concerned with evaluating an aesthetic object, part of the review's aim is to aid in appreciation. Directing our attention to a feature of an object that the writer finds interesting helps us understand and enjoy the work. The goal of aiding appreciation also explains why reviews accompany wines already purchased.

As noted, wine writers and critics do more than simply point out features of a wine. In addition to evaluating wines for quality and guiding reader's perceptions, critics also explain winemaking and viticultural practices. They feature winemakers who explain how their inspiration or approach to winemaking influences their wines. They discuss the quality of vintages and the characteristics of varietals and wine regions, and they describe their own reactions to a wine. Most of these activities are not necessary for producing an evaluative verdict about a wine. The most plausible explanation that ties all these activities together is that the critic aims to help her readers appreciate the wines about which she writes.

In summary, the primary purpose of wine criticism is to aid in the appreciation of a wine by revealing what is there to be appreciated.[4] This might involve pointing out those properties that also figure in an evaluation. Thus, wine criticism often includes advice about purchases and investments. Wine criticism also directs a reader's attention to properties that are there to be savored when the wine is in front of her. Thus, wine criticism as an aid to appreciation incorporates Isenberg's point about the importance of guiding perception. However, wine criticism has a larger goal: to provide an account of the meaning and significance of a wine, its place in the wine community, and the kinds of experiences one can have with it.

How do we mark the difference between appreciation and evaluation? They have different but related aims. The goal of

appreciation is to savor what is there in the object and to discover the various kinds of experiences available to someone who is open to and attuned to the object. These experiences include knowing the meaning and significance of the object as well as savoring its sensory properties. Thus, acquiring knowledge about an object is part of appreciating it. By contrast, the goal of evaluation is to render a verdict and perhaps assign a ranking. Thus, evaluation must focus on properties of a work that can be specified and articulated in advance as markers of quality. Appreciation is open to a wider range of properties of an object, even if they have little to do with appraisals of quality. Wine evaluation aids appreciation by pointing to those markers of quality. However, as we have seen in Chapter Five, there is more to wine than properties that satisfy clear, antecedently specifiable criteria. Part of the purpose of Chapter Five was to expand the range of experiences that wine makes available to us.

Why would this kind of writing be important for people who do not have the wine in front of them or who cannot purchase the wine and will never experience it? For the wine community, knowing the meaning and significance of a wine, the kinds of experiences available when drinking it, and especially whether it represents a new trend or flavor experience is important information, independent of one's ability to experience the wine. The wine community is an aesthetic community held together by norms, standards of excellence, and especially a shared search for differences, flavor experiences that stand out for their uniqueness or originality. Thus, the critic's job is in part discovery, a search for gems that deserve recognition. As an aesthetic system, wine appreciation thrives on differentiation. The critic's job is to support that system by giving recognition to those differences. Therefore, it is essential to have critics with different palates who can expand the community's capacity to discover differences and render them meaningful. That members of the wine community use reviews to decide what to experience is a useful service compatible with the larger aim of enhancing appreciation.

What is Appreciation?

Given that the purpose of wine criticism is to aid appreciation, we need a more fully articulated account of what it means to appreciate a wine. There are, of course, many ways to appreciate a wine depending on one's purposes and the context in which the wine is to be experienced. If you sell wine, you appreciate a wine because it is a big seller. One might appreciate a wine because it gets you buzzed, because talking about it enables you to impress your friends with your knowledge, or because it greases the wheels of social commerce. You might appreciate a wine because it contributes to a meal. But sometimes we drink wine in order to appreciate the wine itself; the flavors and textures of the wine are the main focus even if the experience may serve other purposes as well. With this form of appreciation, we focus on our experience of the wine, an experience that has non-instrumental value because it serves no purpose beyond appreciation. This is the form of appreciation that anchors wine criticism and other kinds of serious communication about wine. This form of appreciation is not the only way to enjoy wine, but it is central to considering wine as an aesthetic object. I will have more to say about the various contexts in which wine is enjoyed in the next chapter. But here we are considering the form of appreciation most relevant to critical judgments about wine.

To appreciate a wine, in this sense, it is not sufficient to know facts about the wine. You can know that the wine is a pinot noir from Burgundy, that it gets high scores from critics, that it was fermented in amphora, aged in oak barrels blessed by Cistercian monks, and made from trees inhabited by wood nymphs. You would still not necessarily appreciate it. A necessary condition for appreciating a wine is to be aware of the wine's properties via modalities that give reliable access to the wine—taste, smell, and tactile impressions in the mouth. To appreciate a wine, you must taste it. However, requiring direct perceptual acquaintance leaves out two cases in which appreciation happens without direct perception of the wine.

In some cases, accurately imagining the finished wine can give one an appreciation of it. Winemakers often imagine the finished wine when tasting the grapes in the vineyard or at some early stage in the winemaking process. To the extent they imagine it correctly, they have some appreciation of the wine. Critics do, as well, when they accurately imagine how a wine will age. In both of these exceptional cases, there is perceptual acquaintance with something—the grapes or the young wine—but not a direct perception of the stage of the object being appreciated. Appreciation is a matter of degree. Accurately imagining the later stage in the development of a wine does not give us full appreciation, but it gives us a degree of appreciation. Thus, a necessary condition of appreciating a wine is tasting it or accurately imagining it based on reliable taste, aroma, or tactile perceptions of the wine or a stage of the wine. Imagination can play a role in appreciation only when the person imagining the development of the wine has the experience and background to enable their imagination to be reliable.

However, perceiving the properties of a wine via reliable perceptual mechanisms is not sufficient for appreciation. One can taste a wine and note its properties without appreciating it because appreciation, as we ordinarily use the term, involves assigning value to the object of appreciation. Thus, a second necessary condition for appreciating a wine involves responding appropriately to it. One example of perceiving the properties of a wine without appreciating it is a blind taster performing an analytic tasting by identifying aroma notes or structural components. This is a useful task in evaluating a wine, but it falls short of appreciation to the extent the taster does not respond to the properties identified. I can note the presence of cassis and vanilla on the nose of a Napa cabernet without responding to them. However, if I go beyond noting their presence and highlight the prominence of cassis or the integration of the oak-derived vanilla aromas, then I am responding to these properties in an appropriate way. Thus, by "responding," I mean assigning some sort of noteworthiness, meaning, or significance to the properties perceived. Appreciation requires that

kind of response. However, appreciation does not require responding with approval. Finding the vanilla cloying and excessive is a form of appreciation because I am not merely tasting the property but responding to it by treating it as noteworthy.

This distinction between identifying features of a wine and responding to them is central to an account of wine criticism. Since the purpose of criticism is to aid appreciation, a good critic must not only identify properties of the wine but respond to them in an appropriate way and communicate that reaction. What then do I mean by "appropriate response?" There are at least four general types of appropriate responses one can have to a wine: perceptual, cognitive, affective, and motivational responses.[5]

The first general type of appropriate response, and the most common response to wine, is perceptual; for instance, appreciating the silkiness of the tannins or the clarity of the aroma notes. Yet, often our response is more laden with cognitive content. Recognizing that an aroma profile is typical of a region or a distinctive expression of a varietal requires knowledge of wine regions and varietals. Cognitive responses also include imagining how the wine might have been different had other vinification methods been used or coming to believe that the wine was from a warm vintage. The third type of response, an affective or emotional response, is also appropriate—taking delight in or being disgusted by a wine. And finally, we can have motivational responses such as being fascinated, charmed, repulsed, or craving a wine. Some appropriate responses to wine involve a complex mix of all four categories. The recognition that a wine is brooding or expresses joy, is comforting or tense, requires perceptual competence, imaginative comparisons between properties of the wine and emotional states, felt responses to the expressive properties of a wine, and sustained interest in the wine. Except for a response based on perceptual acquaintance, one need not have all these responses to appreciate a wine, although having them will increase one's appreciation.

If an appropriate response is necessary for wine appreciation, what would an inappropriate response be? These would be cases in which an appropriate response is blocked by errors of judgment. Thus, part of appreciation is responding to a wine for the right reasons. Some inappropriate responses are rather obvious, although common. If one responds to a wine solely based on its price, snob appeal, or marketing materials rather than the wine itself, then these responses are inappropriate. One's focus on the wine is impeded by failing to properly judge what is relevant. If your appreciation of a wine is based solely on the fact it reminds you of long-lost weekends at the beach, then your focus is only on your own response instead of connecting your response to features of the wine—again, a misjudgment of relevance. Failures to consider the type of wine you are drinking or facts about its origin are also inappropriate. Treating the daily porch pounder as if it were a work of art is inappropriate, as is complaining that a rosé lacks tannin or that a German Auslese is sweet. Both are intended to be that way. Complaining that Amarone is high in alcohol without noting whether the alcohol is well handled or not is inappropriate. Because of the way it is made, Amarone will always be relatively high in alcohol; what matters is whether the alcohol is too obvious. These are all cognitive mistakes that inhibit appreciation of a wine. Although we often think of wine appreciation as primarily involving perception, reasoning correctly about a wine is also central to its appreciation.

There are also failures of attention. As I will discuss in the next chapter, the aim of aesthetic attention is to experience as many aesthetically relevant properties of a wine as possible. If our attention to a wine is so one-dimensional that it blocks our attention to other dimensions, our response is likely to be inappropriate if our goal is to enjoy an aesthetic experience. For instance, if we are attracted only to the superficial, easily accessible aspects of a wine—its power, softness, alcohol content, or ability to refresh—without considering the full range of its properties, we haven't fully appreciated the wine.

To summarize, in order to appreciate a wine, two conditions must obtain: one must taste the wine or accurately imagine it based on reliable perceptions of a component or stage of the wine, and one must respond appropriately to the wine.

The Role of the Wine Critic

Given this account of appreciation, we can now say what wine criticism is. One necessary condition of wine criticism is that the critic must have tasted the wine. Regardless of how much a critic may know about a wine, readers have a legitimate expectation that the critic has tasted the wine and developed her view of the wine based on that tasting. The second condition of wine criticism is that critics must seek to communicate the properties and appropriate responses to those properties that a wine makes available, as well as reasons for why those responses are appropriate. The critic's aim is not merely to describe the wine but to enable the reader to understand that these properties are worthy of their attention and invite a response, whether positive or negative.

The critic responds to what is good or bad in a wine, reports that the wine moves her in some way, and lets the reader know how she is moved and to what degree, often by interpreting or elucidating features of the wine. Thus, a good critic does not simply inform us about facts but about facts that matter and why they matter. For instance, by making readers aware that a winery ages in amphora, a critic might make the wine's perceived minerality more evident and important; by highlighting the herbal notes in a syrah, she may get drinkers to recognize the wine's complexity or relationship to other wines.

As Terry Theise writes in his book *What Makes a Wine Worth Drinking*, "If a wine doesn't cause us to notice it why are we drinking it?"[6] The critic must convey what is noticeable about a wine that calls

us to respond to it, and she must explain what responses are available. Because the critic's job is to report what responses are available, including her own response, wine criticism is, in part, subjective. The ultimate goal of the critic is not to be objective but to enable a reader's responsiveness by using the critic's own response as a reference point. In this sense, wine criticism is no different from literary, film, or music criticism. However, this is not to claim that wine criticism is entirely subjective. There are objective elements to wine tasting, and, up to a point, experienced critics can distinguish the basic quality level of a wine from their own responses.[7] Furthermore, critics must take steps to ensure their judgment is neither biased by personal relationships with producers or financial incentives nor disrupted by contextual factors such as tasting in a distracting environment. For wine criticism, this is a difficult line to negotiate. Personal knowledge of producers often enhances appreciation of a wine since it gives critics access to information about a wine's origins that might be otherwise unavailable. The interaction of a wine with the context in which it is consumed can also reveal features of a wine, especially if food is consumed with it. Appreciation may require relationships that conflict with pure, disinterested evaluation. I doubt there is a bright-line solution to these dilemmas. Only rigorous self-reflection regarding potential biases in particular contexts will yield effective policies. I cover the issue of objectivity in much more detail in Chapter Nine.

If the job of the critic is to aid appreciation, she must provide a perspective that the reader could not easily acquire on her own. That may require that she be more knowledgeable, more perceptive, or more experienced than her readers. A good wine critic should especially be more acquainted with tendencies and trends in the wine world. The fact that a wine constitutes a significant variation from what is typical is a reason to take an interest in it. Getting the reader to appropriately respond in a way she is unlikely to without the criticism is also part of the job of the critic. That means she must be a good judge of the kinds of appreciative responses to a wine that one can appropriately have, whether they be approving or disapproving.

Thus, a good critic must be imaginative. She must be able to think of ways of better appreciating a wine that are not obvious, and she must think of effective ways of communicating that are not conventional.[8] A critic may be particularly impressed by a feature of a wine and find it deeply moving, a response unlikely to be available to someone less aware of the range of appreciative responses that a wine makes available. For instance, a critic with a comprehensive understanding of a vineyard's capabilities may find a particular vintage remarkable (or disappointing), a response unavailable to someone unfamiliar with many vintages from that vineyard. In addition, a good critic must be good at thinking of appropriate responses, even if she does not have those responses herself. Critics must taste wines in various styles, some of which may not be to their liking, yet they must be able to judge what an appropriate response would be for someone else who does like that style. This is an especially important ability for a critic to have. Most critics write for a large audience with diverse tastes and preferences. A critic must be able to think of how people with a broad array of preferences will respond to a wine.

Which features of a wine are the most important to mention in a review? Obviously, how the wine smells and tastes must be the focus, along with any information that might explain why the wine tastes as it does. Most importantly, the critic must convey what is noticeable about a wine that calls us to respond to it. A list of aroma notes is not sufficient. What the reader needs to know is why those aroma notes, textures, or dynamic elements are worth mentioning. Therefore, the most important feature of any wine, the feature on which appreciation depends, is the degree to which a wine is distinctive. By "distinctive," I mean a variation that is of value or of high quality. For a wine to be distinctive, it must be different from its competitors. Variation is the lifeblood of the culture of wine. Barolo, Bordeaux, and Rioja, for example, are important as wine regions because the wines made in each region are distinctive. There is no other location in the world that makes wine that tastes like Barolo. The top wine regions in the world are recognized as such because their products show significant

variation from lesser regions with less distinctive products, and the prestige and prices of wines in these regions reflect, in part, the degree to which their distinctiveness is valued.

Wine appreciation also includes an appreciation of vintage variation. Much of the excitement of a new vintage for enthusiasts results from the expectation that each vintage will show distinct characteristics when compared with earlier vintages. In addition, aged wines are interesting precisely because each bottle ages individually and can show variations that surprise (or disappoint) when opened.

Without distinctive variation as a dominant value, wine would be as uninteresting as orange juice or milk, and there would be no reason for the vast number of brands and the price differentials that distinguish them. It is variation that makes wine the cultural icon it has become. Thus, because of the importance of variation, it is the primary job of the wine critic to track variation and distinctiveness and report it to her readers. The ability to recognize and put into words how a wine varies from other wines within its comparison classes is the most important ability of a wine critic.

Now that we have an account of wine appreciation and criticism in hand, we need to explain how they are related to aesthetic experience more generally. Aesthetic experience is the highest form of appreciation and thus has distinctive features not captured by the general account of appreciation in this chapter. The nature of aesthetic experience, when applied to wine, is the topic of the next chapter.

Inspirations:

Good criticism is, in part, about finding under-the-radar gems that exhibit interesting variations. In the shadow of the better-known regions of Central and Northern California, in San Diego's Ramona Valley, Victor Edwards of Edwards Cellars and

Vineyards is pushing the quality level to new heights with his Syrah and Petite Sirah. Near Albuquerque, New Mexico, Rich Hobson of Milagro Vineyards has mastered the ageing of Merlot and Zinfandel. After 23 months in barrel and several years in the bottle before release, the beguiling juxtaposition of mature nose and youthful, vibrant palate might lead you to believe that a wine could live forever. And in Idaho's Snake River appellation, Cinder Winery's Melanie Krause is turning out one gem after another, especially her Foot Stomp Syrah 2014.

However, the discovery that sticks in my mind occurred in Lubbock, Texas. While chatting with the legendary Bobby Cox at Pheasant Ridge Winery, I mentioned that hot, humid Texas seems to be able to grow almost any varietal except the temperamental, cool climate Pinot Noir. I had been tasting around Texas for several weeks and not encountered any. He smiled and said, "hold on a minute," and disappeared into his bottle room from which he emerged with a 1993 Pinot Noir in hand. 25 years after vintage date, it was still rich, fresh, and vibrant. "It's just a unique site," he said by way of explanation.

Notes

1 See Douglas Burnham and Ole Skilleås, *The Aesthetics of Wine* (New Jersey: John Wiley and Sons, 2012), 151-154 for a comprehensive and insightful discussion of the practice of scoring wines.

2 Monroe Beardsley, "What are Critics For" in *The Aesthetic Point of View: Selected Essays*, ed. Michael J. Wreen, and Donald M. Callen (Ithaca: Cornell University Press, 1992), 149.

3 Arnold Isenberg, "Critical Communication" in *Philosophical Review*, vol. 58 no.4 (1949), 335.

4 My view of the goal of criticism is broadly in agreement with James Grant, who argues that the aim of criticism in the arts and literature is to provide the reader with an understanding of what is available in the work to be properly appreciated. See James Grant, *The Critical Imagination* (Oxford: Oxford University Press, 2013).

5 For a discussion of what it means to respond appropriately to a work of art or literature, see James Grant, *The Critical Imagination*, 31-35. I rely on Grant for this account of the categories of appropriate response and apply them to wine criticism. Grant does not discuss wine criticism.

6 Terry Theise, *What Makes a Wine Worth Drinking: In Praise of the Sublime* (Boston: Houghton Mifflin Harcourt, 2018) Kindle version, location 509.

7 See Chapter Nine for more on this point.

8 The role of imagination in criticism is central to Grant's distinctive account of art criticism. On a conventional view of wine criticism using the referential model discussed in my Chapter Four, the role of imagination would seem to be limited compared to the interpretive imagination required to assess art and literature. If wine criticism is limited to identifying only aromas correlated with identifiable chemical compounds in wine, then the holistic properties accessible through imagination are not relevant. However, on the expressivist account of wine I defend in this book, the role of imagination in characterizing the individuality of each wine is significantly expanded. Thus, Grant's approach to criticism is applicable to wine. See Chapter Five as well as the rest of the chapters in this book for more discussion of the properties of wine accessible via imagination.

CHAPTER SEVEN

WINE AND AESTHETIC EXPERIENCE

"The first demand any work of art makes upon us is surrender. Look. Listen. Receive. Get yourself out of the way. (There is no good asking first whether the work before you deserves such a surrender, for until you have surrendered you cannot possibly find out.)"

— **C.S. Lewis, An Experiment in Criticism**

The account of wine appreciation in the previous chapter is preliminary, the first step toward a full specification of wine as an aesthetic object. This current chapter will deepen our understanding of wine appreciation by embedding it in an account of aesthetic experience. Aesthetic experience is the ultimate aim of wine appreciation when appreciation is focused on the wine itself and its expressive qualities.

Any account of wine as an aesthetic experience must acknowledge that the enjoyment of wine is an everyday affair. Wine has value because it infuses everyday life with an aura of mystery and consummate beauty. Wine is a "useless" passion that has a mysterious

ability to gather people and create a sense of community. It serves no purpose other than to command us to slow down, take time, focus on the moment, and recognize that some things in life have intrinsic value. But it does so *in situ* where we live and play. Wine transforms the commonplace, providing a glimpse of the sacred in the profane. Wine's appeal must be understood within that frame.

Thus, wine differs from the fine arts, at least as traditionally conceived. In Western culture, we typically enjoy the fine arts in a contemplative arena outside the spaces of everyday life—the museum, gallery, or concert hall—in order to properly frame the work. (A rock concert venue isn't a contemplative space, but it is analogous to one—a separate, staged performance designed to properly frame music that aims for impact and fervor rather than contemplation.) However, we seldom encounter wine in autonomous, contemplative spaces. It is usually encountered where other activities are ongoing. Although formal tastings are part of wine culture, we rarely taste wine in contexts where casual conversation or food consumption are discouraged, as would be the case at a symphony concert hall or museum while appreciating works of art.

The "everydayness" of wine varies depending on the kind of wine tasting activity in which one is engaged. Enjoying a glass after work or with dinner, with family and friends at social gatherings, or visiting a charming winery on the weekend—these are fully embedded in a commonplace context. For wine professionals and connoisseurs, even focused, analytic tasting may be an everyday affair. Opening a special bottle from your cellar to celebrate a special occasion or to have a rare and remarkable experience is less routine. In these cases, the experience begins to acquire the exclusiveness and autonomy of some art appreciation. However, even in these cases, the venue and companions are likely to be familiar and the occasion a multifaceted social affair in which other sociable activities accompany the wine tasting. Thus, the contexts in which we taste influence what counts as an appropriate response to a wine. To make sense of wine appreciation

as an activity in which its highest form delivers an aesthetic experience, we need a conception of aesthetic experience that can accommodate wine as an everyday object within these multifaceted contexts. Conceptions of aesthetic experience drawn from the fine arts may not be appropriate.

As noted, there are many things people do with wine. Some drink wine to get drunk, or they sip it distractedly at a social gathering because everyone else is doing so or because it contributes to an atmosphere of good cheer. We use wine to quench thirst on a hot day, provide warming sensations on a cold evening, wash down food, or enhance the enjoyment of a meal. I mention these together because they all share a common feature—you can engage in these activities without paying attention to the wine. While these activities may be part of a larger, holistic aesthetic experience, to the extent they do not involve paying attention to the wine, they are not aesthetic experiences of the wine. The wine is not the primary intentional object.

However, focused attention on a wine is not sufficient to mark the experience as aesthetic. A WSET (Wine and Spirits Educational Trust) student sitting for an exam must describe a wine (or several wines) to pass the exam. If she is tasting blind and must draw inferences about the origins of the wine, she is engaged in identification. If she is required to assess the quality level of the wines, she is engaged in evaluation. A winemaker tasting a barrel sample to see if it is developing volatile acidity or a wine merchant deciding which wine to stock are also engaged in evaluation, as is a taster assessing whether a riesling from Mosel is typical of that region. These activities do not neatly fit the category of aesthetic experience. They require focused attention on some aspect of the wine as well as an appropriate response that meets normative standards embedded in the activity. However, they do not always or necessarily depend on the taster having an aesthetic experience. They can sometimes be competently performed without the experience being aesthetic. These activities are not necessarily aesthetic experiences because they are often focused on a

specific characteristic of a wine and serve a purely utilitarian purpose. Thus, they lack the broad-based attention to the full range of a wine's qualities as well as the contemplative attitude that we associate with aesthetic experience. The broader point I want to make here is that the kind of tasting activity or practice one is engaged in does not, by itself, mark an experience as aesthetic.

However, a wine tasting activity that involves the appreciation of a wine as a whole with enjoyment as the primary goal is at least a candidate for an aesthetic experience. The student, winemaker, or merchant, while engaged in their practical tasks, are not precluded from melding their professional activity with the attentional focus needed for an aesthetic experience. Appreciating a wine's holistic character is compatible with identifying, describing, or evaluating a wine but is a distinctive form of appreciation. The reference to "wine as a whole" is important. Attending to the wine as a whole is one symptom that one's experience is aesthetic. In contrast to the distracted wine consumers mentioned above, wine lovers engage wine with this kind of holistic attention, at least some of the time, even when they drink wine with friends, enjoy a wine with dinner, or attend a wine tasting.

Burnham and Skileås on Aesthetic Practice

The puzzle is how to be more precise about what makes some forms of appreciation an aesthetic experience. How do aesthetic experiences differ from identifying, describing, or evaluating a wine when these are not part of an aesthetic experience? In trying to answer this question, I begin with the view of Burnham and Skileås in their book *The Aesthetics of Wine*.[1] While this is the most comprehensive treatment of the topic available, I think it is fundamentally misguided since it

appears to exclude from the realm of aesthetic experience the kinds of everyday appreciation of wine in which wine lovers routinely engage.

Burnham and Skilleås refer to various tasting practices as distinct projects. Analytic tasters identifying a wine in a blind tasting, a wine critic describing a wine to her readers, or a sommelier pairing a wine with a particular dish are each involved in different projects because they have different aims that require different competencies. Presumably, this would also be true of a winemaker tasting for volatile acidity or a merchant assessing sales potential. Furthermore, according to Burnham and Skilleås, each activity focuses on different aspects of the wine, and thus each project has a different intentional object. However, they argue that none of these projects require an aesthetic experience.

Aesthetic experience, for Burnham and Skilleås, is a function of engaging in an aesthetic project, and this requires that one acquire the competencies to recognize aesthetic properties such as elegance, harmony, complexity, and intensity. Tasters apprehend these properties by participating in a variety of structured activities—choosing the proper glass, deciding on a tasting order, decanting, etc.—which are designed to highlight these distinctive properties. However, neither tasters engaged in blind tasting to identify a wine's origin and type nor a sommelier pairing wine with a dish needs to focus on aesthetic properties such as elegance, intensity, or complexity—their attention is directed elsewhere. Burnham and Skilleås go so far as to assert that tasters engaged in these non-aesthetic projects with wine from the same bottle would be tasting different wines because they apprehend different properties.

The awkwardness of this latter point indicates that something has gone wrong.[2] I agree that exam takers, sommeliers, and wine critics often need not have an aesthetic experience to do their jobs. However, it seems apparent that these tasting projects might sometimes require aesthetic appreciation in some contexts. I doubt that these activities can always be successfully completed without some attention to

aesthetic properties. For instance, it is appropriate when blind tasting a medium-bodied, high-acid wine with distinct dried-cherry and earth notes to argue that it's likely Brunello di Montalcino rather than Chianti because of its elegance and complexity. Yet complexity and elegance are aesthetic properties that, according to Burnham and Skilleås, require an aesthetic project for their apprehension. Food pairings will also sometimes depend on features such as complexity or intensity; and surely winemakers apprehending potential flaws in their wines are aware of how tastes and aromas contribute or detract from complexity and elegance. Tasters engaged in such activities may not be having an aesthetic experience if their aim is purely utilitarian, but at least sometimes they must be attending to aesthetic properties. However, if they do not have an aesthetic experience, these cases show that the apprehension of aesthetic properties is not sufficient for an experience to be aesthetic. Thus, neither the kind of activity one is engaged in nor the type of property apprehended is sufficient for identifying an experience as aesthetic. An aesthetic experience can result from a variety of different tasting activities in a variety of contexts. It is best that we do not isolate an aesthetic project in a way that excludes this variety and complexity.

More importantly, Burnham and Skilleås's definition of aesthetic experience as a kind of project rules out the everydayness of wine, which is crucial to understanding wine aesthetics. They are quite explicit that a necessary condition of aesthetic experience is to possess the competencies that constitute an aesthetic project, including the capacity to describe and evaluate a wine using the vocabulary and tasting skills similar to those employed by professional wine tasters. Referring to an account by wine writer Jancis Robinson of her own "aha" experience with wine as a relative novice, they write, "However much Robinson and her friend agreed in their drooling and grunting, they did not form, apply, or communicate aesthetic concepts."[3] Although they grant "some level of competencies including the aesthetic were probably in play," they deny that Robinson's experience

was properly aesthetic. This excludes the experience of casual yet attentive drinkers whose enjoyment must fall short of being genuinely aesthetic. It implies that a whole range of everyday experiences that one might think are aesthetic are not. There are many wine lovers who lack the highly developed tasting and communicative skills of a sommelier or wine professional and do not think of their wine experiences as "a project." The kinds of experiences that wine lovers often refer to as an "aha" experience—that moment when a casual wine drinker recognizes the consummate beauty of wine and its potential for further engagement—are deemed merely "proto-aesthetic," because the people who have such experiences lack these competencies. Thus, most ordinary appreciative experiences of wine will not count as aesthetic, on the view of Burnham and Skilleås, because aesthetic concepts are not robustly represented and communicated.[4]

This approach to defining aesthetic experience is too restrictive. Wine lovers who may lack the vocabulary or developed competencies of the connoisseur may nevertheless recognize basic aesthetic properties such as intensity or elegance. After all, people who report on their "aha" experience are not simply claiming to enjoy the wine—they find it thrilling, awe-inspiring, or uniquely impressive. They are tasting something out of the ordinary, beyond mere liking, and recognize it as such. Burnham and Skilleås are right that the apprehension of aesthetic properties is not a simple perception but involves holistic judgments about relations among properties of the wine. But elegance and intensity are not so difficult to discern that attentive drinkers with modest levels of experience must miss them. After all, music lovers are sometimes deeply moved by a piece of music without the capability of following the score or articulating genre characteristics. Having such highly developed competencies enhances the aesthetic experience, but their absence does not preclude the experience from being aesthetic.

This notion of an aesthetic project that requires various competencies and practices is useful for articulating the structured, reflective nature of wine appreciation. Burnham and Skilleås deploy

it successfully to show that the casual dismissal of wine as a serious aesthetic object is misguided.

Furthermore, accomplished, dedicated wine lovers are engaged in a distinctly aesthetic project that is well-described by Burnham and Skilleås. However, their notion of a project cannot define aesthetic experience because it orphans too many experiences that intuitively ought to be included. In summary, we cannot define aesthetic experience in terms of the properties apprehended, the practice or activity engaged in, or the competencies required to discern subtle qualities. Instead, an aesthetic experience of wine is a matter of degree and is the sort of activity that can be blended with or accompany a variety of other everyday experiences that may or may not be aesthetic. This suggests that we should understand the aesthetic experience of wine as a distinctive kind of attention.

Aesthetic Attention

Before turning to a defense of the claim that aesthetic experience is a distinctive form of attention, I want to lay the groundwork by including a brief summary of the long philosophical debate about the nature of aesthetic experience. Why do we value successful art works, symphonies, and good bottles of wine? One answer is that they give us an experience that lesser works or merely useful objects cannot provide—an aesthetic experience. But how does an aesthetic experience differ from an ordinary experience? This is one of the central questions in philosophical aesthetics but one that has resisted a clear answer. Although we are familiar with paradigm cases of aesthetic experience—being overwhelmed by beauty, thrilled by music, delighted by dialogue in a play, or awed by a wine—attempts to precisely define aesthetic experience by showing what all such experiences have in common have been less than successful.

The best-known definition of aesthetic experience remains Kant's view that a genuine aesthetic experience requires disinterested attention, a suspension of any personal interest one might have in the aesthetic object so that they might experience it free from the distractions of desire. But perhaps Kant's view is so well known because of the fusillade of objections launched at it over the past several centuries. It is peculiar to argue that what is distinctive about aesthetic experience is the absence of any desire to find the object appealing or satisfying.[5]

Others have tried to define aesthetic experience in terms of the kind of properties apprehended in such an experience, such as beauty, elegance, or unity. However, countless works of contemporary art lack these properties but can nevertheless be the source of an aesthetic experience. Furthermore, the apprehension of a property is not a sufficient condition for having an aesthetic experience. We can recognize beauty or unity in an object without having a moving or distinctive experience at all, especially if one is tired, bored, or preoccupied with a task. In the contemporary art world, any kind of object can be a work of art. Thus, an infinitely disparate list of properties can at least potentially be the source of an aesthetic experience. It is unlikely that a definition that appeals to such a list of aesthetic properties would be successful.

Formalist critics in the mid-twentieth century tried to solve this problem by specifying that only formal properties or design features of an object could generate a genuine aesthetic experience. However, it is hard to take seriously the view that the content or meaning of a work of art plays no role in our aesthetic appreciation of it. Surely it matters that Van Gogh's *Peasant Woman* is about a peasant woman. Given these failed attempts at definition, it is no wonder that some theorists have abandoned the idea of "the aesthetic" on grounds that it is unhelpful in understanding art appreciation.

The problem might be manageable if aesthetic experiences were confined to the art gallery or the symphony hall. But we have

aesthetic experiences of ordinary objects in ordinary contexts—for example, dappled sunlight streaming through a stand of birch trees, an exquisitely prepared meal, or a TV show that leaves one haunted by a character or conversation. An aesthetic experience can arrive when we least expect it, e.g., when preoccupied with a practical task. A mechanic might savor the hum of a well-tuned engine, or a carpenter might admire a well-hung door, not only as an indicator of a job well done but as a perceptual experience that gives aesthetic pleasure. Wine is an especially good example of an aesthetic experience stimulated by an ordinary, everyday object. As noted above, wine lovers usually consume wine when other activities are ongoing, and some attention must be diverted from the wine—at dinner, during engaged conversations with friends, while reading or watching TV, or at celebrations. An aesthetic experience of wine must be capable of being blended with and accompanying these everyday activities.

Given this embeddedness in everyday contexts and the failures in defining aesthetic experience in terms of particular kinds of objects or properties, a more promising approach defines aesthetic experience in terms of the kind of attention we give to an object or scene. Almost anything can be the source of an aesthetic experience, depending on how we attend to it. Perhaps Kant was on the right track in focusing on the kind of attention we give an object, but he needed a more nuanced concept than "disinterestedness" to describe it.

Philosopher Bence Nanay in *Aesthetics as Philosophy of Perception* has helpfully argued that we can distinguish most paradigm cases of aesthetic experience from non-aesthetic experiences by specifying the scope of attentional focus that is characteristic of aesthetic experience. He uses a classic distinction in the philosophy of perception to make his case, the distinction between distributed and focused attention:

> ...[I]n the case of some paradigmatic instances of aesthetic experience, we attend in a distributed and at the same time focused manner: our attention is focused on one perceptual

object, but it is distributed among a large number of this object's properties.[6]

An object, for Nanay, is "a sensory individual," by which he means any entity "we attribute properties to."[7] My coffee cup is a sensory individual, and so is the landscape I see out my window or the concert I attended last night since I can attribute properties to any of these. Nanay then describes four possible kinds of attention:

1. "Distributed with regards to objects and focused with regards to properties." For instance, when searching for a face in a crowd of people, my attention will range over many people but will be focused on only the properties of the face I am looking for.

2. "Distributed with regards to objects and distributed with regards to properties." While listening to a boring lecture, my attention will wander over many objects and many properties of those objects.

3. "Focused with regard to objects and focused with regard to properties." This is the kind of attention most practical tasks require. A mechanic working on an engine will be focused on one object—the engine or a part of the engine in need of repair—and a narrow range of properties that are implicated in the repair.

4. "Focused with regards to objects and distributed with regards to properties."[8] Nanay argues that (4) is the distinctive kind of attention we exercise in aesthetic experience. When viewing a painting or listening to music, I focus on the art object. But every feature of that object potentially matters, and so my attention is distributed across every relevant feature I can find. This is distinct from the kind of attention described in (3), where a practical concern with an object narrows the scope of properties to which one pays attention.

This is a useful picture of aesthetic experience. Any object or collection of qualities can qualify as an object of aesthetic experience

if we attend to them in the right way. Thus, our concept of the aesthetic conforms to the empirical claim that almost any object can be the source of aesthetic experience. Furthermore, attention can be flexibly altered to conform to what a situation requires. The degree of focus and how it is distributed can be dialed up or dialed back depending on circumstances. Nanay's view explains how, at a dinner party with many distractions, I can sometimes have an aesthetic experience of a wine by directing my attention properly. Everyday objects are thus firmly in the realm of aesthetic objects when our attention is properly directed. It can also explain why a relative novice at wine tasting might enjoy an aesthetic experience if her attention is sufficiently distributed. Obviously, the novice will struggle to identify some properties of a wine that are available to a more practiced taster. But the active searching for potential and the experience of being engulfed by hints of nuance, even if dimly perceived, is aesthetically invigorating.

One implication of Nanay's account is that Kant was wrong to reject functional objects as aesthetic objects, but he was right to argue that an excessively narrow focus on function or practical interest would not be aesthetic. Functional objects can be aesthetic objects when our attention is properly distributed over a wide range of properties. However, if I focus narrowly on an object's monetary, practical, or sentimental value to the exclusion of a wider range of its other properties, my experience would not be aesthetic.

As useful as Nanay's account is, I think there are two counter-examples that are important to address. The first I mentioned above. A mechanic who takes time to enjoy the hum of the well-tuned engine, not as evidence of a job well done but as a source of sensory enjoyment, is having an aesthetic experience, in my view. However, the attentional focus is on a single perceptual object—the engine—and a narrow range of the engine's properties—the hum of the engine. Appreciation of the way a single color in a painting interacts with light involves a similar narrow distribution of attention. In Nanay's schema, these would seem to be a case of (3) rather than (4). These

examples raise an important issue that Nanay does not explicitly address. Attentional focus is a matter of degree—we can dial it up and down as warranted by the object and our interest in it. Thus, these categories of attentional focus are not discreet, rigidly bounded categories. "In the wild," so to speak, outside the need to categorize them philosophically, these categories of attention can bleed into one another. The mechanic enjoying the hum of his engine is carrying something of the phenomenology and open sensitivity of (4) into the intentional focus of (3). But then the question becomes how we maintain that phenomenology with such a narrow focus. I will suggest an answer to this below.

The second counter-example shows why Nanay's account of perceptual attention may not provide a sufficient condition for aesthetic attention. I will use the example of wine tasting, but any form of art criticism would provide a suitable example. Wine tasters tasked with providing a comprehensive description and evaluation of a wine must be intensely focused on a single object, the wine, while openly searching for a wide variety of the wine's properties. This would seem to be a clear case of Nanay's fourth category that he argues is properly aesthetic. Yet a wine critic intensely focused on providing an accurate description and evaluation of the wine she is sipping may not be having an aesthetic experience. One can recognize and list features of the wine without experiencing them as meaningful or eliciting the powerful responses—enjoyment, awe, or fascination—that we associate with paradigmatic aesthetic experiences. In other words, the intense focus on an object that is distributed with regard to properties is compatible with a flat affect that seems unlike the paradigm cases of aesthetic experience.[9]

Nanay, in fact, grants this. "It has happened to many of us that although we have entered a museum with the specific intention of having an aesthetic experience of a specific artwork, it just didn't happen. We stand in front of it and we fail to experience it in an aesthetic manner…"[10] I am not quite sure what he means here. He

may mean that because of fatigue, distraction, or being in the wrong mood, I may not be able to hold my attention on enough properties to attain the "wow" factor typical of aesthetic attention. Be that as it may, I am arguing a somewhat different point. Despite the wine critic's adequately distributed mode of attention on many properties, she still might not achieve aesthetic attention. This suggests that something more than focused, distributed attention is required for that attention to be aesthetic.

What might that something more be? In the phenomenology of aesthetic attention, we often feel like we are giving in to the object. My will is relaxing, so I am maximally sensitive to what the wine, painting, or piece of music has to offer. I am not suspending my interest in the object, as Kant would have it; I am surrendering to a kind of affective infection generated by the object. The object is not just a bearer of properties; it is expressing those properties. Part of aesthetic attention is feeling the force of that expression, feeling its urgency. There is an affective, receptive dimension to aesthetic attention that depends not only on the scope of attention but on our sensitivity to the force and fullness of the object's expressiveness. This is what the mechanic enjoying the hum of his engine brings to what would otherwise be a narrow, practical focus on repairing the car; it is what a wine critic can experience in addition to her accurate identification of the properties of the wine. We are attending to the object's "glow" or allure. Our attention is rapt, fascinated, drawn in by the power of the object's expression.

Such sensitivity and fascination are matters of degree. But I doubt that attention is aesthetic without some minimal level of this fascination. Aesthetic attention is not only a matter of how attention is distributed but a matter of sustaining a kind of open sympathy for the object of attention—a willingness to allow one's feelings to resonate with the object. Perhaps we should call it "resonant attention;" in wine tasting, we call it savoring. This willingness to yield to the object is something even a relative novice can possess.

Wine Tasting and the Sublime

This account of aesthetic attention has been general enough to accommodate a variety of aesthetic encounters, including the moments of charm and fascination that enliven everyday experience. However, aesthetic attention can sometimes achieve extraordinary heights, moments of awe and potency that characterize our experience of great works of art or extraordinary natural objects. Their power and relative rarity suggest that these experiences are not merely a form of widely distributed, resonant attention but involve some additional element that an account of aesthetic attention must capture.

Wine can induce such awe-inspiring experiences. The writer most adept at describing them is Terry Theise, a wine importer whose book *What Makes a Wine Worth Drinking: In Praise of the Sublime* is a compelling work of philosophy by a non-academic. Theise writes of what he calls "these incandescent moments of meaning": "Great wine can induce reverie; I imagine most of us would concur. But the cultivation of reverie is also the best approach to understanding fine wine."[11] And later he writes, "Some wines such as a wine called Souches Meres...are so haunting and stirring that they bypass our entire analytical faculty and fill us with image and feeling.[12] Another quote reinforces the claim that certain kinds of aesthetic experience transcend the analytic tasting typical of wine professionals when doing their job:

> When a fragrance is evocative yet indistinct—when it doesn't specify its cognate (such as lemons or peaches or salami or whatever)—it seems to bypass the analytical faculty and go straight to your imagination and from there you climb about the fugue state directly to your soul...[13]

For Theise, wine has the kind of meaning we reserve for the most profound works of art. How are we to understand these rare moments of extraordinary aesthetic attention? Theise invokes the sublime but

provides no analysis of it. I want to argue that the initial experience that brings about these "incandescent moments of meaning" and induces moments of reverie is a failure of recognition. This failure of recognition is the key to unlocking the kind of experiences that Theise describes.

When experienced wine tasters taste wine, in the typical case, they use habits built up over many years; their background knowledge regarding varietals, regions, and winemaking methods; and their capacity for retrieving explicit memories to bring order to and make sense out of what they taste and smell. As they bring all of that to bear on an analysis of the wine in front of them, they deploy conceptual categories that enable them to organize that experience. Aroma descriptors, judgments about balance, intensity, and length, etc., are not merely sensations but are organized conceptually. A taster might report that the wine is tart, bold or lush. They might say it is a good example of Marsannay or the Sonoma Coast or alternatively mention that, as a pinot noir, it is out of balance and showing too much alcohol. These are all judgments that require well-formed, conceptual categories that help tasters recognize what they are tasting. They use recognition skills to "wrestle the wine to the ground," as Theise says, by passing sensations through a battery of analytic categories. Wine education is primarily about teaching these categories and how to recognize them when tasting.

The tasting experiences that Theise extolls, by contrast, are tasting experiences in which recognition fails. He might know that the wine he is tasting is a riesling from a particular producer along Germany's Mosel River and from a particular vintage. However, placing the wine within those categories does not bring closure. There is something about the wine that escapes these conceptual categories because none of them capture the sensations he experiences. In other words, there appears to be no way to assimilate these sensations to previous experience in a way that feels complete with no residue. He is confronted with a unique individual for which there are no ready-made ways of understanding it.

That is a failure of recognition, and it is not limited to wine but is at the heart of the kinds of aesthetic attention that I earlier referred to as "moments of awe and potency."[14]

There are two important points to draw from Theise's account of his experiences with wine, and both apply to aesthetic attention when directed toward extraordinary works. We are moved by some aesthetic objects without fully perceiving them or grasping them conceptually. We feel their effects tentatively as an intimation or via allusion or metaphor, effects that are often just below or barely crossing the threshold of conscious perception. Thus, the experience lacks fully constituted phenomenological intentionality.[15] This sense of mystery is characteristic of many aesthetic experiences and is, ultimately, what transforms aesthetic attention into a peak experience. We sense that something is beautiful even before we recognize what makes it beautiful. Think of the experience of wandering through an art gallery and being attracted to a work without being able to put your finger on why.

Secondly, this experience of recognitional failure is partly constitutive of at least one distinctive kind of experience of beauty.[16] This experience of beauty is an overflowing of sensation through which we experience the inadequacy of our concepts to capture it. The object stimulates thinking, but the object's dimensions cannot be expressed by any particular thought. No concept will be adequate to it because it is a radical particular, not a summation of general properties.[17]

At this moment of recognitional failure, what does the mind do? Some people, most people perhaps, just say "wow" and leave it at that. But that would be to miss an opportunity—that failure of recognition is at the very heart of creative response. For someone like Theise in his pursuit of beauty, when recognition fails, he switches to a kind of interrogative attention that sends the mind cascading through a series of possibilities. That sense of *je ne sais quoi* poses a problem—the mind must create the connection or category that will

make sense of the experience and solve the problem. Imagination takes over. But the wine will remain beautiful only as long as the problem-solving fails and the mystery persists. We are experiencing our faculties of cognition, imagination, and sensibility taxed to their limit without resolution. What is radically particular and incapable of conceptualization forces itself on us as that which must be perceived, an affective resonance that demands we pay attention because the object cannot be conceptualized. This is the truth that aesthetic experience reveals—a truth about radical particulars. Beauty fades when mysteries are solved. It might ruffle the feathers of analytic tasters, but the marker of quality is the ability of a wine to stimulate the imagination.

In summary, this account of aesthetic attention builds on the account of appreciation in Chapter Six. There are a variety of experiential layers that bring the full appreciation of wine into sight: attentional focus distributed across a wide range of properties, diminished attention on functional or instrumental values, some degree of affective resonance with features of the wine, and the potential for recognitional failure. These concepts will play a role in Chapters Nine and Ten when we get an account of the beauty of wine.

Inspirations:

Napa Valley cult wines receive a lot of criticism mainly because they are outrageously expensive and inaccessible. Indeed, some are disappointing given their price. But on the few occasions I have had to sample Screaming Eagle, the experience has been transcendent. The marriage of power and delicacy tends to produce the most sublime moments in wine. The 2009 Screaming Eagle was powerful, long, deep, and with a ceaselessly mutating flavor profile, yet as lithe and shapely as a figure skater's spin.

Early in my wine foraging travels, we were exploring Burgundy with a dialed-in local guide who caught wind of a private tasting for high profile industry guests. A couple of hours after the tasting, she took us in the back door and, sure enough, there were four half-empty bottles from the legends lined up on the bar. The standout was a 2005 Charmes-Chambertin from Drouhin. Charm is precisely what this wine exhibited, along with great depth and dimension. It was a wine that made me melt with the kind of surrender discussed in this chapter.

Notes

1. Douglas Burnham and Ole Skilleås, *The Aesthetics of Wine* (New Jersey: John Wiley and Sons, 2012).

2. My worry about this idea that tasters involved in different projects are tasting different wines is that it suggests relativism if not subjectivism. If we are tasting different wines, there is no common wine that we aspire to appreciate and understand. Burnham and Skilleås' solution to this worry is to appeal to the intersubjectivity of tasting practices. However, in Chapter Nine, I argue that intersubjectivity cannot account for the disagreements we see in the wine world and cannot provide a foundation for objectivity.

3. Burnham and Skilleås, *The Aesthetics of Wine*, p. 126.

4. To be fair, Burnham and Skilleås grant there is no "conceptual abyss" between proto-aesthetic and aesthetic experience, and they argue that the full set of competencies are not "absolutely necessary" for an experience to be aesthetic. They are right to abjure arbitrary line-drawing here. Nevertheless, the point still stands that to insist that aesthetic experience is about having the right aesthetic concepts sets the bar for aesthetic experience too high to capture everyday aesthetic experiences.

5. Kant's analysis of "disinterestedness" is notoriously difficult to interpret, and the debate about what Kant meant by this crucial term is ongoing. What all interpretations share, however, is that Kant meant to exclude experiences in which the person undergoing the experience had a personal interest in or desire for the object. I find it perplexing how I could appreciate the aesthetic properties of an object without having a personal desire to engage with the object. See Chapter 10 for more discussion of this concept of disinterestedness.

6. Bence Nanay, *Aesthetics as Philosophy of Perception* (Oxford: Oxford University Press),13.

7 Bence Nanay, *Aesthetics as Philosophy of Perception*, 61.

8 Nanay, 24.

9 I argued in Chapter Six that part of appreciation is having an appropriate response to a wine. As noted in that chapter, ticking off characteristics without recognizing them as noteworthy or meaningful does not satisfy that condition.

10 Nanay, 16.

11 Terry Theise, *What Makes a Wine Worth Drinking: In Praise of the Sublime* (Boston: Houghton Mifflin Harcourt, 2018) Kindle version, location 153-160.

12 Terry Theise, *What Makes a Wine Worth Drinking*, location 616.

13 Theise, location 1025.

14 My use of the idea of a failure of recognition relies on my reading of Gilles Deleuze, *Difference and Repetition*, (New York: Columbia University Press, 1995), especially Chapter Three. Deleuze, however, did not necessarily have peak aesthetic experiences in mind. My application of his idea in the context of wine tasting is my own.

15 All intentional experience is incomplete in that we perceive only aspects of objects. But the experience under discussion here is an intentional experience that cannot be filled in via expectations, protentions, retentions, etc.

16 The connection of beauty with the aesthetic experience of wine receives more focused attention in Chapter 10, where I also take up the relation between beauty and the sublime. I hesitate to say that all experiences of beauty involve a failure of recognition. We can experience the beauty of familiar objects. I do not seek a comprehensive theory of beauty here. Rather I seek to highlight the experience of recognitional failure as an element in a distinctive kind of beauty.

17 Kant, it should be noted, termed this an experience of the sublime, and he was very much aware of this dimension of aesthetic experience. In contrast to Kant, on my view, no moderation via reason is available while sustaining the experience. The sublime collapses when understanding is achieved. I describe our response to the sublime in wine tasting at the end of Chapter Nine.

CHAPTER EIGHT

METAPHOR, IMAGINATION, AND THE LANGUAGE OF WINE

"Unless you are educated in metaphor, you are not safe to be let loose in the world."

— Robert Frost

Wine writers are often derided for the flowery, imaginative language they use to describe wines. Some of the complainants are consumers baffled by descriptors such as "brooding" or "flamboyant." Others are experts who wish wine language had the precision of scientific discourse. The *Journal of Wine Economists* went so far as to call wine writers "bullshit artists."[1] Even the sommelier-trained author of the bestselling book *Cork Dork*, Bianca Bosker, has reservations about the accuracy of such language. After taking writers to task for using terms such as "sinewy" and "broad-shouldered," she writes, "It seems possible that what we 'taste' in a fine wine isn't so much its flavor as the

qualities of good taste that we hope it will impart to us."[2] She seems to suggest that wine writers just make stuff up to sound impressive. The general objection is that these descriptors are metaphorical and are, therefore, too subjective and ambiguous to give readers an accurate verbal portrayal of the wine.

These complaints are misguided. Writers cannot avoid using metaphors to talk about wine because there is no adequate, literal vocabulary that can replace them. Even the commonly used and widely accepted fruit, vegetable, and earth descriptors that have now become standard in the wine industry are metaphors. Cabernet sauvignon from some Napa Valley vineyards often smells like black cherry. But, of course, cabernet sauvignon is not literally a black cherry. It may smell vaguely like a black cherry, but the word "like" there is the tell. Black cherry aroma in a wine is a likeness, a metaphor useful for approximating the aroma of some cabernets. Except for "grapey," no fruit descriptor used to describe wine is close enough to its source, i.e., the actual fruits, to count as a literal description. The same is true of "mushroom" to describe pinot noir or "smoky" to describe syrah from the Northern Rhone. These descriptions have become commonplace and are no longer treated as figurative, just as "that is a deep problem" or "a road runs through my property" are considered literal even though they started out as metaphors.

We compare wine aromas to fruits and other edible substances because these are the most easily recognized source domains for useful metaphors to describe wine. However, if metaphors based on fruits and vegetables are appropriate for describing wine, why not metaphors from other source domains? Critics of our wine vocabulary need some additional argument to rule out source domains such as "wine is like a body" or "wine is like a person," from which "sinewy," "broad-shouldered," or "brooding" are drawn. Thus, if there is a problem with our current wine vocabulary that would justify these complaints, it cannot be that the vocabulary is metaphorical since fruit and vegetable metaphors are now widely accepted; it must be

that certain other source domains for metaphors are inappropriate when describing wine.

It is important to recognize that a scientific vocabulary will not come close to usefully describing a wine outside the laboratory or the production area of a winery, where highly technical discussions of odor compounds are necessary. It is fine to point out that a wine has a distinct odor of pyrazines laced with hints of thiols. But pyrazines can smell like bell pepper or olive, thiols like grapefruit or gooseberry, and those differences matter aesthetically. To claim that a sauvignon blanc contains pyrazines is almost tautological; that aroma is part of what defines sauvignon blanc. That is far too generic a description to be useful to readers of wine reviews who want to know the relative virtues of a specific wine. What the reader needs to know is how aroma and flavor work together to create an overall impression of the wine, an account that no list of chemical compounds or aroma esters will provide. Chemical compounds do not exist in isolation; they interact with other compounds to form emergent properties such as harmony, explosiveness, finesse, or flamboyance. These aesthetic properties are not reducible to underlying chemical properties. It is these emergent, aesthetic properties that we enjoy, and any description that leaves them out will be misleading. More importantly, even the metaphorical fruit and vegetable aroma descriptors give us only limited access to what makes a wine enjoyable. If you enjoy cabernet sauvignon from Napa, it probably is not because you have a fetish for black-cherry aromas. Wine writers need a more robust vocabulary if they are to do their jobs, and it will inevitably be both metaphorical and indicate the holistic, aesthetic properties of the individual wines they describe.

Perhaps, then, the problem is with the use of source domains that include non-edible substances in tasting notes, especially when describing texture or mouthfeel. We routinely speak of wines as having length, as caressing and round, as assertive or having an acid kick, as languid or soft, as if these were literal descriptions. We are in even more obvious figurative territory when tasting notes include reference to a

wine's personality with metaphors such as sexy, brooding, reserved, or exuberant. "Wine is a person" is perhaps the most ubiquitous source of metaphor to describe the distinctiveness of a wine and probably the source domain that provokes much of the consternation. The iconic wine writer Robert Parker, Jr., was notorious for his florid tasting notes. Here is one noteworthy example:

> [T]he 2001 Batard-Montrachet offers a thick, dense aromatic profile of toasted white and yellow fruits. This rich, corpulent offering reveals lush layers of chewy buttered popcorn flavors. Medium-bodied and extroverted, this is a street-walker of a wine, making up for its lack of class and refinement with its well-rounded, sexually-charged assets. Projected maturity: now-2009.[3]

The reference to "street-walker" might seem over the top, although Parker clarifies what he means in the tasting note. It is obvious what Parker intends with this description—some wines have pumped-up flavors that are overtly hedonistic but lack finesse. It isn't obvious why this example of "wine is a person" is less useful than the widely accepted "wine is a fruit" as a source domain of metaphor.[4]

Throughout this book, I have been giving an account of wine appreciation in which tracking distinctive variations, the surprise of unpredictability, and a provocative, affect-laden sensory experience are fundamental to what we love about wine. Finding a way to communicate that experience is essential to the health of the wine community, but it poses a daunting task for wine writing and wine criticism.

Wine writing that purports to aid in wine appreciation must describe the individuality of wines and capture the full range of their expressiveness while being on the lookout for novel variations that are aesthetically meaningful. This is a daunting task for several reasons. As many have noted, in Western culture, we lack a fully developed vocabulary for describing sensory experiences. Furthermore,

all language is built on conventions and general concepts. Thus, describing something that is both new and unique requires some degree of linguistic innovation. Writers must stretch the conventions of language to accommodate something that does not quite fit those conventions. We cannot satisfy the need to describe individuality or the need to identify novel variations by using generalities that refer to what is typical of a wine region or varietal. Yet, if the writer is to be understood, those novel descriptions must remain sufficiently bound to conventions to be grasped by the reader. That is the dilemma—to be creative yet conventional.[5]

In most contemporary wine writing, the problem of describing the individuality and uniqueness of a wine has been solved by focusing on a winery's story. The path to quality winemaking is often circuitous, full of problems to be confronted, and requires vision, courage, and dedication. A winemaking story is often a story about the uniqueness of a place, and if the personalities and traditions behind a wine are also distinctive, that may go some way toward explaining the distinctiveness of a wine. This is a reasonably successful strategy. We love stories, and when they are about places and people, uniqueness and individuality can be evident in the unfolding tale. However, there are limitations to this approach. The features of the wine itself may slip into the background, especially those holistic properties to which descriptions of aesthetic attention must point. Although the distinctiveness of a winery's story may have some aesthetic appeal since narratives can be aesthetic objects, the wine itself is the primary locus of aesthetic attention. If the wine is not distinctive, the aesthetic appeal of the winery's story is diminished.

Furthermore, many outstanding wines are blends of grapes from several vineyards or regions. They lack the sense of place that is seemingly required by a compelling backstory. Many wineries that make compelling wines lack a long and storied tradition, and their owners and winemakers walked a conventional, unremarkable path toward their achievement. In other words, it is their wines that are distinctive, not the story behind them.

The stories of place and struggle are an essential part of the appeal of a wine; the wine world would be a poorer place without them. But telling that story cannot replace the need to describe and evaluate what is in the glass. In the end, this fascination with stories, to the extent that it replaces concern for what is in the glass, will not serve wine culture well. We drink wine to enjoy flavors and textures; we have other media for telling stories. To the extent that communicating about those flavors and textures is important, nothing can replace the need for compelling tasting notes.

Thus, we need to investigate how metaphor works to advance the goals of wine criticism that I described in Chapter Six. Are some metaphors better than others? What makes them so? How do readers know what wine metaphors mean? And how best can we teach them what they mean?

Metaphor and Interpretive Challenges

Difficulties with interpreting metaphors are not unique to wine. Unless metaphors have become dead metaphors, there will always be ambiguities about how to interpret them in any field. Poetic metaphors are obviously complex and difficult to parse, but even conversational metaphors such as "Bill is a bulldozer" or "Jane is a block of ice" may raise questions about which features of Bill or Jane the metaphor is highlighting. You must know something about Bill or Jane before being confident about what the metaphor means. All living metaphors require interpretation.

Context is essential when interpreting metaphors. To grasp how a "sinewy" wine might taste, one must know something about the range of textural and tactile differences in wine and have tasted enough to sense them. To know what Robert Parker, Jr. meant when he referred to the 2001 Batard-Montrachet as a "streetwalker," you must know

that some wines are flamboyant and expressive, but also unrefined, superficial, and lacking substance. Critics of wine writing often complain about ambiguity from the perspective of a wine novice. But, of course, wine metaphors will be opaque to a novice. Understanding a metaphor often requires a refined capacity to taste. It would be a peculiar writing practice if its most excellent examples were aimed only at novices. We do not have such an expectation regarding the language of art appreciation, baseball, or bird watching. With regard to more experienced tasters, many metaphors are so common they require only a bit of thought to figure out what they mean. Wine writers routinely describe wines as "generous," "brooding," or "shy." Surely, these pose no special interpretive difficulties for someone with some tasting experience, and there is no reason to think these are more subjective than fruit-aroma notes. Thus, it is only new metaphors with no established history of conventional use that might be troublesome.

Before assessing how to interpret novel metaphors, we need to say more about the primary job of metaphor in a wine tasting note. That job is to describe the holistic properties of a wine. Too often, wine writers use a divide-and-conquer strategy to describe a wine. A wine is broken down into its elements—individual aromas, flavors, textures, and tactile impressions—from which we are supposed to gain an overall sense of the wine. Here is a typical tasting note:

> The 2016 Monterey Pinot Noir has bright cherry aromas that are layered with notes of wild strawberries and black tea. On the palate, you get juicy, black cherry flavors and notes of cola with hints of vanilla, toasted oak, and well-balanced tannins. A silky texture leads to a long finish.[8]

Such a list of individual elements does not reveal how these elements interact to form a whole. We get pleasure from a wine because the elements form complex relations that we taste as a unity. Thus, a review based on analytic tasting requires that the reader guess the overall impression of the wine or, more likely, rely on a numerical

score as an indicator of quality. A proper review, by contrast, must describe that unity. A well-placed metaphor pulls the elements together and makes the wine as a whole intelligible. Describing a wine as boisterous and assertive, or voluptuous and sexy, goes a long way toward describing the kind of appeal a wine might have.[7]

Although contemporary tasting notes sometimes include references to non-metaphorical, holistic properties such as intensity, power, elegance, finesse, etc., these characterize most high-quality wines and thus fail to characterize the individuality of a wine. Most premium cabernet sauvignon from Pessac-Leognan or Napa Valley will have intensity and power. Most quality pinot noir will be elegant. Language that distinguishes between them must be more precise about what kind of power, intensity, or elegance a particular wine exhibits. Metaphor is one way to accomplish this. To call a wine "fleshy" suggests one kind of intensity; "broad-shouldered," another; and "sinewy," yet another.

"Fleshy," "broad-shouldered," and "sinewy" are common metaphors in wine writing. As noted, the metaphors that receive the most criticism from frustrated readers are novel metaphors, new ways of describing wine that will seem unfamiliar even to experienced wine enthusiasts. To describe a wine as "anxious, kinetic, feverishly rebelling against its pretty face" or "praying for joy at a scene of decay" might, indeed, leave readers wondering what is being said about the wine. But we should not dismiss such language as merely ornamental. Wine aesthetics is about variation and distinctiveness. We prize the unique character of a vineyard or style of winemaking, and we get enjoyment from tracking these variations across parcels, regions, and vintages. Wine writing must capture such variation and distinctiveness. A conventional vocabulary will fail to describe flavors that are not conventional. Linguistic innovation is a necessary corollary to flavor and texture distinctiveness. We cannot successfully describe new impressions by using old expressions. Thus, while some might object to particular metaphors and find them difficult to understand, there is no obvious alternative linguistic strategy.

Conceptual Metaphor Theory

Innovative wine metaphors nevertheless depend on an underlying system of sense-making, and it is important to see how that system works. The Department of Modern Languages at the University of Castilla–La Mancha in Spain has underwritten extensive research into wine tasting notes and their foundation in metaphor. Entitled "Translating the Senses: Figurative Language in Wine Discourse," Drs. Ernesto Suarez-Toste, Rosario Caballero, and Raquel Segovia collected a data set of twelve thousand tasting notes from a variety of wine trade publications and analyzed them using one influential theoretical paradigm, conceptual metaphor theory. As Toste and Caballero show in their articles based on this research, there are standard source domains that wine writers use in order to make sense of what they are tasting. Referring to descriptors that aim to capture a wine's texture and mouthfeel such as "iron wall of tannin," "extremely long," "caressing and round," "assertive and sexy," Suarez-Toste writes:

> These schemas point to the existence of asymmetrical mappings across two domains, and in our case include among others A WINE IS A BUILDING, A WINE IS A PIECE OF CLOTH, and conspicuously the one I shall claim is ubiquitous A WINE IS A PERSON (which is but a part of the much more comprehensive primary schema WINES ARE DISCRETE LIVING ORGANISMS).[8]

This research shows that wine metaphors are neither flights of fancy, mere pretty words, nor "bullshit." They are systematically related to a few source domains that provide conceptual anchors for describing a wine's holistic properties. Yet even Suarez-Toste laments the ambiguities associated with wine language that relies on personification. He writes:

>...brooding, friendly, sexy, voluptuous, boisterous, assertive, sensitive, demure, shy, or expressive... Most people consider most of these attributes extremely subjective ones, and it is both curious and frustrating that anyone should resort precisely to this grey area in the vicinity of morality in order to transmit anything with precision.[9]

Despite this useful research demonstrating the underlying systematic connections that govern metaphorical attributions, the charge of subjectivity and ambiguity persists. Furthermore, there are limitations to analyzing metaphor as a system. Caballero and Suarez-Toste are linguists trying to demonstrate the logical categories that systematize wine language. That is a worthy theoretical aim. However, if wine language is to do its practical job of tracking novel variation and individuality, it cannot ultimately be systematized. New expressions will require new categories, and the need to describe this novelty and individuality will eventually outrun any account that relies on a conventional vocabulary. Wine writers are continually inventing new ways of describing wine because wine itself is subject to variations that must be captured in language.

In addition to these underlying source domains that systematize the use of metaphor in wine language, metaphor must also capture that elusive dimension of wine that is not reducible to a list of features and may not rest on an "objectively identifiable trait." The holistic properties of wine are not always analyzable into discrete elements. As I noted above, no list of primary, secondary, or conventional tertiary properties such as finesse, power, or elegance will ever capture the individuality of a wine. And no list of individual elements can convey the complex inter-relationships between these elements. If emergent properties are irreducible to more fundamental properties, then a metaphor may have to stand on its own, without paraphrase into some collection of clearly identifiable underlying features.

This has significant implications for our current wine-tasting practices. If we must describe wine in terms of holistic or emergent

properties that are irreducible to chemical compounds in wine, then the referential vocabulary of wine tasting reflected in current wine tasting practices is inadequate. Students of wine today are educated by means of a tasting model based on the assumption that our wine language picks out actual chemical compounds in wine that are discoverable by science. The descriptors associated with fruit and other edible substances refer to these chemical compounds. This is, in part, the source of the claim that our judgments about wine are objective. No doubt, chemical compounds in wine cause our experiences. But it does not follow that we can adequately describe those experiences using a referential vocabulary. This is especially true of complex metaphors that try to characterize the individuality of a wine. There is no greater obstacle to an expressivist account of wine than this assumption that wine descriptions must be limited to this referential vocabulary.[10]

Thus, when describing the individuality of a wine, the use of the source domain "wine is a living person" is precisely the right vocabulary. Our interest in persons as individuals provides a rich vocabulary for describing wines as individuals. It is no accident that this domain is ubiquitous in tasting notes, despite the fact that comparing wine to a person might seem far-fetched.

Imagination and Metaphor

Linguistic research on wine metaphors is useful for identifying the common source domains used in wine descriptions. But how do writers identify, within these source domains, which likenesses will be compelling, and how do readers come to understand what a metaphor means? Identifying source domains for wine metaphors must be supplemented by an account of how the activity of interpretation works.

Given the importance of variation and distinctiveness in wine appreciation and the need for linguistic innovation to capture these dimensions, theories of metaphor that explicitly link metaphor to the exercise of imagination will be most useful. The use of metaphor in wine language looks backward to conventional, entrenched descriptions while looking forward to capture the emergence of innovative taste profiles that require linguistic imagination. To add more complexity to the mix, the use of metaphor in wine language serves two broad purposes that are sometimes opposed: On the one hand, writers use metaphor to communicate an accurate description of the wine they are tasting. On the other hand, metaphor expresses the remarkable experiences of a wine that wine importer Terry Theise calls "sublime," as discussed in Chapter Seven. "Some wines," he writes, "…are so haunting and stirring that they bypass our entire analytical faculty and fill us with image and feeling."[11] These are experiences in which the wine seems to transcend any conventional linguistic categories and induces an experience of reverie and imaginative play. As I argued in Chapter Six, wine writers are tasked with both describing a wine and describing the kinds of experiences a wine makes available. Confusion regarding which purpose a metaphor serves is the source of some of the consternation afflicting readers of wine reviews.

The general theory of metaphor most suited to this complex role of wine metaphor is advanced by the philosopher of aesthetics Kendall Walton.[12] Although Walton does not discuss wine metaphors, he articulates the subtleties of how our imagination figures in our understanding of metaphor, thus providing an explanatory framework for grasping how wine metaphors work. Walton argues that metaphors are prop-oriented games of make-believe, which he contrasts with content-oriented games of make-believe. In content-oriented make-believe, such as children playing a game of cops and robbers, it is the pretense, the fiction, that is of interest to the children. They may use props such as sticks to stand for guns to help in the imaginative

game-playing, but they focus on the ongoing game and its roles and activities, not the sticks. But when mom says, "Don't poke someone's eye out with that gun," she too is entering the game but only to say something about the props themselves—sticks are dangerous, so be careful with them. Mom's comment is prop-oriented rather than content-oriented. Walton argues that metaphors are prop-oriented, like mom's comment. The point of using the metaphor is to describe something; the game of make-believe is only a means to that end.

Metaphors are games of make-believe because, when using metaphor, we typically make a statement that is literally false. But the communicative goal is to provide a true characterization of something—the prop in Walton's scheme. If I say, "John is a tiger," although my claim is literally false, I am letting you know that John is relentlessly predatory and, depending on context, warrants defensive measures. I am pretending to claim John is a tiger while asserting an alleged truth that John is a fully human predator. The game is "prop-oriented" because it is the information about John that is important; the literally false claim is the means through which the truth about John's character is conveyed. Our focus is on John, the prop, not on a game in which John and tigers would figure in some further imaginative activity. In other words, interest in the game is over once the information contained in the metaphor has been conveyed. Similarly, when a wine is described as assertive or generous, it does not literally have a personality, but the metaphor is designed to accurately characterize the wine, and it is that characterization that is the communicative goal. The wine is a prop in a game of make-believe that draws on human personality traits to describe it.

Metaphors thus involve taking things of one kind to prescribe imaginings about things of another kind. Importantly, however, according to Walton, they do not typically involve imagining things of one kind to be another. I understand John's character as prescribing various ways of being tiger-like. I understand a wine as having features prescribing various ways of being person-like. I do not have to imagine

John as a tiger or a wine as a person. Metaphors do not always require actual imagining; they require only that one recognizes that a game of make-believe is afoot and that one be aware of prescriptions to imagine in a certain way. Thus, it is best to understand metaphors as potential exercises of imagination. The degree to which imagination must be active will depend on the metaphor and the experience of the metaphor's receiver. To use one of Walton's examples, if I point out the threat of a thundercloud by saying, "The big angry face near the horizon is headed this way," to understand what I'm pointing to, you may have to perceive a cloud as an angry face, which involves some imaginative make-believe. However, once the cloud is recognized as angry, you need enter the game no further. On the other hand, you may know immediately what I mean when I say a wine is generous—robust and expressive, displaying its features in an obvious way—with no imaginative game-playing at all. What matters in understanding a metaphor is that the user invokes a potential game of make-believe. Dead metaphors require no imagination at all.

More difficult wine metaphors, such as "brooding" when used to describe a cabernet sauvignon, may require more than a potential game of make-believe. Whether one must enter a game of make-believe depends on how familiar one is with the metaphor and with the features of certain cabernets. For experienced wine drinkers, it may require no imagination, since "brooding" has become part of the standard wine lexicon. However, the first time you encounter the description, you might deploy extensive imaginative resources to determine what the person using the metaphor has in mind. A brooding wine is darkly fruited with depth and concentration, but not particularly dynamic or lively—the structural components suggest turmoil, but just below the surface.

However, it is crucial that we not be misled by Walton's use of "make-believe" to describe metaphors. In games of prop-oriented make-believe, we are not licensed to imagine anything we want of the object being characterized. If I claim that "John is a tiger," but

John is mild-mannered, lazy, and shy, the claim would not only be literally false; it would be metaphorically false as well. It would be false in the make-believe world of the metaphor. The actual features of the prop determine which metaphors are apt and which are not. Walton argues that the game of make-believe is governed by "principles of generation"—ground rules for how the game is to proceed. Just as children in the game of cops and robbers will specify who is a cop, who is a robber, which structure is the police station, and which kind of object serves as a pretend weapon, metaphors also involve implicit rules about which properties are part of the game. It is John's goal-directed behavior, not his appearance or food preferences, that makes him a tiger. Similarly, the tone of the fruit and the wine's perceived weight supply the generative rules for describing a wine as brooding and determine the truth conditions of the metaphor in the imaginative world. If the metaphor is to be straightforwardly intelligible, the game must be firmly rooted in the features of the prop. A rich, tannic petite sirah will not license "pert and sweetly seductive" as metaphorically true.

However, as Walton points out, in most cases, we do not use the principles of generation for guidance in participating in the game. We often cannot identify the features that give rise to a metaphor, and we need not formulate them for ourselves. The imagining comes first. We imagine a wine as brooding without specifying the features of the wine that generates that description. Walton notes, "To spell out the principles we would have to read them off from the practice noting which sorts of designs result in which imaginings and then generalizing."[13] This is not to say we cannot provide that analysis; only that it is not necessary to do so in order to grasp the metaphor. You can perceive a wine as brooding without providing the analysis of the underlying properties that make it so.

Thus, Walton argues that one fundamental function of metaphor is to activate dispositions—they stimulate us to think or explore. The use of a metaphor stimulates the receiver's knowledge and experience

with objects in the source domain to make the target more intelligible within the context in which the metaphor is used. Although sometimes we have active dispositions to recognize games, we must often be prodded into it. Metaphors make us implicitly aware of the game being played. "I might come across an instance of a 'weighty' argument or a 'writing style with punch' without the game of make believe occurring to me," writes Walton.[14] We need to be reminded to use our imaginations through the use of metaphor.

Thus, metaphors bring to mind features of an aesthetic object that we might otherwise miss. A taster might identify and enjoy the dark fruit, depth, concentration, and subtly bridled turmoil of a Napa Valley cabernet while never thinking of it as brooding. Does the identification of the metaphor "brooding" add anything to the experience? I think it does, in just the way that noticing how an arrangement of lines and colors in a painting gives it a sense of dynamic motion or hearing a melodic passage in a musical piece makes us think of it as melancholic. In each case, meaning is assigned to the underlying properties that, in the absence of the metaphorical description, the work might not appear to have. Wine metaphors provide us with a way of interpreting what we are tasting that contributes to our experience of the wine and adds to our understanding of the range of experiences that a wine can generate. The point is not just to taste the likeness-makers, the elements of the wine that make it "brooding," but to see that they acquire that meaning, to see brooding as a feature of the wine. And because we are attributing to wine the likeness of a vibrant, changeable living organism, seeing the wine as "brooding" is experiencing its vitality.[15]

However, a receiver may have various motivations that affect how she interprets a metaphor. Although metaphors aim to convey precise information about an object, there are other dispositions they might activate. As noted, metaphors are often hard to interpret. They may not wear their interpretation on their sleeve. On the other hand, they often mean more than what they appear to mean. The target never picks up all the features of the source. In calling a wine "muscular," we

don't expect it to bench press two hundred pounds. Which aspects of the source domain will be picked up by the metaphor is always up for grabs if the metaphor is innovative, and the destiny of a metaphor is often uncertain. Thus, sometimes we must explore metaphors in order to reveal their meaning.

In fact, we often use a metaphor when we are trying to figure out what we mean. Metaphors give us a new angle on something and thus help us improvise and experiment. For example, the wine world is currently exploring the notion of minerality. It began as a term mistakenly used to describe the influence of soil on "flinty" wines such as Chablis or the "wet-stone" aromas of Mosel rieslings. Its use has burgeoned to describe a host of earth-like aromas in both white and red wines, most of which have little to do with minerals. The complaint, advanced by oenologists, that the term is misleading because soil does not transmit minerals to the wine is wholly beside the point—a failure to recognize the metaphorical use of "minerality." Minerality is now emerging as a canonical category for classifying a plethora of aromas, all because the term was given free rein as a metaphor. The next time you read a wine description that seems like gibberish, you may be witnessing a metaphor taking flight.

Inspirations:

I am no poet, as you surely have gathered if you have read this far. But some wines trigger even my leaden poetic sensibility. I found the Bernard Baudry "Les Grezeaux" from Chinon in France's Loire Valley to be "earthy, spontaneous, and trippy. If it were a person, she would be dressed in a long flowing skirt, tank top with love beads, and a daisy in her hair. The mouthwatering, stony palate bounces like a caffeinated bunny." That's enough of my poesy. The wine world still awaits its Walt Whitman.

Notes

1. Richard E. Quandt, "On Wine Bullshit: Some New Software?" *Journal of Wine Economics*, vol. 2, No. 2, (Fall 2007), 129–135.

2. Bianca Bosker, "Is There a Better Way to Talk About Wine?" in The New Yorker, July 29, 2015. https://www.newyorker.com/culture/culture-desk/is-there-a-better-way-to-talk-about-wine

3. Quoted in Ernesto Suárez-Toste, "Metaphor Inside the Wine Cellar: On the Ubiquity of Personification Schemas in Winespeak,"in *Metaphorik*. Vol. 12 (2007), 58. https://studylib.net/doc/8134494/metaphor-inside-the-wine-cellar--on-the-ubiquity-of-perso...

4. It should be noted that the use of gendered language to describe wines may involve unwarranted stereotypes. Complaints about attributing gendered characteristics to wine have merit if they make readers uncomfortable. That, however, is a different worry than the one I am addressing here.

5. Another difficulty is that almost any taste descriptors we use will be culturally specific and thus unintelligible to those who don't share cultural references. As wine becomes a global phenomenon, this problem becomes more acute.

6. From the winemaker's notes regarding the 2016 Carmel Road Monterey Pinot Noir posted at Wine.com.

7. Jamie Goode, in his book *I Taste Red*, agrees that analytic tasting notes are limited in their capacity to describe a wine as a whole. "It reflects a fundamentally reductionist view of wine, isolating and identifying individual components one by one. Such an approach results in a description of the wine, but it fails to capture its essence because the wine is a whole." However, he stops short of recommending metaphor as the solution. He endorses a creative approach to wine tasting but leaves open how that approach to tasting can be expressed. See Jamie Goode, *I Taste Red: The Science of Tasting Wine* (Berkeley: University of California Press, 2016), 196-202.

8. Ernesto Suárez-Toste, "Metaphor Inside the Wine Cellar," 54.

9. Ernesto Suárez-Toste, 59.

10. This description of wine's referential vocabulary relies on Steve Shapin's account of history of the development of wine tasting terminology. See Steve Shapin,"The Tastes of Wine: Towards a Cultural History" in "Wineworld: New Essays on Wine, Taste, Philosophy and Aesthetics," ed. Nicola Perullo, special issue, *Rivista di Estetica* 51 (2012).

11. Terry Theise, *What Makes a Wine Worth Tasting: In Praise of the Sublime* (Boston: Houghton Mifflin Harcourt, 2018) Kindle version, location 616.

12. Kendall Walton, "Metaphor and Prop-oriented Games of Make Believe," *European Journal of Philosophy*, 1:1 (1993), 33-56.

13. Kendall Walton, "Metaphor and Prop-oriented Games of Make Believe," 52.

14. Walton, 52.

15. See my Chapter Five for a discussion of vitality forms, which, I argue, anchor some wine metaphors in objective features of our psychology.

CHAPTER NINE

BEYOND OBJECTIVITY AND SUBJECTIVITY

"The idea of the future, pregnant with an infinity of possibilities, is thus more fruitful than the future itself, and this is why we find more charm in hope than in possession, in dreams than in reality."

— Henri Bergson, Time and Free Will

The claim that wine appreciation is wholly subjective is ubiquitous in discussions of wine quality, although there is little recognition of the implications of this claim. If wine tasting is entirely subjective, each person's response to a wine is unique, and there is no basis for shared flavor experiences. If we subscribe to this line of thinking, statements about wine flavor are statements about one's own subjective states, not about the wine. How things seem to us individually is just how things are. There is no right answer to what a wine tastes like and no standards of correctness for judging wine quality.

In fact, no one in the wine industry believes this. Everyone, from consumers and retail salespersons to wine critics and winemakers,

must distinguish good wine from bad wine and communicate that distinction to others. Ask any winemaker why she controls fermentation temperatures, and she will respond that doing so makes better wine. If wine quality were wholly subjective, there would be no reason to listen to anyone about wine quality. Wine education would be an oxymoron; quality control, an exercise in futility; wine criticism, just empty talk; price differentials, based on nothing but marketing. To the contrary, the culture of wine is full of meaningful discourse about wine quality. Abundant reviews, guides, and social media like buttons presuppose that judgments about aesthetic value are meaningful and have authority even if we disagree about which wines are worthy. In such cases, we are not submitting to authority but viewing others as a source of evidence about where aesthetic value is found. The wine industry has an interest in the reality and authenticity of quality distinctions. Of course, we could all just be fooling ourselves. Hence the need to clarify the status of objectivity.

Unfortunately, a variety of indisputable facts seem to support subjectivism. There are vast disagreements among wine experts when evaluating and describing wines. These disagreements suggest they are describing their individual subjective states, not a common object. Furthermore, well-known biases influence our judgments about taste. Peer pressure, price, personal relationships, one's mood, a wine's reputation, and environmental conditions all influence our judgments and disrupt our ability to accurately describe and evaluate a wine. Blind tasting can reduce only some of these factors. Finally, science shows that the ability to detect aromas and flavors varies from person to person. Each person has their own sensitivities to flavor and aroma compounds, as well as a unique tasting history, educational background, and preferences, all of which cause one person's judgments to differ from another's. This suggests, as some have argued, that we live in our own private "taste worlds." To top off the argument for subjectivism, a variety of studies purport to show that expertise in wine tasting is unreliable.[1]

There appear to be compelling arguments on both sides of this debate. But are there arguments that tip the scale in favor of objectivity in wine tasting? It is worth noting that, although a full assessment of a wine's quality can be determined only by tasting, we gain important information about a wine's quality by looking at the process that produced the wine—and much about that process can be objectively described. If facts about the farming and production processes of a particular wine show an intent to realize the full potential of the grapes or vineyard and an effort to produce a distinctive wine, then we have an initial assessment of its quality based on the intentions behind its production. In other words, part of determining whether something is an aesthetic success involves assessing the degree to which an aesthetic intention was realized. Objective facts about the production process provide evidence for that intention. Nevertheless, to confirm whether the wine is an aesthetic success requires tasting, and this is where the threat of excessive subjectivity can undermine our judgments.

In assessing the arguments about the tasting and objectivity, we must begin by setting aside one of the premises in the argument for subjectivism. The studies purporting to show the unreliability of wine expertise are invariably poorly designed. They either fail to control for the expertise of tasters in the study or demonstrate only that wine tasting is unreliable when tasting conditions are not optimal, especially when tasters are deceived by something in the test conditions. No doubt, wine tasting is difficult, and many people lack the training and experience to be good at it, especially in sub-optimal conditions. But the fact that an activity is difficult does not mean it must be subjective.[2]

One important argument for objectivity in wine tasting is the fact that many wine experts successfully pass the rigorous Master of Wine or Master Sommelier exams. To pass the tasting portion of the Master of Wine exam, candidates must sit for three twelve-wine blind tastings, each lasting two and a quarter hours, in which wines from anywhere in the world must be assessed for variety, origin, winemaking, quality, and style. They are not consulting oracles or divining their answers.

If you don't know your stuff, you don't pass. If wine tasting is entirely subjective, what explains their ability to pass the exam? In fact, by tasting attentively and learning about wine regions, viticulture, and winemaking processes, you can bring your judgments into conformity with objective properties of wine. The demonstrated expertise of those who pass rigorous tasting exams shows that training and discipline can overcome some of the biological, cultural, and personal differences that lead to disagreements about wine.

Nevertheless, well-trained, experienced wine critics do disagree about what they are tasting and how to evaluate wine. The expertise demonstrated on an exam under exam conditions is real, but "in the wild," outside the classroom, wine discourse is fraught with disagreement, even among experts. Thus, the problem is to reconcile the fact that there are genuine properties of the wine that experts can discern with the equally obvious fact that there are vast disagreements among experts when describing and evaluating individual wines.

The debate about objectivity is often put in stark terms. Are wine flavors and textures "in the mind" and thus subjective, or "in the wine" and thus objective? This stark dichotomy between objectivity and subjectivity is unhelpful. Clearly, the answer is both. There are objectively measurable chemical compounds in wine that reliably affect our taste and olfactory mechanisms—pyrazines cause bell-pepper aromas in cabernet sauvignon, diacetyl explains buttery aromas in some chardonnay, and tannins cause a drying sensation in the mouth. However, the perceived character of the flavors and textures of wine depends on sensory mechanisms that involve complex mental processing. Flavor and aroma cannot appear without someone having an experience. Without mental processing, the compounds in the wine would exist, but there would be no experience of flavor. The right account of objectivity must accommodate these facts.

The argument for objectivity is coming into view. The first three premises in the argument are as follows:

1. There are compounds in wine that cause flavors and aromas to be detected by human sensory mechanisms.
2. Wine expertise is reliable under the appropriate conditions.³
3. The distinction between thinking (x) and (x) being true is maintained within wine discourse. It is possible to be mistaken when tasting wine according to the conventions of the wine community.

However, the sharp disagreements among experts must be explained, and the basis for (3) must be established. Contemporary work in the philosophy of wine has not looked favorably upon the arguments for subjectivism. There are three main discussions of this topic, which I describe below, and all make room for objectivity in wine tasting. The task for philosophy is to explain how independent perceivers have access to a common object and to tease out the appropriate criteria that guide accurate judgments about wine.

In broad strokes, there are two approaches to these questions. Realism asserts that perceivers have access to a common object because the object and its properties exist independently of what we say or think about them. Correct judgments conform to the actual properties of an independent object. By contrast, non-realism asserts that object perception is mind-dependent, but we perceive a common object because of the way our minds, linguistic conventions, and social norms operate.⁴ The non-realist explains correct judgment by appealing to inter-subjective agreements among tasters based on common ways of conceptualizing the properties of wine and their value. Both approaches have their virtues and their faults. It is important to see where they go wrong if we are to find our way out of this morass.

Smith's Realism

Barry Smith's realist approach is the most straightforward defense of objectivity.[5] As noted, the general form of realism asserts that objects and their properties exist, and this existence is independent of what we say or think about them. Aesthetic realism asserts the same of aesthetic properties. Aesthetic properties such as complexity, balance, elegance, and intensity are in the wine, not in the mind. Smith grants that the apprehension of these properties depends on our subjective response—to know elegance you must experience it. But the term "elegance" refers to real properties of the wine.

Smith's primary argument for realism is that it provides the best explanation for our wine-tasting practices. When tasting, we make a distinction between appearance and reality—a wine might appear to be balanced, but on further inspection we determine it lacks acidity. There is something in the wine to which our judgments must conform. We do not taste wine after sucking on an orange because that will make the wine taste excessively tart and cause us to misperceive the real character of the wine. At a wine tasting class, if the instructor points out that we missed the tar-and-rose aromas that provide a clue to the wine's origin in Barolo, we assume the wine has characteristics that differ from our subjective impression of them. Just as a red object really possesses the property of redness, a Barolo really possesses the aromas of tar and roses.[6] However, apprehending the qualities of wine requires training and concentrated attention. We do not apprehend aromas or their relationships in the same way we see the color red. Coming to know a wine's properties requires technique, skill, and knowledge—genuine expertise. The best explanation, Smith argues, of this demonstrated expertise is that the flavors and textures apprehended are really in the wine. There is a common, independent object that successful tasters correctly describe.[7]

The main obstacles for Smith's view are the disagreements between experienced, well-trained wine tasters. If the properties are in the

wine, and tasters have genuine competence in discerning them, why don't they agree on what is there? Thus, much of Smith's essay attempts to explain away the disagreements. He argues that wine contains many different flavors and aromas. Given our differing thresholds for the detection of chemical compounds, different tasters will be sensitive to different flavors and aromas. They are all in the wine, but each of us can detect only some of them. Even well-trained tasters have specific anosmias—aromas they cannot readily detect—or aromas detectable only in higher concentrations. However, as Smith rightly insists, the fact that someone is less able to detect an aroma than her colleague is not evidence that the aroma is not "in the wine." The fact that unique brain processes influence our sense impressions does not entail that there is nothing in the object to which our judgments must conform.

In addition, Smith insists we distinguish between preferences and a description of wine quality. A critic's ability to describe the properties of a wine is independent of whether she likes it. Many disagreements among critics concern their preferences, not the properties of a wine and its general quality level. Preferences are subjective; wine quality is not.

Smith's argument regarding the distinction between preferences and judgments of quality is attractive and true, up to a point, but ultimately unpersuasive. I doubt we can sharply distinguish preferences from evaluations of quality. Consider "thick" descriptive terms that are both evaluative and descriptive. A wine described as "delicate" is finely structured and lightweight, and this is usually a term of praise. In wine discourse, it has a neutral to positive connotation. Someone else might describe the same dimension of the wine as meager and thin, a negative evaluation. Smith is right that an expert can ascertain delicacy even if she does not like delicate wines. But if she did so, there would be something missing from her account—the sort of pleasure this example of delicacy makes available. If she does not experience pleasure from some dimension of a wine, then she cannot describe the kind of pleasure that dimension makes available. She can imagine

it, but surely imagining pleasure is not the same as experiencing it for purposes of evaluation.[8]

I argued in Chapter One that the promise and potential for further engagement with an object is part of aesthetic appreciation. Do I want to experience more of it or not? The real test of a wine is whether I enjoy it when I am open to being moved by it. If the wine critic's job is to make readers aware of the kinds of responses a wine makes available, then this includes the kind of quasi-emotive responses discussed in earlier chapters. The willingness to be drawn into "the world" of the wine will reveal properties inaccessible without that engagement. I doubt that a full exploration of a wine's delicacy can be undertaken without taking pleasure in that delicacy and being moved by it. Does this amount to "liking" the wine? Not precisely. One can take pleasure in a wine even though it may not compare favorably with other wines one likes better. Nevertheless, because engagement with the wine is necessary for describing some of its properties, we cannot neatly distinguish evaluation from a pleasurable response. Smith is correct that experienced wine critics can judge a wine's basic quality level and a variety of its descriptive properties, independent of their personal preferences. However, such an evaluation will be limited in its scope. Disagreements about preferences do not leave all our descriptive capacities unaffected. The parties to the disagreement may be having quite different experiences.

Another serious threat to Smith's version of realism is the possibility that two critics might validly attribute incompatible properties to a wine. He argues that wine contains many different flavors, but differing sensitivities to chemical compounds means that tasters will differ in which ones they detect. One taster could validly report that a wine possesses fine-grained tannins, and another might validly report the tannins are coarse, thus attributing contradictory properties to the wine. As Cain Todd points out in his critique of Smith, this is "metaphysically suspicious."[9] The value of realism is that it asserts that there is some set of properties a wine possesses,

independent of how observers experience them. If reality possesses incompatible properties, then there is no particular way the world is to which our judgments must conform, thus seeming to render realism incoherent. Thus, Smith's realism captures the importance of genuine quality distinctions but doesn't resolve all the worries about disagreement that support subjectivism.

The Non-Realist Account of Objectivity

In philosophy, the most important development in the last three hundred years is the idea that what can be intelligibly said about reality is constructed out of our mind-dependent responses, suitably constrained by logical rules that govern reason, social norms, and norms of intersubjective communication. This is the essence of Kant's so-called Copernican Revolution in philosophy, which converted us from naïve realists who took reality at face value to sophisticated anti-realists constructing reality via the structures of consciousness and language. Kant's influence has put realism on the defensive. One modern way of expressing the objection to realism is from twentieth-century philosopher Wilfrid Sellars, who calls the standard realist picture "the myth of the given."[10] Sellars argues that a statement or belief is meaningful only because of its inferential relationship with other sentences or beliefs. All facts are already conceptually structured and meaningful, and thus mind-dependent before we apprehend them. There are no facts independent of how they are conceptualized by human beings within the social practice of using language and giving reasons. Therefore, the correctness of a claim is a matter of its endorsement by conversational peers, as a variety of post-Sellarsian philosophers put it. For both Kant and Sellars, we have no direct access to reality independent of how we conceptualize it, and social practices deeply influence those concepts. We access reality only through the filter of conceptual categories and linguistic norms.

Given these limitations, the best we can do is look for signs or symptoms within experience that indicate we are in touch with reality. According to non-realism, the tendency of beliefs or perceptions to converge on a consensus among qualified observers is the best evidence we have that we share a common world. Thus, our ability to experience "grassy" flavors in response to pyrazines in a wine is constructed out of complex tasting practices as well as social and linguistic norms that we have learned from our enculturation as members of the wine community. No doubt, chemical compounds in wine stimulate our taste and aroma detectors. But, for the non-realist, we apprehend those chemical compounds only via conceptual categories and sensations that are mind-dependent. Thus, "grassiness" is not in the wine but is a matter of how we conceptualize our experience caused by the pyrazines. It is a sensation structured by concepts and thus is "in the mind." Furthermore, we are trained to focus on and identify that aroma note, treat it as significant, and call it "grassy." To the extent the wine community agrees we should attend to it, and others are able to confirm our judgment that a wine exudes that aroma, we are justified in claiming objectivity for our assertion. Our experience depends on mental processing as well as social and cultural influences that feed our judgments. "Objectivity" is secured via intersubjectivity—implicit agreements on social and linguistic norms as well as shared logical rules that govern concepts.

This non-realist argument has four important difficulties to overcome. One philosophical worry about intersubjectivity as a foundation for objectivity is that in the absence of direct, unmediated contact with reality, our ideas and assertions might just be spinning in a conceptual void, with no anchor in a real world. If everything is a linguistic or conceptual representation of reality, how do we know that representation resembles the real thing? Pyrazines can be detected via chemical analysis, and we can explain how our perceptual mechanisms discern them, but how do we know if our *concept* of "the grassy notes in sauvignon blanc" latches on to something real? The problem is

even more difficult with abstract concepts such as balance, finesse, or elegance, for which there are no straightforward causal explanations linked to chemical compounds in the wine. My conversational peers may be as deluded as I am and thus cannot provide a warrant for my assertions. How, then, can we be sure our agreements about wine properties are not some sort of collective illusion?

This question raises a more practical worry. If the correctness of a claim is a matter of "endorsement by conversational peers," how do we know which conversational peers matter, given all that disagreement between wine experts? In the history of aesthetics, this problem is often dealt with by invoking an ideal observer. A value judgment made about a work of art or bottle of wine is justified if it would be assented to by a perfectly trained, ideally talented observer under ideal conditions.[11] This view assumes that if all critics were ideally competent and they experienced aesthetic objects under ideal conditions, they would come to an agreement on matters of aesthetic value. Disagreements are the product of less-than-ideal conditions or a lack of proper training or ability on the part of one or more observers.

This argumentative strategy can often be the product of illicit circular reasoning: How do we know what wine quality is? The ideal observer determines what wine quality is. But how do we know who the ideal observers are? They're the ones who determine what wine quality is. Because non-realism relies on a consensus among experts for its account of objectivity, it will have to explain how to avoid circular reasoning by providing an independent account of wine quality.

A third concern about non-realism is known as the stability problem in aesthetics. For the non-realist, aesthetic properties are dependent on the observer. However, one would think that if a painting is beautiful, it remains beautiful even when locked away in a closet unobserved. The same is true of a wine. If a wine is elegant with great complexity, it has those properties even when still in the bottle untasted. Non-realism does a poor job of explaining the stability and

persistence of aesthetic properties because aesthetic properties, on this view, have no mind-independent existence.

Finally, non-realism must also account for the vast disagreements among critics. If individual tasters are tasting a common object constructed out of intersubjective norms, why is there so much disagreement among qualified tasters? The question is whether any of the contemporary non-realists writing about wine have adequately addressed these issues.

Cain Todd's Limited Relativism

Non-realists deal with the problem of disagreement by showing that most disagreements are superficial. When we look more closely at how our judgments are formed, they argue, there is more agreement than meets the eye. We may disagree about which wines have certain desired qualities, but we agree about what those desired qualities are. According to non-realists, there is broad agreement on the nature of wine quality and the aesthetic values that support it.

Philosopher Cain Todd provides a version of this argument.[12] Todd grants that the chemical compounds that explain the aesthetic features of wine are "in the wine." But the aesthetic properties caused by those compounds are thoroughly response-dependent—properties of a perceiver, not the perceived. He then argues that tasters can validly detect different, even incompatible properties in a wine. Nevertheless, we can secure a degree of objectivity for our judgments and descriptions. Even though each of us tastes from a different point of view, there are correct judgments from within each point of view if other tasters who disagree can nevertheless see each other's point. The fact that we disagree does not preclude the value of debate based on reasons. We disagree because of differences in education, culture, or because we are using different comparison classes against which to

judge a wine. But we can sort out these differences through reasoned conversation, and our judgments are often close enough that we can see the point of another taster's judgment even when we disagree. It is, in part, this capacity for reasoned debate that accounts for the objectivity of wine tasting. I may disagree with you about the merit of a syrah from Hermitage, but if I get you to grasp my point of view even when we disagree, the conditions for objectivity have been satisfied.

For this reasoned debate that reduces the scope of disagreement, Todd emphasizes the importance of categories and long-settled norms about which aesthetic properties are important within those categories. The most important categories are the varietal of the grapes used to make the wine, the geographical origin of the grapes, and the style in which the wine is made. The characteristics that a wine should have depend on what is a typical expression within one of those categories. A Spätlese riesling from the villages along Germany's Mosel River will have a distinct flavor profile. An aesthetically successful wine from that region must exhibit that profile. Thus, being correct about a wine involves choosing the proper category for one's assessment, categories that Todd argues are well established and sometimes governed by strict classification systems. Apparently, the most important point of assessment regarding a wine is its typicity—does it express flavors that are typical of the category in which it belongs? Judging a Napa cabernet using categories appropriate to a wine from a commune in Burgundy would be simply wrong. Of course, each wine will fit multiple categories. Part of reasoned discussion involves specifying the reasons why a wine should be judged in one category rather than another. Thus, Todd characterizes his position as a form of limited relativism. Our judgments about a wine are relative to the categories we use to judge them: "…there may sometimes be more than one incompatible but equally well justified—and hence 'objective'—judgment that can be applied to it."[13]

Importantly, according to Todd, we share fundamental values that distinguish good wines from inferior wines within these categories.

These aesthetic values include complexity, intensity, expression of origin, and balance. "Complex objects are more interesting than non-complex objects and the more complex it is the more the object rewards our attention," Todd argues.[14] Over the centuries of winemaking and wine tasting, these features have emerged as markers of quality. Although critics might disagree about which individual wines have these features, there is little disagreement about their aesthetic importance. This agreement on background values is another important factor that enables fruitful, reasoned debate about wine. Todd then uses these fundamental values to mark the distinction between preference and judgment. All these features—typicity, complexity, clarity of expression, and intensity—can be apprehended whether we like a wine or not. Experienced critics can separate preferences from judgments of quality. Their disagreements are often a failure to maintain that important distinction.

Burnham and Skilleås and the Authority of Traditions

Although Burnham and Skilleås have quite different theoretical commitments from Todd, the central thrust of their view deepens Todd's non-realist approach by identifying additional value commitments that give normative structure to the wine world. For them, the kind of serious wine tasting engaged in by critics and experienced connoisseurs is part of an aesthetic practice—a set of procedures, norms, and critical standards that are designed to highlight the aesthetic properties of a wine. This shared practice helps explain how wine tasters engaged in that practice are tasting a common object—the same intentional object—since the practice has a shared aim which focuses attention on the aesthetic properties of a wine rather than other factors such as price or reputation.

For Burnham and Skilleås, diversity is the fundamental value in the wine world. Wine lovers value the differences that wine makes available; they are the foundation of the aesthetic appreciation of wine. The value of diversity is captured by the importance of *terroir*, which they define broadly to include some elements of the cultural context and decision-making that contribute to winemaking traditions. *Terroir* speaks to the value of distinctive origins, especially regarding the long-established chateaux in Bordeaux or the famous domains and communes of Burgundy.

These exemplars of wine royalty are the ultimate expression of the value of *terroir* because, like masterpieces in the art world, they have withstood the test of time.[15] This is not because they have long been popular, but because authenticity is a function of time. The concept of *terroir* requires the development of firmly entrenched norms that explain the distinctive flavor signature of a place. These norms cannot develop overnight. The finely wrought matches between soil, climate, and varietal in these regions have developed over several centuries, and their flavor signature is unique—no other region in the world produces wines like those from these classic regions. That distinctiveness is a product of established expertise that emerges only after "a set of descriptive and aesthetic features acquires both a canonical status in discourse about that wine and a canonical role within the aesthetic evaluation of that wine."[16] Such a distinctive wine is thus an authentic witness to both a piece of land as well as long-standing winemaking and wine tasting traditions, and that authenticity is a fundamental, unifying value which rests on our interest in diversity. Wine royalty—the vineyards and producers with a record of centuries-long success—set the parameters of the aesthetic project and define the various competencies that structure the wine world. The wine world's intersubjective norms were developed and continue to be advanced by these exemplars. Burnham and Skilleås grant that authenticity is not a necessary condition for a wine to be successful. Some wines may be great without the imprimatur of a

historically sanctified origin. However, it is apparently a sufficient condition.

Thus, for Burnham and Skilleås, a wine is authentic if and only if (A) it exhibits a sensory identity which (B) seems throughout to bear witness to its origin, and (C) both facts are relevant to the aesthetic success of the wine. *Terroir* is expressed when the wine exhibits constancy and a unique identity. (B) is understood to require settled, historically developed norms that have withstood the test of time.[17]

To summarize, the non-realist accounts of objectivity provided by Todd and Burnham and Skilleås add the following premises to (1)–(3) discussed above.

4. Disagreements between wine experts are not evidence for subjectivism. They are usually the result of the following:

 a. Disagreements over subjective preferences and a failure to isolate those from descriptive claims and judgments about quality;

 b. The fact that wines exhibit a variety of flavors and aromas only some of which are detectable by any individual taster, and;

 c. Disagreements about the appropriate category or comparison class for a particular wine.

5. There are widely accepted standards and criteria for judging wine quality, including complexity, intensity, clarity of expression, and balance, as well as criteria established via correct categories.

6. Reasoned debate can meet a standard of shared intelligibility even when disagreements are present. The wine community, when engaged in an aesthetic practice, shares a commitment to historically developed values of diversity and authenticity exhibited especially in the sensory identities of wines from historically sanctioned terroirs of France and other old-world sites.

(4), (5) and (6) are the non-realist's answer to the problem of circular reasoning discussed above. Objectivity is not established by mere endorsement by critics. It is the product of widely accepted historically established standards developed from many points of view over successive generations.

This non-realist account of objectivity vindicates the importance of expertise. Without a thorough knowledge of the categories and classifications we use to organize the wine world, we quickly lose our grip on one very important normative framework for evaluating wine. Wine appreciation is, in part, about origins, and the classification schemes used in wine tasting are ways of meaningfully linking particular wines to standards embedded in their origins, whether that is a geographical entity, varietal, or style of winemaking.

Non-Realism and the Clash of Values in the Wine World

Despite the coherence of the reasoning, non-realism fails to capture important aspects of the contemporary wine world. Premises (5) and (6) make unwarranted assumptions about the extent of agreement on evaluative standards. First, there are many successful wines that are atypical because they violate norms held to be characteristic of their origin. Many wineries use unsanctioned varietals, unusual blends, or winemaking techniques that are not approved by governing authorities. This is especially true in today's era of rampant experimentation as winemakers strive to differentiate their products from their neighbor's. In some traditional wine regions, such innovation is prohibited by law if the producer wants to benefit from the marketing advantage of using a wine's origin on the label. However, such strict regulation is becoming less salient throughout most of the wine world, as many producers choose innovation over adherence to settled norms.

Furthermore, most wine regions, especially in the new world, have less restrictive regulations. This does not mean the normative categories are unimportant. We can assess deviation from the norm only if we know what the norm is. However, if we are dealing with an innovative product, assessment can no longer be a matter of noting its typicity or the degree to which it conforms to an ideal of that type.

Secondly, wine production is rapidly expanding from traditional regions with settled norms about what their wines should taste like to new regions seeking an identity. An answer to the question what a wine from Texas or Uruguay should taste like is still being negotiated. Furthermore, many traditional wine regions, such as Croatia or Greece, are entering the global wine market, and their traditional flavor profiles are shifting as they are being compared to wines from other regions. A global market often makes traditions less important as a source of criteria for excellence.[18] In all these cases, it is not obvious that we should be using typicity as a quality marker. In addition, climate change has already had significant impact on alcohol levels and ripeness in traditionally cooler climates such as Bordeaux. It is likely to scramble the wine map in the near future and make settled norms about taste profiles largely irrelevant. Thus, our categories and classification schemes are useful as organizational devices but inadequate as the primary source of norms for judging wine. Under these circumstances, the charge that a judgment is flawed because it presupposes the wrong category against which to judge a wine loses some of its normative force.

More importantly, I doubt that some fundamental disagreements in the wine world can be mitigated by rational argument. Certainly, some can be. Disputes about which fruit aromas are exhibited by a wine or whether a wine's tannins are fine-grained or medium-grained can represent faultless perceptual differences. Disagreements about whether a wine is balanced or not may arise from the use of different comparison classes. These disagreements can be worked through via discussion. However, there are fundamental disagreements about

values in the wine world that are not merely about preferences or comparison classes. The recent movement toward more balanced, lower-alcohol wines, epitomized by the now-defunct winery association In Pursuit of Balance, is not just a dispute about preferences. Supporters believed that most warm-climate wines using ripe grapes with alcohols above fourteen percent are inferior and that winemaking has gone astray by producing wines that are too heavy, sweet, and powerful, and thus a poor match for food. Although this movement emphasized balance, it rejected fruit and alcohol intensity as a fundamental quality criterion and judged food-friendliness to be as important as complexity. Agreements regarding fundamental values seem less secure than the non-realist suggests.

Similarly, the natural wine movement believes that winemaking has gone astray in using technological interventions to shape the development of a wine, since this shows a lack of respect for the particularities of vineyard, winery, or vintage. The tasters who extoll the virtues of glou-glou do not merely prefer bright, fruity, funky flavors over the smooth, refined, heavily oaked wines from, for instance, mainstream Napa producers. Many of them think the latter, which represents the epitome of winemaking excellence in that style, are abominations that no one should drink. This is a fundamental disagreement about aesthetic value that extends to the aesthetic values that Todd argues the wine world agrees on—complexity, intensity, and balance.[19] Bottlings of cult cabernet sauvignon from Napa Valley all have complexity, intensity, and balance. But many fans of natural wine want no part of them and are looking for a different kind of aesthetic experience. They value complexity and balance but define these criteria so differently that they are not helpful in resolving disagreements about wine quality. Thus, the resources we have available to forge agreements on aesthetic matters are not sufficient to maintain our grip on normativity or to ground the objectivity that Todd thinks characterizes judgments in the wine world.

Can wine royalty and the concept of authenticity advanced by Burnham and Skilleås supply the unifying criteria needed to establish

objectivity? No doubt, diversity is a unifying value in the wine world. However, the diversity Burnham and Skilleås have in mind is a static diversity freighted with tradition that is becoming increasingly less relevant. One significant problem for their account of authenticity is the problem of accessibility. The normativity they seek to preserve via their account of authenticity requires settled, historically developed norms regarding the status of the highly regarded, long-standing vineyard sites in France. But this normativity cannot be based on experience because the best products of the famous vineyards of Bordeaux and Burgundy are not available for much of the wine world to sample. They are simply unaffordable and cannot serve as sources of information or intersubjective agreement for much of the wine community since direct acquaintance with a wine is a necessary condition for appreciation.

Furthermore, the comparison with masterworks in the art world is inapt. The works of Rembrandt still serve as sources of inspiration, enlightenment, and instruction for members of the art world today because these works are still available to be viewed. By contrast, the great wines that have been touchstones for the historical development of the norms Burnham and Skilleås invoke can no longer be tasted since they no longer exist. Their status is purely reputational. Whatever judgments we make about typicity can reach back only a few decades, at best. Thus, the sensory identity, which is at the foundation of their account of authenticity, cannot be confirmed and preserved since it is no longer available to be experienced. There is an inevitable aspect of presentism to aesthetic judgments in wine. A wine world that takes its cue from a few objects that cannot be tasted is bereft of direction.

The notion of *terroir*, which anchors their account of authenticity, is itself a contested concept. Natural winemakers and their fans give due respect to wine royalty and its accomplishments. However, their approach to winemaking and wine appreciation is a far cry from the polished, flawless, consistent, controlled products from the great chateaux of Bordeaux. No doubt, within natural-wine circles, *terroir*

is important, and most would argue that natural wines allow the character of the vineyard to express itself. However, authenticity is understood differently among natural-wine lovers. They do not aim for a consistent flavor identity over time. Instead, they value the role of chance in winemaking. Vintage variation and the vagaries of a hands-off approach to fermentation and ageing are part of the excitement and aesthetic allure of natural wine, as discussed in Chapter Two. Furthermore, many of the prized elements of natural wine among aficionados are not a product of the vineyard alone. A hint of volatile acidity, oxidation, or creative use of brettanomyces are largely a product of how wines develop in the winery. The ideal of not interfering with where a wine "wants to go" is as much about winery practices as it is about vineyard expression. The native yeasts natural winemakers rely on for their fermentations are often yeasts dominant in the winery rather than the vineyard.

The definition of *terroir* that Burnham and Skilleås employ is capacious enough to include factors beyond the vineyard, and they acknowledge the importance of winery practices in establishing flavor identity. However, the fundamental disagreement introduced by the natural wine movement is between control vs. chance in both the winemaking process and the expectations of tasters—a fundamental clash of distinct schemes of value. As I argued in Chapter Two, the natural wine movement is enamored with the diversity and variations of "thing-power." Unexpected variations, the surprise itself, has an aesthetic charge, in part because it is an engagement with something outside human control, which is the heart of the notion of objectivity I elaborate below. This is a celebration of diversity but better understood as variation. For these new movements, origins matter not because of their history or identity based on a consistent flavor signature, but because the origin is the source of unpredictable variation. Winemaking and wine tasting bear witness to that variation as a source of authenticity of a different sort, one that reflects the contingent variability of nature.

Does this clash between values threaten the unity of the wine world? I think not. Many wine lovers are happy drinking Chateau Haut Brion one day (if they can afford it) and a *"sans souf"* from Beaujolais the next. This is because variation is the fundamental value, not a static diversity guaranteed by the overriding value of tradition. What Burnham and Skilleås call authenticity is too freighted with tradition to accommodate the real source of diversity in the wine world: continuous variation.

Any culture needs the constant infusion of new input if it is to remain vibrant. Today there are pockets of consensus about wine quality competing with other pockets of consensus, with no unifying vision other than the value of variation. Meanwhile, as wine royalty becomes less accessible, vineyards are sprouting up throughout the world. To understand them, we need a tasting regime that is open to this variation. Burnham and Skilleås elevate tradition, consistency, and typicity as supreme values, which exclude wines that can be aesthetically successful because they are atypical and subject to variation. Such a view cannot comprehensively define competence and the parameters of the aesthetic project in the contemporary wine world. Wine royalty is important, but the wine community is equally interested in the new.

The importance of variation puts pressure on the idea of intersubjective agreement as the foundation of objectivity. Intersubjectivity emphasizes conformity and the imperative to value what we can agree on and what is typical. The stamp of a signature profile and its provenance is a persistent value, and Burnham and Skilleås do an excellent job of articulating its role in the wine world. However, it is only one value among others and not a unifying vision. The importance of variation requires the unraveling of norms and the highlighting of variations that are not connected to sedimented identities. The wine world is burgeoning with new vineyards, new regions, and new varietals in styles that are not merely extensions of Bordeaux or Burgundy. It is not obvious that the account of

intersubjectivity provided by Burnham and Skilleås can accommodate these disruptions in the wine world.

It is important to note that neither Todd nor Burnham and Skilleås address the general problem of the stability of aesthetic properties when not being experienced. This is understandable given that they are not focused on problems in ontology. However, it remains a substantial obstacle for non-realist theories in aesthetics. A theory that seems to suggest that a wine loses its complexity or elegance while in the bottle untasted lacks plausibility on its face.

The upshot of this discussion is that we need an account of objectivity compatible with the fundamental disagreements that persist in the wine world and the emerging variations that wine lovers seek, yet one that preserves standards of assessment and genuine expertise. We do that by highlighting distinctive variation as a quality marker and standards of assessment as themselves subject to variation. That will require an account of objectivity less focused on intersubjective agreement as the dominant norm. This suggests that realism is the most promising approach.

However, if we are to endorse realism in order to seek a firmer foundation than intersubjective agreement on which to rest an account of objectivity, there are legions of problems to overcome. There is the problem of attributing multiple, incompatible properties to the same wine. Given the amount of fundamental disagreement in the wine world, we need to make sense of that disagreement in a way that does not contravene the realist notion that there is something mind-independent and aesthetically relevant that constitutes the wine. We also need an account of wine expertise that does not presuppose traditional exemplars but provides standards for assessing variation while explaining why critics and experts deserve their authority. In short, we must preserve the distinction between appearance and reality, between thinking a wine is (x) and the wine really being (x).

Dispositional Realism

To provide an alternative to standard realism and non-realism, we will have to briefly put the discussion of wine aside and turn to more general questions in aesthetics and ontology. In this section, I want to sketch an alternative way of looking at how we conceptualize our relationship to reality. Given the complexity of these metaphysical issues, this will fall far short of a full defense of this alternative. My aim here is to provide an intuitively appealing outline of a view that will help us to see the problem of objectivity in a new light.

According to the widely accepted Kantian understanding of beauty, judgments of beauty are based on subjective feelings of pleasure. From those feelings of pleasure, assuming we have adopted a disinterested attitude toward an object, we judge the object beautiful. But this ignores the fact that there is something in the object causing that feeling of pleasure. We are lured, drawn to, captivated by the beauty of a flower, which is a better way of capturing the phenomenology of beauty as more like a response to an object than an inference from feelings of pleasure. If beauty is a lure for feeling, it cannot be the result of that feeling. The pleasure is a by-product of this allure. The judgment that a flower is beautiful might depend on pleasure, but the attraction has already taken place. The allure is not constructed by us; it constructs and guides our experience. Twentieth-century philosopher Alfred North Whitehead, trying to reverse Kant's Copernican Revolution, argued that subjectivity arises from objectivity:

> For Kant, the process whereby there is experience is a passage from subjectivity to apparent objectivity. The philosophy of organism inverts this analysis, and explains the process as proceeding from objectivity to subjectivity, namely, from the objectivity whereby the external world is a datum, to the subjectivity, whereby there is one individual experience.[20]

Kant's mistake was to see subjectivity and intersubjectivity as prior to and thus unmoored from their rootedness in the object. Of course, Kant grants that reality causes our experience. But for him, reality, the so called "thing-in-itself," can only be posited, not known, a mere logical requirement about which we can say nothing. By contrast, Whitehead's radical empiricism asserts that nothing comes into existence on its own; there is always an actual entity that explains all emergence, including the emergence of beauty. We experience beauty through causation, through real objects pressing upon us, not through a judgment based on subjective feelings.

The problem is that no straightforward causal account of beauty seems plausible. Causality operates according to laws, generalizations about what sorts of things cause other sorts of things. By contrast, aesthetics is not governed by laws or general principles. Just as there is no law that connects a song slow of tempo in a minor key to feelings of sadness, there is no law that connects symmetry and vivid color to beauty. Neither can we infer beauty from a set of physical properties. What is beautiful in one object may be ugly in another. But this problem arises because the causal account connecting aesthetic properties with our responses to them is not straightforward. Recent work by theorists such as George Molnar on powers, capacities, and dispositions as objective properties of reality helps make the case that beauty is at least in part in the object, although we experience it indirectly.[21]

How can competent perceivers disagree if aesthetic properties are in the object, just there to be perceived? The answer is that aesthetic properties such as elegance, delicacy, or beauty are dispositional properties, objective properties of objects in the external world, which under the right conditions cause us to have an aesthetic experience. We experience these dispositional properties only through their manifestations, the way they show themselves, which may vary from person to person. However, the dispositions themselves are properties of the object and thus explain why we see the object as beautiful and justify that attribution.

To see this, consider a non-aesthetic property, such as the red color of a rose. We see red because of the reflective properties of rose petals. These reflective properties are the foundation of the rose's disposition to cause the experience of red for standard human perceivers under normal viewing conditions. The redness of the rose is presented to us in a manifestation event, an experience, that occurs because the appropriate manifestation conditions for displaying the redness of the rose are present. The physical features of the rose dispose it to be perceived as red, just as the physical features of a glass bowl dispose it to break when dropped.

The property "looking red" is, of course, relative to a perceiver, i.e., any perceiver who is equipped to view the rose as red and is thus disposed to do so under the appropriate conditions. A person who is color blind lacks that disposition. But, although "redness" is *defined* in terms of its subjective manifestation, the *existence* of the property being manifested is not relative to a perceiver. The appearance of the property red is relative to human perceivers, but that does not entail the existence of the property red is response-dependent. The disposition to appear red is in the rose; the manifestation of the disposition is in the observer.

A metaphysics of powers views dispositions and capacities, which are causal powers, as objective features of an independently existing reality. There is a causal relationship between the properties of an object and a perceiver's response. However, on a dispositional analysis, those properties are not mere qualities but are causal powers that aim at bringing about particular responses in observers. This relationship is only a potential relationship until a manifestation event occurs. We experience the disposition, the causal power, only via the manifestation event, making the relationship between the objective property and the perceiver indirect. The manifestation event is a sign of an underlying capacity or causal power. Yet, these causal powers in no way depend on observers for their existence. The power to produce a response exists independent of its manifestation.

A fragile glass bowl remains fragile even if it never crashes to the floor; a red rose remains red even when there is no one to perceive it. It is crucial for understanding dispositional realism that we keep in mind the distinction between the disposition, the manifestation of the disposition, and the manifestation conditions. The disposition to cause an experience of red is in the rose. The manifestation of the rose's disposition is a subjective experience of the rose's red color, and the manifestation conditions are those features of reality and the experiencing subject that enable the manifestation to occur.

A similar analysis is available for aesthetic properties. We experience the dynamic motion of a painting because the artist employed strong directional lines along with irregular shapes and sizes that force the eye to move about the painting. The perception of dynamism is response-dependent, relative to a properly situated observer trained to look for it. But the quality of dynamic motion is also a disposition of the painting, an arrangement of lines and shapes directed toward their manifestation as dynamic motion for an appropriately disposed observer. We can apply the same kind of analysis to the properties of a wine. We experience a wine as elegant because of the causal and dispositional properties of the wine. Our perception of elegance is response-dependent, but the quality of elegance is also a disposition of the wine, a capacity of the wine to cause perceptions of elegance in properly situated observers. Our ability to form or understand an aesthetic concept depends on having subjective experiences of the object—that may be the only access we have to it. But this does not mean that the existence of the properties apprehended depends on our response. The existence of the property in question depends on the object to which it belongs.[22]

The aesthetic disposition is distinct from the aesthetic response it causes and from the conditions under which it can be observed. Thus, the dynamic painting, when locked away in the closet unobserved, does not lose its dynamic motion; the dynamic motion is latent, unmanifested, yet still very much part of the painting. On a

dispositional analysis, the properties of objects have a stability they lack on a subjectivist or non-realist view.[23]

This dispositional analysis is significant because it easily explains disagreements among competent observers. Disagreements among competent observers are the product of differences in manifestation conditions—the background of observers, their biological constitutions, or the circumstances under which observation occurs. On this realist conception of aesthetic disposition, some aesthetic properties may appear to some observers and not to others. And no individual observer could experience all of a work's properties. In fact, the very same object might produce contradictory responses in different observers, despite these properties being genuine features of an independent object. A rose may appear red to one person but gray to a person who lacks photopigments in the cones of her eyes. The manifestation conditions are different for each person. Similarly, a painting may appear vivid and ebullient to one observer and garish to another because the manifestation conditions differ. The painting is disposed to exhibit either manifestation because its features cause such responses in observers.[24]

Beauty is also a dispositional property of some objects. The recognition of beauty involves apprehensions of complex relations between properties that are experienced together as strikingly harmonious or intense. There is no reason to think complex arrangements of aesthetic properties that we perceive as harmonious are any less the product of causal powers that exist in the object than simpler properties such as redness. No doubt, beauty only shows itself when we experience it under the appropriate conditions, but it is, for that, no less a dispositional property of real independent objects. The next time someone tells you beauty is in the eye of the beholder, just point out that it depends on whether the beholder has an eye for beauty.[25]

There are several key points to take away from this discussion. The first is that these capacities and dispositions are real properties

of objects. The glass bowl sitting on the shelf really is fragile. The properties that make it fragile under certain conditions are as real as any other property of the object. Even though a knife is safely stored away in a drawer, its capacity to cut is every bit as real as any of the other properties of a knife. The second point is that although capacities and dispositions are not observer-dependent, they are fundamentally relational. A standard knife has a capacity to cut when in relation to a block of wood. It does not have the capacity to cut when in relation to a block of steel under standard conditions. Whether a wine will manifest elegance in a particular context depends on its relation to a taster's ability to discern elegance.

Thirdly, we now have an additional argument in support of a theory of dispositional realism for aesthetic properties. The disagreements we find in wine tasting among competent observers lends support to a dispositional analysis. As noted above, competent observers often attribute contradictory properties to an art object or wine. Recall that this is a problem for conventional realism; a real property cannot be both present and not present. However, if perceivers are apprehending dispositions through manifestation events, contradictory responses are what we would expect. For example, magnetism is a power, a dispositional property.[26] A magnet attracts objects with opposite charges but repels objects with like charges. It is both attractive and repellent, depending on its associations. Similarly, the range of responses typical in art and wine criticism suggests critics are exploring a broad-based disposition rather than a collection of discrete properties. The aesthetic object has the capacity to produce contradictory responses depending on the manifestation conditions.

Finally, we are in a position to defend dispositional realism against an important criticism. Barry Smith, in his defense of conventional realism, is skeptical that dispositional realism can explain how a wine taster could be mistaken about what they're tasting. He writes:

If the tastes of a wine only consist in dispositions to produce effects in us, which ones should count? A wine tastes less agreeable when combined with certain foods or tasted at the wrong temperature. Are we to countenance all these dispositions to taste different ways to different people under a variety of circumstances—as tastes the wine has? All the variations would have to be included if we thought of tastes as interactions between us and the wine. Why stop at one set of conditions as the crucial ones concerning our interaction with the wine? Why not include them all? To do so would lead to a proliferation of tastes and offer no definitive criteria for talking about the tastes of a wine.[27]

Smith's concerns that a theory of dispositional realism cannot maintain the distinction between thinking (x) and (x) being true fails to take into consideration the importance of manifestation conditions. We need not countenance "all dispositions to produce effects in us" as providing an accurate description of a wine because some manifestation events occur under manifestation conditions that are non-optimal. Tasting a wine with the wrong food, at the wrong temperature, or if the taster lacks expertise in wine tasting are reasons to discount a judgment made under those conditions. In other words, the dispositional realist has available the very same criteria the conventional realist uses to determine which tasting experiences have veracity.[28]

Thus far, I have been discussing objects as static entities with fixed properties and capacities. However, the relational nature of capacities makes the static conception of an object largely irrelevant. Any entity is positioned within a constantly shifting milieu of other entities with their own dispositions and capacities. What an object can do, as well as the actual properties it exhibits, depends on a complex interaction among the capacities of the entities to which it is connected. A knife's capacity to cut depends on what it is cutting, who is wielding the knife, and a host of environmental conditions that condition that capacity.

The entire list of an object's capacities is endless since a knife can be related to an infinite list of objects.

The milieu of a knife may be relatively stable, but the milieu of a person is not. We continually find ourselves in new relations with other persons and a multitude of objects with which we interact continuously. When we consider something like the practice of wine tasting, the increase in complexity is exponential. We taste against a shifting, kaleidoscopic background of influences even as we ourselves are changing. Each time we taste, we re-shape our sensibility and our sense of what is significant, and we form new comparison classes that influence our judgments about what we taste. The wine shapes our own capacities and dispositions, and we, in turn, modify the dispositions of the wine. The properties of the wine do not necessarily change, but the capacity of a wine to affect us changes as we find new ways to think about and compare it.

Furthermore, our imperfect memories that we rely on to make comparisons fluctuate unpredictably and are continually shaped by new experiences, once again shifting how we relate to a wine. What we taste is influenced by what else we've been tasting, our tendency to adapt to and get bored with tastes that are too familiar, and the random assortment of messages we take in as others we taste with discuss a wine or as we read about it in wine media. Meanwhile, metaphorical associations and the emotional charge we get from the contexts in which we taste continue to modify our sensibility and sense of what is significant and worthy of attention. All of this occurs against a background of the variations that grapes and wines undergo throughout their life cycle and the norms of the wine community that also change through time. The capacities and dispositions of ourselves and the wines we taste are in constant flux.[29]

The subjectivist argues that we taste in our own separate worlds. But that is not the problem. Instead of too few connections, we have too many. Disagreement is not a product of our living in different taste worlds; it is a product of living in a crowded world of multiple

connections made possible by shifts in the capacities of ourselves and what we taste. There is a sheaf of instability around all objects. A wine is not just a wine but an assemblage that interacts with a shifting collection of persons, meanings, and other wines to which it is being compared, and thus it continually shows new dimensions. These capacities are in the wine and in ourselves as we interact with the wine, but they change depending on the multiple relations that surround any entity.[30] Given this picture of the practice of wine tasting, what are we to make of wine expertise and the notion of objectivity?

The Failure of Representation

For the non-realist, objectivity requires a background consensus forged through shared values and canonical exemplars. However, the non-realist's approach to the practice of wine tasting does not emphasize one core meaning of objectivity, the idea that what we think must be constrained by something not within our control. Objectivity refers to the resistance of the world, thought that is structured by something that is not thought and not language—something that poses an obstacle to our ability to conceptualize it because it is not wholly a mental entity. In what follows I want to formulate a new approach to objectivity based on this often-ignored dimension.

Non-philosophers reading this will likely find the reasoning here unfamiliar and difficult to follow. Let me briefly try to explain some of the background that will hopefully clarify matters. There are long-standing, contentious debates in philosophy about what it means to say that something is mind-dependent or "in the mind." The general point I wish to make in this section is that when something in our perceptual awareness cannot be conceptualized or articulated using language, its status as a mental entity is open to question. At the very least, it is inappropriate to claim that the mind is projecting something onto the perceptual object. This is because the most likely candidates

for what the mind can "project" would be concepts, beliefs, or socially constructed linguistic categories. However, in cases where concepts, beliefs, and linguistic categories fail to capture the experience, the best explanation is that we are confronted by something non-mental and is thus neither subjective nor a matter of intersubjective agreement. This is what I mean by the resistance of the world.

For the non-realist, we achieve objectivity through the practice of giving reasons. But language and reasoning will not secure objectivity. To see why, we must investigate how language works to provide reasons. The non-realist is correct that the relation between a statement and what it is about takes place within the framework of culturally embedded meanings and norms that govern language. Giving reasons is inherently a social process in which we must follow the norms of our language to persuade and be understood. However, this includes making our discourse itself an object of discussion as well. Given anything we say, someone can always question it, ask for clarification, or point to its failure to capture experience, and that very questioning itself can be put into question. In other words, the working out of what we mean and what we refer to is a continuous, open-ended problem, one that is never settled and always available for disruption. Fixed concepts and accepted norms are often insufficient to clarify what we mean. Disputes in the wine world about tasting norms and aesthetic values fit this pattern of a continuous, open-ended problem.

However, working out what we mean and what we are talking about in a specific context is never a matter of language and social engagement alone. In order to say something true and meaningful, all our capacities are involved. In addition to engaging our capacity for language and social discourse, solving problems about what to say implicates our sensibility (the capacity to receive sense impressions), imagination, memory, reason, and bodily states, especially when the topic is art or wine. These various capacities (or faculties, as they are sometimes called) must communicate; memory, imagination, reason, language, and bodily states must work together to produce

meaning. However, as French philosopher Gilles Deleuze argues, these faculties are anything but harmonious because they do not have as their referent precisely the same object. Each faculty communicates something different about the object and treats that communication as itself a problem.[31]

Consider what happens when we encounter something in the world, a glass of wine, for example. Kant was right that we do not experience an independent object—the wine as it is in itself—but an object structured by human consciousness and language. But what we encounter, as our sensibility confronts the resistance of the world, is not a single, discrete object either. A wine is many things. It is a perceptual object, a memory object, an imaginative object, a concept which is an object of reason, a body (in the case of wine in liquid form) that our own bodies interact with, and a linguistically and socially embedded object that we're accustomed to talking about in a variety of ways. The object of each faculty—the subjective manifestation of the wine present to each faculty—is different in each case because perception, memory, imagination, sociality, sensibility, and reason are different capacities. The wine as a perceptual object differs from the wine as an object of memory or the wine as imagined. It is as if there is no unified wine, only a collection of "wines" each marked by the faculty processing the object. How then does the wine appear to us as a single, unified, discrete object?

This is not the place to delve into philosophical and psychological debates about how the mind attributes persistent identity to objects in our awareness. Part of the answer must be that we develop habits of viewing an object as the same object when our experiences of it are similar, and that feeling of familiarity is part of the experience. If there is nothing to disrupt these habits, no stark differences that bring us up short, objects appear to have a persistent identity across the various faculties. This is what routinely happens in wine tasting when our wine education enables us to understand a wine. But what happens when we perceive something new that lacks these habitual patterns

of familiarity; when we taste something we've never tasted before; something that violates our preconceived notions of what a wine, or what this wine, should taste like? What happens when we confront a wine that Terry Theise describes as sublime?[32]

Deleuze's answer is that differences, when not suppressed by our conventional habits, push the faculties to perform their characteristic function all the way to a limit. For example, as our experience of the wine invokes memories of this or similar wines, we are forced to confront the fact that we cannot trace these memories back to an origin. There is no way to certify them or discover their foundation except by means of another memory, which itself can be questioned. Imagination, as we try to conjure what might explain what we are tasting, is forced to recognize that it lacks any foundation aside from the very tenuous associations that are in question. Our linguistic capacities for sense-making must grapple with our inability to name what we taste. Each faculty's unique character is a limit because its activity is unconscious and cannot be the object of reflection. We have limited access or control over how we process information via memory or imagination. When we cannot find the words to describe our experience, we are without recourse. As each faculty runs up against this limit, which it cannot resolve on its own, it communicates this difference to the other faculties, and we experience a chaos of impressions and a feeling of being unsettled, bewildered, and confused by paradox, all of which increases the intensity of the experience. Deleuze hyperbolically claims that this produces a shock which indicates that thought has reached the limit of its power, encountering something outside of thought that cannot be assimilated. Whether such disorientation is shocking depends on the situation. Being confused about what one is tasting happens rather too often to be shocking.

Notice that, at this point, subjectivity, as well as intersubjectivity, has reached their limits. None of the psychological resources we use to process our sensations provide us with an experience of a unified

object with a clear identity. We confront something outside our control that is constraining thought, resisting the feeling of familiarity and unity we experience with familiar objects. This is the dimension of objectivity I want to highlight.[33] Only by pushing beyond the limits of subjectivity can the bewilderment be alleviated. When confronted with these limits, thought is forced to be creative in order to cope. When we confront something resistant to our will, our ability to modify our behavior and receptivity in response to new information is evidence that we are in contact with something beyond our subjective states and beyond our linguistic and conceptual categories. Learning to successfully cope with that resistance is evidence that something about our grip on the world is correct, that our activity is conforming to something beyond our subjectivity rather than projecting that subjectivity onto the world. How do we accomplish this successful coping? For Deleuze, this requires a process of learning that he calls an apprenticeship of signs. An apprentice of signs pushes each faculty to its limit because this is what provokes thought and, through the disciplined thinking-through of alternatives, enables meaning to emerge.

An Apprenticeship of Signs

At this point, my argument will take an unexpected turn, but one that I hope will make sense of the process of coping with the unknown. Wine tasting is a skill, and we can learn something about how we extend that skill to new circumstances by considering the improvement of a skill that is more familiar to most people—swimming. In fact, Deleuze's clearest example of learning is the process of learning to swim, and his discussion of it will provide insight into the kind of skill development required when faced with paradox and uncertainty in wine tasting. Learning to swim or to taste wine requires finding one's bearings without familiar reference points, and both involve expanding what the body can do.[34]

In order to acquire a flexible skill that can be deployed in diverse circumstances, one must be immersed in and learn to navigate a field of potential differences, a field of dynamically active elements and points of coherence that can take diverse potential trajectories. The ocean and its wave functions are one such field of dynamically interacting water molecules. Every state of the wave system is subject to degrees of variation that are continually changing as wave functions expand and contract. The actual behavior of the wave system is unpredictable, and no two waves are exactly alike.

A wave is a system of multiple potential trajectories embodied in the actual movement of the waves. These potential trajectories are dispositional properties briefly discussed above—a wave is disposed to take a variety of trajectories depending on shifting patterns of kinetic energy propagating through the water. Each actual wave is an actualization of a set of potential outcomes; the wave could have acted differently under different circumstances, and only some of those potential outcomes will be actualized.

Deleuze argues that "To learn to swim is to conjugate the distinctive points of our bodies with the singular points of the objective Idea in order to form a problematic field."[35] By "objective Idea," in this context, Deleuze means the set of potential wave functions under a given set of circumstances. An Idea is not a mental entity in Deleuze's technical vocabulary. By "singular points," or what he sometimes calls "singularities," he means inflection points within matter that enable forces operating on an object to take one direction rather than another. Because the swimmer's body also embodies a set of potential movement functions characterized by singularities, when diving into the sea, the singularities which characterize the swimmer's bodily movements must link to the singularities which characterize the sea if the swimmer is to successfully swim. The swimmer and the sea together form a field of mutually interacting capacities. Of course, the sea will actualize certain specific wave functions and not others. The swimmer will then have to actualize specific bodily movements

to propel herself through the water. The swimmer possesses an actual body, and the ocean consists of actual waves, but the dispositions and potentialities of each, and their degrees of variation, allow the swimmer to adjust to the contour of the waves and successfully navigate them even as the contours shift. The greater the capacities of the swimmer, the better she can adjust to the actual motion of the wave. An expert swimmer must have a broad set of capacities and dispositions and thus can navigate a variety of potential trajectories the wave may take. Learning to swim is a confrontation between the potential differences of which the waveforms of the ocean are capable and the potential differences of which the swimmer's body is capable.

To learn is to be temporarily united with the surfaces about which we learn in a common space of affectivity, the wave affecting the body and the body affecting the wave in what Deleuze calls an encounter with signs. In swimming, the dominant tendencies, potentialities, and dispositions of the wave are made manifest through the subliminal micro-perceptions of the swimmer's body as she adjusts her motion to the rollicking waves. The swimmer's body and the waves, together, form a system of intersecting dispositions and potentials only some of which are actualized when the swimmer successfully navigates the waters.

Although learning to swim is a conscious activity and a struggling swimmer is trying to stay afloat and propel herself through the water, the learning happens via micro perceptions that take place at the border or below the level of consciousness, as the body adjusts to minute changes in the motion and pressure of waves of water molecules. These are the signs to which the swimmer is an apprentice. You cannot learn to swim by reading about it, watching a video, or listening to instructions; you learn only through bodily micro-perceptions that mesh with the activity of the waves.

In summary, learning a skill is, to a significant degree, unconscious and depends on a partnership between reality and our nervous system. But the reality we partner with must include dispositional properties

and tendencies. The role of these diverse tendencies that support the actual perceivable properties of the body and the sea is crucial. When you learn to swim in one body of water, you learn to swim in any body of water with similar singularities and dominant tendencies. Bodily micro-perceptions learn to deal with multiple thresholds and ranges of properties; they respond to broad tendencies with broad tendencies of their own, a process that requires that these tendencies be part of the fabric of reality. If the swimmer is tracking only actual properties rather than a system of dispositions, she could never acquire the flexibility to respond to difference. This is the crucial point. A swimmer cannot learn to navigate a body of water unless the swimmer is tracking potentialities, powers, and capacities in addition to actual properties.

The swimmer's body is an actual object interacting with another actual object, the sea. However, the dynamically unfolding dispositions of both form a non-personal, pre-individual domain constituted by potential zones of contact in which actual movements take place as the swimmer swims and the sea roils. These potential zones of contact are neither actualized properties of the subject (the swimmer) nor actualized properties of the object (the sea) but are an intersection where that distinction between subject and object collapses. In order to learn, the swimmer must find access to these zones, reaching beyond subjectivity to a plane not well captured by "subject" or "object."

In this process of learning, no two swimmers are alike. There is no single right way to navigate a body of water, and expert swimmers differ in how they do it, if only because each body has a different set of potentials and every sector of a particular body of water will exhibit differences to which the swimmers must adapt. There are many styles of swimming and many ways to navigate a body of water. But this does not mean swimming is subjective. Every swimmer must meet certain thresholds and find common singularities in their bodily movements that mesh with the singularities of the water's dynamic fluctuations. Swimming is an attunement of the unique with the unique but one

that passes through shared singularities—common features of human bodies and ocean waves.

The Skill of Wine Tasting

A wine taster must be sensitive to minute variations in how wine molecules affect taste, haptic, and aroma sensors. Like the sea, a wine is also a field of dynamically active molecules. A wine exhibits a variety of aromas, flavors, and textures at varying intensities, depending on circumstances and who is tasting. These differences are enabled by multiple potential system states which are capable of degrees of variation. Like the sea, a wine is not a collection of fixed properties but an open-ended set of capacities that are actualized or not depending on conditions such as the temperature of the wine, the type of glass used, interaction with oxygen, the food it is served with, etc. To taste wine is to conjugate patterns of salience—the capacity of aromas and textures to stand out from their background—regulated by sensitivity thresholds in human tasters that function as singularities, the operations of which are largely unavailable to consciousness.

Again, these are capacities that can be actualized under certain conditions and not others and differ from taster to taster, just as expert swimmers differ subtly in their sensitivity to the velocity and amplitude of waveforms. Thus, the singularities—fluctuating sensibility and memory thresholds—which characterize the taster's set of capacities mesh with the wine's capacities to effect tasters to form a field of mutually interacting dispositions. The aromas, flavors, and textures sensed will be actualizations of this meshwork of dispositional states. The wine will actualize specific chemesthetic responses in some tasters and not others. For experienced tasters, their knowledge of facts about wine, and their ability to apply holistically formed concepts and a wine vocabulary to the output of their sensory skills, are crucial elements in their aesthetic response. This is where the analogy with

swimming breaks down. Unless one is a swimming teacher, swimming does not require linguistic or conceptual skill.

The greater the capacities of the taster—the more extensive their thresholds for detecting aromas and flavors, the more responsive their memories are to what is sensed, and the wider their net of conceptualization—the more ability they have to taste and make intelligible a variety of wines with different dispositional properties. Learning to taste is a confrontation between the differences of which the wine molecules are capable and the differences the taster's sensory and cognitive capacities are capable of discerning.

Regarding the general picture of learning, wine tasting is similar to swimming. To learn is to be temporarily united with the surfaces about which we learn in a common space of affectivity—an encounter with signs. The dominant tendencies, potentialities, and dispositions of the taster's body are made manifest through subliminal micro-perceptions caused by the wine, as the body tries to discern the signs the wine makes available. They form a system of intersecting dispositions and potentials, only some of which are actualized when we successfully taste the wine. As with swimming, much of the learning takes place via micro-perceptions that operate below the level of consciousness.

For experts who have pursued an apprenticeship, their micro-perceptions acquire sensitivity to multiple thresholds and ranges of properties; they respond to broad tendencies in the wine with broad tendencies of their own. Thus, among wine experts, there is unlikely to be much agreement since everyone possesses at least some different dispositions. Just as there is no single right way to navigate a body of water, there is no single right account of what a wine tastes like. But this does not mean tasting is subjective. Every taster who can claim legitimacy for their judgments must meet certain thresholds and find common singularities in their sensibilities that mesh with the singularities of the wine's multiple dispositions and with the dispositions of other tasters. Wine tasting, too, is an attunement of the unique with the unique but an attunement that passes through

the shared singularities of human sensory mechanisms.

This detour through the metaphysics of learning demonstrates the inadequacy of our concepts of "subjective," "objective," and "intersubjective." These concepts do not adequately describe what I call "the meshwork" of mutually interacting dispositions that enable us to move about in the world. More importantly, we now have a handle on how to reconceptualize "objective" to mean "constrained by something not within our control." Learning requires that we conform to the contours of a reality that maintains a degree of independence from our mental states. However, under ordinary circumstances, neither swimming nor wine tasting pushes our faculties to their limits. Learning to swim or taste wine are examples of successful coping with the resistance of the world, both of which involve building habits within contexts that become increasingly familiar as we learn. We need to return to the question of how we cope when we are confronted with something that simply resists assimilation and our conventional habits fail. This is where this account of an apprenticeship of signs will earn its keep—in its ability to explain creativity.

Creative Wine Tasting: Tasting the New

Wine lovers are often preoccupied with how a wine reveals its origins. However, wines of sublimity reveal something new and unexpected—a dynamic process of differentiation that shifts our understanding of what that grape or region or winemaker can do. They reveal the hidden potential of the materials and the production process when affected by often unknown factors. Thus, I want to shift the focus of standard accounts of wine tasting. Most accounts of wine tasting are educational—they instruct tasters in how to conform to the norms of the wine community. I want to look at how wine tasting proceeds when the norms are unraveling or no longer give us a foothold on what we're tasting. The learning that interests me is not merely an acquisition of

skill but learning that requires a new way of understanding the world, or, for our purposes here, the wine world. To interpret signs is to overcome habitual ways of comprehending reality. What we typically think of as learning is often just the reinforcement of orthodoxy or conventional beliefs. But there is always more to an object than can be immediately experienced, and that "something more" offers opportunity—it is where the joy of aesthetic attention is most acute.

This search for "something more" begins with a disruptive event because only a disruptive event will motivate thought. Wine importer Terry Theise captures the experience; for ease of reference, I will quote the passage again:

> When a fragrance is evocative yet indistinct—when it doesn't specify its cognate (such as lemons or peaches or salami or whatever)—it seems to bypass the analytical faculty and go straight to your imagination and from there you climb about the fugue state directly to your soul....[36]

We tend to assimilate new experiences to a conventional understanding. Only disruption that resists that lure of a conventional understanding will motivate genuine thought. To learn in this situation of promise and peril is to experience the disorientation of something new, something that doesn't fit, something that makes no sense—a series of signs that must be interpreted to expose the differences they embody.

Wine tasting is sometimes an aesthetic experience that aims at aesthetic pleasure. However, part of that pleasure is the joy we take in what our bodies can do. The activity of the sensibility—the exploration of the world's surfaces—is inherently pleasurable, just as an athlete enjoys pushing her body to discover what it can do. We feel joy when we achieve mastery—when the previously obscure becomes intelligible. When confronted with flavors that do not fit our conventional categories, we seek to make the wine intelligible by expanding what we can taste or smell.

What concrete activities will put us on the road to intelligibility when confronted by a wine that does not fit? As wine tasters, we are surprised by anomalies, and we have an arsenal of thought experiments to help us understand what we are tasting. We can deploy more focused attention, memories of past anomalies and how they were resolved, and an understanding of how weather or winemaking processes might explain the anomaly. But all of that may fail when confronted with a wine that points toward uncharted paths and that remains unintelligible. At this point, creativity and imagination are needed. We must drop our assumptions, unlearn what we had thought was well established, and embrace experimentation.[37]

An anomalous wine is not just an organized collection of aromas and textures; it is also a problematic field requiring a new reconciliation. We experiment by tasting and comparing more wines to try to understand how the new tendencies make certain flavor profiles more or less significant, looking for signs of a shift in aesthetic value. We engage the imagination to try to find new ways of tapping into how these relationships of significance are being reorganized. Most importantly, we test any new conclusions we come to against more tasting experiences. The recent interest in minerality among wine tasters and writers is an example of how new ways of conceptualizing flavor emerge. Forget, experiment, test, rinse, and repeat—this is an apprenticeship of signs.

When we engage in this apprenticeship, we are still functioning as the swimmer did as she learned to navigate unfamiliar waters. We are still focused on the wine and what it can do, but thought is engaged as we map the differences we detect across tasting experiences and trace how our sense of what is significant is being affected. Creativity in tasting requires that we place the dispositions of things and the dispositions of thought on the same plane in a continuous, variable encounter as we seek signs of variations, new relations, and break points that indicate new potential. Thought, in this case, is not a deduction or an inference, as is the case in standard blind-tasting

decision trees. Instead, thought requires sensitivity to trajectories and inflection points where some new quality emerges that traces how differences affect our sense of what is significant. In learning to taste the new, there is a necessary element of reflection. Reflection allows experience to slow down so we can hold these differences in mind, compare them, and assess their impact and significance. In the end, the test of whether we are getting something right is whether some particular arrangement can be tasted and made intelligible through articulation.

At this point, the process seems irredeemably subjective. We are no longer entirely focused on the wine but also on our responses to it. I taste the wine from my own perspective, which is, after all, the only access I have to the wine. Yet the whole process is still enabled by the meshwork of my dispositions and tendencies entangled with the dispositions and tendencies of the wine. The meshwork of dispositions and degrees of freedom do not disappear when we move on to more cognitive activities. In the face of the unintelligible, the mind must create, but in doing so it is still intrinsically tied to the dispositions of the object via its own dispositions.

Despite the dependence on our unique perspectives, we are still engaged with something outside our control. An individual taster is connected to the capacities and dispositions of the wines they taste, which are continuously in flux, not only because of further tasting experiments but because others are tasting and commenting on the wines as well. We taste as members of a community, not as isolated flavor detectors. The wine world is an open field of continuous variation, not a closed world strictly regulated by norms. The exceptional points of the wines we experiment with, and our concept of them, will be assigned different degrees of being related or unrelated by different tasters. This complexity is like the sea that embeds and enfolds the swimmer. What an individual can do depends on context, what she is connected to, and the elements of the experiment, which include not only the physical properties of the wines but the language and discourse that surround them.

Thus, in wine tasting, we are open to something beyond the individual: the limitless circumstances that frame our activity. Yet how we are influenced by context is neither within our control nor traceable as an item of knowledge. Such tasting with an eye on difference, the exceptions, and the forces that generate them is not a matter of emphasizing or de-emphasizing elements within standard accounts of wine tasting. It is a series of experiments that involve a continuous shift in the relationships and capacities of what we're tasting that, in turn, shapes and re-shapes our own sensibilities through novel association. Try red wine with fish, compare Chianti with Texas sangiovese, make Baco noir that's seventeen percent alcohol, study the new cold-hardy grapes coming out of the University of Minnesota or the heritage varietals reborn by Miguel Torres in Spain or Vox Vineyards in Kansas City. In making creative associations, we are open to a world of unstable, fluctuating potential.

Objectivity Revisited

Although this experimentation seems wild and open-ended, there are better and worse ways of doing this. Learning cannot be reduced to a formula, but in the end it must produce intelligibility, not scattershot impressions. How do we protect this process from undue subjectivity? That is the key question as we try to answer the problems raised by the limitations of traditions and conventions discussed earlier in this chapter.

Each tasting experiment is a test that can reveal the first sign of mutation from any current representation. However, the integrity of this learning process is protected as long as the apprentice refuses to settle on a new representation that would then be presented as the truth. More wines must be encountered as we experiment with a provisional representation and begin to discern common singularities. But we must always challenge any attempt to settle on a

generalization while looking for the anomalous, the unexpected, and the unpredictable. This apprenticeship is a process of mapping the tensions between various taste profiles, alert to the moments when one's experience calls into question what was previously established. There is always more—the relational nature of capacities means the potential for new experience is continuous. This openness to new sensations is a constraint on thought, which is not unlike the skeptical attitude and openness to new evidence that is essential in science.

The two most important factors in maintaining an openness to new experiences may come as a surprise in the context of wine appreciation and evaluation, but they are essential. We must strive, as much as possible, to suspend pleasure responses and reserve judgment. Our pleasure responses are reinforced by habit. Familiarity and comfort are part of what we find pleasurable in an experience, and they exert inexorable influence on how much pleasure we feel. This is not to say new experiences cannot be pleasurable; rather, it is to say that only those new experiences that seem consistent and related to familiar experiences will have an unambiguous positive charge. When faced with something radically new and unintelligible, our ability to experience pleasure will be inhibited. Thus, we should ignore the question of whether we like a wine or not until it begins to make sense to us. Of course, we love wine because it gives us aesthetic pleasure. However, if our goal is learning, we must bracket our immediate responses—whether pleasurable or painful—until we've gained enough familiarity to use pleasure as a reliable indicator of quality. Our capacities for pleasure must be educated as well—instantaneous responses are not a good indicator of what we might find pleasurable after further exploration. As noted above, I doubt that we can separate our judgments from our preferences. It thus becomes essential that we are not railroaded by those preferences.

Similarly, the tendency to make a judgment prior to the wine achieving intelligibility also inhibits our ability to appreciate it. Judgment requires categories, criteria, and general concepts that can

be applied across many examples. But in the absence of intelligibility, we lack stable criteria or categories. Learning about the new cannot operate through judgment, because we are working with something that has already escaped capture by our categories. A judgment in such a case reflects prejudice only. Wine criticism, of course, requires judgment. My argument is not that we should avoid judgment—only that we should reserve it to allow learning and appreciation to take place first.[38]

We cannot avoid seeing or tasting the world through our own outlook, which will be different from the outlook of others. The key to learning is to work through that subjectivity while avoiding anything that might inhibit making further connections in order to fully engage, as much as possible, the meshwork—the dispositions and capacities waiting to be unlocked in the wines we taste. When we bracket pleasure, categorization, and judgment, we relinquish control and allow our own dispositions the freedom to unfold with the trajectories of the wines we are tasting. Like any object, a wine is not just a set of properties but a set of capacities to be manifested—a limitless field far beyond the tasting capacities of an individual. Striving for objectivity is striving to uncover as much of that field as possible. An objective judgment is the outcome of that process.[39]

In the end, we will make judgments and we will find something pleasurable or not. What matters for objectivity is whether those judgments and responses are imprinted with a process of learning that avoids mere prejudice and employs the critical virtues of suspended judgment and pleasure agnosticism. We cannot remain in this condition of a suspended self but tracing these newly discovered patterns of salience and significance gives us a re-ordered conception of the wine world. After a process of learning, our conception of a wine is no longer cut off from the wider dispositions of that wine.[40]

Collections of objects, including wines and tasters, form relations of greater and lesser distinctness and obscurity depending on their relations. The capacities of an object shift depending on how it is

used and the circumstances in which we engage with it. This is true of aesthetic objects such as wine as well. Thus, it is misleading to say we exist in separate taste worlds because "world" suggests something closed and unavailable. Aesthetic value is not relative to a perspective. Perspectives give us access to a field of continuous variation from which aesthetic value may emerge through an apprenticeship. Because we taste as part of a tasting community, agreed-upon standards are influential but not determinative. Each individual brings a different set of dispositions to the table and will experience different patterns of salience. Similar sensations can occur in multiple individuals. The sensations of individuals may or may not be shared, but they are not, in principle, inaccessible. They do not form a bounded world. Thus, there is no justification for asserting that judgments are relative to one's tasting community; there is ultimately no fixed domain that supplies criteria for judgment aside from the practical categories we use to orient beginners in the world of wine.

When articulated, my sensations and their significance will have an expressive impact on other individuals. In turn, their sensations, when articulated, will have an expressive impact on me. The relationship we share with other tasters is a matter of what each can provoke in the other regarding the dimensions and significance of a wine. We neither exist in separate worlds nor share the "worlds" of others. Instead, we participate in the interferences and crosscurrents of different dynamic processes that are available to us through a learning process. This encounter with the taste sensibilities of others makes my world stranger and more intense, not more comfortable. By articulating what enlivens your sensibility, you prompt others to express what is significant to them. It is mutual inspiration, not agreement on tasting norms, that enables the functioning of the tasting community.

Regarding objectivity, the central point is that what survives this process of experimentation, apprenticeship, and articulation has some independent claim on our endorsement. The process of an apprenticeship of signs is evidence that we confront resistance from

what is not in our control. By learning to cope with that resistance, we uncover real capacities and dispositions in ourselves and the wines we taste. As communicators or educators, we cannot teach this; we can only induce an encounter with the new by emitting signs of exceptions or anomalies, posing problems, and encouraging apprenticeships. Creative tasting is an enhancement of our capacity to sense and feel through which we learn what an object can do and what we can do. Such a picture of our relatedness to the world better fits the changing world of wine than the staid traditions we've learned from the wine books. Although useful in some contexts, blind tasting is not particularly helpful in this process because, to identify trajectories of change and significance, we have to know the elements we're dealing with—knowledge of the varietal, the region, and the producer affect how we discover the significance of the new. Without this knowledge, there is no way to attach the wine to a newly developing pattern.

Objectivity, as I am using the term, is about the constraints placed on us by the exposure to differences that lie just beyond the reach of the concepts of which our subjectivity is comprised. Our sensibility must adapt to those differences; they do not adapt to us. The constraints on thought are not exclusively conversational or logical constraints. We are constrained by an involuntary process of learning provoked by a recalcitrant experience that forces us to take up a problem. The involuntary nature of this apprenticeship is key. The openness to something beyond our ken arrests the spinning in the conceptual void that non-realism foists upon us.

Subjects and objects are a provisional stage within the unfolding of the forces of nature and culture. These forces are greater than any person or group of people and less stable than what we typically think of as an "object." Subjects and objects merge within a plane of potential where each thing, living or non-living, is formed by events beyond it—there is always more than meets the eye or the "mind's eye." The personal is overcome by the impersonal; the individual becomes a node in a network of transformation beyond any individual's

control. The object collapses into a swarm of differences that serve as a "foothold" for change. Consciousness merges with developing matter as it learns to "swim," as the swimmer learned to navigate the sea. Whatever the solution turns out to be, it will only be a solution until the next shock to thought.

We strive for objectivity because we wish to anchor our judgments in something stable that can resolve disagreements between competing points of view. As discussed above, there are a variety of objective elements in wine that we can identify and confirm through science or rigorous tasting. If we are willing to hold fixed the traditional conceptual categories for organizing wine, we can give an account of reliable expertise that explains what we might call a mainstream consensus on general quality indicators. My aim has not been to denigrate that expertise. Expertise is to be admired and celebrated and is, in fact, the foundation for a genuine apprenticeship. We cannot taste the new as new without mastering what it is replacing. But what I've attempted to show is that there is more to the wine world than can be admitted within that conceptual model. We need a different conception of objectivity to capture the kind of expertise that can identify and articulate that "something more."

This issue of objectivity is about the judgments we make about wine. But wine appreciation is not primarily about judgment. Except in professional contexts where evaluation is essential, what matters more are not the judgments we make but the experiences of which we are capable. In the end, aesthetic practice is not well served by this preoccupation with judgment. In the final chapter, I will turn to the question of beauty, a concept notoriously resistant to judgment.

Inspirations:

Some wines repay patience and forbearance, a refusal to judge them until their charms come into view. Sagrantino, the signature grape from Italy's Montefalco region, is one example. Mouth ripping tannins are an obstacle even when the wine has aged for several years. After two weeks in Montefalco, I became a believer but only when I'm in the mood and with the right food.

On a visit to Oregon's Elkton AVA, we stopped at Bradley Vineyards, a small farmhouse winery offering Baco Noir. Baco Noir is a hybrid grape and usually not impressive. I was even more skeptical when I looked at the bottle—16.9 % alcohol. Yikes! In a cool climate. What are they thinking? It turned out to be a wonderful imitation of Amarone if you can't afford the real thing. Searing acidity kept the sumptuous fruit in balance, and the alcohol creates a very active wine. The rush to judgment does not serve us well.

Notes

1 The most often cited study casting doubt on the objectivity of wine tasting is from research carried out in 2001 by Frédéric Brochet and his team. Brochet asked a panel of wine experts to describe two glasses of wine—one white and the other red. In fact, the two wines were identical except the "red" wine had been dyed with food coloring. None of the members of the panel identified the dyed wine as white, and all used red wine descriptors in describing what was, in fact, a white wine. Gil Morot, Frédéric Brochet, and Denis Dubourdieu, "The Color of Odors" in *Brain and Language*, 79 (2001), 309-320. Another often cited study published as a working paper by the Journal of Wine Economics tested non-expert wine tasters in their preferences for inexpensive vs. expensive wines when tasted blind. The study found no correlation between price and enjoyment, suggesting that recommendations by experts are unreliable guides for non-experts. Robin Goldstein, Johan Almenberg, et al, "Do More Expensive Wines Taste Better? Evidence from a Large Sample of Blind Tastings," *Journal of Wine Economics* 3, no. 1 (Spring 2008), 1-9.

2 For a thorough discussion of the problems with the aforementioned study by

Morot, Brochet, and Dubourdieu see Douglas Burnham and Ole Skilleås, *The Aesthetics of Wine* (New Jersey: John Wiley and Sons, 2012), 64-69. A similar account is also provided in Burham and Skilleås, "Patterns of Attention: "Project" and the Phenomenology of Aesthetic Perception" in "Wineworld: New Essays on Wine, Taste, Philosophy and Aesthetics," ed. Nicola Perullo, special issue, Rivista di Estetica 51 (2012), secs. 1-9. It is worth noting that tasters in the study by Morot et al based their descriptions on aroma only. They did not taste the wines. Burnham and Skilleås report further empirical evidence, including their own study, showing that visual clues overrule taste and smell cues only when tasters are deliberately deceived. The expert tasters in Morot et al ruled out red wine descriptors because their attention was directed away from them by the deception. Tasting under deceptive conditions tells us little about tasting when no deception is involved. As to the preference of non-experts for cheap wine, such a preference is neither surprising nor remarkable. Surely the fact that most readers prefer Danielle Steele to James Joyce tells us nothing about the reliability of literary criticism. Fine wines have a variety of features that may be inaccessible to non-experts.

3 I discuss the threat of personal biases such as financial incentives or personal relationships in wine evaluation in Chapter Six.

4 I use the term non-realism to refer to several related positions—anti-realism, quasi-realism, which understands aesthetic properties as projections of subjective states, and theories such as phenomenology that decline to take a position on the ontology of perceptual objects or properties.

5 Smith's wide-ranging defense of the objectivity of wine tasting is distributed throughout several articles. His basic case for realism is delivered in Barry C. Smith, "The Objectivity of Tastes and Tasting" in *Questions of Taste: The Philosophy of Wine*, ed. Barry C. Smith (Oxford: Oxford University Press, 2007). See also Barry C. Smith, "Beyond Liking: The True Taste of a Wine" in *The World of Fine Wine*, Issue 58 (2017).

6 Smith makes an important distinction between intrinsic and extrinsic properties. "Fragrant" is an intrinsic property of the wine because the wine is literally fragrant. However, properties such as "tar" or "roses" are extrinsic properties because they are likenesses. The wine is not literally a rose, but it smells like roses. It is via the extrinsic property "like roses" that we gain access to what is there in the wine. See Smith, "The Objectivity of Tastes and Tasting," 58.

7 In Smith's 2007 essay, the natural way to read what he means by an independent object is the wine itself and the chemical constituents that make up the wine. However, in an interview published by Jamie Goode on his blog, Smith has a different characterization of that independent object. Smith reports: "What I say is, you need an intermediate level. We need a level in

between the chemistry and the variable perceptions, and this is flavour. Flavours are emergent properties: they depend on but are not reducible to the chemistry. Then these flavours are things which our varying and variable perceptions try to latch onto. Each flavour perception is a snapshot of that flavour. We don't even want to think of it as static: we want to think of a flavour profile: something which itself evolves and changes over time. As a professional taster you are taking snapshots in each of your tastings and trying to figure out what the flavour properties of that wine are that will continue to endure and alter as the wine ages." It is not obvious to me what the ontology of this intermediate object is on Smith's view. I agree that flavor is an emergent property. I understand emergent properties in terms of linked dispositions between tasters and the wine chemistry. Thus, it seems to me Smith's realism requires something like the dispositional analysis I provide below. See Jamie Goode, "The Barry Smith Interview," *The Wine Anorak* (blog), October 29, 2015. https://www.wineanorak.com/wineblog/wine-science/the-barry-smith-interview-what-is-the-nature-of-wine-perception-and-is-wine-flavour-objective

8 Jamie Goode makes a similar argument about the difficulty of separating style preferences and one's judgment about quality in fine wines. Jamie Goode, *I Taste Red: The Science of Tasting Wine* (Berkeley: University of California Press, 2016), 210-212.

9 Cain Todd, *The Philosophy of Wine: A Case of Truth, Beauty, and Intoxication* (Montreal: McGill-Queens University Press, 2010), 99.

10 Wilfred Sellers, "Empiricism and the Philosophy of Mind" in *Minnesota Studies in the Philosophy of Science*, eds. H. Feigl & M. Scriven, vol. I (Minneapolis, MN: University of Minnesota Press, 1956), 253–329.

11 This issue was raised by the 18th Century empiricist David Hume whose essay "On the Standard of Taste" remains the launching pad for contemporary discussions about objectivity in aesthetics in general and wine in particular. Hume is usually interpreted as advancing an ideal observer theory. David Hume, *The Philosophical Works of David Hume*, eds. T. H. Green and T. H. Grose. Vol. 3 (London: Longman, Green, 1875).

12 Cain Todd, *The Philosophy of Wine*. In earlier work, Todd defends a quasi-realist conception of aesthetic properties in which aesthetic properties are projections of subjective states. See Cain Todd, "Quasi-realism, Acquaintance, and the Normative Claims of Aesthetic Judgement" in *British Journal of Aesthetics*, vol. 44 (3) (2004), 277-296.

13 Todd, *The Philosophy of Wine*, 131.

14 Todd, *The Philosophy of Wine*, 114.

15 The phrase "wine royalty" is my way of putting this point; Burham and Skilleås do not use it.

16 Burham and Skilleås, *The Aesthetics of Wine*, 206.

17 Burnham and Skilleås, *The Aesthetics of Wine*, 206.

18 See Chapter Four for more discussion of this point.

19 Todd's relativist view is compatible with the existence of such disagreement, but these disagreements reduce the scope of the objectivity he wishes to defend.

20 Alfred North Whitehead, *Process and Reality* (New York: Free Press, 2nd edition, 1979), 156.

21 The seminal work in a metaphysics of powers is George Molnar, *Powers: A Study in Metaphysics* (Oxford: Clarendon Press, revised edition, 2007). See also Stephen Mumford and Rani Lill Anjum, *Getting Causes from Powers* (Oxford: Oxford University Press, 2011). Both are works about metaphysics, not aesthetics. My aim is to sketch the implications of this metaphysical view for aesthetics.

22 The literature on dispositional analyses of aesthetic properties is limited. To my knowledge, the most comprehensive treatment is a dissertation by Elizabeth Compton. I have benefited greatly from her analysis. Elizabeth Ashley Zeron Compton, "A Dispositional Account of Aesthetic Properties," Ph.D. dissertation, State University of New York at Buffalo (2012). https://fdocuments.us/document/elizabeth-zeron-compton-a-dispositional-account-of-aesthetic-properties.html

23 At this point, I can address one of the perennial philosophical questions associated with realism. On my account, aesthetic properties supervene on basic perceptual and structural properties of wine. Aromas, tastes, and mouthfeel characteristics, and their motion summarized in terms of vitality forms are the underlying supervenience base for aesthetic properties. But the aesthetic properties are not reducible to them and are thus emergent. If the aesthetic properties were reducible, we could eliminate them from our ontology, and my view would no longer be aesthetic realism. The holism I advocate depends on the non-reducibility thesis; and holism seems justified. We experience aromas, flavors, and textures as a unity, not as a disjunctive list of chemical compounds, individuated aromas, or naked textures. Traditionally, supervenience is cashed out as "no change in aesthetic properties without a change in non-aesthetic properties." On my view, manifestation conditions, especially related to attention, influence which aesthetic properties are perceived given the available non-aesthetic properties. In order to sustain this definition of supervenience, manifestation conditions are included in the non-aesthetic supervenience base.

24 It is worth spelling out the relationship between metaphors, aesthetic concepts, and dispositions. Our concepts of aesthetic properties depend

on our responses to them. Concepts are mind-dependent and response-dependent. But the existence of the aesthetic property is neither. The property of elegance exists in the wine even when the bottle is unopened as a disposition to generate elegance under the appropriate manifestation conditions. The aesthetic property "elegance," when applied to a particular wine, will get its identity, in part, from how we conceptualize it and from the manifestation event through which we have access to the wine. But its identity is also influenced by the manifestation type towards which the disposition is directed. To the extent the proper manifestation conditions are in place, the causal and dispositional properties of the wine contribute to that conceptualization. I have argued that imaginative metaphors are necessary in order to conceptualize what we're tasting. Metaphors are manifestation events and thus are response-dependent. However, to the extent the causal properties of the wine contribute to the formation of metaphor, the existence of the property manifested by the metaphor is not response-dependent.

25 Ophelia Deroy finds the notions of powers and dispositions useful in reconciling subjective and objective dimensions of wine tasting. However, she focuses on quality as the "power to bring about a consensus." I place less emphasis on consensus. Powers and dispositions enable us to talk about objectivity despite the lack of a firm consensus. See Ophelia Deroy, "The Power of Tastes—Reconciling Science and Subjectivity" in Barry C. Smith, *Questions of Taste*, 99-126.

26 This example is from Compton, "A Dispositional Account of Aesthetic Properties," 121.

27 Barry C. Smith, *Questions of Taste*, 67.

28 According to my understanding of dispositions, we perceive dispositions or powers in objects via manifestation events. In the literature on dispositions, the main objection to this is that perceptual properties revealed in manifestation events do not look like dispositions. They look like static, presently occurring qualities rather than a power. The color red looks red; it does not look like a power to cause red or a tendency to appear red. I reject this premise. My argument is that manifestation events do look like dispositions in one respect. They reveal directedness, which is an essential property of a disposition. Manifestation events are almost never single, spontaneous, individualized perceptions. As I argued in chapter 7, aesthetic attention is dispersed over a variety of properties, involving sequences of eye movements for visual experience, temporally distributed hearings for audition, or temporally distributed patterns of flavor impressions for taste and aroma. Furthermore, any revelation of an aesthetic property will be incomplete because the nature of the experience will depend on a variety of similarity and dissimilarity relations to paradigm aesthetic appearances our apprehension of which also are likely to unfold over time. These patterns are experienced as a

trajectory culminating in our apprehension of a property. Thus, manifestation events occur in patterns with a trajectory which reveals the directedness of the underlying disposition. The disposition qua disposition is revealed via the manifestation. Manifestation events are thus explorations of underlying dispositions. For an articulation of this objection to dispositions, see Paul A. Boghossian and David J. Velleman, "Colour as a Secondary Quality," *Mind*, vol 98 (1989), 85.

29 Jamie Goode also points to changes in individual tastes as well as contextual influences and changing cultural norms in expressing skepticism about the notion of an ideal wine critic. However, he moves too quickly from the claim that individuals taste differently, an epistemological claim, to the apparently ontological claim that we live in different tastes worlds or that "reality as we experience it is something we create ourselves." See Jamie Goode, *I Taste Red: The Science of Tasting Wine*, 207-213.

30 This is why wine tasters tend to be inconsistent in their judgments over time. Wine changes and so do we as tasters. Physiological, psychological, and contextual change make it unlikely that we should find consistency in tasting over time.

31 I rely here on my understanding of Deleuze's account of this conflict between faculties in *Difference and Repetition*, Chapter III, "The Image of Thought." Gilles Deleuze, Difference and Repetition (New York: Columbia University Press 1994). The application of these ideas to the context of wine tasting is my own.

32 See Chapter 7 for a discussion of Terry Theise and the sublime.

33 The relationship between Deleuze's thought and the idea of objectivity as a confrontation with something not in our control is a central theme in Sean Bowden's essay, "Deleuze's Antirepresentationalism: Problematic Ideas, Experience, and Objectivity" in Bowden, Bignall, and Patton (eds.) *Deleuze and Pragmatism* (New York: Routledge, 2015). My analysis here relies, in part, on Bowden's understanding of Deleuze.

34 Deleuze never develops a comprehensive theory of learning. In the first chapter of *Difference and Repetition*, Deleuze uses the example of learning to swim to illustrate how difference and repetition intersect. From this example and others scattered throughout the corpus, a literature on Deleuze and learning has developed. My discussion in this chapter has benefited especially from Ronald Bogue, "The Master Apprentice" in Inna Semetsky (ed.) *Deleuze and Education* (Edinburgh: Edinburgh University Press, 2013), 21-36. See Deleuze, *Difference and Repetition*, 22-23.

35 Deleuze, *Difference and Repetition*, 165.

36 Theise, location 1025

37 This is another point at which I diverge from the way Burnham and Skilleås articulate their notion of an aesthetic project. One of the functions of a "project" is to regulate "salience filters." We look for various features of a wine, depending on what our project is. To the extent the aesthetic project requires the development of salience filters defined in terms of conventional categories, it isn't obvious such a project is equipped to, as they write, "lead us to new intentional objects and new expectations," especially if top down filters regulate bottom up cognition. Discerning the new may require a distinctly different project. See Burnham and Skilleås, "Patterns of Attention," sec. 31.

38 The limits of judgment as the aim of wine tasting will be addressed in the next chapter.

39 An apprentice is not an ideal observer. A judgment is not correct because it is what an ideal apprentice would endorse. The primary goal of an apprentice is discovery, not correct judgment. Since there is not one way a wine must be, correctness is always open-ended and provisional. The goal of an apprentice is credibility, not correctness as a completed task. Thus, what matters is that the apprentice's judgments are based on the possession of epistemic virtues that establish credibility, the most important being responsibility not only toward other members of the wine community but responsibility toward the wine and its dispositions.

40 The relationship of these critical virtues to Kant's notion of disinterestedness will be addressed in Chapter 10.

CHAPTER TEN

BEAUTY, PATHOS, AND RHYTHM

"The beauty of the world...has two edges, one of laughter, one of anguish, cutting the heart asunder."

— Virginia Woolf

In discourse about wine, we do not have a term that both denotes the highest quality level and describes the aesthetic qualities that such wines possess. We often call wines "great." But "great" refers to impact, not to the intrinsic qualities of the wine. Great wines are great because they are prestigious or highly successful—Screaming Eagle, Sassicaia, Chateau Margaux, Penfolds Grange, etc.—but "great" does not tell us what quality or qualities the wine exhibits in virtue of which they deserve their greatness. Sometimes the word "great" is just one among many generic terms—delicious, extraordinary, gorgeous, superb—we use to designate a wine that is really, really good. But these are vacuous, interchangeable, and largely uninformative.

It is a peculiarity of the wine community that when designating the highest quality, we sometimes refer to a score assigned by a critic.

But that tells us how much that critic liked the wine in comparison to similar wines. It does not tell us why this wine deserves such a rating. We have criteria to judge wine quality, such as complexity, intensity, balance, and focus. But these refer to various dimensions of a wine, not an overall judgment of quality.

Although most wines provide pleasure, some wines are not merely pleasurable. They stand out from the ordinary and have a special claim on our attention. We need a way of describing the depth and meaning of that experience. In the history of aesthetics, "beauty" has filled this role as an indicator of remarkable aesthetic quality. It is less frequently used today than in centuries past because many works of modern and contemporary art do not aim at aesthetic pleasure. After the disruptions of twentieth-century art, it seems most people in the art world are disillusioned by beauty, as if it were a fusty old term genuflecting toward conventions left behind, something false or inflated that no longer interests reflective people. However, since aesthetic pleasure plays a central role in wine aesthetics, the travails of modern art need not deter us from using the term "beautiful" to describe wine of the highest quality, if the term's usefulness can be specified. No doubt, in ordinary conversation the term "beauty" has become as generic as "delicious" or "superb" and is often too narrowly associated with feminine appearance. Nevertheless, in serious discussions of wine quality, there is some utility in resurrecting "beauty" for our purposes because I think we can learn something about wine quality by connecting it to the long history of debate about the nature of beauty.

The logic of the concept of beauty is peculiar.[1] Identifying beauty is not like recognizing that the flower is yellow, or the wine is full-bodied. Beauty is not an ordinary property that we simply and reliably perceive. Furthermore, there is no straightforward way of demonstrating "this pinot noir is beautiful" to someone who, thoughtfully and in full awareness, disagrees. No gathering of evidence will suffice. The judgment that something is beautiful is not an

inductive generalization based on evidence. Neither is it a report about whether one prefers or likes an object. To call a Puligny-Montrachet beautiful is not equivalent to asserting "I like Puligny-Montrachet," which would be an unremarkable and entirely subjective claim. I am the most reliable authority on my preferences. However, in calling an object beautiful, I call attention to the object itself and its qualities, not my preferences alone. In philosophical discussions, one of the most persistent claims about beauty is that judgments of beauty invite others to see what we see (or taste what we taste), with the expectation that they might also share the experience.

Thus, judgments about beauty seem to occupy a logical space perched tenuously between objectivity and subjectivity. To say something is beautiful invites a demand for evidence and argument that would not be demanded of a claim such as "I like chardonnay." Yet, because there is no way of certifying claims about beauty by gathering empirical evidence, there is plenty of room for a skeptic to doubt there is such logical space. The skeptic about beauty might well argue we do not need the term to describe our experience. Talking about how much pleasure we get from an experience suffices in most contexts to communicate something about that experience. "I really enjoyed this sensual pinot noir" conveys our judgment of the wine without inviting argument or the expectation that others should enjoy it as well. What does the idea of beauty add?

Thus, to justify invoking the concept of beauty to convey something important about the aesthetic experience of wine, we need to identify the need it fulfills, especially because the claim seems to be making demands on others. Of course, we would rightly think someone was crass or simply nuts if they claim to care nothing for beauty. On what grounds would someone legitimately claim to be indifferent about it? Yet, it is a peculiarity of beauty that we are supposed to care deeply about it, but no one can say quite what it is. We can point to examples of beauty, but when forced to say what all the examples have in common, we come up empty, thus reinforcing the skeptical belief that we are just referring to ordinary pleasure.

However, there is reason to think that beauty is not only about pleasure. When I am enjoying a glass of wine with dinner, no one can coherently question whether I'm having a pleasurable experience, if indeed I am. This is not something I can be mistaken about. I could not coherently say, "I thought this wine gave me great pleasure this evening, but it turns out I was mistaken. That wasn't pleasure at all." But such a claim is not absurd with regard to beauty. It is perfectly coherent to say, "I thought that was beautiful, but, upon further scrutiny, I think I was wrong." This suggests that there is something more than just pleasure that beauty captures. Beauty is something that investigation or thought can discover or reject. Thus, it seems the skeptic is wrong that beauty is just an expression of subjective preference. But we still must uncover what the idea of beauty can add to a discussion about wine quality.

Mystery, Ephemerality, and Pathos

The stories we have told about beauty through the ages give us some clues about what the idea of beauty might add to our concept of wine quality. One of the more persistent themes associated with beauty, beginning with Plato and continuing into the present day with thinkers such as Alexander Nehamas, is that beauty is connected to mystery.[2] The occult light tripping across a Turrell installation, the pulsating color fields of Rothko, the strange cadences of Messiaen's unraveling of bird song—in each case, beauty emerges from the sensory surface only to then refer to something beyond what we can experience in the moment as if the object is withholding something from us. We often describe beautiful objects as enthralling or captivating, as if there were something active in the object to which the perceiver must respond with curiosity, something emerging but only dimly perceived.

As noted in Chapter One, wine, too, has this aura of mystery about it. The taste of something unusual intrigues, provoking the

suspicion that there is more here than is apparent, a potential not yet fully realized. The phenomenology of the experience of beauty suggests this is on the right track. When experiencing beauty, we feel drawn to the object. We engage the object with rapt attention because it seems to call us to further sensory exploration. This anticipation of something more, this sensing of a surfeit of potential, means we have succumbed to an object's enigma. It is characteristic of our highest experiences with wine that the need for further exploration is more like compulsion than enjoyment. Complexity that cannot be grasped all at once gives us an intuitive sense of the wine as pregnant with possibility.

Wine is a vague object with features difficult to detect, and wine and wine grapes are subject to variations that continually surprise both tasters and winemakers. This unpredictability and constant variation, in part, explains why people are devoted to wine. A wine that has the complexity, surprise, and originality to arrest our attention, that can hold us captive waiting for its next move, and that exudes paradoxical features, has this aura of mystery about it. Most of the world's celebrated wines have it, although finding mystery in a wine need not cost a fortune. You might well find it at that small winery across town. Thus, if mystery is in part what constitutes beauty, then, according to this standard, some wines qualify as beautiful. The term "beauty" identifies a quality that makes a wine distinctive. However, there must be more to beauty than mystery, or we could simply designate mystery as the relevant property. Obviously, some things are mysterious yet not beautiful.

Another feature of beauty that has a long history of discussion is its relationship to change and mortality. Beauty is often characterized as ephemeral—fleeting, inevitably fading, and ultimately damaged by the passage of time. Unlike ordinary pleasures, the pleasure of beauty's ephemerality is especially moving because something beautiful is unique and thus irreplaceable.

Wine is nothing if not ephemeral. "Ephemeral" comes from the ancient Greek word "ephemeros," which meant lasting only a day. Wine literally lasts only a day once the bottle is open unless you take special steps to protect it from oxygen. Unfortunately, for most casual wine consumers, ephemerality means little. But for wine lovers, ephemerality may be the most important feature of a wine's aesthetic appeal. Once the wine is in the glass, aromas come and go. Some last only a few seconds, others appear then disappear only to reappear after several minutes. Some wines change profoundly over the course of an evening. A wine from a particular vintage will change as it ages in the bottle, giving connoisseurs who purchase a case an opportunity to observe those changes as they open each bottle. The tracking of a wine's ephemera over an evening or a decade is one of the real joys of appreciating wine. Yet, this is an experience wholly lacking in a wine critic's preparation of the typical tasting note, which involves a few seconds of sniffing and spitting before moving on to the next wine.

The ephemerality of wine makes sharing it especially poignant. Knowing we have only a few hours to drink a bottle, we devote special attention to how we will share the wine and with whom. The fact that its time is short makes our experience of the wine more vital. Even if you have squirreled away another bottle, there is no guarantee you can have that experience again since each bottle ages differently. When drinking an aged wine, the experience you are having is singular. It is likely the only time you will have that precise experience. That is surely an occasion worth savoring.

The poignancy of fading beauty and its connection to mortality acquires exquisite intensity through a wine's ageing process. The ageing of a wine is, in some respects, like the ageing of a living organism. As we age, life becomes a struggle to invent sub-optimal norms of health and vitality, a defensive struggle to maintain integrity in the face of sickness, injury, and decline.[3] Ageing organisms extract elements from the environment and modify them as needed to maintain equilibrium. However, a return to health will always be partial, incomplete, and

ultimately a failure. The purpose of life is to keep going. Yet, that persistence is fraught with wandering irresolution and contingent environmental exchange, with the outcome always in doubt.

Wine, too, "invents" sub-optimal norms. All wine, as it begins to age in the bottle, loses some of its original flavor components. It will never taste young and fresh, and, as the years go by, its original flavor becomes more distant, never to be tasted again as each bottle takes on its own character and develops unpredictably. As the wine suffers diminishment from the gradual exposure to oxygen, the sub-optimal norm each wine settles on is a matter of negotiation with the environment. The winemaker is a physician, not by healing the sick, but by encouraging the modification of the internal structure of a wine so it will persist and reveal the effects of its normative diminishment.[4] The intimation of that inner strength, diminishing but still expressive, resistance at a different normative level, is aesthetically appealing. The fading of strength and power introduces new perspectives, a weakening that reveals nuance and finesse but also a sense of the beauty of vulnerability, of time passing inexorably and without recovery. The aesthetic appeal of this vulnerability to time is, of course, not limited to wine. We feel something similar as autumn brings summer to a close. The Japanese tradition of *wabi-sabi* has made imperfection and vulnerability to time an aesthetic touchstone. Unlike life, however, wine has a determinate purpose—to provide an aesthetic experience. But how it realizes that purpose is as wandering and indeterminate as life is. And, of course, both wine and life ultimately fail in the invention of sub-optimal norms.

It is common practice among wine lovers to purchase a wine from the vintage of a child's birth year—a commemoration of a singular event. However, although the wine is in part a product of the growing conditions from that vintage, it is also a product of the ageing process. Twenty or thirty years after vintage, when the wine is opened, its taste is much more an allusion to a process of development and decay. It is time passing that is revealed, not a singular moment in the past.

Drinking aged wines is not about nostalgia for a past moment but an appreciation of lost time, a celebration of decline, for what is revealed is the result of oxygen, the polymerization of anthocyanins, aroma esters collapsing and reforming, and color molecules becoming sediment. The cumulative result of these changes is an individual wine no longer firmly linked to its origins.

However, we experience none of those changes. A bottle from a past vintage alludes to the utter recalcitrance of the past, a past never to be retrieved. Wine is a metaphor not just for what is forgotten, but what has never been remembered, time irretrievably lost and available only as a sensation of flavor and texture. We have no idea what happened in that bottle over the intervening years. It sat mutely in the cellar for decades, never revealing its narrative, locked away in glass, giving away almost nothing to our awareness. Only when it is opened does it reveal itself as flavor and texture, a summation of effects, but never as memory. Unlike family heirlooms and other treasured objects that we pass down through generations, all wine is destined to be utterly and completely lost. Once the bottles are consumed or stored for such a long time that they turn to vinegar, nothing remains of that unique and singular work. That is a tragedy worthy of Shakespeare.

Rival Communities and the Normativity of Beauty

Beauty has long been associated with those moments in life that cannot easily be spoken about—what is often called the ineffable. When astonished or transfixed by nature, a work of art, or a bottle of wine, words even finely voiced seem inadequate. Are words destined to fail? Can we not share anything of the experience of beauty? On the one hand, the experience of beauty is private; it is after all my

experience of beauty, not someone else's. But we also seem to have a great need to share our experiences. Words fail, but that doesn't get us to shut up. Some shared responses to beauty seem possible, raising our hopes that communication is not fruitless. Most everyone agrees the *Mona Lisa* is beautiful (if you can actually get close enough to enjoy the diminutive painting amid the hordes at the Louvre). Most everyone agrees that Domaine de la Romanée-Conti makes lovely wine if you can afford a taste. However, disagreements are just as common. As Alexander Nehamas argues, beauty forms communities of like-minded lovers who share an affection for certain works of art (or wine) and who do find it possible to communicate their obsession.[5] Something escapes the dark tunnels of subjectivity to survive in a clearing where others mingle. But this excludes people who don't get it. We are often bored to tears by something that fascinates others. Across that barrier, words may well fail. Beauty forms communities of rivals. The contretemps between conventional and natural wine is the latest to divide the wine world. May it not be the last, because these conflicts matter and are a symptom of the fundamentally normative response which beautiful objects, including wine, demand of us.

This idea of rival communities highlights one of the stranger notions that has persisted throughout philosophical discussions of beauty. It was Kant who defended it most stridently—beauty, despite being grounded in subjective feelings of pleasure, makes universal claims of validity, he argued. When I judge an object beautiful based on my own feelings of pleasure, not only does the object merit such a response from me, it merits such a response from anyone. Beauty demands universal agreement.[6] This is not to say everyone will agree; Kant was aware of the serious and intractable disagreements about beauty. He is claiming everyone ought to agree. It is a normative claim. Thus, if we fail to agree, someone is mistaken. Someone is failing to conform to the demands the object makes on us. This is the main difference between what is beautiful and what is merely pleasant or preferable, according to Kant. We do not demand that others share our

preferences for chocolate ice cream. But we think someone who finds Rembrandt boring is coarse and deserves criticism for lacking taste.

Kant's view was that we approach pleasure differently when the object is beautiful, as opposed to just agreeable or pleasant. We take a disinterested attitude toward a beautiful object, an attitude whereby our personal desires and idiosyncratic attitudes are bracketed, and we enjoy the object for itself, not because of some antecedent desire or personal interest. I will not belabor the tortuous logic that gets Kant to this conclusion. But the thumbnail sketch is that Kant wanted to show how our judgments can be rational and free. He thought that if we are pushed around by yucky, personal things like desires and emotions, our actions will not be our own. Genuine freedom can be attained only when we are governed by principles that any rational being must assent to, since, as a rational being, I must by necessity assent to them. (Yes, I know, it's peculiar. You are most free when forced by logic to draw a conclusion.) Once we free ourselves from interests and emotions and achieve disinterested attention, the conditions for universal assent to judgments of beauty are in place. According to Kant, rival beauties are created by personal interests that we should strive to overcome.

I must confess I have never quite grasped the attractions of Kant's view of disinterestedness. I think actions not motivated by personal desires or emotions are incoherent and presuppose a seriously mistaken view of human action. Thus, the concept of disinterestedness does not capture our motivations to seek aesthetic experiences. Why would I seek to experience beauty if I had no personal interest or desire in doing so? Far from being disinterested, we fall in love with great works of art, beautiful men and women, and lovely bottles of wine. Without love, appreciation is a feeble, inhibited gesture, like a preference for chocolate ice cream. But, thankfully, no one is obligated to love what I love. (My wife doesn't think she's that lovable.) Universal validity in matters of love is nonsense, and the experience of beauty (and beautiful wines) is a matter of love. As explained in Chapter One,

referencing once again the work of Alexander Nehamas, when we find an object beautiful, we experience the need to converse with it, submit to it, and make it part of our lives, just as we do with the people with whom we fall in love. We tend to find beautiful the things we love and fall in love with what we find beautiful.

However, that does mean Kant was right that beauty is normative, although he was mistaken about the nature of the demand beauty makes on us. Beautiful objects do not demand universal assent to their beauty. Neither do they demand praise or a ritualized response. The demand has nothing to do with evoking strong emotions or paroxysms of pleasure. The demand can be quite subtle and hard to fathom. Instead, there is a sense that the object embodies aspirational standards that ordinary objects like ice cream do not exhibit. A beautiful object is something that instructs us. It demands a response from us that is tailored to the object, and we can fail to respond appropriately because we are not up to the task of tracking its full measure. Beautiful objects are open to the murmuring of the universe and invite us to "listen in." They demand that we be up to the task of "listening."

What does wine demand of us? A quality wine challenges our powers of discrimination. It provokes curiosity and requires that our sensibility expand to give the wine its due. Such a wine demands we take it all in—its aromas, flavors, textures, and movement—and view it as a unity with an overall sense of its character. And as I have been arguing throughout this book, a wine demands we then see it as an individual, which requires we become sensitive to the subtle emotive and "personality" traits that constitute its vitality. The wine then invites comparisons with other wines so that we see it in its complex relations with them, thus placing demands on our cognitive capacities and memories.[7]

Importantly, these are standards set by the object. As I argued in Chapter Nine, to approach the full measure of an object, we must set aside our personal preferences and pursue the object where it leads,

not as disinterested observers or pleasure hounds but as committed lovers.[8] Beauty's demands and my responses to those demands are not independent of my needs. We all need love, and we need to love some of what we make part of our lives. I have a variety of antecedent interests in a beautiful object since it is a candidate for satisfying those needs. But it is important that we distinguish two kinds of desires. Some things I pursue simply because I desire them. These desires motivate without obligating. It makes little sense to say I'm obligated to find pleasure in this or that object. Other things I pursue because I must. Beautiful objects are in this latter camp. Part of the intensity I experience with beautiful objects is the object demanding my attention, even if it is difficult or discomforting. Some things are worthy of love and some are not, and part of what I sense in a beautiful object is that worth. But how do we mark that distinction? In the absence of something like Kant's attitude of disinterestedness, how do I know, when I'm drawn to an object, whether it's a non-obligating desire or an object of consummate worth exerting its force? Sometimes the difference can be felt within the pleasure itself—a sense of being inadequate in the face of the object, the failure of recognition discussed in Chapters Seven and Nine. However, not every beautiful object is so opaque.

To answer this question, we need to distinguish ordinary desire from a more rarified species of motivational state. Most desires are episodic. They come and go and, when absent, they exert little influence on us. But some desires are not episodic. They are standing desires that I am always ready to act on, circumstances permitting. With regard to standing desires that persist in the background of experience even when I'm not actively craving something, my attention is disposed to be drawn by the object of desire, and that attention is invariably accompanied by motivations to discover, preserve, enhance, respect, or celebrate the object's value. In other words, I am committed to discovering, securing, and preserving the "interests," so to speak, of the object. Thus, the needs and characteristics of the object set the

standard that governs my treatment of it and the kind of attention I give it. I call such desires of commitment "cares." Having a distinctive set of cares is fundamental to what it means to be an individual person, and to fail to respond adequately to an object of care may involve a loss of self if the care is an identity-conferring commitment.[9]

This notion of care has obvious application to the people we love. But in what sense does a beautiful painting or bottle of wine have "interests" for which I must care? The "interests" of valued objects are, of course, conferred on them by the people who use them. One of the main functions of aesthetic communities is to sustain and nurture the value of the aesthetic objects that are the focus of their attention. Thus, it is in the "interests" of wines made with care to be tasted with care because that is how the value of wine is preserved and nurtured. In this sense, as wine tasters, we have obligations to the wine community to participate in the activities that preserve the value of wine. Yet, that can be accomplished only by caring for the wines of beauty that each of us loves.[10] Our obligation is to give each wine its due, and that may or may not involve assenting to the alleged intersubjective norms currently in authority in one's community.

The Sensual Dimension

Mystery, ephemerality, and normative commitment—these are some of the core traditional elements of beauty that cast light on our appreciation of wine. The earlier chapters in this book have attempted to establish distinctiveness, significant variation, and "personality" as also central to wine quality, and they contribute to beauty as well. Yet, we have not quite gotten to the core of the beauty of wine. A wine could exhibit these features and thus be interesting, compelling, or pleasant yet not be beautiful. This is because concepts such as mystery, ephemerality, and variation are largely cognitive, at least as they have been presented thus far, and do not strongly suggest a sensuous

element. Both variation and distinctiveness have to do with how we compare a particular wine to others. Personality is about identifying certain emergent properties of a wine using the imagination to understand how the unity of a wine can be conceptualized. Although mystery and ephemerality have an affective dimension—we feel drawn to and captured by mystery and feel saddened and regretful with loss there is nevertheless an overlay of cognition regarding what is understood or lost, and neither seems directly related to the sensation of flavor and aroma molecules. Cognitive activity—thought—plays an important role in our experience of beauty, but tasting wine is also a sensuous experience.[11] The beauty of wine is surely related to the sensuous responses wine makes available. It is the nature of that sensuous experience of beauty in wine to which I now turn.

Let me put a definition of vinous beauty on the table. This definition will seem abstract at first but, hopefully, will become clear as I fill in the details. Beauty in wine is the sensuously alluring dramatization of significant variation. Beautiful wines stage the allure of a distinctive variation or series of variations and express these mutations and their ephemerality. But what does it mean to stage the allure of distinctive variation? The allure of wine is staged or dramatized by its depth and its rhythm. I will first unpack this idea of depth before turning to the more difficult and less familiar notion of a wine's rhythm.

We gain some insight into depth by considering a similar phenomenon in the appreciation of art. Paintings often display visual elements that we cannot clearly identify. Inchoate, half-formed shapes and marks that create vague sometimes spectral presences generate energy and intensity in a work.[12] Abstract art derives much of its emotional intensity from these non-objects. (Helen Frankenthaler's *Scarlatti* is one example).

This kind of depth is also familiar in wine. It has to do with flavors and aromas that give only hints and nuance and often remain just below the threshold of our full discernment. Excellent wines often have aromas that exhibit remarkable clarity and focus. We can

immediately identify the aromas, and their sharpness and lucidity stand out. However, beautiful wines show an additional dimension. The clarity is set off against a background that hints at a complexity in which some aromas are indistinct, shadowing and disrupting clarity with intimations of something unusual, wild, or deviant just below the surface. Such wines have mystery, ambiguity, and depth because they indicate something more to be discovered about them. Sometimes we experience this background depth as richness or fullness. Sometimes we sense it as ethereal or penumbral, a pregnant yet diffuse ambience that seems to operate in between and around the dominant flavors and aromas. This dimension of depth—more like an atmosphere than a property—contributes to a wine's sensuality. It contributes to the staging of wine's variations as a shadow stages the light.

Rhythm is an even more profound form of depth and one that supports the staging of allure. We are, of course, familiar with metered rhythm in music, the repeated patterns of accents and pulses that dance music utilizes so effectively. But metered rhythm is not the only form of rhythm. In music, sounds that are not quite melodies or harmonies and that disrupt predictable patterns and complicate formal structure provide interest and complexity. For instance, the use of tonal effects and shifts in sonority operating in the background of rock or classical music provide a sense of movement operating in contrast to the main melody or dominant pulse. (The rock band Radiohead is particularly adept at this). A sense of background movement or depth that cannot be precisely picked out and given conceptual specification is crucial to intuitively grasping the richness of works of visual art as well. Lines, shapes, and color gradients that manipulate the movement of our eyes as they dart around the canvas give some paintings a sense of agitated movement that disrupts clearly articulable form, as if the painting embodied a play of forces in the process of transition. (I have in mind the work of Willem de Kooning.)

Beautiful wines, too, have this play of forces as they evolve on the palate. Although the metaphor of "wine is a building" is common in tasting notes, wine is more like the sea. In the mouth, a wine unfolds

in time in a continuous process of evolution. Young wines often pulsate with nervous energy, darting about the palate in micro-bursts of kinetic flavor before settling into a rhythm of discernible phases. An aged wine might sinuously spread like the tide encroaching on a beach or gently carry our attention as if floating on a placid stream. Some wines build momentum in undulating waves exhibiting an explosive quality at midpalate before ushering in a gently fading finish. Others seem on the verge of falling apart before finding their center, or they embody paradoxes with features that seem incompatible but somehow manage to achieve unity. A wine assembles itself, takes itself apart, and then reassembles, all within the space of the few seconds in which a sip of wine is consumed and savored. Ripe, oaked wines tend to be concentrated, dense, and relatively static, while wines with higher acidity are teeming with activity; others are more diffuse yet still animated. These energies give wines their character, and they determine how and when we perceive the aromas and flavors.

As noted above, beautiful wines tend to have determinate properties that exhibit clarity and focus. These are the features delineated in tasting notes. For example, purity of fruit is often one prominent marker of beauty. But these determinate properties rest on the reverberating dispositions just described that are less than clear and not readily articulable. Aromas and flavors are seldom delivered simultaneously on the palate. What captivates is the fluctuating clarity and obscurity of a wine's properties—some become salient, forcing others to the background only then to be enveloped and covered over as new features appear. We sense the wine coordinating itself, as unifying forces become prominent, but then disassembling as the wine's shape and trajectory shift. From these expansive and contracting rhythms, we gain a sense of the elements finding expression and then withdrawing.

I call what emerges from this activity "fecundity"—a plethora of emergent properties that give character to a wine. Wines can be inert, agile, solid, sharp, dense, sparse, clear, profound, brooding, or

shadowy—beautiful wines show many of these dimensions in a single swallow as they transition from one to the other. While in the mouth, the fruit can tend toward minerality and earth, head in the opposite direction, or split into layers that exhibit both. Acidity launches a crescendo, and the tannins pull it back and anchor it, finally either losing or re-asserting their control. Wine qualities oscillate between emerging into clarity and becoming immersed, less defined, more subtle, volatile, or imperceptible. The best wines have an ability to show many sides, not just many aromas or flavors, but a multi-faceted complexity of felt richness and force. Apprehending beauty is not just about how many aromas you can pick out. It is about a through-line of expressive energy that controls how fecundity is displayed. It would be strange if this dimension did not contribute to aesthetic appreciation, although it is not routinely included in tasting notes. All of this produces what we might call affective intensities, micro-perceptions that contribute significantly to the sensuous dimension of a wine.

Significant variation, dynamism and stillness, ephemerality, and personality—these are what I mean by "tasting vitality." The particular way in which these dimensions unfold is the wine's rhythm. Rhythm determines how the qualities we identify in tasting notes are staged and that staging can be well done or poorly executed. Thus, rhythm determines how much is perceived and when; how a wine's properties are covered over, enveloped, or revealed. Rhythm contributes to beauty because it directs fecundity, the surging and fading of which is a tracing of ephemera. I am suggesting that we call the performance of this process of directing "beautiful" because we experience it as sensual. Of course, there are no rules for how wines must unfold. There are as many singular examples as there are singular wines. These rhythms and resonances need not be kinetic or powerful. It is a mistake to see, in this dynamism, effects that are necessarily loud, large, or momentous. The elements of wine are highly sensitive to each other, and the conversation between them can be a whisper, especially in aged wines. In beautiful wines, subtlety penetrates everywhere. The

ephemeral deviations at the threshold of discernment are among the most prized. A beautiful wine takes these dynamic processes and gives them contour, precision, and atmosphere. Like the shimmering of light on water, they can appear as a gossamer-like delicacy, even in wines of great power and intensity.

Beauty does involve a sense of unity, as most traditional accounts of beauty suggest. Fragmentation and disjointedness that lacks a contribution to the whole destroys beauty. But that sense of clarity and unity is subtended with something wild, a restless energy that suggests incompleteness. Beautiful objects have a struggle going on within them. There is purity, clarity, and focus, but then something that tugs against it or resonates with it so it has contrastive energy. The energy does not come from the purity itself but from the in-between, the lines of development that operate in between determinant qualities. Even the properties of wine that show themselves with great clarity and determinacy shade off into the indeterminate. Like undulating waves, peaks appear and then disappear, the tone lightens then darkens, textures thicken then melt. There is oscillation between determinate properties and their shadows, great differentiation and misty indistinction, some features emerging and others being enveloped by that emergence. It is not only what emerges most clearly, but the felt transitions between the clear and obscure that give wine its dynamic character. Yes, we can pick out elements and fix their relative prominence, but this misses the communication between those elements where they meet, envelop, dissemble, and reform. This is what I referred to in Chapter Two as *"shi,"* referencing Jane Bennet's use of that term borrowed from Chinese philosophy.

Beautiful wines present themselves as in process, embodying an instability that is ultimately resolved but experienced in its transitions. It is a challenge to follow, unequivocally, the transformations taking place, with the flavors and textures in agitated motion. Clark Smith writes, "Just as the heart of rock and roll is the beat, the soul of wine lies in its texture."[13] I agree if the wine puts texture in motion. In

summary, in a beautiful wine, the rhythm of its elements stages a conversation and directs our attention to the variations that have significance and generate fecundity. For the most beautiful wines, identities are destabilized, and a sensation without category emerges on the back of fecundity—this is what Terry Theise called "sublime."

In aesthetic experience generally, but more particularly in aesthetic wine tasting, we take an active interest not merely in what is immediately apparent but in allusion, intimation, and connotation. The nineteenth-century novelist Stendhal wrote that beauty is "nothing other than the promise of happiness," suggesting that beauty invokes something not immediately present, not quite actual, but promised.[14] In the experience of beauty, it is not a stable, delineated object that attracts but something not yet fully present, a shifting play of presence and absence that points to something just beyond our ability to track it, a swelling and contracting tide of meaning where foreground and background continually shift, and the feeling of something just beyond the horizon is palpable. This is why beautiful objects do not simply capture our attention. They sustain it—they seduce, coerce, provoke, arouse, and even intimidate but always from a time beyond the present.

To put this in the language of dispositions, beautiful wines possess an abundance of dispositional properties made manifest in different ways by a variety of different palates. Yet that depth, that richness of dispositional properties, is something we can sense as partial manifestations even though we often cannot put our finger on exactly what we are tasting and smelling. In beautiful wines, it is not the individual aroma and flavor notes only that impress but the sense that the wine is in process, shapeshifting, with more to give, more to be revealed. It is not the unity of a determinate form but of an active process of integration that supplies the sensuality. It is the wine at work that is beautiful.

Our inability to fully grasp all of this deepens the mystery of wine.

The slow art of wine requires an acceleration of sensibility of which, as tasters, we are not fully capable. Wine's vagueness and ephemerality, and the limits of our memories and attention, contribute to this sense of mystery. This fundamental instability, the pace at which these transitions in the wine occur on the palate, and our inability to clearly and comprehensively track them mean that multiple interpretations of a wine are likely. There is no predicting precisely which side a complex wine will show to a particular taster.

Significant variation, depth, and a rhythm that stages fecundity, ephemerality, and mystery—these are the elements of vinous beauty. Objects become beautiful when some difficulty is introduced, something that disrupts harmony and makes us think or react emotionally. The intensity of beauty comes from contrast, not symmetry. A symmetrical face is pretty; it becomes beautiful when animated by the complexities of a personality that hints at something tumultuous just below the surface. Musical passages are beautiful when they contain sufficient tension to elicit powerful emotions. The great composers are masters at building tension that never fully resolves. What makes a painting such as Monet's *Water Lilies* beautiful, and not merely pretty, is that it draws us into a maelstrom of swirling color that has no border, so we feel on the edge of the infinite, bound to something beyond comprehension. Similarly, wines are beautiful when the tumult of its staging acquires a trajectory that we can sense if not fully describe.

Beauty lost its cachet in the art world because the conventional association of beauty with unity and harmony was in constant danger of collapsing into the pretty and comforting, thus becoming inadequate in expressing the full range of human experience. Beauty can be revived if we admit that it is the unraveling of good form, the wild and untamed, which fascinates.

Inspirations:

I argued in this chapter that beautiful wines have clarity set off against a background that hints at complexity, in which some aromas are indistinct with something unusual, wild, and deviant just below the surface. Chris Howell at Cain Vineyard and Winery uses the spoilage yeast brettanomyces as such a flavor element in his celebrated Cain Five Bordeaux-style blend. In the 2004, subversive hints of saddle leather and mushroom, along with the distinctive texture of mountain grown fruit, give this wine a feral, tough quality that works in tension with the rich, plush fruit to make a truly bewitching wine.

If great wines, beautiful wines, bring unity to opposing features then Romano Dal Forno's Amarone della Valpolicella 2009 certainly qualifies—powerful yet elegant, both sweet and savory, subtle and in your face, massive while light and fresh on its feet. The Dal Forno is all of those. If beautiful wines have a struggle going on within them, the Dal Forno is at war.

Notes

1. The general thrust of my argument here is informed by Richard Moran's insightful discussion of Kant's views on beauty, especially Moran's stage setting discussions of the peculiar logic of the concept of beauty and its historical connection to mystery, ephemerality, and normativity. See Richard Moran, "Kant, Proust, and the Appeal of Beauty," *Critical Inquiry*, vol. 38, no. 2 (2012), 298-329.

2. See Chapter One for a discussion of the connection between beauty and mystery in Alexander Nehamas, *Only a Promise of Happiness: The Place of Beauty in a World of Art* (Princeton: Princeton University Press, 2007).

3. I rely here on the analysis of life in Georges Canguilhem, *The Normal and the Pathological*, ed. Carolyn R. Fawcett (New York: Zone Books, 1989). See also, Thomas Osborne, "Vitalism as Pathos" in Biosemiotics, Vol.9 (2016), 185–205. Published online, Feb. 2016, https://www.ncbi.nlm.nih.gov/pmc/articles/PMC4982892/#CR7

4 See Chapter Two for an account of techniques winemakers use to encourage the ability of wine to maintain a sub-optimal norm.

5 See Nehamas, *Only a Promise of Happiness*, 58-59.

6 Burnham and Skilleås endorse this understanding of the normativity of beauty and of wine as well. See Burnham and Skilleås, *The Aesthetics of Wine* (New Jersey: John Wiley and Sons, 2012), 28. For the original articulation of this account of the normativity of beauty, see Immanuel Kant, *Critique of Judgment*, trans. Werner S. Pluhar (Indianapolis: Hackett Publications, 1987), 43-96.

7 For a related discussion of the cognitive demands beautiful wines impose on us see Christopher Grau, "Can Wine Be Beautiful: A Philosophical Perspective," in *The World of Fine Wine*, September 2007.

8 Moran's discussion cited above is relevant here as well. However, Moran gives more credence to Kant's notion of disinterestedness than I do in that he argues that the normative status of beauty does not depend on my current desires. By contrast, the notion of love and care, to which I appeal in what follows, provides for a variety of standing, and thus current, desires that motivate one's concern for beauty.

9 I provide a more comprehensive treatment of this notion of care in Dwight Furrow, *Ethics: Key Concepts in Philosophy* (London: Continuum Publishing Group, 2005).

10 Thus, I disagree with Burham and Skilleås that the responsibility that I as a taster bear is primarily to the community of wine tasters and their intersubjective norms. As I argued in Chapter Nine, wine tasting is a communal activity, and there are regulative norms to which we must adhere as tasters. But part of our responsibility is to the wine itself, and these two strains of commitment may be in conflict.

11 It is worth noting that the important role I give to cognition is in conflict with claims that our appreciation of wine is non-cognitive. The most persistent defender of non-cognitivism in wine appreciation is Roger Scruton, who asserts that "gustatory pleasure does not demand an intellectual act." When we look at the practice of wine tasting, the comparisons and knowledge required to make sense of what we're drinking, and the important role of imagination as well, Scruton's claim seems patently false. See Roger Scruton, *The Aesthetics of Architecture*, (Princeton: Princeton University Press, 1979), 114.

12 Heidegger's discussion of Van Gogh's painting of peasant shoes emphasizes the significance of inchoate forms that constitute the background of a painting, which he describes as "the tension of emerging and not emerging." For the discussion of Van Gogh, see Martin Heidegger, *Poetry Language, and Thought*, A. Hofstadter, trans. (New York: Harper & Row, 1971), 33.

13 Clark Smith, *Postmodern Winemaking: Re-Thinking the Modern Science of an Ancient Craft* (Berkeley: University of California Press, 2013), 131.

14 Stendhal, De L'Amour" (On Love), Ch. 17, footnote, 1822.

BEAUTY AND THE YEAST

ABOUT THE AUTHOR

Dwight Furrow is Emeritus Professor of Philosophy at San Diego Mesa College in San Diego, California. He received his Ph.D. in Philosophy from University of California, Riverside in 1993 and specializes in the philosophy of food and wine, aesthetics, and ethics. Furrow is also the author of *American Foodie: Taste, Art, and the Cultural Revolution* and many other books and professional journal articles on ethics and social philosophy. He is certified by the Society of Wine Educators and owns an advanced level certification from WSET. (Wine and Spirits Educational Trust) Professor Furrow is the author of *Edible Arts*, a blog devoted to food and wine aesthetics; *Roving Decanter*, a food, wine, and travel blog; and is a monthly contributor to *Three Quarks Daily*.

When not teaching, Dwight and his wife Lynn travel throughout the U.S. and the world looking for interesting wine and food experiences.

The link to Edible Arts blog is https://foodandwineaesthetics.com

APPENDIX: TASTING VITALITY

Current tasting models used in tasting notes and in certification programs focus on aromas, flavors, and structure, and we have a well-developed vocabulary for describing these elements. Aroma descriptions are especially sophisticated. Tasting models focus on aromas for good reason. The paradigmatic procedure for wine assessment is blind tasting, the goal of which is to infer a wine's origin and quality level solely from a wine's sensory properties. Because aromas are the signature of a wine, they provide important clues about the varietal, where the grapes were grown, and how the wine was made. Furthermore, the intensity, complexity, and delineation of aromas are primary criteria for judging wine quality and play a crucial role in our overall enjoyment of a wine. However, as important as aromas and flavor notes are, they are not the whole wine. Our enjoyment of a wine depends, crucially, on structure and mouthfeel but also on a related dimension that is seldom emphasized in our tasting models—the perceived movement of wine on the palate.

I argued in Chapter Ten that a wine's perceived movement on the palate, its rhythm, is not only a determinant of wine quality but is an important element of a wine's personality and what I've been calling "vitality" throughout this book. A wine will reveal different properties at each stage of its evolution on the palate, and part of the character of a wine has to do with how that evolution unfolds. The level of interest the unfolding attracts, in part, determines a wine's quality. In

other words, the structure of a wine is not static. Wines have a kinetic dimension that influences our overall impression of a wine and, in part, constitutes a wine's individuality. Yet, our way of describing these features is not nearly as well developed as our description of flavors and aromas.

Wine, the physical liquid, changes as it mixes with saliva in the mouth. However, when tasting a wine's motion, it is not only changes in the physical properties of the wine that are the subject but changes in our perception of the wine as we become aware of various structural components. Perceptual shifts, changes in attentional focus caused by the sensory impressions the wine leaves—what draws your attention as you taste the wine—give wine a sense of motion on the palate.

In emphasizing the impact of the movement of wine on wine quality, I am not uncovering something radically new. Tasting notes often mention finesse, elegance, liveliness, or tension, which speak to a wine's motion. A whole class of white wines are called "racy," indicating something about movement. The length of the finish is, of course, important in wine evaluation and that, too, suggests something unfolding in time. However, we lack a systematic way of discussing this dimension of wine, and we typically do not make the connection between motion on the one hand and a wine's personality and individuality on the other. Thus, our current tasting model underplays the role of perceived motion in explaining the expressiveness of wine. What follows is an attempt to open a conversation about this dimension.

Another dimension of wine's expressiveness that has been a central theme in this book is the use of metaphor to capture the individuality and "personality" of a wine. As discussed in Chapter Eight, the use of metaphor is well established in wine discourse, and we have a theoretical understanding of how metaphors work in wine discourse. However, we do not have a practical understanding of how the holistic or emergent properties attributed to wine through the use of metaphor are related to the underlying structural, dynamic,

and aromatic properties of wine. Another aim of this appendix is to demonstrate some of the links between metaphor and wine properties.

Other writers have developed tasting regimes for aromas and flavors, and I will rely on conventional understandings of how aromas are linked to varietals, geographical location, and chemical constituents in the wine. My goal here is to show how aromas, mouthfeel, and dynamic qualities contribute to the holistic properties that are crucial to wine aesthetics. This appendix supplies the linkages needed to make practical use of the theoretical claims in Chapter Ten regarding the connection between a wine's rhythm and its beauty. In most cases, I will express the qualities a wine exhibits as a range of variations distributed on a continuum bounded by polarities. Individual wines differ in where they fall on each continuum. Structure in motion is available to us via a wine's mouthfeel. Thus, we begin by identifying various dimensions of mouthfeel.

Mouthfeel Characteristics:

Body:

Tasting notes often include reference to the body of a wine as if it were one simple impression—full, medium, or light. However, judgments about body are more complex than these references would indicate. The body of a wine has four dimensions.

Weight: Light...Heavy

Wines differ in how heavy they feel on the palate. Wines with high alcohol, more sugar, rich tannins, low acidity, or deeply concentrated fruit may feel heavy. Perceptions of weight may also be affected by perceived movement on the palate, which is

discussed in more detail below. Wines that are lively may be perceived as lighter.

Concentration: Dilute...Dense

There is some overlap with weight on this dimension, but they are not precisely the same. Concentration refers to the perceived richness of the fruit, which is often the result of more flavor compounds (extract) as a percentage of water content. A concentrated wine will usually feel heavy on the palate, but, if it has robust acidity or lower alcohol, it may not feel heavy. High-quality Burgundy wines can sometimes feel concentrated yet not weighty. Some wine vocabulary glossaries define concentration in terms of intensity. This is a mistake. Some deeply concentrated wines lack intensity; they taste flat and lack movement.

Viscosity: Thin...Thick

Viscosity is a quantifiable physical dimension defined as the resistance to an object passing through a substance. But, in wine tasting, we are referring to perceived resistance. Again, while there may be overlap with weight or concentration, viscosity is its own dimension. A good viognier from Condrieu may feel viscous yet light. Wines with residual sugar feel viscous, but some lack fruit concentration. "Creamy" is a descriptor that sometimes indicates viscosity.

Shape: Fat...Round...Stocky...Angular...Slender

"Round" is a common descriptor for wines that have a sense of fullness but with no hard edges.

Each component seems to blend into the others with little resistance. Fat is the extremity of this feature. By contrast, other wines are full bodied but stocky because the tannins or acidity seem to resist or contain the fruit power, and the perceived transitions the wine undergoes on the palate seem full of effort. "Slender," the opposite end of the continuum, refers to wines that seem compressed. This is not to be confused with "thin," meaning lacking in viscosity or diluted. Slender wines may not taste diluted if they have flavor intensity, and they may have a texture, which is perceived as adding body. White wines, such as those from the Italian region of Lugana, that are light bodied but with dry extract are a good example of slender wines that have texture. "Angular" suggests that the wine is sharp and has what some tasters describe as "cut." "Lean" is often a descriptor for thin wines. But lean also tends to connote wiry, sinewy, or tough, adjectives that are not about shape but muscularity, and thus covered below.

Texture:

Softness...Hardness

Smooth...Particulate...Rough/astringent

These two continua are the most basic, immediately accessible impressions of mouthfeel. These are holistic impressions based on the overall sensation left by tannins, acidity, alcohol, and fruit. Analytic tasters can break these components of a wine's structure into separate sensations to

gain an understanding of how the wine is put together. However, here I'm referring to a basic overall impression of the wine. Some tasters refer to the "knit" of a wine. "Tightly knit" means compact, less expressive, which puts the wine further toward the hard side of the continuum. That contrasts with "open knit," which means soft and giving. There are many precise texture descriptors that wine tasters use and more textural dimensions than these two continua. But novices readily report wines falling on these continua as an initial impression. Thus, these continua are foundational.

Layered: Single-layered…Multi-layered

Some wines seem to have layers that express varying degrees of hardness and softness, or other mouthfeel dimensions and are arranged vertically. As will be discussed in more detail below, as a wine moves on the palate, the relative prominence of a wine's layers, and their hardness or softness, may shift as the wine is savored.

Irritation:

Effervescence: Fine…Heavy

Peppery: Faint…Sharp

Sparkling wines, of course, are effervescent because of the bubbles, which range from a fine, almost foamlike texture to larger, weightier bubbles. Tannins and acidity in red and white wines can leave prickly sensations, which are often referred to as "peppery."

Reactive: Puckering...Chewy...Grippy

This dimension refers specifically to acidity, tannins, and their interaction that causes a bodily reaction.

Minerality: Mineral-focused...Fruit-focused

This is a hybrid flavor/mouthfeel property. Minerality has recently received a great deal of attention. Prior to the 2000s, it was seldom mentioned in tasting notes, but it is increasingly used as a descriptor to capture a variety of earthy aromas and textures. Sometimes, minerality refers to a basic sensory impression, for instance, the aroma of "wet stone" in a riesling or crushed rock in pinot noir. As such, it doesn't belong here in a discussion of mouthfeel. However, the term also seems to be a flavor/mouthfeel hybrid quality. "Flinty" involves both a "stony" or "struck-match" aroma, along with an angular mouthfeel. Red wines such as Left-Bank Bordeaux often have a gravel-like aroma note with an angular, textured layer affecting mouthfeel. Winemaker and consultant Clark Smith uses the term minerality to refer to an "electric spark" on the finish of a wine that is, at least in part, a tactile impression.[1] "Chalky" is also a minerality descriptor, which refers to mouthfeel.

Structure in Motion

A wine's structure is accessed via mouthfeel. The development of that structure, as the wine evolves on the palate, is my focus in this tasting model. I have found it useful to divide a wine's development into five stages: introduction, front of the midpalate, back of the midpalate, finish (i.e., what happens after swallowing), and terminus (the final impression that the wine leaves as it fades). These can be called "zones of intensity," because we use these stages to organize the relative prominence of various structural components. Wines can move toward greater or lesser intensity at each stage. For simplicity's sake, it is often useful to include only three stages—introduction, midpalate, and finish.

Rhythm

This is the most general concept regarding a wine's movement. It refers to dynamic changes discerned through mouthfeel, taste, and aroma, and the pace, duration, and relative prominence of these changes through time. Features of the wine that undergo change have varying rates of change. Some happen quickly, others more slowly. Some components persist, while others emerge or disappear. Some become more intense; others less intense. These changes give character to the wine, and quality wines tend to have more force points at which changes occur, which is a dimension of complexity.

The point at which various dimensions of the wine become perceivable is important to the overall character of the wine. How clipped is the keynote, and when

do tannins or acidity assert themselves? How is the emergence of acidity or tannins influenced by fruit power? When does the fruit fade? Does the wine feel as if it is expanding or contracting? When do these changes occur, and what is their frequency and envelope? These factors help define the temporal contour of the wine. Much of the action happens at midpalate when most of the structural components have made an appearance, and the interaction between them is at its height. All the dynamic features of the wine have a duration in time, so there will be some pattern that constitutes the wine's rhythm. Remember, "rhythm" need not refer to repeated patterns. In music, a pattern of accented notes is a rhythm even if the pattern is not repeated.

Polarities

I describe a wine's rhythm in terms of polarities. Polarities are the maxima and minima of the various dimensions that describe the way wines are perceived to change while in the mouth.

Keynote:

> In music, the keynote is the first note of a scale and is, therefore, the tonal center of a piece of music. The introduction of a wine functions as a keynote, which reveals the initial weight, shape, volume, and fruit power of a wine. All motion is perceived as relative to this starting point. Why is fruit power the keynote? Because it begins as the center of attention, and the changes that occur during the tasting experience spread out from that initial set point. The keynote anchors our perceptions as a reference point. In some wines,

you might encounter oak-derived flavors or earth notes as the more dominant initial sensation, in which case they would constitute the keynote. Cool-climate wines tend to have different keynote properties than warm climate wines.

Vitality Forms:

As described in Chapter Five, vitality forms are the "flow pattern" of human experience. We perceive the movement dimensions described below as exhibiting flow patterns for which we have a rich descriptive vocabulary. I have included some of this descriptive vocabulary in the account of these movement dimensions.

Movement Velocity: Slow...Rapid

Movement velocity refers to how quickly the wine moves through its evolution. As the wine moves through its stages from keynote through the finish to terminus, the properties can appear to change rapidly or more slowly. Some of the stages may last longer than is typical; others may be clipped. Wine tasters have traditionally commented on the length of the finish. But the introduction and midpalate of a wine also have duration, and the perceptual shifts within each stage also have velocity. Very ripe red wines may have a long introduction before acidity and tannins become more assertive. In other wines, acidity and tannins may enter the picture early, generating a more rapid evolution. Fruit power can be sustained and remain prominent even after the other elements make an appearance, giving the midpalate extreme length before diminishing on the finish.

Sub-categories:

Duration: Short...Long

> Any stage of a wine can have duration. Some changes will persist, exhibiting greater duration. Others are ephemeral, disappearing rapidly. The duration of the various stages make up the overall movement velocity of the wine.

Rate of Change: Accelerated...Decelerated

> This refers to changes in velocity that occur as the wine, or some component in the wine, moves through its stages. Often, acceleration in one dimension of a wine attracts our attention and can be accompanied by deceleration in another dimension.
>
> Vitality forms associated with movement velocity: accelerated, decelerated, delay, retardation, brisk, rapid, bursting, fleeting, drawn out

Degree of Movement Variation: Linear...Subtle... Expansive/compressed

> This dimension measures whether the changes perceived are large or small relative to the keynote. As noted, the keynote reveals the initial weight, shape, and volume of a wine. A linear wine shows modest deviations from the keynote. Wines exhibiting large deviations from the keynote are expansive or compressed.
>
> Movement variation influences the perceived volume of a wine. Volume refers to the amount of space a substance occupies. In this context,

"volume" refers to the perceived "space" created by a wine's movement variation on the palate. The keynote may show a wine to be round or lean. As the wine evolves, the interaction of structural components, especially tannins and acidity and their relative prominence, gives a wine a sense of expansion and contraction from the keynote. Wines with high acidity or minerality, and sometimes alcohol, seem to expand as the wine evolves. Robust tannins yield a sense of breadth that may contribute to the sense of expansion. However, expansive tannins give the wine a sense of horizontal expansion; expansive acidity yields a sense of vertical expansion. The use of "vertical" and "horizontal" here is a cross-modal metaphor involving comparisons with spatial directionality.

Wines with more prominent acidity and less robust tannins will seem angular or narrow. This dimension of volume will sometimes characterize the whole wine, but it can also be applied to layers or stages as well. The perceived volume will be affected by, and partly overlap, the perceived shape of the wine, but it is a distinct dimension. Wines that exhibit this expansive quality do not become fat, viscous, or dense. Slender or angular wines may also exhibit breadth.

"Finesse" is a traditional descriptor that fits on these Movement Velocity and Movement Variation continua. "Finesse" refers to small movements relative to previous changes that distribute various features of the wine at a measured pace with many subtle shifts. The horizontal movement through time is active because of the wine's complexity,

but it doesn't throw everything at you at once. Wines full of finesse show small yet frequent modifications of linear movement.

Vitality Forms associated with movement variation: Crescendo, spreading, swelling, creeping, sprawling, graceful, nimble, stable, mobile, volatile, unstable, decrescendo, shrinking, disappearing.

Frequency of Variation: Static...Kinetic

The activity level of a wine is a function of the frequency and duration of the changes that occur. A kinetic wine has many changes of relatively short duration, or fewer changes with extended duration, that are high on the expansive/compression pole of the movement variation continuum. Oscillation is an important kinetic property of a wine. Some wines seem to move back and forth, shifting your attention from one dimension of the wine to another as the relative prominence of various features shift. For instance, our attention might shift from fruit to minerality and back again, or from angular acidity to expansive tannins to the persistence of fruit power. As tasters, our attentional focus is something we have some control over. However, with kinetic wines, the wine seems to be in the driver's seat, forcing attentional shifts because of the degree and frequency of the variations.

Vitality forms associated with frequency of variation: pulsing, bounding, swirling, whirling, floating, gliding, still

Force: Powerful...Muscular...Sinewy...Supple...Gentle... Delicate...Weak

In addition to movement, we can also sense what is behind the movement, a sensation of force. Force is related to the amount of mass or energy behind a movement, the feeling of power or the lack of it. Some wines have force but little tension; for instance, heavy, rich wines with low levels of acidity. Other wines are active but without much force behind them—delicate or gentle wines, for example. There are traditional descriptors that characterize the degrees of force behind the changes a wine undergoes on the palate. "Sinewy," for instance, suggests a wine that is unyielding and energetic but lacking mass.

Vitality forms: weak, hesitating, tentative, pent up (stifled), forceful, explosive, effortful.

Tension: Relaxed...Tense

The summation of all this motion and force is a perception of various degrees of tension. In recent years, descriptors indicating tension have become increasingly prominent in tasting notes. Tension occurs when structural components seem to resist each other, especially because of differential velocities. A wine showing rapid midpalate expansion with floral and mineral notes increasing in prominence—but also displaying increasing breadth as expansive tannins pull in the opposite direction giving the wine additional weight—would exhibit great tension. Tension also increases when one dimension of the wine is changing rapidly, and another is developing more

slowly. Oscillation between various dimensions of the wine can also introduce tension as if flavors or textures are pushing and pulling each other, and our attention is directed from one to the other.

Andrew Jefford locates tension in "sappy wine from a green place" and goes on to discuss energy in a wine as a "pulling or restoring force."[2] By "sappy wine from a green place," he means cool-climate grapes picked when slightly underripe. Such wines do have great tension. However, I think we sell the concept of tension short if we fail to acknowledge "that pulling or restoring force" as a general feature of many quality wines from both cool and warm climates. "Tension" refers to a restoring force that results from altering an initial state of equilibrium, like a bowstring being pulled and released. Thus, tension refers to how much disturbance from an equilibrium we perceive as the wine evolves on the palate. It is about differential velocities in the perceived movement of the wine's components. The tension is between the expansions or contractions of the wine as it generates deviations from the keynote.

Vitality Forms: taut, tight, jittery, loose, relaxing, languorous.

Solidity: Flabby…Fleshy…Meaty…Hard…Sturdy

It might seem odd to understand solidity in terms of movement. But this continuum is based on perceived resistance to the flow of the wine, which is a function of the active interplay between the structural components. Solidity is an amalgam of

force; the perceived weight, shape, and volume of the wine; and a lack of movement velocity.

Finish:

Length: Short…Long

Quality: Fruity…Bitter/Alcoholic burn/Sour

Dominant Force: Fruit…Acid…Tannins…Balanced

Texture quality: Hard…Soft

Movement quality: Linear…Full of finesse

Evolution quality: Clumsy…Elegant

Elegance is one of the most important aesthetic properties of a wine. It is almost always one marker of superior quality. The property of elegance can refer to the whole wine or some dimension of the wine. The changes a wine undergoes as we savor it can happen abruptly or gradually. "Elegant" suggests smooth transitions between stages; clumsy wines show abrupt changes between stages. However, there is more to elegance than this. Elegance relies on several of the movement characteristics discussed above:

- Medium-plus frequency of variation. Elegant wines are neither static nor kinetic, but they must have a degree of complexity in their evolution.

- Subtle variation. Elegant wines are not linear, but neither are they expansive or compressed. They are characterized by many small changes.

- The transitions between stages are smooth and gradual rather than abrupt. This is probably the most important condition. Abrupt changes feel clumsy.

- Tension is low to moderate. The various structural components of the wine do not offer excessive resistance to each other. The structural components all evolve at a similar pace.

Elegance is about the pace and degree of variation and the gradient of the transitions.

The Intersection of Movement and Aromatics

Frequency range: Narrow…Wide

Frequency Direction: Low…High

High…Low

The horizontal evolution of a wine reflects vertical development along an additional qualitative axis. This vertical development refers to the wine's frequency range, low-to-high or vice versa, in which the wine deviates from the keynote. The reference to "low" and "high" is a cross-modal metaphor that evokes a comparison with musical frequencies. Below, I discuss "top notes" and "bottom notes" in referring to aromas. Although aromas are part of the sensory experience of vertical movement, texture, shape, and volume are also important in understanding frequency range.

It is useful to think of frequency range in three layers. The midrange is established by the initial impression left by the fruit at the keynote. Low frequency refers to the sense of depth one gets from the fruit, especially how concentrated the fruit is, as well as the action of the tannins and/or dry extract, which give the wine a sense of breadth and foundation. High frequency is generated by acidity and ephemeral, or lighter, aroma notes, such as floral, red-fruit, and most mineral notes. One could, of course, discover more gradations— an upper-middle or lower-middle layer. The number of layers of vertical development is a practical distinction.

When related to the movement of the wine, frequency range refers to the range the wine covers as it moves toward higher frequencies, lower frequencies, or both simultaneously. Some wines are compressed, with little frequency range. Other wines have great frequency range with tannins that increasingly give a wine depth, while acidity and minerality cause the wine to appear to soar toward the top notes. From an assessment of a wine's frequency range, we get a judgment described by a continuum that ranges from narrow to wide. Shape, discussed above, also changes as the wine moves through its phases. A wine might become more rounded as it expands or more angular as it compresses. Frequency range and movement variation are related because variations will occupy a position on the narrow-wide continuum.

Attention to vertical and horizontal development

reveals force points where the wine seems to change. These changes are changes in intensity and frequency range, but there is also additional qualitative change as new flavor or tactile experiences occur. I discuss frequency range in more detail in the section on aromas since there is an aromatic component to this dimension.

Bringing Movement Characteristics into Focus

I argued, in Chapter Ten, that a beautiful wine gives contour, precision, and atmosphere to these dynamic processes and provides a through-line of expressive energy that I identified as a wine's rhythm. The various continua described above that measure these processes isolate and highlight features that are central to our experience of a wine but are seldom given much attention in descriptions of a wine's quality. When we pay attention to these dimensions, wine becomes more interesting, manifesting properties that are not obvious, and that inattentive tasting passes over. However, we need to organize these dimensions into a coherent "picture" of a wine. It is one thing to locate where a wine falls on the various continua discussed above. But we then must determine what all of that means in terms of wine quality. However, it is not yet clear how these continua are related to wine quality. Using the continua, we might describe a wine as having a round, mellow keynote, but it acquires greater frequency range at midpalate with expansive acidity soaring toward top notes and tannins that increasingly give the wine added breadth before

undertaking a dramatic compression on the finish. That may be descriptively accurate, but one might wonder, "so what?" Active wines are interesting because they are active. But not all changes are pleasing, and quiet wines are often the most profound. We have increased our powers of description but still need an account of what it all means.

To make sense of this, I think we must again invoke the power of metaphor as discussed in Chapters Five and Ten. We must grant that wines have "personality" and that wines with personality are of higher quality than wines that lack personality. The ultimate significance of structure in motion is that it gives us a foundation for attributing personality characteristics to wine.

From Vitality Forms to Personality: Describing the Individuality of a Wine

The purpose of this lengthy classification scheme is not simply to establish a list of categories. As noted, the movement of wine is crucial to a wine's distinctive "personality." The location of a wine on these various continua and the vitality forms associated with them contribute to this personality, although, to complete the model, we will need the discussion of aroma notes below. The list of personality traits, moods, and emotions that could be metaphorically expressed by wine would be lengthy. I will not attempt an exhaustive list, but I will select a few common themes that will illustrate what I have in mind.

Aggressive: The wine will be brisk or accelerated

on the movement-velocity scale; volatile, forceful, or explosive on the movement-variation scale; and high on the tension scale.

Dignified: The wine will be low on the velocity and variation scales, substantial in weight and concentration, toward the static and relaxed side of the activity and tension scales.

Energetic: The wine will be high on the movement-velocity and variation scales, on the low side of weight and viscosity, and midpoint to high on the kinetic scale.

To gain a complete picture of the power of metaphor to describe wine, we now must turn to the more familiar territory of wine aromas to show how they contribute to the attribution of feeling states and personality traits.

The Meaning of Aromas and Flavors

Basic and Formal Sensory Impressions: Aromas and Flavors

The most familiar aesthetically relevant properties for wine lovers are individual sensory impressions. These are aroma, flavor, or texture notes, the kind of information we find in aroma and texture wheels and in the tasting grids used by certification organizations. These basic sensory impressions can be identified as individual properties—for instance, a wine might taste of black cherry or vanilla. But with regard to aesthetic appreciation, how these aromas are presented matters more than

their individual identities. The intensity or clarity of the aroma note makes it aesthetically appealing. And individual sensory impressions interact with each other and are part of larger complexes of aromas, which then exhibit properties such as complexity or balance. Because intensity, balance, complexity, and clarity are about how the aromas are presented, they are formal properties—they refer to the wine's form. Many of these formal properties are complex, relational, and emergent properties that characterize a group of elements or the wine as a whole. To consider a wine balanced, pleasant, muscular, delicate, or harmonious is to take into account a wide variety of properties or elements and to characterize them as a whole.

Included among the holistic or emergent properties are abstract meanings that we attribute to wines based on their formal, relational, and holistic properties. Metaphors such as "profound," "generous," "flamboyant," or "majestic" attribute properties to a wine that give it meaning and are thus essential to wine's aesthetic potential. Part of my goal in this appendix is to lay out some of the various dimensions of wine that express these meanings.

The sensuous enjoyment we get from a wine has less to do with which specific aromas are present and more to do with their impact or presentation, although whether an aroma is typical of the grape or region can sometimes be an aesthetic consideration. Tasting notes are often criticized for being a list of fruit aromas—a so-called "fruit salad." There is some truth to that criticism because

a list of fruit aromas tells us nothing about how they are presented or how they interact with other features. The formal and emergent properties that explain how aromas and flavors are organized are the most important considerations for aesthetics. Thus, in what follows, I will focus on formal properties and ignore specific, individual aromas, which are covered in almost every book devoted to wine appreciation.

In addition to individual aromas, the basic tastes—sweet, sour, bitter, and umami (in aged wines)—are crucial to a wine's overall impact. (Saltiness is seldom a dominant taste in wine.) These basic tastes also contribute to a wine's meaning.

Formal Arrangement of Flavors and Aromas

Tone

"Tone" refers to the general character of the aroma and flavor notes. The dominant aroma and flavors in a wine will exist along three tone continua:

Light…Dark

Fresh…Developed…Decayed

Bright…Dull

Light-dark is a multi-modal judgment that relies on the color of the fruit with which the aroma is associated and the degree of concentration and

density of the aromas. A young, red raspberry-scented Beaujolais with airy, diluted flavors will be perceived as light in tone. A rich merlot with dominant black-plum and chocolate aromas will be perceived as dark. The fresh-to-developed continuum refers to the degree to which the aromas seem subject to heat, age, or oxidation. Fresh peach is one thing, stewed peaches quite another, peach degraded by oxygen exposure yet another. Associations with life stages readily come to mind. The bright-to-dull continuum may seem to overlap with the first two, but it is important to keep them separate. A dark-fruited wine showing cassis and fig can be bright or pale. The bright-dull continuum suggests a variety of metaphorical associations with personality.

I am devoting attention to the tone continua because the location of a wine on these continua has an important impact on the metaphorical meanings we might assign to a wine. Dark wines that are midway on the bright-dull continua might exhibit a somber or brooding dimension. Light wines, especially when bright, may express something summery or light-hearted. Brooding and light-hearted are relational and holistic properties and will be discussed in more detail below. But there is an obvious association with dark personalities and light-hearted personalities that provide some content to the metaphorical meanings attributed to a wine.

Category-relative Continua

General categories of aroma notes also have meaning. Aromas can be earthy, minerally,

fruity, floral, meaty, or herbaceous, and these will often have connotations suggesting metaphorical meanings. I doubt that in wine appreciation we can ignore these connotations, even though they are likely to introduce a degree of subjectivity.

Basic Character: Fruit…Earth…Mineral

Herbaceous: Green…Pungent

Spice: Peppery…Warm

Intensity

Faint…Bold

Intensity is a prominent feature of some wines and a marker of quality for some varietals and regions. "Intensity" here refers to the prominence and assertiveness of aromas and flavors. (Intensity was also important in the discussion of mouthfeel and movement above.) Some varietals and some wine styles may lack intensity, featuring finesse and subtlety over power. Thus, intensity isn't always a virtue. Intensity can characterize individual aromas and flavors or the wine as a whole. Intensity can be a regional property, as well, characterizing certain aspects of the wine, while other aspects may exhibit subtlety.

Complexity

Simple…Complex

With regard to judgments of quality, complexity may be the most important. It is almost always a virtue, other things being equal. However, mere complexity without balance may make a wine

seem too loud or garish. Complexity refers to the number of flavors, aromas, variations, or textures that can be discerned. However, there are a variety of ways a wine can be complex. Some wines are filigreed. Their complexity comes from aromas and flavors that present as delicate or ornamental. The complexity can be ephemeral, with aromas notably emerging and disappearing over time. In some wines, their complexity is dappled with aromas and flavors that seem to exist in patches and show a variety of tones or shades. And wines can appear layered, with flavor seams built on top of each other.

Delineation

Clear...Ambiguous

Delineation is an important marker of quality. Aromas can present themselves with clarity, or they can be ambiguous or even murky. Generally, wines that present with clarity are considered of higher quality, although I will mention an exception below in the discussion of background. This dimension is distinct from open...closed. A wine's aromas can have clarity without much shading of one aroma into another, yet still seem muted.

Identity

Candid...Allusive

I mention this here because there is some overlap with delineation. However, the aromas of a wine can be sharply delineated without their identity

being clear. Candid aromas present their character clearly and without ambiguity. Allusive aromas don't announce what they are so clearly. They provide hints and feints.

Foreground/background

Some aroma notes are more prominent than others. The most dominant aromas are in the foreground. Some of the less dominant aromas appear to be less prominent but are, nevertheless, persistent as a kind of foundation. They do not come and go but always seem discernable without being assertive. That is what I mean by background. Background aromas exist on a continuum of clear to murky. Depth is a quality that refers to wines with complexity in the background and allusiveness—the aromas are suggestive hints that never develop clear delineation.

Penumbral and Framing Effects

A penumbra is the outer edge of something. Some aromas seem to frame or surround other aromas. These effects encourage the relevant metaphors. A dark outer edge would be haunting; a lighter outer edge is a halo.

Frequency Range

Top notes…Mid-range notes…Bottom notes

This dimension relies on an analogy with the perception of musical pitch. Frequency range was also discussed above as a dimension of a wine's structure in motion. "Top notes" refer to aromas

and flavors that have some of the character of high-pitched musical melodies. Just as higher musical pitch refers to rapid oscillation of sound waves, often associated with lighter, ephemeral sounds or piercing, sharp sounds, the aromas and flavors described as top notes may be light, active, and ephemeral, or they may appear sharp, angular, or bright, pushed to the foreground by acidity. Bottom notes are defined in terms of dark fruit flavors, tannins which often have a bitter taste, and the richest earth notes. These are analogous to bass notes in a musical piece. Fruit, earth, and herbal notes supply the mid-range notes because they are midway on the tonal range discussed above. These are often the core aromas and flavors in a wine, establishing a center around which other properties circulate.

Aroma Profile

Balanced…Unbalanced

This refers specifically to aromas, not to structure, which was covered above. It relates to the relative prominence of particular aromas and whether they seem proportionate. Identifying aromas as unbalanced requires a judgment about the whole aromatic picture of the wine. Aromas that might be acceptable in small doses may be unpleasant if too prominent. This is especially true of aromas that, when too prominent, are considered flaws, such as the "barnyard" aromas caused by brettanomyces or the sharp, pungent aroma of volatile acidity. Simple wines can be pleasant if their aromas are balanced but unpleasant if one aroma is too dominant.

Innovation

>Typical…Unconventional…Otherworldly

>This continuum refers to whether the aroma profile is expected, given the varietal and region or whether it is atypical or unusual.

Intelligibility

>Accessible…Difficult…Incomprehensible

>There may be some overlap with "innovation." Intelligibility refers to how easy or difficult it is to understand and contextualize a wine. Difficult wines present aromas that resist assessment and leave one uncertain about what to say. Difficulty is not necessarily a defect. The very best wines leave us speechless.

Metaphorical Attributions

As noted above, part of the significance of the continua is that they provide the foundation for using appropriate metaphors to describe wines. Metaphors can be used to make associations that will help pull together the various dimensions of a wine and view it as a whole, thus providing a description of the overall character of a wine more informative than a list of flavors or textures. Although we can break a wine down into individual flavors and textures, a full appreciation of a wine involves understanding how multiple dimensions form holistic properties. Metaphor helps us articulate those holistic properties.

The Attribution of Emotion or Personality Characteristics: A Few Examples

The complexity of wine provides a foundation for abundant metaphorical associations that help us characterize the "personality" of a wine. I list a few here in order to provide examples of what I have in mind. These are not intended to be precise characterizations. We cannot expect precision from this exercise.

> Amiable: The wine will occupy a low-to-midpoint position on the velocity scale, low on the forceful scale, and relaxed on the tension scale. Aromas will be light or bright in tone, and not excessively allusive or ambiguous, and no more than midpoint on the intensity scale.

Carefree: The wine will be high on the movement-variation scale, relaxed but kinetic, lightweight, and not too dense. Aromas will be light and bright but could be ambiguous, allusive, and tend toward higher intensity.

> Brooding: Highly concentrated, dark-fruited red wines, with intensity coming from just a few focused aromas, with depth that comes from multiple nearly-indiscernible flavor notes that require exploration, with low acidity to generate a deliberate sense of movement, an impression of weight on the palate, and broad tannins with some grip to add to the sense of massive force exerted by the wine.

> Languorous: The wine could be white or red and fruity enough in tone to be modestly hedonistic but without much complexity. There should be

some weight to suggest torpor, and deliberate, low-intensity textural changes between beginning, mid-palate, and finish, with nothing that would jump out and grab your attention, yet with fluttering, inconstant flavor and aroma notes to suggest a lack of focus.

Angry: An angry wine will show bold, dark fruit; thick, aggressive tannins; high alcohol; and searing acidity supported by accelerated movement. It will be on the powerful side of the force scale, expansive on the movement-variation scale, and high on the tension scale. Some cabernet sauvignon is best described as angry, especially if it hasn't had time to age in the bottle.

A Summary of Important Holistic Properties[3]

1. Dimension: Complex…Simple
2. Impact [quantitative]: Intense…Muted
3. Impact [qualitative]: Striking…Delicate
4. Balance: Harmonious…In equilibrium…Disjointed
5. Size: Large…Spare
6. Structure: Integrated…Disjointed
7. Tension: Tense…Relaxed
8. Energy: Dynamic…Static
9. Distribution: Blunt…Full of finesse
10. Maturity: Fresh…Evolved

11. Expressive Range: Generous…Austere

12. Luminance: Bright…Dull

13. Allure: Seductive…Aloof

14. Drinkability: Ready…Age-worthy…Peak…Declining

15. Architecture: Angular…Rounded

16. Mood: Cheerful…Dour

17. Style: Polished…Rough

18 Originality: Distinctive…Generic

19. Dynamic Range: Wide…Narrow

20 Clarity: Candid…Allusive

21. Evolution: Elegant…Clumsy

Notes

1 Clark Smith, *Postmodern Winemaking*, Berkeley: University of California Press, 2013, p. 100.

2 Andrew Jefford, "Understanding Tension in Wine," *Decanter*, September 17, 2018. https://www.decanter.com/magazine/andrew-jefford-tension-in-wine-400209/ accessed 9/5/2020

3 I thank Clark Smith for providing an initial schema for these holistic properties.

INDEX

A

Adagio, Samuel Barber, 150
aesthetic, the
 aesthetic attention, 176, 186, 190, 192, 194–200, 207, 263, 276, 306, 317
 aesthetic concepts, 9, 79, 188–92, 247, 275
 aesthetic experience, 16, 70, 176, 180, 183, 185–95, 199–202, 239, 245, 285, 288
 aesthetic experience of wine, 161, 190, 192, 281
 aesthetic intentions, 71–72, 79, 81, 84, 89–91, 94, 223
 aesthetic objects, 53, 165, 171, 191, 194, 207, 218, 291
 aesthetic pleasure, 12, 80–81, 94, 192, 263, 280
 aesthetic properties, 79, 81–82, 84, 86–87, 89, 187–88, 205, 232, 234, 243, 247, 249, 275–76
 formal, 191, 326–27
 supervenience, 275
 aesthetic response, 14, 40, 49, 247, 260
 aesthetics, history of, 136, 231, 280
 aesthetic value, 10, 35, 39, 130, 222, 234, 239, 269
 judgments, 12, 17–18, 240
 non-aesthetic properties, 81–82, 85–86, 94, 246, 275
 practice, 186, 234, 236, 271
 See also holistic properties
 aesthetics, general account of, 7, 10, 15, 53–54, 65, 74, 80, 231, 243–45, 275, 280
affective states, 148–49, 156, 159, 162

agreements, intersubjective, 9, 17, 40, 230–32, 234, 237–40, 242–43, 253, 269, 276
alcohol levels in wine, 105, 113, 238
Alexis Bailey Vineyards, 36
American Wine Industry, 104–5, 120
anti-realism, 229, 273. See also non-realism
apprenticeship of signs, 256, 258, 261, 264, 266–70, 278
aroma wheel, 18, 121–23, 133
Arp, Jean, 76
art, 69–77, 79–82, 87–88, 90–95, 99–100, 135–38, 140, 142, 145, 181–82, 184
 art worlds, 54, 80, 101–3, 240, 280, 298
 definition of, 80, 82
 value of, 80, 84
art criticism, 168, 170, 182, 195
Artesa Winery, 24
assemblage theory, 51, 67, 115, 133, 138, 252
authenticity, in winemaking, 41, 59, 100, 235–36, 239–42
Azimov, Eric, 68

B

Barolo, 100, 103, 114, 179, 226
Barolo, Aurelio Settimo, 131
Baudelaire, Charles, 162
Baudry, Bernard, 219
Beardsley, Monroe, 168, 181
beauty, 17–18, 23, 28, 191, 200, 202, 244–45, 248, 279–83, 285–92, 294–300

judgments of, 244, 281, 288
Bechtold Ranch Vineyard, 132
Becker, Howard S., 99, 101, 132
Bennett, Jane, 13, 48–54, 56, 67
Bergson, Henri, 39, 139, 164, 221
biodynamic farming, 58–59, 68, 92
Black Star Farms Winery, 35
Bloom, Paul, 30, 37
Bodegas Torres, 125
Bogue, Ronald, 277
Bonné, Jon, 133
Bonny Doon, 67, 79, 92–94
Bosker, Bianca, 203, 220
Brown, Elaine Chukan , 134
Burham and Skilleas, 12, 16–19, 71–72, 79, 81, 90, 93, 186–90, 234–36, 240–42, 273–75, 278, 300
aesthetic project, 187–90, 235, 242, 278
The Burial of the Count of Orgaz, 170

C

Caballero, Rosario, 211–12
Cain Vineyard and Winery, 299
Callen, Donald M., 181
Canguilhem, Georges, 299
capacities, relational nature of, 250–51, 267
categories, used to classify wines, 121, 198–99, 233, 237–38, 267–68, 297
conventional, 263, 278
new, 103, 212
normative, 236, 238
Central Coast Group Project Winery, 162
Cézanne, Paul, 78
Chateau Margaux, 279
Château Montelena, 108

Chateau Musar, 35
Child, Julia, 105
Cinder Winery, 181
clarity, as an aesthetic criterion, 175, 292–96, 326, 330, 336
Climate Change, 149, 238
Clarke, Oz, 108
Cochran, Courtney, 41, 66
cognition, and wine appreciation, 175–76, 200, 278, 292, 300. See also knowledge
communities, aesthetic, 125, 127, 169, 172, 291
community, of wine lovers, 36, 41, 98–99, 102–3, 130, 137, 265, 300
Compton, Elizabeth, 275
conventions, as organizing features of communities, 85, 99–103, 108, 207
Coturri, Tony, 64
Cox, Bobby, 181
creative theory of art, 81, 86–87, 92
creativity, 56, 73, 76, 78–86, 88, 90, 97–99, 262, 264
creative intentions, 73, 76, 87–88, 90
criticism, 114, 168, 175, 178, 180–83
criticism and wine reviews, 112–13, 166, 168–69, 171–72, 179, 209–10. See also metaphor and wine description

D

Dal Forno Winery, 299
Darwinian evolution, 42, 46, 139
Deleuze, Gilles, 54, 67, 133, 163, 202, 254–58, 277
Deroy, Ophelia, 276
Dewey, John, 36
Dierberg and Starlane Vineyards, 131–32

differentiation, importance of, 47, 119, 122–24, 140, 172, 262. See also variations, importance of

disagreements in describing and evaluating wine, 201, 222, 224, 226–29, 231–32, 234, 236, 238, 243, 248–49, 251

disinterestedness, 191–92, 201, 278, 288, 290, 300

dispositional properties, 74–75, 77–78, 245, 247–49, 251, 257–58, 261, 265, 276, 297
and manifestation conditions, 247–48, 250, 275–76
and manifestation events, 246, 249–50, 276–77

dispositional realism, theory of, 163, 244, 249–50

dispositions
manifestation, partial, 297
manifestation type, 276
unactualized, 138, 140

distinctiveness, as a criterion of wine quality, 89, 121, 128, 180, 206–7, 210, 214, 292

diversity, importance of, 125, 235–36, 240–42

Domain Drouhin, 201

Duchamp, Marcel, 81

E

Edwards Vineyard and Cellars, 180

El Greco, 170

Elster, John, 76, 93

emergent properties, 10, 19, 67, 123, 205, 212, 274, 306, 326

emerging wine regions, 115, 125

emotions
cognitive dimension, 147, 153
expressed by wine, 141–43, 145–53, 155–60, 163, 165–66, 175, 324–25, 334

empiricism, 245, 274

ephemerality, of beauty, 283

ephemerality in wine, 162, 282–84, 291–92, 295, 298–99, 330, 332

European wineries, 107, 169, 227

evaluation, of wine, 114–15, 168–69, 171–72, 185, 195, 227–28, 235, 237, 267, 271

exemplification, in Goodman, 141, 143

expertise in wine tasting, 222–27, 231, 237, 243, 250, 261, 271–72

expression, 18–19, 71–72, 79, 138, 140, 142–43, 146, 148, 158, 160–65, 167, 206, 306
theories of, 15, 136, 142, 148, 163

F

Fasoli Geno Winery, 65

Feiring, Alice, 60, 68

fine arts, 80, 184–85

France, 68, 105, 107, 111, 113, 120, 125, 127–28, 143, 236, 240

Frédéric Brochet, 272

French-American hybrid grapes, 36

French image of wine, 105–6, 109, 113, 119

Frey, James, 80

Frost, Robert, 203

G

Gallo, E & J, 104

Gaut, Berys, 94

generalizations, in science, 55, 120, 245

Goldsworthy, Andy, 78, 93

Goode, Jamie, 68, 133, 164, 220, 273–74, 277

Goodman, Nelson, 143, 163–64

Grahm, Randall, 67, 80, 90, 92–94

Grant, James, 181–82
Grau, Christopher, 300
Gravner Winery, 162
Guattari, Felix, 67, 133
Guernica, 137

H

Harrop, Sam, 133
Heidegger, Martin, 300
Heimoff, Steve, 132
Helen Frankenthaler's Scarlatti, 292
Hemingway, Ernest, 21
Hisano, Ai, 133
Hochar, Serge, 35
holistic properties, 58–59, 182, 186, 189, 205, 209–10, 212, 306–7, 309, 326, 328, 333, 335
homeostasis, 42, 45–46
homogeneity, threat to wine industry, 88, 115–19, 121, 123–25
Howell, Chris, 299
Hume, David, 274

I

ideal observer theory, 274
imagination, 78, 81–82, 85, 88, 174–75, 182, 197, 200, 214, 216, 218, 253–55, 263–64
Impressionism, in art, 77
industrial winemaking, 12, 55, 58
innovation, 109–10, 131, 207, 210, 214
intentions, 15, 49–52, 54–55, 71–72, 79–80, 82–84, 86–88, 90–92, 94–95, 163, 223
 artistic, 79–80, 84
 See also, aesthetic, the, aesthetic intentions
 unconscious, 87, 94

interpretation, 89–90, 144, 149–50, 153, 208
intersubjectivity, 201, 229–30, 242, 245, 255, 262
 and norms, 232, 235, 291, 300
intoxication, 18, 70, 163, 274
Isenberg, Arnold, 170–71, 181
Itzhak Perlman, 75

J

James Grier Miller, 66
Jefford, Andrew, 319, 336
Jolie-Laide Winery, 65
Joyce, James, 273
judgments
 of quality, 234, 329
 suspended, 268

K

Kant, Immanuel (*see also* disinterestedness), 12, 63, 191–92, 194, 196, 201–2, 229, 244, 254, 287–89, 299–300
Kelly, Ellsworth, 76
Kivy, Peter, 147–48, 154, 165
knowledge, and wine appreciation, 27, 162, 172–73, 175, 226, 237, 260, 266, 270
Korsmeyer, Carolyn, 18
Kramer, Matt, 63, 68, 71, 93
Krause, Melanie
Kundera, Milan, 167

L

Lafite-Rothschild, 31
learning, its role in appreciation and criticism, 36, 161–62, 224, 256, 258–59, 261–63, 265–70, 277

Left Foot Charley Winery, 35
Lewis, C.S., 183
life
 characteristics of, 14, 39, 42, 46, 141
 expression of, 140, 142
 and living systems theory, 14, 46, 66
 See also vitality
Livingston, Paisley, 95
love, 21–23, 25–28, 30, 32, 35, 65, 288–91, 300–301

M

Master of Wine, 223
materialism, 54
Messiaen, Olivier, 282
metaphor
 conceptual metaphor theory, 211
 cross-modal, 316, 32
 as game of make-believe, 215–17
 novel, 209–10, 276
 theories of, 146, 214
 and wine descriptions, 141, 165, 204–6, 208–20, 275–76, 293, 306–7, 326, 331, 333
micro-oxygenation, 57, 93
Milagro Vineyards, 181
minerality, as wine descriptor, 219, 264, 295, 311, 316–17, 322, 329
Molnar, George, 245, 275
Mona Lisa, 137, 287
Mondavi, Robert, 106
Monet, Claude, 92, 298
Moran, Richard, 299–300
mouthfeel, of wine, 45, 205, 211, 305, 307, 309, 311–12, 329
movement, perceived, of wine on the palate, 151–57, 162, 289, 293–94, 296, 305–8, 312–14, 318–22, 324, 331, 334, 336
Mozart, Wolfgang Amadeus, 92, 149

Mumford, Stephen, 275
music
 and composition, 90–91
 and emotion, 148–50, 153
mystery, of wine, 29–30, 32, 55, 156, 199, 283, 297–98

N

Nader, Ralph, 110
Nanay, Bence, 193–95, 201–2
Napa's Beaulieu Vineyards, 106
natural wine, 57–66, 68, 88, 103, 125, 239, 241, 287
nature, wine's expression of, 7, 9, 11–14, 30, 33–34, 36, 51–52, 55–56, 61–62, 64–65, 71, 73, 97–98, 101–2, 137–38
Nehamas, Alexander, 25, 36, 282, 287, 289, 299
Nine Inch Nails, 149
Noble, Ann, 121
non-aesthetic supervenience base, 275
non-realism, 225, 230–32, 234, 237, 239, 243–44, 248, 252–53, 270
norms
 role in regulating wine production and appreciation, 99–102, 109, 125, 131, 169, 172, 233–38, 240, 242, 262, 265
 sub-optimal in living systems, 284–85, 300

O

objectivism, 10, 13, 39–40, 54, 65, 224, 233, 245–46, 272–73
objectivity
 non-realist accounts of, 229, 236
 in wine tasting, 14, 17, 221–26, 230, 232–33, 237, 239–42, 244, 248, 252–54, 256, 268–71, 273–76

ontology, of wine, 11, 14–15, 18–19, 40, 244, 274–75

originality, in winemaking, 13, 80, 85, 87, 89, 172, 283, 336

oxygen, importance in winemaking, 44–46, 72, 285–86

P

Pacheco, Stephen, 93

Parker Jr., Robert, 110–13, 115–17, 121, 206, 208

Penfold's Grange, 279

perception, philosophy of, 16, 192, 201–2

Perissos Vineyard and Winery, 65

personality, in wine, 143, 156, 159–63, 289, 291–92, 295, 298, 306, 324–25, 328, 334

Perullo, Nicola, 41, 66, 94, 133, 164–65, 220, 273

Peynaud, Emile, 113

Pheasant Ridge Winery, 181

phenomenology, 195–96, 244, 273, 283

Picasso, Pablo, 69, 84

pleasure, in wine tasting, 26, 31, 209, 227–28, 244, 263, 267, 280–83, 289–90

Pollock, Jackson, 76, 84

Ponty, Jean-Luc, 75

Popelouchum Vineyard, Bonny Doon, 92

preferences, subjective, 62–63, 228, 236, 282, 289

Prial, Frank, 110

Proust, Marcel, 299

R

Radiohead, 293

realism, 19, 225–26, 228–29, 243, 275
 aesthetic, 19, 226, 250, 275
 See also dispositional realism

receptivity, 74, 78, 85–86, 256

recognition, failure of, 198–200, 202

relativism, 201, 233

Rembrandt, 240, 288

representation, in art, 136–37
 resemblance theories, 146–47

rhythm, in wine, 156, 292–95, 297–98, 305, 307, 312–13, 323

ripeness, of grapes at harvest, 103, 113, 120–21, 126, 238

Robinson, Jancis, 134, 188

Robinson, Jenefer, 165

Romanée-Conti, 287

Rothko, Mark, 282

S

Sam Harrop MW, 68

Sampler, Scott, 162

Sassicaia, 279

Scholium Project, 132

Schooner, Abe, 132

Schoonmaker, Frank, 107, 111

Screaming Eagle, 200, 279

Scruton, Roger, 300

self-expression, artistic, 72–73, 77, 135

Sellers, Wilfred, 229, 274

sensibility, 26, 87–88, 90–91, 251, 253–54, 261, 263, 266, 269–70, 289, 298

sensitivity thresholds, 260

sensual dimension of wine, 30, 143–44, 291, 293, 295

Shakespeare, 286

Shapin, Steve, 133, 164, 220

Shepherd, Gordon M., 134

shi, Chinese concept of, 53, 67, 296
significance of wine, 10, 137, 171–72, 174, 264–65, 268–70, 297, 300, 333
Simcic, Marjan, 163
Smith, Barry C., 12, 17, 19, 226–27, 229, 249, 273–74, 276
Smith, Clark, 66–68, 92–93, 296, 301, 311, 336
sommeliers, 11, 99, 122, 130, 167, 187, 189
Souches Meres, 197
Stag's Leap Wine Cellars, 108
standards, evaluative, 116, 119, 121, 130, 169, 185, 234, 237
Steele, Danielle, 273
Stendhal, 297, 301
Stern, Daniel, 151–53, 157–58, 165
Stravinsky, Igor, 149
structure, in wine, 43, 45, 65–66, 155, 165, 305–7, 309, 312, 324, 331–32, 335
Suárez-Toste, Ernesto, 211–12, 220
subjectivism, 9–10, 12–14, 17, 39–40, 54, 56, 222, 229, 236, 248, 251
argument for, 222–23, 225
subjectivity, 14, 17, 19, 221, 223–24, 244–45, 247, 255–56, 259, 266, 268, 270, 276
sublime, 197, 202, 214, 255, 297
supervenience, 275
Sweeney, Kevin W., 18, 165
swimming, account of learning a skill, 256, 258–59, 261–62
system, self-organizing, 46

T

tasting notes, 144, 155, 205, 210–11, 213, 220, 294–95, 305–7, 311, 318, 326

Tchelistcheff, André, 106
Teague, Lettie, 25, 36
technology, in winemaking, 33, 58, 60, 62, 68, 72, 239
tension, in wine, 300, 306, 318–19, 321, 335
territorialization, 133
terroir, 68, 73, 79–80, 88–90, 100–101, 125, 132, 137, 235–36, 240–41
texture, in wine, 31, 260, 264, 286, 289, 296, 309, 319, 321, 330, 333
Theise, Terry, 135, 177, 182, 197–99, 202, 220, 255, 263, 277, 297
thing-power, 14–15, 50–52, 54–57, 60–61, 64, 67, 241
Thomas, Tyler, 131
thresholds, aroma sensitivity, 53, 199, 227, 259, 261, 292, 296
Thurman, Howard, 97
Todd, Cain, 12, 17–19, 163, 228, 232–34, 236, 239, 243, 274
Tomasi, Gabriele, 94
Torres, Miguel, 266
traditions, wine, 15, 27, 97–98, 102–3, 108–9, 112, 114, 234, 238, 240, 242
Trail Estates Winery, 65
Trisaetum Winery, 80
Tucker, Don M., 36
typicity, as a criterion of quality, 233–34, 238, 240, 242

U

uncertainty, aesthetic appeal of, 21, 50, 55, 256
unity, as aesthetic criterion, 191, 209–10, 256, 275, 289, 292, 294, 296–99
unpredictability, of nature, 34

V

value
 instrumental, 200
 non-instrumental, 62, 173, 184
Van Gogh, Vincent, 300
Van Gogh, Vincent, Peasant Woman, 191
variations, aesthetic importance of, 17–18, 40, 46, 56, 64–65, 68, 117–21, 125–27, 129–31, 138, 140, 160–61, 178–80, 210, 212, 241–43, 264–65, 291–92
varietal labeling, 107, 123–24
Velleman, David J., 277
vitalism, 53–54
vitality, 7, 12–16, 18, 48, 54, 56, 138, 140–42, 151–53, 161, 167
 aesthetic appeal of
 as an expression of life, 25, 43, 46–48, 56, 136–40, 142, 163–64, 284–86
 and forces, 46, 54, 56, 67, 139–40, 151–53, 257, 320
 how to taste
 and living systems, 46–48, 59
 how to taste, see appendix
vitality forms, 151–57, 159–62, 275, 314–15, 318–19, 324
 in music, 160
Vox Vineyards, 125, 266

W

Walton, Kendall, 214–18, 220
Whitehead, Alfred North, 244, 275
Whitman, Walt, 219
Wine and Spirits Educational Trust, 185
wine appreciation, responses, appropriate, 175–77, 179, 182, 184–85, 202
wine criticism
 authority of, 111, 114–15, 243
 purpose of, 168–69, 173
wine critics, ideal, 277
wine education, 9, 122, 198, 222, 254
wine evaluation, wine scores, 112, 116–17, 168
winemaking, 13–15, 34, 36, 44, 46, 49–51, 55–57, 72–73, 79–81, 88–92, 95, 97–100, 107, 132–33, 240–41
 artisanal, 32, 67, 98
 and creativity, 88-92
 building structure, 43–45, 93
 industrial, 32, 55, 67, 72
 low intervention, 45, 63, 67–68
 natural, 58–59, 68, 240–41
wine science, 98, 107, 120, 122, 124, 128
WineSmith Winery, 93
wine tasting
 blind tasting, 10, 108, 187–88, 222–23, 270, 305
 creative, 112, 270
 referential model of, 122–23, 182
 tasting vitality. See appendix
 in winemaking, 88–89, 185, 187
wine writing, 110, 130, 167, 171, 203–5, 209, 212, 214
Woolf, Virginia, 279

Z

Zangwill, Nick, 81–84, 86–87, 94

BIBLIOGRAPHY

Andreasen, Nancy C. "A Journey into Chaos: Creativity and the Unconscious." in *Mens Sana Monographs*, 9 (1) (2011). https://www.ncbi.nlm.nih.gov/pmc/articles/PMC3115302/

Azimov, Eric. "Natural Winemaking Stirs Debate." *New York Times*, June 16, 2010. https://www.nytimes.com/2010/06/16/dining/16pour.html

Beardsley, Monroe. "What are Critics For" in *The Aesthetic Point of View: Selected Essays*. Edited by Michael J. Wreen, and Donald M. Callen. Ithaca: Cornell University Press, 1992.

Becker, Howard S. *Art Worlds*. Berkeley: University of California Press, 2008.

Bennett, Jane. *Vibrant Matter: A Political Ecology of Things*. Durham: Duke University Press, 2010.

Bergson, Henri. *Creative Evolution.* Mineola: Dover Publications, 1998.

—*The Creative Mind. An Introduction to Metaphysics*. New York: The Philosophical Library, 1946.

Bloom, Paul. How Pleasure Works: The New Science of Why We Like What We Like. New York: W.W. Norton and Company, 2010.

"The Lure of Luxury" in *Boston Review*, November 2, 2015. http://bostonreview.net/forum/paul-bloom-lure-luxury.

Boghossian, Paul A. and David J. Velleman. "Colour as a Secondary Quality." *Mind*, vol. 98 (1989).

Bogue, Ronald. "The Master Apprentice" in *Deleuze and Education*, edited by Inna Semetsky. Edinburgh: Edinburgh University Press, 2013.

Bonné, Jon. "When It Comes to Wine, Weird is the New Normal—And That's for the Better." *The Washington Post,* 4/19/2019. https://www.washingtonpost.com/lifestyle/food/when-it-comes-to-wine-weird-is-the-new-normal--and-thats-for-the-better/2019/04/19/c2f878a4-611c-11e9-bfad-36a7eb36cb60_story.html. accessed 9/7/2020

Bosker, Bianca. "Is There a Better Way to Talk About Wine?" *The New Yorker*, July 29, 2015. https://www.newyorker.com/culture/culture-desk/is-there-a-better-way-to-talk-about-wine

Bowden, Sean. "Deleuze's Antirepresentationalism: Problematic Ideas, Experience, and Objectivity" in *Deleuze and Pragmatism*, edited by Sean Bowden, Simone Bignall, and Paul Patton. New York: Routledge, 2015.

Brown, Elaine Chukan. "The Story of California Chardonnay, Part 1-4." *Jancis Robinson* (website) https.//www.jancisrobinson.com/articles/the-story-of-california-chardonnay-part-1, accessed 6/24/2020.

Burnham, Douglas and Ole Skilleås. *The Aesthetics of Wine*. New Jersey: John Wiley and Sons, 2012.

—"Patterns of Attention: "Project" and the Phenomenology of Aesthetic Perception" in "Wineworld: New Essays on Wine, Taste, Philosophy and Aesthetics." Edited by Nicola Perullo, special issue *Rivista di Estetica* 51 (2012). https://journals.openedition.org/estetica/1388

Canguilhem, Georges. *The Normal and the Pathological*. Edited by Carolyn R. Fawcett. New York: Zone Books, 1989.

Capra, Fritjof and Pier Luigi Luisi. *The Systems View of Life: A Unifying Vision*. Cambridge: Cambridge University Press, 2014.

Clark, Andy. Surfing Uncertainties: Prediction, Action, and the Embodied Mind. Oxford University Press, 2015.

Cochran, Courtney "Is Wine Living?" *Appellation America* 5/6/2009. http://wine.appellationamerica.com/wine-review/700/Is-wine-living.html

Compton, Elizabeth Ashley Zeron "A Dispositional Account of Aesthetic Properties," PhD. dissertation, State University of New York at Buffalo (2012). https://fdocuments.us/document/elizabeth-zeron-compton-a-dispositional-account-of-aesthetic-properties.html

Deleuze, Gilles. *Bergsonism*. New York: Zone Books, 1991.

—*Desert Islands and Other Texts 1953-1974*. Los Angeles: Semiotext(e) Foreign Agents Series, 2004.

—*Difference and Repetition*. New York: Columbia University Press, 1995.

Deleuze, Gilles and Felix Guattari. *A Thousand Plateaus: Capitalism and Schizophrenia*. Minneapolis: University of Minnesota Press, 1987.

Deroy, Ophelia. "The Power of Tastes—Reconciling Science and Subjectivity" in *Questions of Taste: The Philosophy of Wine*, edited by Barry C. Smith. Oxford: Oxford University Press, 2007.

Dewey, John. "Qualitative Thought" in *On Experience, Nature, and Freedom*, edited

by Richard Bernstein Indianapolis: The Bobbs-Merrill Company, 1960.

Elliot, Andrew J. "Color and Psychological Functioning: A Review of Theoretical and Empirical Work." *Frontiers in Psychology*, Vol. 6 (2015). https://www.ncbi.nlm.nih.gov/pmc/articles/PMC4383146/

Elster, John. *Ulysses Unbound*. Cambridge: Cambridge University Press, 2000.

Feiring, Alice. "SF Natural Wine Week," *The Feiring Line* (blog) 8/25/2010. http://www.alicefeiring.com/blog/2010/08/sf-natural-wine-week.html

Furrow, Dwight. American Foodie: Taste, Art, and the Cultural Revolution. Lanham: Rowman & Littlefield, 2016.

Furrow, Dwight. *Ethics: Key Concepts in Philosophy*. London: Continuum Publishing Group, 2005.

Frey, James. Interview conducted by Dwight Furrow. Available at *Edible Arts*. https://foodandwineaesthetics.com/2017/02/08/winemaker-interview-james-frey-of-trisaetum-winery/

Gaut, Berys. "The Philosophy of Creativity." *Philosophy Compass*, vol. 5, no. 12 (2010).Goldstein, Robin, Johan Almenberg, Anna Dreber, John W. Emerson, Alexis Herschkowitsch, and Jacob

Katz. "Do More Expensive Wines Taste Better? Evidence from a Large Sample of Blind Tastings." *Journal of Wine Economics* 3, no. 1 (Spring 2008).

Goldsworthy, Andy. *Passage*. New York: Abrams, 2004.

Goodman, Nelson. *Languages of Art: An Approach to a Theory of Symbols*. Indianapolis: Hackett Publishing Company, 1976.

Goode, Jamie and Sam Harrop (MW). *Authentic Wine: Toward Natural and Sustainable Winemaking*. Berkeley: University of California Press, 2011.

Goode, Jamie. *I Taste Red: The Science of Tasting Wine*. Berkeley: University of California Press, 2016.

Grau, Christopher. "Can Wine Be Beautiful: A Philosophical Perspective." *The World of Fine Wine*, September, 2007.

Grahm, Randall. Interview conducted by Dwight Furrow. Bonny Doon Vineyard Blog, Posted May 15, 2017. https://www.bonnydoonvineyard.com/aesthetics-of-wine-prof-dwight-furrow/ accessed10/14/2020

Grant, James. *The Critical Imagination*. Oxford: Oxford University Press, 2013.

Heidegger, Martin. *Poetry Language, and Thought*, Translated by A. Hofstadter. New York: Harper & Row, 1971.

Heimoff, Steve. "I Learn a New Lesson About Wine Writing." Steveheimoff.com (blog), 6/1/2015. http://www.steveheimoff.com/index.php/2015/06/01/

ambiente-i-learn-a-new-lesson-about-wine-writing/ accessed 9/7/2020

Hisano, Ai. "Reinventing the American Wine Industry: Marketing Strategies and the Construction of Wine Culture." Harvard Business School Working Paper, 2017. https://www.hbs.edu/faculty/Publication%20Files/17-099_7df59b7d-8e42-414c-8478-7bb14ca90ba1.pdf Accessed 6/18/20

Hume, David. "On the Standard of Taste," *The Philosophical Works of David Hume*, edited by T. H. Green and T. H. Grose. Vol. 3. London: Longman, Green, 1875.

Isenberg, Arnold. "Critical Communication." *Philosophical Review*, vol. 58, no.4, 1949.

Jefford, Andrew. "Wine and Astonishment." *World of Fine Wine*, issue 36, 2012.

—"Understanding Tension in Wine." Decanter, September 17, 2018. https://www.decanter.com/magazine/andrew-jefford-tension-in-wine-400209/

Kant, Immanuel *Critique of Judgment*, translated by. Werner S. Pluhar. Indianapolis: Hackett Publications, 1987.

Kivy, Peter. Sound Sentiment: An Essay on the Musical Emotions including the complete text of The Corded Shell. Philadelphia: Temple University Press, 1989.

Korsmeyer, Carolyn. *Making Sense of Taste*. Ithaca: Cornell University Press, 2002.

Kramer, Matt. "When Did Wine Become So Partisan." *Wine Spectator*, July 15, 2014

—"Why Wine Isn't Art—and Why That Matters." *Wine Spectator*, October, 2008.

Livingston, Paisley. *Art and Intention: A Philosophical Study*. Oxford: Oxford University Press, 2005.

Lu, Xin, Poonam Suryanarayan, Reginald B. Adams Jr., Jia Li, Michelle Gayle Newman, James Z. Wanget

"On Shape and the Computability of Emotions" in *Proceedings of the 20th ACM International Multimedia Conference* (2012). https://www.researchgate.net/publication/262403563.

Mele, Alfred. *Effective Intentions: The Power of Unconscious Will*. Oxford: Oxford University Press, 2009.

Miller, James Grier. *Living Systems*. New York: McGraw-Hill, 1978.

Molnar, George. *Powers: A Study in Metaphysics*. Oxford: Clarendon Press, revised edition, 2007.

Moran, Richard. "Kant, Proust, and the Appeal of Beauty." *Critical Inquiry*, vol. 38, no. 2 (2012).

Morot, Gil, Frédéric Brochet, Denis Dubourdieu. "The Color of Odors." *Brain and*

Language, 79 (2001).

Mumford, Stephen and Rani Lill Anjum. *Getting Causes from Powers*. Oxford: Oxford University Press, 2011.

Nanay, Bence. *Aesthetics as Philosophy of Perception*. Oxford: Oxford University Press, 2016.

Nehamas, Alexander. Only a Promise of Happiness: The Place of Beauty in a World of Art. Princeton: Princeton University Press, 2007.

Osborne, Thomas. "Vitalism as Pathos." *Biosemiotics*, Vol.9 (2016). Published online, Feb. 2016, https://www.ncbi.nlm.nih.gov/pmc/articles/PMC4982892/#CR7

Parker, Jr., Robert. "Interview with Wine Critic Robert Parker, Jr." conducted by Ken Adelman, *The Washingtonian*, March 1, 2005, https://www.washingtonian.com/2005/03/01/interview-with-wine-critic-robert-parker/ accessed 8/20/2019

Perullo, Nicola, Editor. Wineworld: New Essays on Wine, Taste, Philosophy and Aesthetics. special edition, Rivista di Estetica, 51 (2012)

— "WineWorld: Tasting, Making, Drinking, Being" introduction to "Wineworld: New Essays on Wine, Taste, Philosophy and Aesthetics," edited by Nicola Perullo. *Rivista di Estetica*, issue 51, 2012. https://journals.openedition.org/estetica/1388?lang=en

Quandt, Richard E. "On Wine Bullshit: Some New Software?" *Journal of Wine Economics*, vol. 2, No. 2, (Fall 2007).

Robinson, Jenefer. Deeper Than Reason: Emotion and its Role in Literature, Music, and Art. Oxford: Clarendon Press, 2007.

Scruton, Roger. *The Aesthetics of Architecture*. Princeton: Princeton University Press, 1979.

Sellers, Wilfred. "Empiricism and the Philosophy of Mind" in *Minnesota Studies in the Philosophy of Science*, edited by H. Feigl & M. Scriven, vol. I, Minneapolis, MN: University of Minnesota Press, 1956.

Shapin, Steve. "The Tastes of Wine: Towards a Cultural History" in *Wineworld: New Essays on Wine, Taste, Philosophy and Aesthetics*, edited by Nicola Perullo, special edition, *Rivista di Estetica*, 51 (2012). https://journals.openedition.org/estetica/1388?lang=en

Shepherd, Gordon M. *Neuroenology: How the Brain Creates the Taste of Wine*. New York: Columbia University Press, 2017.

Smith, Clark. Postmodern Winemaking: Re-Thinking the Modern Science of an Ancient Craft. Berkeley: University of California Press, 2013.

Smith, Barry C., ed. *Questions of Taste: The Philosophy of Wine*. Oxford: Oxford University Press, 2007.

—"Beyond Liking: The True Taste of a Wine." The World of Fine Wine, Issue 58, (2017).

—"The Barry Smith Interview." Interviewed by Jamie Goode. *The Wine Anorak* (blog), October 29, 2015. https://www.wineanorak.com/wineblog/wine-science/the-barry-smith-interview-what-is-the-nature-of-wine-perception-and-is-wine-flavour-objective

—"The Objectivity of Tastes and Tasting" in *Questions of Taste: The Philosophy of Wine*, edited by Barry C. Smith. Oxford: Oxford University Press, 2007.

Spence, Charles and Qian Wang. "Wine and Music (I): On the Crossmodal Matching of Wine and Music" in *Flavour*, 4, article number 34 (2015). https://flavourjournal.biomedcentral.com/articles/10.1186/s13411-015-0045-x

— "Wine and Music (II): Can You Taste the Music? Modulating the Experience of Wine Through Music and Sound" in *Flavour*, 4, article number 33 (2015). https://flavourjournal.biomedcentral.com/articles/10.1186/s13411-015-0043-z

—"Wine and Music (III): So What If Music Influences Taste? *Flavour*, 4, article number 36, (2015). https://flavourjournal.biomedcentral.com/articles/10.1186/s13411-015-0046-9

Stendhal, De L'Amour" (On Love), Ch. 17, footnote, 1822.

Stern, Daniel. Forms of Vitality: Exploring Dynamic Experience in Psychology, the Arts, Psychotherapy, and Development. Oxford: Oxford University Press, 2010.

— The Present Moment in Psychotherapy and Everyday Life. New York: W.W. Norton and Company, 2004.

Stupacher, Jan, Michael J. Hove, Giacomo Novembre, Simone Schütz-Bosbach, Peter E.Keller. "Musical Groove Modulates Motor Cortex Excitability: A TMS Investigation." *Brain and Cognition*, vol. 82, Issue 2 (July 2013).

Suárez-Toste, Ernesto. "Metaphor Inside the Wine Cellar: On the Ubiquity of Personification Schemas in Winespeak." *Metaphorik*. Vol. 12 (2007). https://studylib.net/doc/8134494/metaphor-inside-the-wine-cellar--on-the-ubiquity-of-perso...

Sweeney, Kevin. "Structure in Wine," in "WineWorld: New Essays on Wine, Taste, Philosophy, and Aesthetics." Edited by Nicola Perullo, special issue, *Rivista di Estetica* 51 (2012) https://journals.openedition.org/estetica/1388?lang=en.

—The Aesthetics of Food: The Philosophical Debate about What We Eat and Drink. London: Rowman Littlefield, 2018.

Teague, Lettie. "A Case of You: When Oenophiles Fell for Wine." *Wall Street Journal*, February 10, 2016. https://www.wsj.com/articles/a-case-of-you-when-oenophiles-fell-for-wine-1455116412, accessed 8/25/18.

Terzis George and Robert Arp, eds. Information and Living Systems: Philosophical and Scientific Perspectives. Cambridge: MIT Press, 2011.

Theise, Terry. What Makes a Wine Worth Drinking: In Praise of the Sublime. Boston: Houghton Mifflin Harcourt, 2018.

Thomas, Tyler. Interview with Dwight Furrow. Available at *Edible Arts*. https://foodandwineaesthetics.com/2018/04/05/the-art-of-wine-a-conversation-with-tyler-thomas-of-dierberg-and-star-lane-vineyards/

Todd, Cain. *The Philosophy of Wine: A Case of Truth, Beauty, and Intoxication*. Montreal: McGill-Queens

University Press, 2010.

—"Quasi-realism, Acquaintance, and the Normative Claims of Aesthetic Judgement." *British Journal of Aesthetics*, vol. 44 (3) (2004), 277-296.

Tomasi, Gabriele. "On Wines as Works of Art" in *Wineworld: New Essays on Wine, Taste, Philosophy and Aesthetics*, edited by Nicola Perullo, special edition, *Rivista di Estetica*, 51 (2012). https://journals.openedition.org/estetica/1388?lang=en pp.

Tucker, Don M. Mind from Body: Experience from Neural Science. Oxford University Press, 2007.

Walton, Kendall. "Metaphor and Prop-oriented Games of Make Believe." *European Journal of Philosophy*, 1:1 (1993).

Whitehead, Alfred North. *Process and Reality*. New York: Free Press, 2nd edition, 1979.

Wine Institute press release, "California Wine Sales in U.S. market Hit $40 Billion in 2018," June 24, 2019. https://wineinstitute.org/press-releases/california-wine-sales-in-u-s-market-hit-40-billion-in-2018/ accessed 9/7/2020.

Zadra, Jonathan R. and Gerald L. Clore. "Emotion and Perception: The Role of Affective Information." *Wiley Interdisciplinary Reviews: Cognitive Science*, vol. 2, issue 6, Nov-Dec (2011).

Zangwill, Nick. *Aesthetic Creation*. Oxford: Clarendon Press, 2007.

Made in the USA
Monee, IL
24 September 2023